	•		

TATTOO

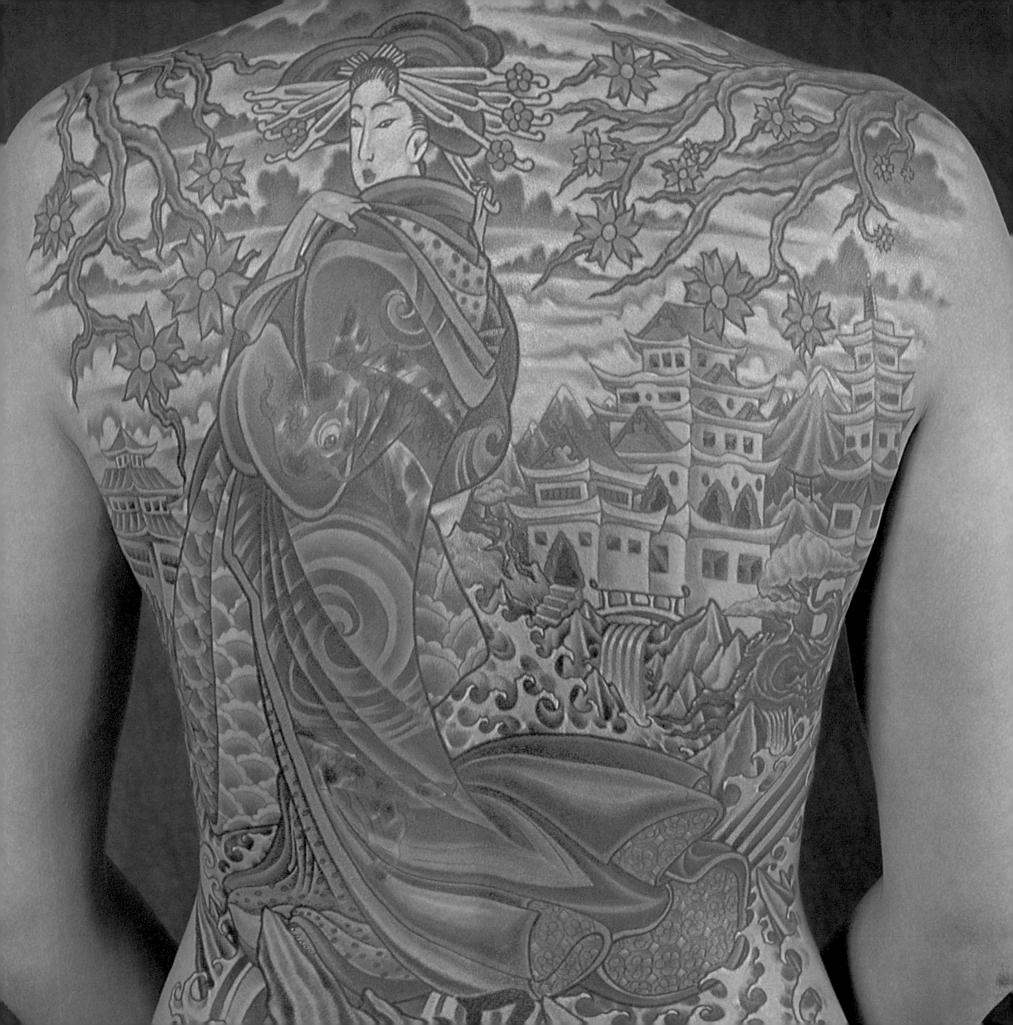

DALE RIO & EVA BIANCHINI

This edition published in 2004 by Greenwich Editions The Chrysalis Building Bramley Road, London W10 6SP An imprint of Chrysalis Books Group

Produced by PRC Publishing Limited The Chrysalis Building Bramley Road, London W10 6SP An imprint of Chrysalis Books Group

© 2004 PRC Publishing Limited

All rights reserved. No part of this publication may be reproduced, stored in a retrieval system, or transmitted in any form or by any means, electronic, mechanical, photocopying, recording, or otherwise, without the prior written permission of the Publisher and copyright holders.

ISBN 0 86288 648 I

Printed and bound in China

Jacket Acknowledgments:

Front cover, left to right, top row: © Dale Rio, © Doralba Pincerno, © Dale Rio. Bottom row: © Doralba Pincerno.

Back cover, left to right: © Chrysalis Image Library / Simon Clay, © Dale Rio, © Dale Rio.

Picture Acknowledgments:

The publishers would like to thank Dale Rio (www.dalerio.com), Simon Clay, and Doralba Pincerno (www.doralba.com) for contributing photographs to the book.

© Chrysalis Image Library / Simon Clay 5, 17, 18, 19, 22, 26, 29, 46, 58, 72, 73, 76, 77, 85, 86, 88, 93, 100, 101.
© Dale Rio 2, 7, 9, 10, 11, 12, 14, 15, 16, 21, 24, 25, 28, 30, 33, 36, 37, 38, 39, 45, 48, 49, 50, 51, 52, 53, 55, 56, 57, 61, 62, 63, 64, 65, 66, 67, 68, 69, 70, 71, 74, 75, 79, 81, 82, 83, 84, 90, 91, 92, 94, 95, 96, 97, 98, 99, 102, 103, 104, 105, 106, 107, 108, 109, 110, 111, 112, 113, 114, 115, 116, 117, 118, 119, 121, 122, 123, 125, 126, 127.
© Doralba Pincerno 6, 8, 13, 20, 23, 27, 31, 32, 34, 35, 40, 41, 42, 43, 44, 47, 54, 59, 60, 78, 80, 87, 89, 120, 124.

Chrysalis Books Group Plc is committed to respecting the intellectual property rights of others. We have therefore taken all reasonable efforts to ensure that the reproduction of all content on these pages is done with the full consent of copyright owners. If you are aware of any unintentional omissions please contact the company directly so that any necessary corrections may be made for future editions.

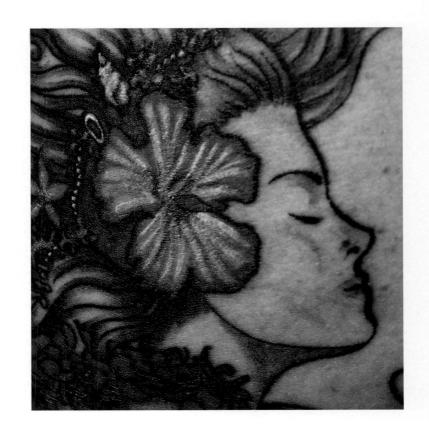

INTRODUCTION	7
THE LINE TO THE PRESENT	17
eastern influences	57
BLACKWORK	73
NEW SCHOOLTATTOOING	91
BEFORE GETTING A TATTOO	124
INDEX	128

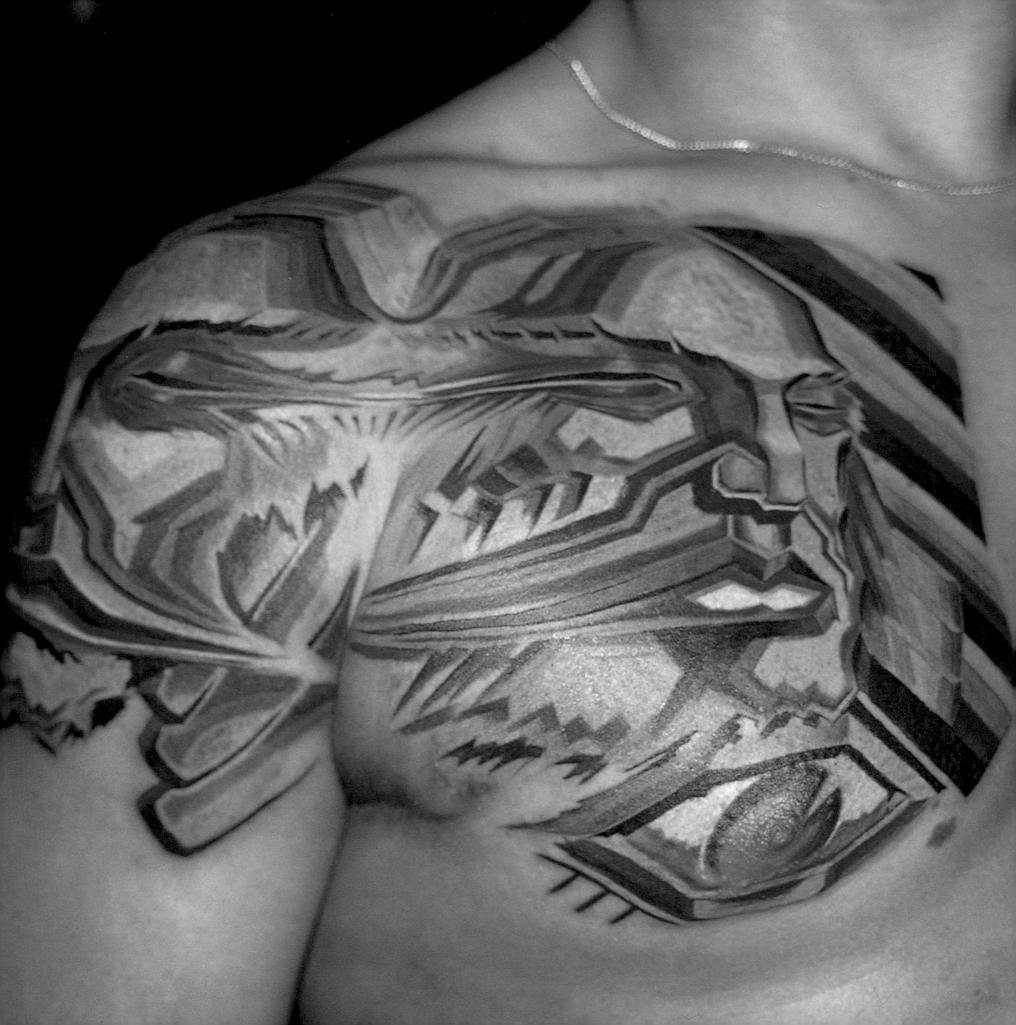

INTRODUCTION

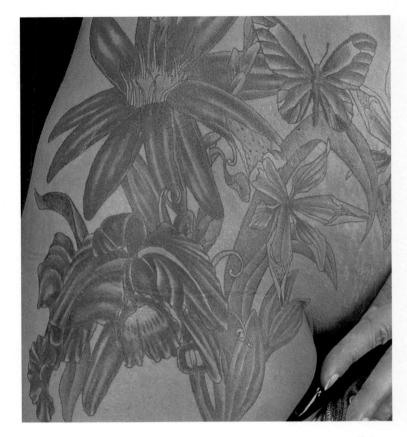

Above: Lisa Adams tattooed by Ken Lewis. This floral design extends across the stomach and leg and is complemented by a backpiece.

Left: Sergio by Waldi Wenner. This amazing tattoo shows just how the art has evolved away from standard "flash" designs in recent years.

"Tattooing has many facets, it's like a diamond. You can't see the facets from one view. You have to see it from all different angles. There is no formula to it. People get tattooed for different reasons. For some people, it's a mild rebellion. There is the peer pressure element. The word 'coward' has probably caused more people to get tattooed than any other reason. For some, it's a form of finding their lost tribal ancestry, so sometimes there is a cultural wave that causes a boom. Tattooing has changed radically over the years."

Lyle Tuttle—tattoo artist

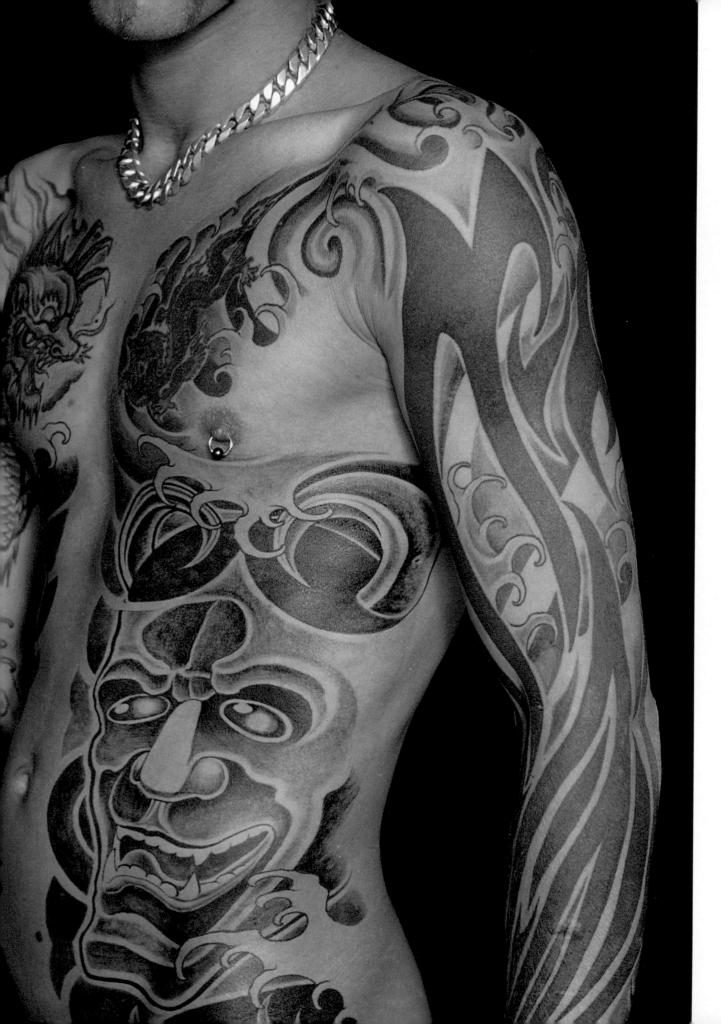

Left: Steffen by CTC, photographed at Berlin in 2001. Extending over the arms, torso, and legs this is quite major coverage, yet the consistency of the design work means that the tattooing works as a whole.

Right: Jennifer Chitwood tattooed by Josh Kilgalion. Inspired by Ink, in Columbus, Ohio. This tattoo is a contemporary take on a popular traditional sailor tattoo; the swallow. Such a reworking of older tattooing conventions is typical of New School artists.

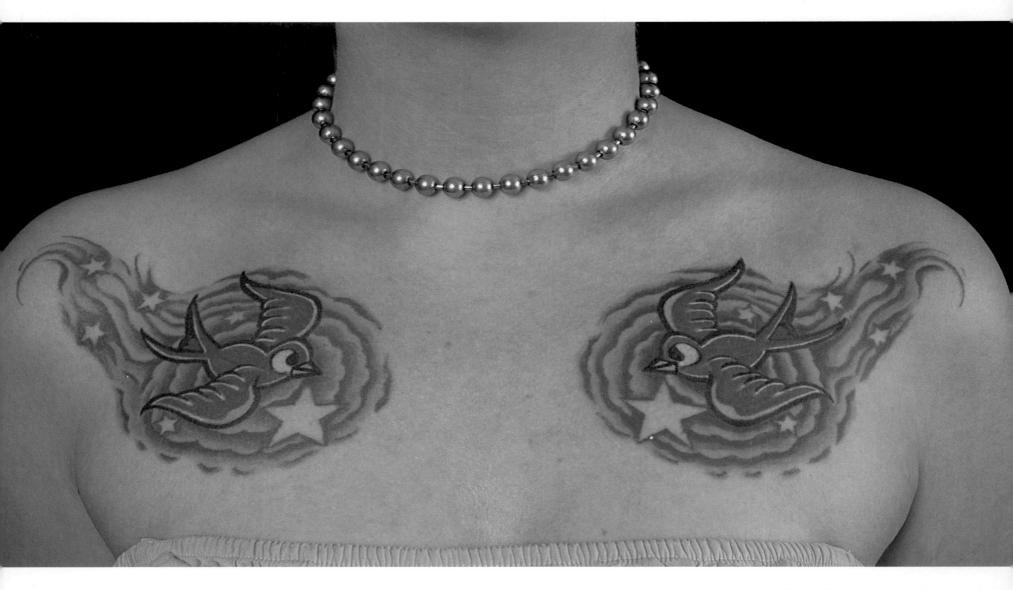

To pose the question, "What is modern tattooing?" is to pose a question with no single answer. It is true that tattooing has an extensively reported lineage and there is a wealth of literature on the subject available today, but to view any one book, article, or opinion as definitive would be naïve and incorrect. So many people, places, cultures, and events have marked the progression of the practice of ornamenting the skin with colored pigments that it would be impossible to define who was responsible for what style and when exactly it emerged.

The role of this book is not to tackle the enormous history of tattooing or give a comprehensive account of its current trends; to do so

one would almost have to talk to every individual with a tattoo, so diverse are today's styles. What is offered here is an overview of contemporary tattooing and a look at the factors that have lead to its overwhelming popularity at present. This book is intended to introduce the reader to the world of tattooing with a little look at its history and the development of today's varying styles, together with some speculation about what the future might hold. The text accompanies some beautiful examples of contemporary work and provides a little practical advice for anyone feeling inspired by these images and are considering getting tattooed. Most importantly the aim is to encourage and provoke the reader to ask their

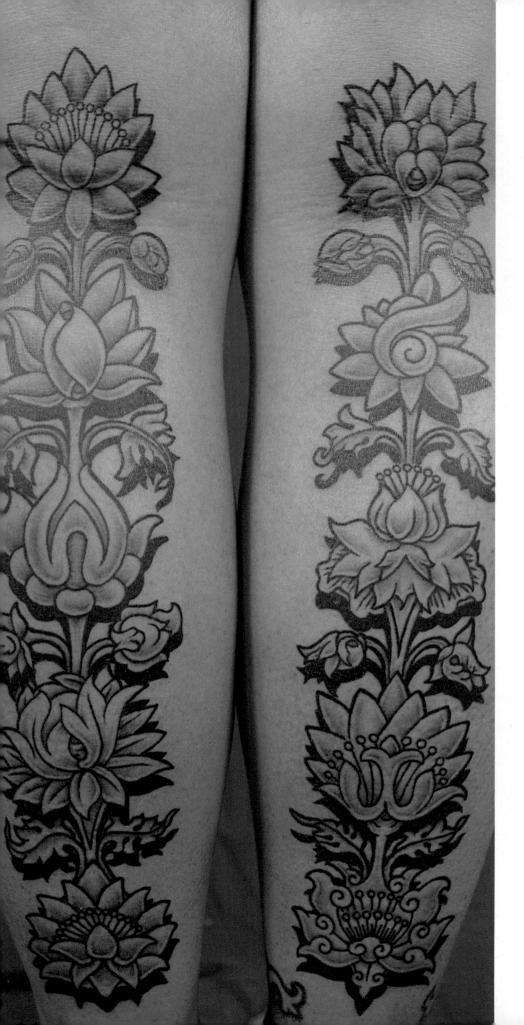

Left: Jackie Pullen by Neil Bass. These stylized floral designs in black ink are unique to the wearer. A comparison to the tattoo opposite will give an idea of the array of styles available today. Each design is inspired by flowers, but they are very different, though equally striking, in their execution.

own questions and to look for their own answers about the art of tattooing. With an awareness of the possibilities, anyone contemplating a tattoo might get a piece of work that is truly original and reflects their own personality, rather than simply picking a "flash" picture from the wall of a tattoo parlor whose work would not suit their desires.

So, what do these tribal or primitive markings and decorations mean in a Western society? What drives Westerners to have tattoos inspired by those seen in the South Sea islands hundreds of years ago or in Japan or Egypt? What is the point of having Manga cartoon characters or ferocious beasts pricked into your skin? Why are so many people spending their time and money on having an artist inflict pain in order to have an indelible mark upon their body?

The answer to this is to imagine the body as a canvas, an artistic space to mix and match physical and cultural elements in defining who or what you want to be. It seems young Westerners have appropriated once underground practices to gain entry into a trendy club, with the tattoo a prerequisite at the door. Unlike the physical and symbolic violence of initiation rites in traditional societies though, these bodily alterations are the result of a conscious personal choice; literally wearing your heart on your sleeve. Or as you will find throughout this book, right across your chest.

Right: Vicki Whalen tattooed by Jack, from Fate in Columbus, Ohio. Flowers have been a staple of tattooing for generations. This delicate tattooruns down the spine and is extremely femin ne.

Of the millions of people who flirt with body decorating, the vast majority are fulfilling the desire for self-knowledge and recognition from others. There is, however, a paradox in this. From such a personal and permanent form of art one would expect to see a constant originality and innovation. In fact, the world of tattooing is something of a melting pot, drawing on body-altering techniques and styles long used by ancient cultures for purposes of religion or identity and still using styles that have been in vogue for decades, centuries, even millenia. They might now invoke aesthetics, spirituality, sex games, or the desire to belong to a group, but whatever the reason, the process of altering the body and putting it to the test comes down to playing with identity.

This reflects a profound change in Western culture, and a relatively recent one. The urge to assert oneself goes hand in hand with a desire to challenge social norms and values, and to advocate different ways of experiencing, feeling, and displaying one's body. Many fans of body art, piercing, and tattooing say they no longer accept the Western ideal of physical perfection that is forced down their throats by movies, TV, and magazines. While shooting a TV documentary, the tattooist Alex Binnie was asked why he chose to have the arch angel Gabriel tattooed on his back. In response he offered this immortal line, "Because I'm turning my body into an icon." It seems this is what we are all striving for—a sense of

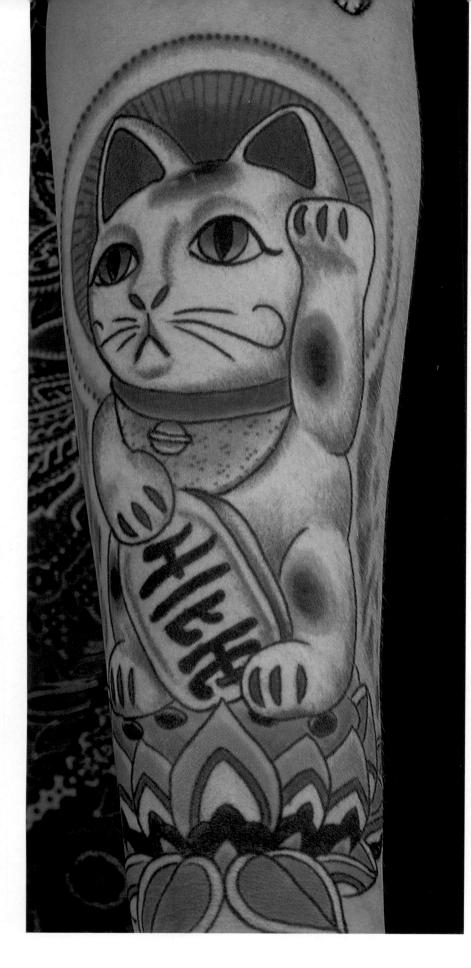

Left: Ceri Mackenzie tattooed by Josh Strader. A combination of modern cartoon influence and the Japanese style.

our own uniqueness, to make our mark... and in these days of mass markets and popular culture if we can't do that within our own society perhaps all that's left is our own skin.

This is a very exciting time for tattooing. Not only has it gained social acceptability in Western society, but the advances in inks and machine technology have made virtually anything possible. For as many people as there are making and collecting tattoos, there are as many styles. Collectors are moving away from simply picking flash designs off the wall and are having their tattoos custom designed by their tattooists. There are people who prefer the tried and true traditional tattoo styles, whether it be traditional American (or sailor style), Japanese, or tribal, and study the techniques and design meanings with the masters and old-timers. There are people who use traditional motifs as a starting point and incorporate their own particular vision into accepted subject matter. There are tattooists doing life-like portraits and wildlife scenes. And then there are people exploring new areas of tattooing, utilizing styles normally relegated to other artistic media, be it comic book art, graffiti-inspired work, cubist painting techniques, biomechanical or biomorphic artwork, or any other style historically restricted to painting or drawing. Collectors feel confident that no matter what they want to get tattooed on them, there is an artist who specializes in what they're looking for; if they want a portrait of their

Right: Armelle by Final Tribal, Valladolid, Spain. A splendid work of custom tattooing that draws inspiration from both Japanese style and tribal tattooing.

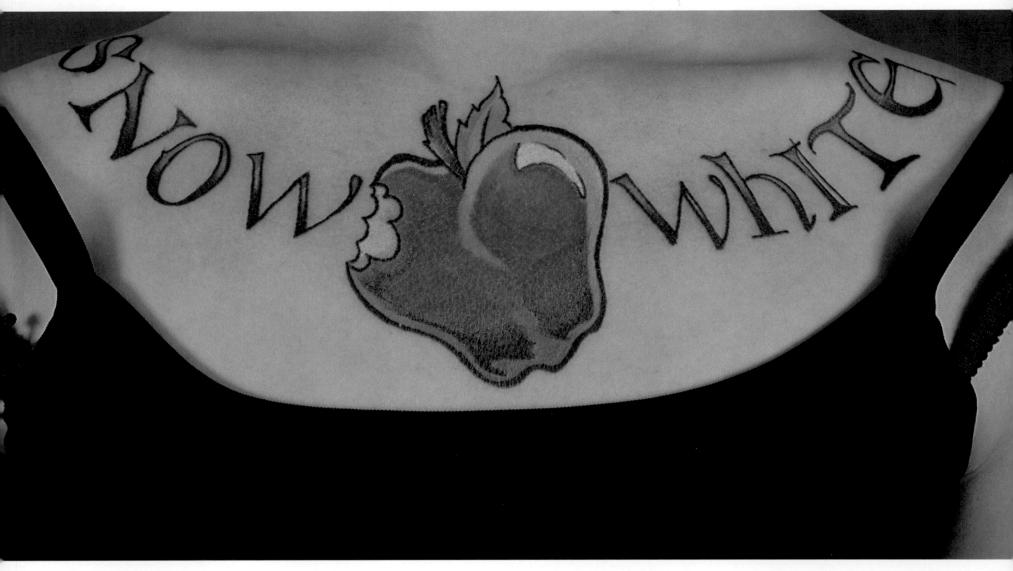

Above: A design on Kat Day by Frankie D., of the Tattoo Emporium, Florida. The use of lettering in tattoo work was very popular in traditional tattooing and, as with these images, this has been revived with a modern twist for a new generation.

mother copied faithfully, an event in their life represented symbolically, their favorite painting reproduced or book interpreted on their body, or if they want delicate black and gray wash or vibrant colors, there is someone who will happily fulfill their vision.

There are iconographic tattooists whose names are synonymous with the style they specialize in: say the name Paul Booth and people automatically think of dark, heavy, demonic scenes; Leo Zulueta translates to bold, large-scale, black "tribal" tattoos; Jack Rudy pioneered the East L.A. black and gray script styles; Tom Renshaw is the man to go to for photorealistic work; Guy Aitchison specializes in biomorphic, painterly

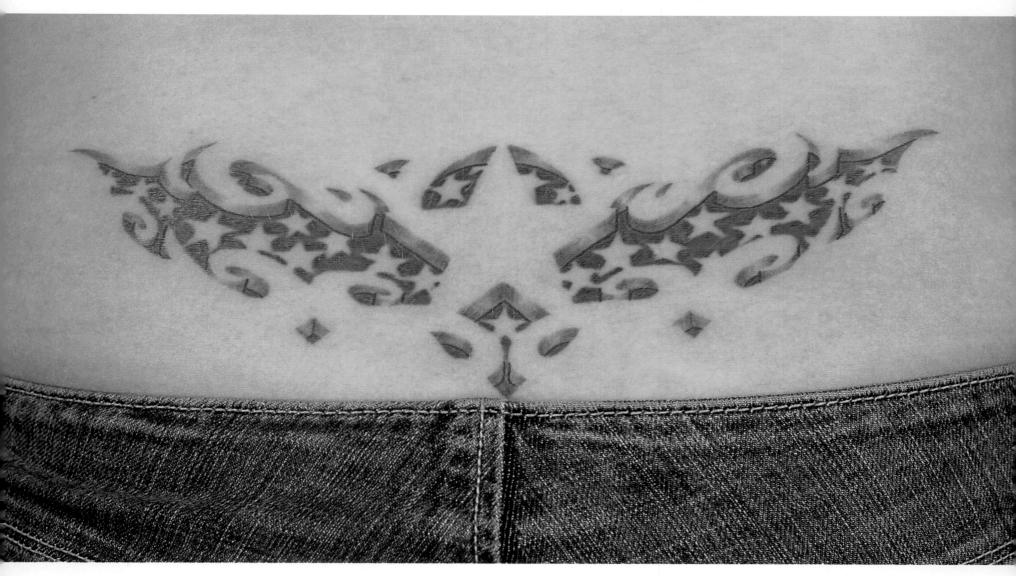

Above: Jennie Webster tattooed by Cory
Ferguson, Way Cool Tattoos, Oakville,
Ontario, Canada. Like many tattooists Way Cool
still offer a large selection of flash tattooing, but
are proud of a team that can offer a broad
range of styles for those seeking a customized
tattoo. This piece is simple but effective, and
takes stars as its theme.

pieces. There are scores of exceptional, younger tattooists, in their twenties or thirties, focusing on the time-tested traditions as well as developing their own personal style.

The observations and photos in this book are by no means the be all and end all of what is going on in the world of tattooing today; they're restricted to the cities that the photographers have visited and to those tattooists who attend tattoo conventions. We realize that there are many top artists who don't work conventions, and unless we've heard of them through other channels, our access to them is limited. Our apologies in advance to anyone who may feel like they've been overlooked.

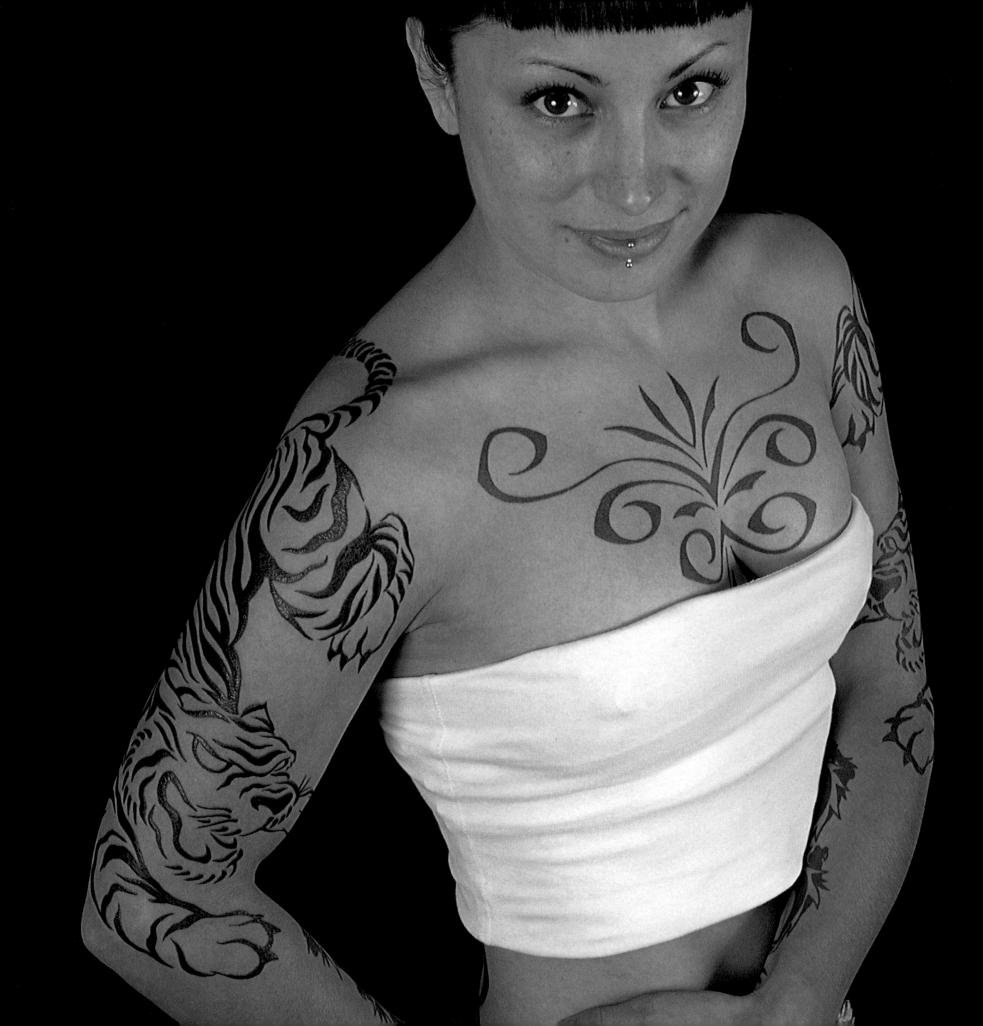

THE LINE TO THE PRESENT

Above: An abstract blackwork design which takes its inspiration from ancient tribal tattooing. Such work became fashionable from the beginning of the 1990s and is still immensely popular.

Left: Lisa M. Duhl tattooed by Matt Victor: Lisa has symmetrical blackwork designs on her upper body, including tigers going from each shoulder down her upper arms.

Tattooing is everywhere in today's society, with people from all walks of life being inked in a vast array of styles. Skateboarders, supermodels, punks, businessmen, mothers... where once tattooing in the West was the preserve of circus freaks or those on the far fringes of society, now there are very few demographics where tattooing is disdained. One estimate suggests that in the U.S. alone, one in seven people has a tattoo. Not all are obvious—while some wear their tattoos very publicly, many more prefer subtle work that only a few will know about.

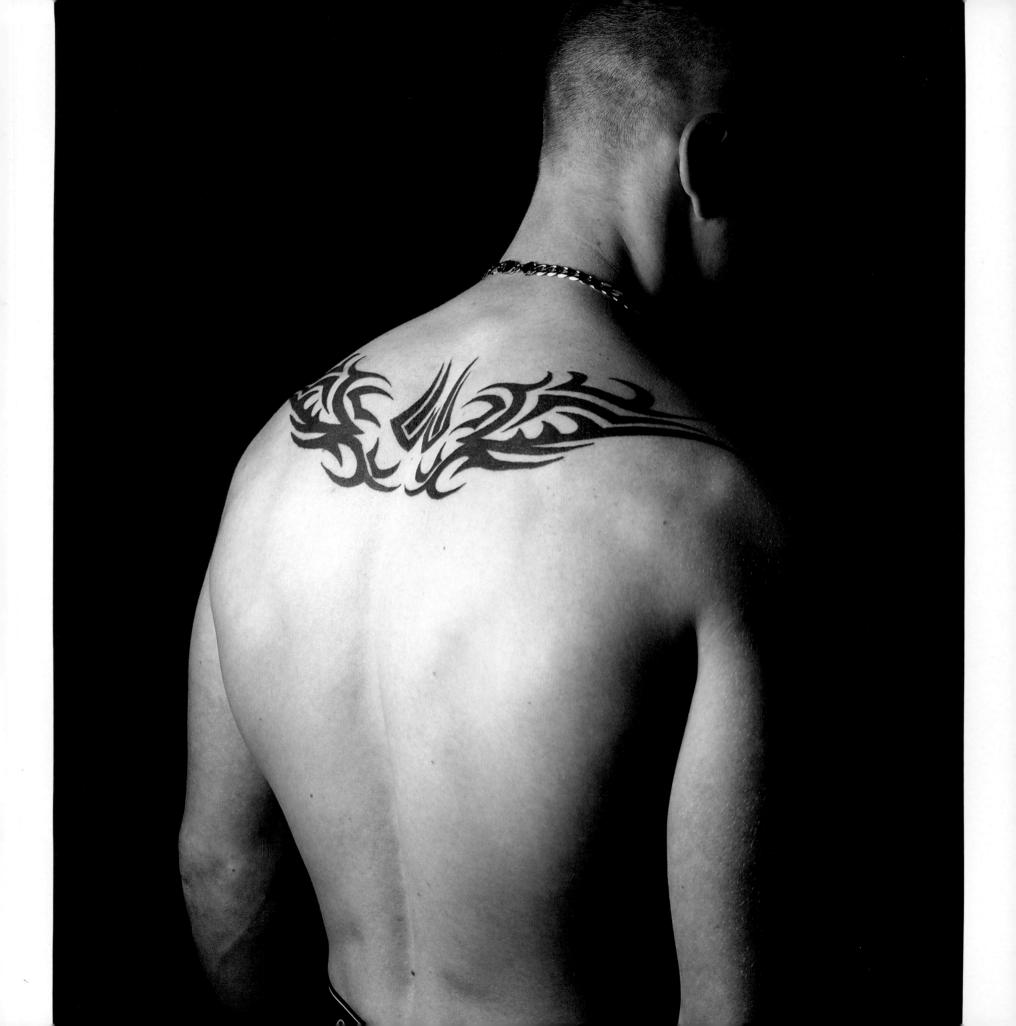

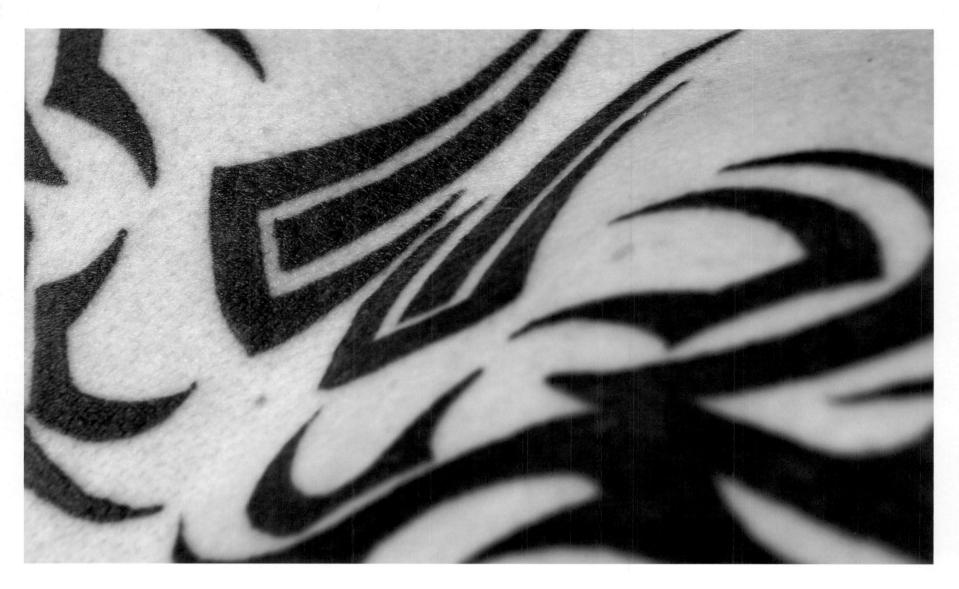

Left and Right (detail): This tattoo by Simon Read at Scribe Tattooing, in the U.K., is representative of a lot of today's tattooing. Influenced by both Celtic and tribal work, it is simply an attractive design that suits the wearer. The shoulders are one of the most popular areas for a tattoo.

Whatever the tattoo is and wherever on the body the collector chooses to have it placed, however, it seems that there is a growing awareness of what is possible with tattoo art. There is a proliferation of tattooists, many of whom are considered masters of the art, celebrities in their own right, with clients booking months in advance and crossing continents in order to get a piece of their work. The art of today's best tattooists might combine traditions from around the world with their own style to lesser or greater degrees, creating a modern body of tattoo art around the world that is

Left: Natividad by One More Tattoo. This discreet tattoo is another example of the popularity of the flower.

phenomenally creative. From Los Angeles to Sydney, London to Berlin, tattooing is enjoying a popularity unthinkable a few years ago. Barriers of gender, class, and wealth have also been breached. Today, one is just as likely to find a wealthy young female socialite with a fine tattoo as anyone else.

With such a dynamic modern scene it would be easy to think of tattooing as a relatively modern concept. However, it is valuable to remember that the art is as old as civilization itself and even a brief look into its history is worthwhile for anyone who either has or is considering a tattoo. In fact, to have a tattoo is to be a part of a story that stretches back thousands of years. A tattoo connects the owner to a lineage that includes people from all over the world and throughout human history, from Siberian princesses to American circus performers. And it's amazing how relevant the millennia of tattoo history is today. For example, though we may not now mark criminals with tattoos or view them as inherently evil (though it's arguable that this legacy lives on in the fear that some people feel when meeting a tattooed person), there is still something of an "outcast" connotation to the tattoo.

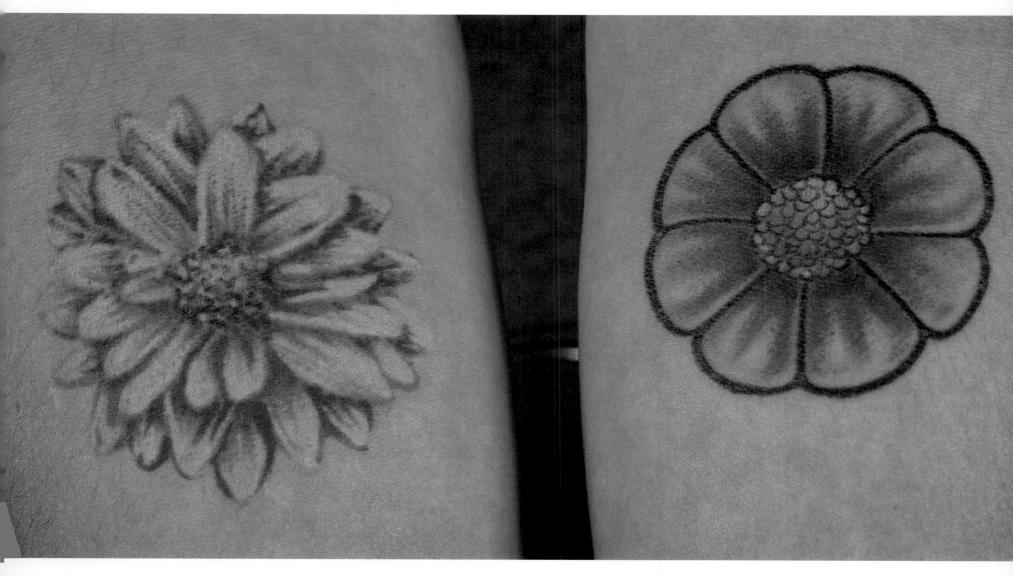

Above: Another popular floral design. A revolution in tattoo designs has meant that tattooing has cast off many of its old connotations. Art such as this has come a long way from the days of anchors and swallows, and tattoos are now just as likely to grace a model as a sailor.

Right: A series of Mayan themes adorning Tom, by Pier Tatu of Temple Tatu in Brighton, U.K. 22 Tattoo

Right: Mike by Waldi, photographed at Barcelona 2000. This stunning piece of work takes its inspiration from the work of abstract art.

Tattooing and other forms of body modification such as piercing and scarification are inextricably tied to human concepts of aestheticism and identity. Such practices are part of overall body decoration and adornment, which are similarly illustrated by costume, hairdressing, and cosmetics. All of these forms of personal expression are rooted in the individual's idea of social conformity and affiliation. They symbolize a commitment to a group or a concept and are a visible sign of that commitment, whether the tattoo is worn loud and proud by a biker, or as a secret sign of gang membership.

Since tattooing appears to have developed simultaneously worldwide, in such far-flung places as Peru and Egypt, it is unlikely to have

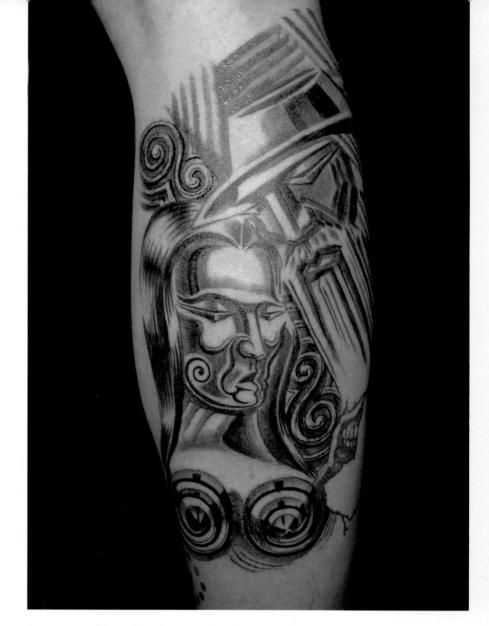

been spread by migrating peoples, though this is a common theory. From what can be gathered through archeological evidence, it more probably developed as a reaction to the circumstances affecting the peoples who first began to tattoo themselves. Although there are convincing arguments for tattooing being over 10,000 years old, the earliest known firm evidence dates back to ancient Egypt where records of tattoos can be reliably traced back 4,500 years (around the time of the great pyramid building), though it would seem obvious that tattooing was first practiced even earlier than this. The oldest preserved tattoos from this period are from Thebes, during Dynasty XI, about 2,160 years ago. These tattoos are from a preserved

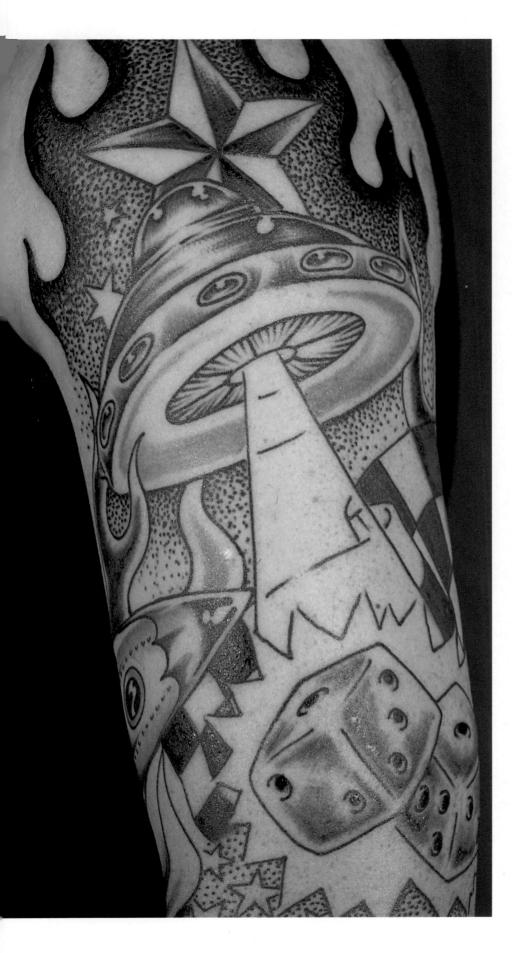

Left: Brett Jones tattoed by Adam Dutton in Derby, U.K.

mummified female and comprise of a series of "abstract patterns of individual dots or dashes randomly placed upon the body." The earliest tattooed Egyptian mummies are of people who seem to have been associated with Nubia, and indeed, Nubian mummies discovered in Kubban and dated to 2000 BC, display similar tattoos to the Egyptian finds. More recent excavations at Aksha uncovered tattooed mummies of both adolescent and adult women with similar tattoo patterns, but at a much later date of 400 BC.

It is significant to note that most early examples of tattooing are on women, which shows a distinct mind-shift through history, as until recently tattooing had become associated with men. In short, tattooing may once have been the sole preserve of females. The women of today who are being tattooed with as much confidence as men are simply reclaiming their heritage!

The motivations behind the tattooing of indigenous people are as varied as the races themselves. Anthropologists have in the past suggested that some tattooing from the period in Eygptian history known as the "Middle Kingdom" (about 2000 BC) may have had erotic overtones. There may be connections between the tattoo traditions and the goddess Hathor "the most lascivious of all Egyptian goddesses."

Right: Casey Romey tattooed by Durb Morrison and Dave Ski at Stained Skin, Columbus, Ohio.

However, contemporary opinion differs on this view of the ancient world. Clay figurines found from that period show decorations of dot and diamond-shaped patterns often interpreted as tattooing, though they may in fact be body painting or scarification. Such decoration may have been more to do with vilifying enemies than the glorification of sexuality. Some have interpreted these figurines as a depiction of the divinity Bes, associated with the household and employed as a protective talisman.

Elsewhere in Asia, Scythlan bodies from frozen burial mounds in Southern Siberia were recovered with elaborate and extensive tattooing. At Pazyruck, bodies of a Scythian "princess" and "chieftain" have been excavated. The pair date back over 2,500 years and have patterns of tattoos that are highly elaborate. Natalie Polosmak, the excavator of the "Princess" speculates that, "the tattoos may contain some kind of code. They may say something about her life." Body art, then as now, is more than just decorative.

In Japan, tattooing was known by 600 BC. Clay figurines from the Jomon (c. 10,000–300 BC) and Yayoi (c. 300 BC–300 AD) periods show markings which have been interpreted as either facial tattoos or scarification. Also from the Yayoi period, a reference from Chinese dynastic histories compiled by Chien Shou in 297 AD refer to the inhabitants of

Left: This tribal tattoo on the ankle and foot is evocative of original designs that have been used in the South Pacific since time immemorial. The use of this style in the West was pioneered in the early 1990s by a group who wished to display a connection to a more environmentally harmonious culture.

Right: In a similar way to tribal tattooing, this Tibetan mantra connects the wearer to an ancient spirituality.

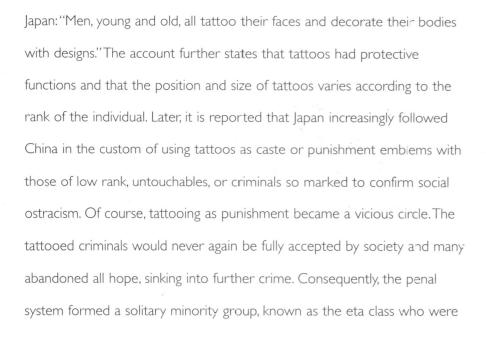

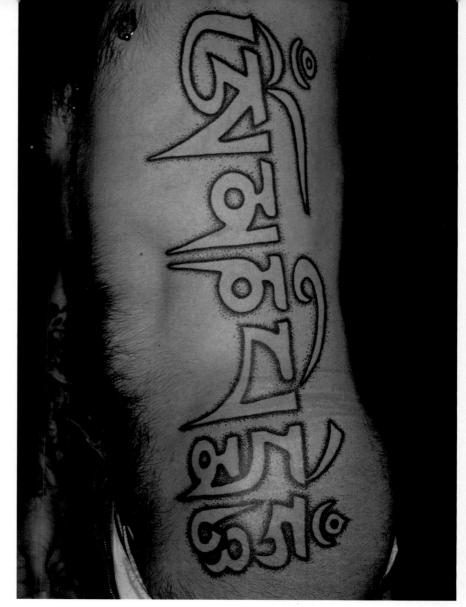

social outcasts and a person with a tattoo was generally feared by society at large.

The decorative traditions which we now associate with Japanese tattooing developed much later—in the seventeenth century—though they are still associated with the Japanese underworld, the Yakusa. Conversely, in the West, Japanese-style tattooing is regarded as high art and tattoos in the Japanese style are highly sought after.

Moving across Asia and into Europe, an "ice man" found in the Austro-Italian Alps in 1991, possibly dating back some 2,500 years, represents another example of some of the earliest archaeological

Left: Richard Serena tattooed by Fabrice,
Screaming Needle, Lyon, France. Mermaids were
another motif often seen in traditional Western
tattoos, due to the popularity of tattooing among
sailors.

Right: Jez by Simon Read at Scribe Tattooing. This style is more directly connected to the Western tradition, though its execution is more thoughtful and delicate than would have been usual in the past.

evidence for the practice of tattooing. In this instance it is believed that the tattooing has strong talismanic connections. The "ice man" had a series of bands tattooed around his knee and elbow joints and could be interpreted as protection against the effects of disease or misfortune.

In Europe, very early body art was arguably practiced by, among others; Ancient Britons, Thraciens, Gauls, and Germans. In Greece there is mention of the art of tattooing in works by writers such as Cicero and Herodian. The Romans too had an interest in tattooing, with great authors such as Virgil, Seneca, and Galenus reporting how criminals and slaves were marked as a stigma. There are also reports from Roman authors that groups such as the Picts were tattooed or painted, though this may in fact simply be a case of the authors attempting to depict Rome's adversaries as savage or criminal in nature; there is little actual evidence that the Picts were tattooed.

Early Christians tattooed a cross on either their arms or face (much as Coptic Christians in Armenia, Abyssinia, Syria, and Russia do today).

However the tradition fell out of favor in the West and, rather strangely given the nature of the markings, even came to be considered a sign of paganism. Later still, any tattooing on the face was forbidden by Emperor Constantine and in 787 AD, a Council of Churches meeting at

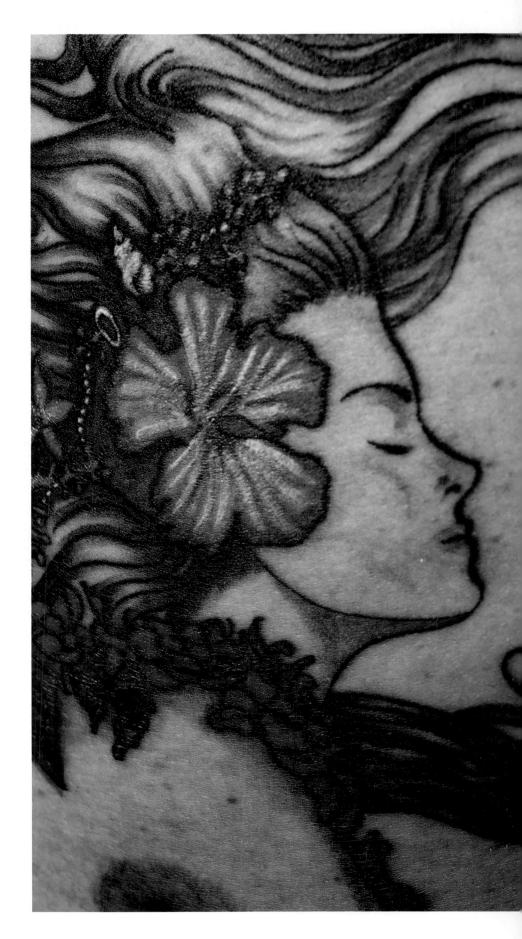

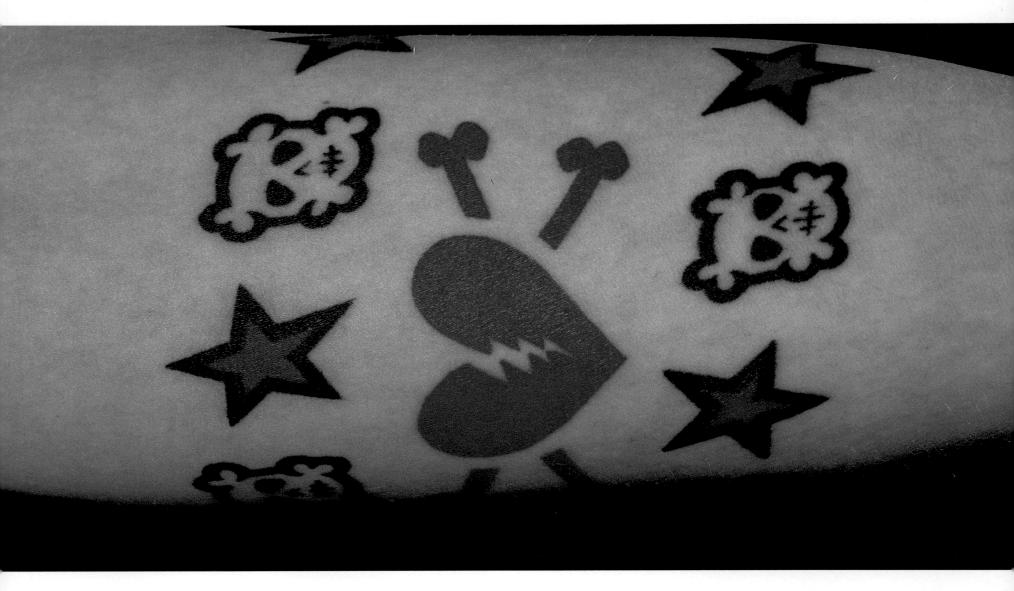

Calcuth in Northumberland, England, prohibited all forms of tattooing anywhere on the body.

At that time the power of the church across Europe was consummate and this edict gave rise to suspicion of anyone with a tattoo. They were viewed as outside of society or even evil. From this time in Europe tattooing was rejected, and abhorred and began to decline "almost to a point of disappearance during the Dark and Middle Ages in Europe." It would be centuries before the art again found some kind of acceptance.

In fact, the history of modern tattooing in Europe, and subsequently America, can be traced back to the first adventures into the

South Pacific, and especially the voyages of Captain Cook in 1769. Cook, having visited Polynesians with a rich tattoo culture even brought back the word "tattoo" (derived from the Tahitian *ta tau*, "to mark"). On his return to England, Cook described the traditions and tattoo patterns of Polynesia with accuracy and enthusiasm, and generated considerable interest across Europe.

Western notions of body art were colored at the time by the idea of the "painted savage." Into this category now came the tattooed sailor, the first Westerners ever to be influenced by Polynesian tattoo culture.

These European sailors and adventurers whose enthusiasm for tattooing

Left: Ryan Hardwick tattooed by Justin Urban-Style, Atom Bomb Tattoo, Willoughby, Ohio. This very contemporary design was executed by a tattoo parlor that now only undertakes custom work, producing a personalized tattoo for each and every client.

Right: Mario by Massimiliano, photographed at Rome 2003. As with the tattoos on the previous pages this piece can trace its ancestry back to "sailor style" designs of previous generations. However, it has a very modern feel, more akin to the artwork from a graphic novel than a traditional tattoo.

surfaced during their very first encounters with Polynesian culture, employed this form of decoration spontaneously as an "expression of class position, lifestyle, or the mariners habitués." These, then, were the first people in the West to wear a tattoo as art, and in order to express themselves.

In the island societies from whence it came, tattooing was the norm and played a "key role in the construction of the person." In Tahiti for example, women may have been tattooed to indicate that they had a certain skill, such as weaving. The tattoo would have been a visible symbol of her prowess and would have made her much more attractive as a

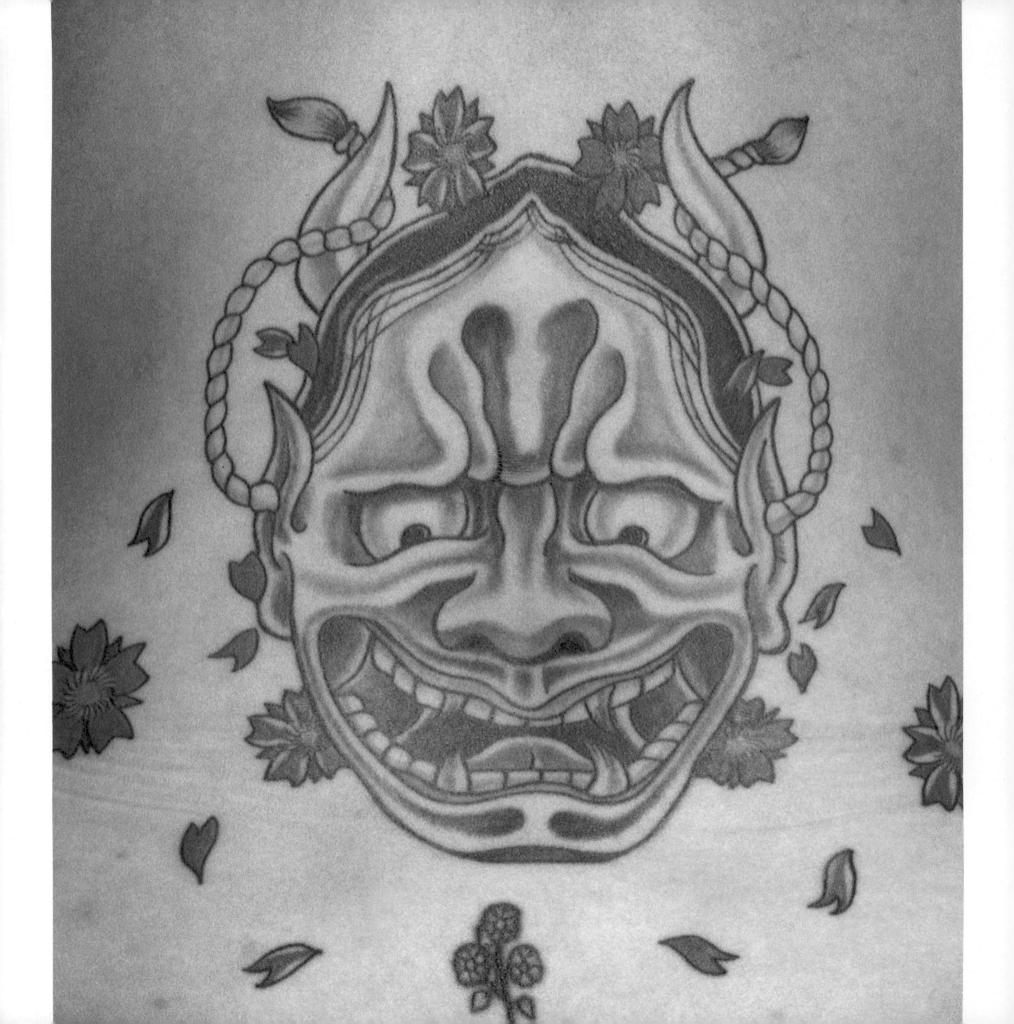

Left: Sandrijn by Marco Bratti, photographed at Berlin in 2002. This playful design takes its inspiration from Oriental mythology.

Right: The carp is a common motif in Japanese inspired tattoos.

marriage prospect. In Polynesian countries such as Hawaii, New Zealand, the Marquesas, Samoa, and Melanesian Fiji, the people, while not sharing a cultural reason, exhibit a strong similarity as body art is used as a means of expression and communication within society.

Back in Europe, although tattooing was now becoming increasingly popular with the lower classes it was still generally frowned upon in "polite" society in both Europe and the United States. In the mid to late nineteenth century however, for a short period, tattooing was considered the height of fashion among European nobility. Edward VIII, the Czar Nicholas, King Frederik of Denmark, and the infamous Prince Constantine of Albania, among others, were decorated and a discreet tattoo was considered *de rigeur* for men.

In 1891, the first electric tattooing machine was patented, and this development effectively revolutionized the tattooing process. Prior to this all tattoos had been executed by time-consuming hand techniques.

Tattooing at this time was mainly the preserve of traveling artists, with information on techniques often circulating via an "underground communication network." This new technological advancement more than any other, before or even since, had a profound effect upon the style and the possibilities of design. In fact, the simple tattoo apparatus is

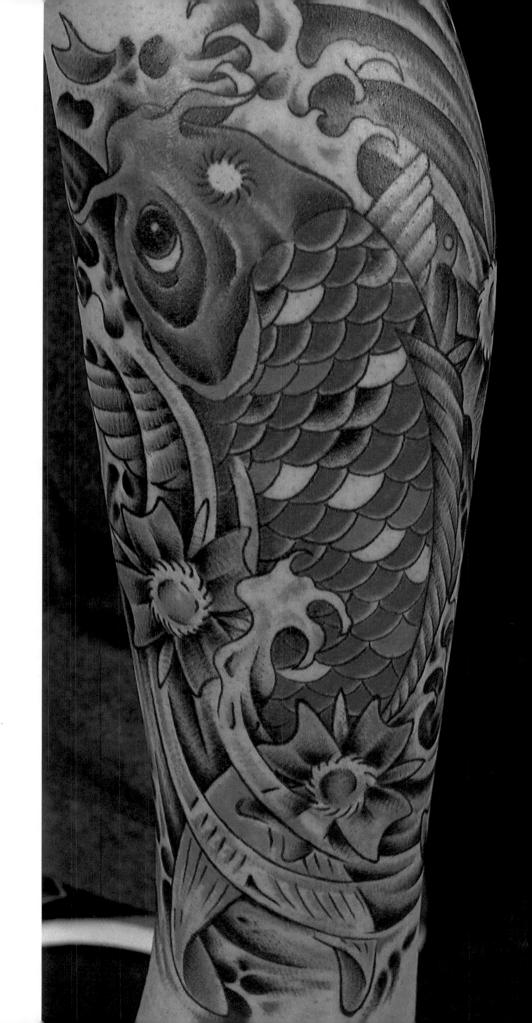

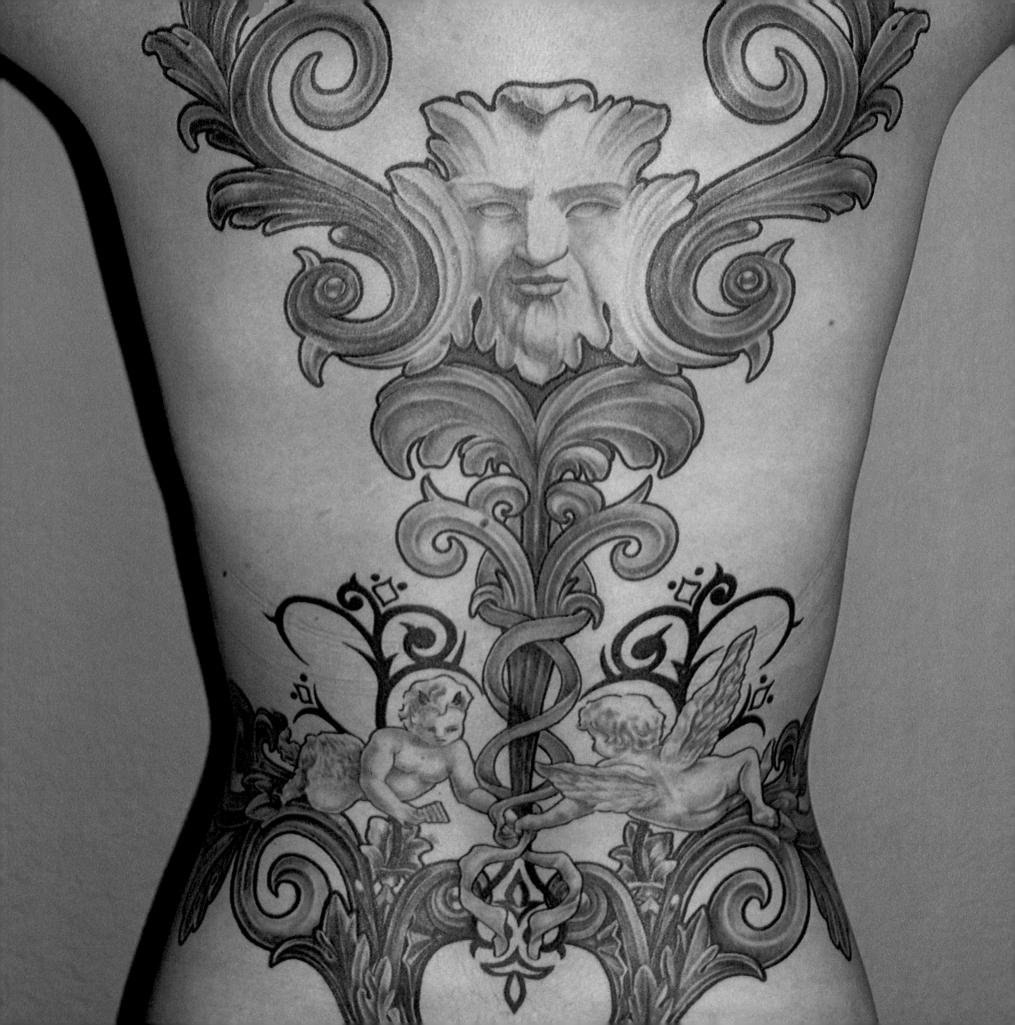

Left: Bianca by Errol Inkstitution, Rotterdam. A tattoo that mixes the anc ent symbol of the green man with pre-Rapaelite cherubs. The green man symbolizes the power and wildness of nature, while in Christian iconography cherubim symbolize divine wisdom and innocence.

Right: Fozzie by Darren Stares. The very masculine tattoo style is popular, and this design is particularly well done.

The Line to the Present

Left: Michelle Corwin tattooed by Gunnar, Gods & Monsters, Columbus, Ohio. People get tattoos for very different reasons. This new school tattoo is highly personal and part of a sleeve that tells a story of the pain of growing up with a very abusive, drug addicted brother.

Right: Christine Ostrander tattooed by Jack Kat, Primal Graphics, Albany, New York. This extreme but amazing haunted house tattoo wouldn't be for everyone.

still basically the same now as when it was first produced, though it is much improved.

Many early tattoo collectors became part of the very distinct subculture of circus or sideshow performers. Most fabricated lurid tales about how they acquired such body art. Typically they had been "captured" in exotic locations and "forced" to undergo the life-threatening art of tattooing. Performers such as Annie Howard, The Beautiful Irene, Lady Pictura, Creola, Miss Stella, and Don Manvelo adopted exotic dress as well as outlandish tales to attract audiences.

The tattoos were often in similar styles—scrolls of words among decorative vignettes of hearts, animals, and flowers. This came to be known as the "American manner" of tattooing. It was a highly stylized form and bore messages such as "Nothing without Labor," "Never Despair," and "Death before Dishonor." As a style it became increasingly conventionalized and widespread and is now commonly known as the "International Folk Style."

The fairground attraction element of tattoo subculture flourished until World War I, when, as tattooing became more common in the general populace, interest wore off. There were exceptions of course. In the English circuses, a post-war figure called The Great Omi who boasted

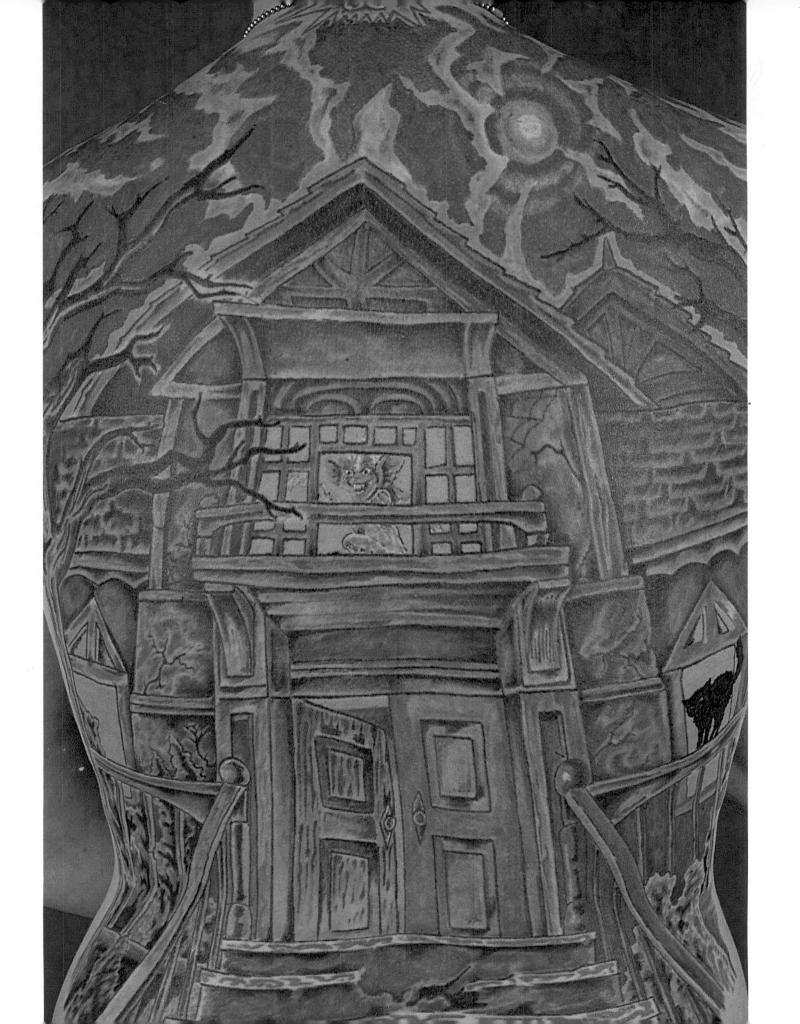

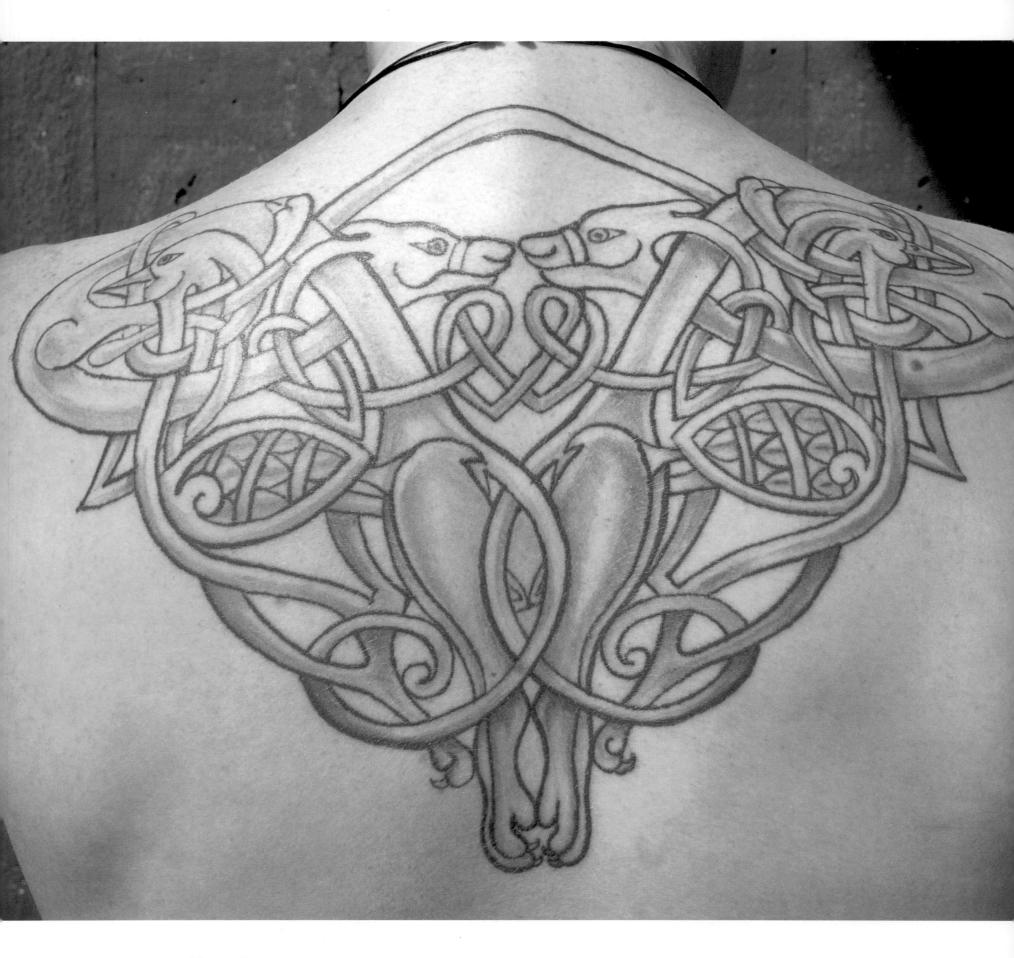

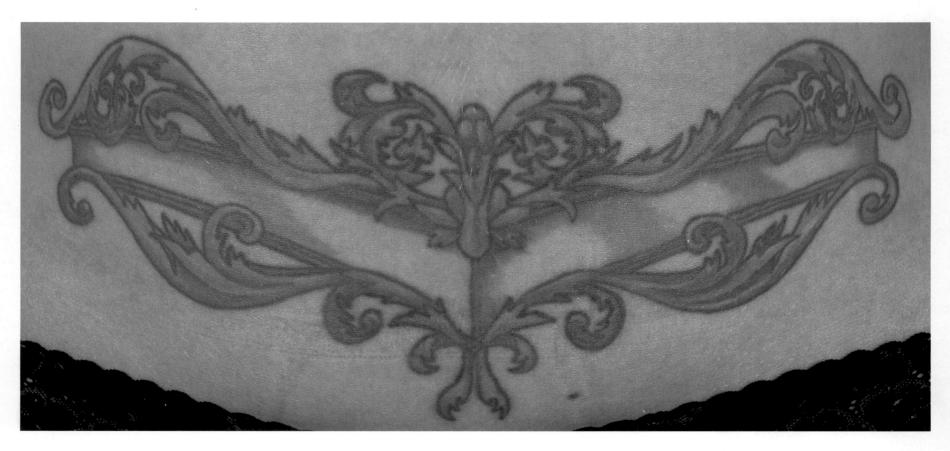

Left: Lana Raill tattooed by Bernie Shaw, Tauranga, New Zealand. This is an excellent example of tattooing derived from Celtic designs, which can be seen as the forerunner of tribal tattooing.

Above: Suzanne Beam tattooed by Chip, Gargoyle Productions, Athens, Pennsylvania. A black and gray piece in the gothic style.

zebra-striped tattooing proved a popular attraction for many years. Today, however, this tradition is almost dead, due primarily to the decline of circus in general and also the fact that extensive tattooing is no longer such a rarity. Despite this there are a number of people who have managed to carve a niche, often due to the "extreme" nature of their performances. These include the late great Michael Wilson formerly of Bradshaw's Circus of World Curiosities in Britain, The Enigma of the Jim Rose Circus, and U.S. performance artist Ron Athey.

Generally, though, much of the twentieth century was a wasteland for tattooing. Disease epidemics in the U.S., mostly around New York,

which was the spir tual home of tattooing at the time, caused a disaffection with the art and for the following decades it would be the preserve of those on the extreme fringes of society. Notable among these were bikers, who emerged in the U.S. during the early sixties, and claimed tattooing as their own. These were often extreme figures, rejecting society entirely and living wild and violent lives. Tattoos were, and are, a big part of the biker lifestyle, and along with the notion that tattooing was somehow "unclean" this stigmatized the art for many years.

It was not until the late 1980s that the art began to stir again. In an effort to kick against the materialism and the body fascism of the day, San

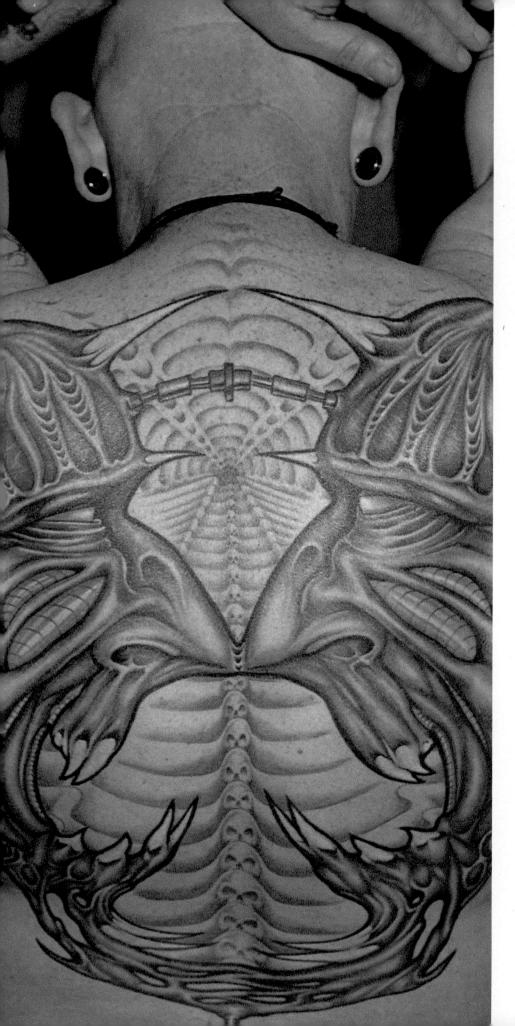

Left: "E" by Tom Rolo Mey. Monsters and demons were popularized by tattoo artists working in the 1980s, when they were highly regarded by heavy metal fans. This custom back piece shows how a good tattooist can produce work that rivals traditional illustration.

Right: Stuart by Mark, Chester, U.K. A tattoo with a fantastic "Tolkien-esque" theme, this has been executed in incredibly detailed line work.

Francisco skate punks turned to more ancient, honest cultures to mark their separateness and camaraderie. The "Modern Primitive" movement was born. Now middle class, educated white kids began to cover themselves with blackwork tattooing taken from the traditions of Samoa, Borneo, Maori, and Marquessia in a battle against what they saw as a creeping standardization in culture; a quest to escape a destiny spelled out in terms of sex, age, and social origin. In this way, tattoos came to have political implications. Global products and all pervading western ideologies have shaped our view of how the world is and how it is ordered. Body art in this world view was generally consigned to a very marginal position, "something that primitive people do," the caste mark of low status or the dispossessed.

The result of this stand against standardization has been the rise of custom tattooing. Previously, tattooists had relied heavily on the use of "flash"—the sheets of pre-drawn images commonly not even designed by the artist themselves but purchased via mail order and used as stencils for their work on skin. There was now a growing demand for a more personal tattoo. Kids started designing their own pieces, then buying their own machines and tattooing each other. This saw a huge growth in the number of shops and studios across the U.S. and Europe: within a few

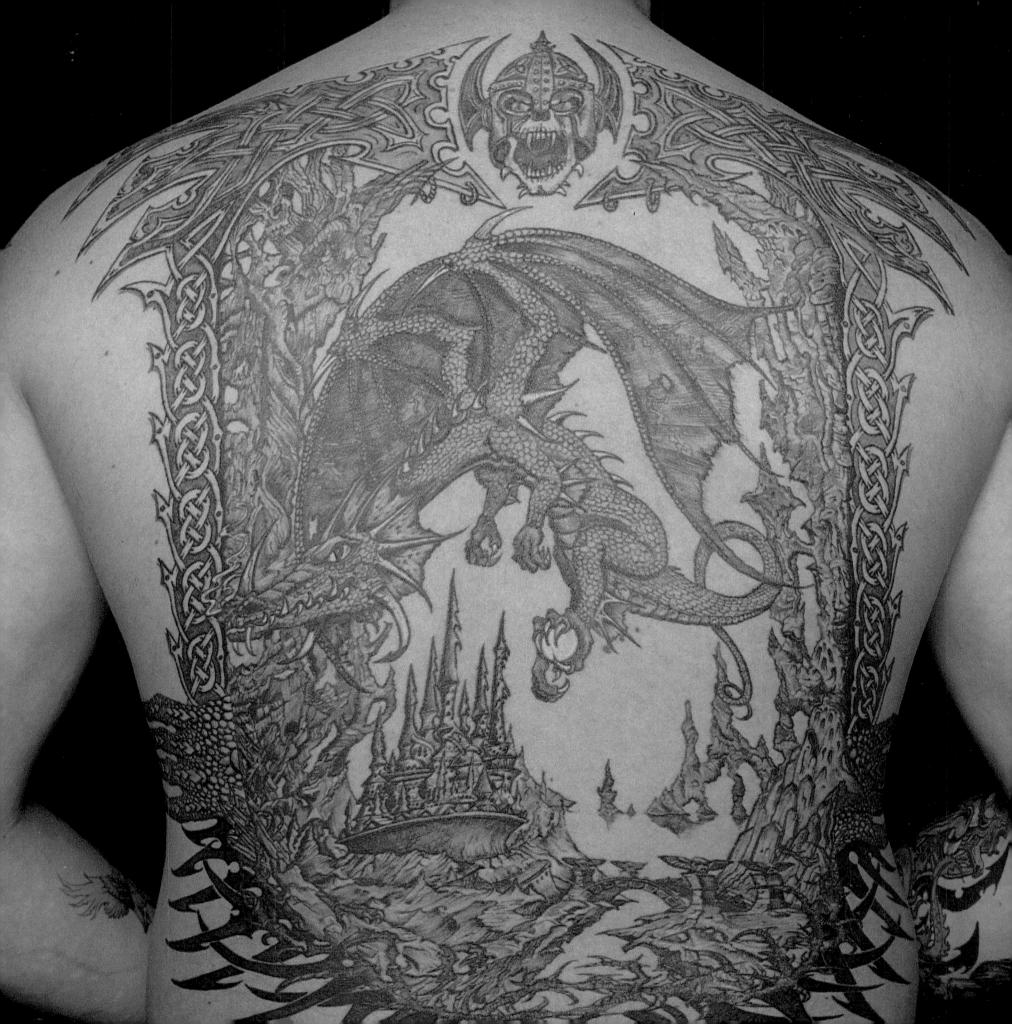

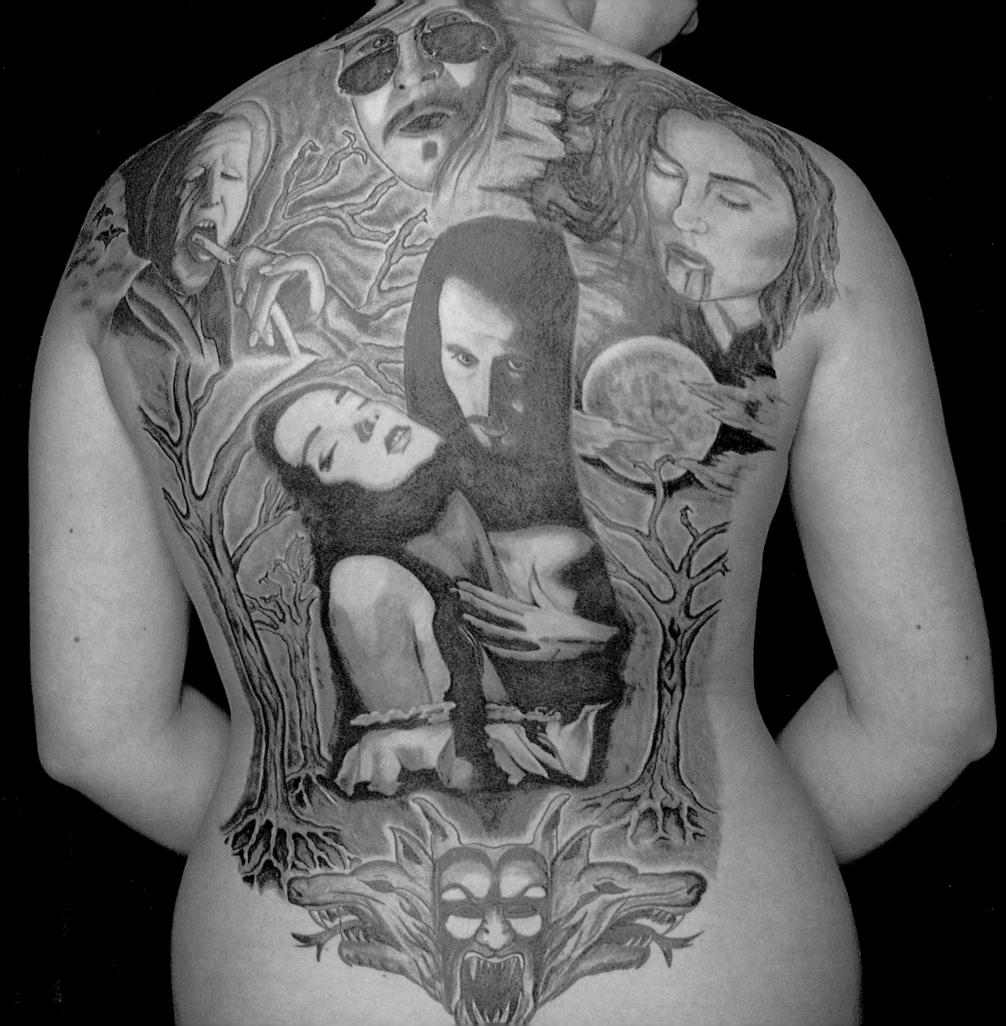

Left: Manuela by Crazy Needles, Germany. New techniques and better machinery have meant that the tattooist's palette is bigger than ever before. However, photorealistic images such as these are also the product of great talent, whatever one feels about the subject matter.

Right: Flavio by Diego Macri of Turin. Again, the subject matter would not be to everyone's taste but there is no denying the skilful and highly detailed execution of this Medusa.

short years the tattoo industry was no longer the preserve of the blue collar and the back room.

By shattering models, rejecting beauty standards circulated in the mass media, and asserting the right to do, wear, and display whatever they see fit, this avant-garde is holding up the body as one of the last bastions where individual freedom can be expressed. Throughout the 1990s the industry saw sweeping changes—new techniques pioneered by new artists, greater technical innovation, and a greater professionalism. Some see the process as a joining of the "upper and lower stratas of society... aristocrats, rock musicians, primitives, and criminals... come together in asserting their nonconformity to conventional middle class attitudes and values... a dissemination of unconventional, individualistic values, and also a reflection of better education, enhanced economic security, and openness to a wider range of experiences (including other cultures and subcultures through travel, music, dance, literature, food, dress, adornment etc.)." More simply, tattooing has become increasingly fashionable. By the turn of the new millennium what was once regarded as something of a marginalized practice had hit the mainstream. In an effort to assert their individuality and depth of

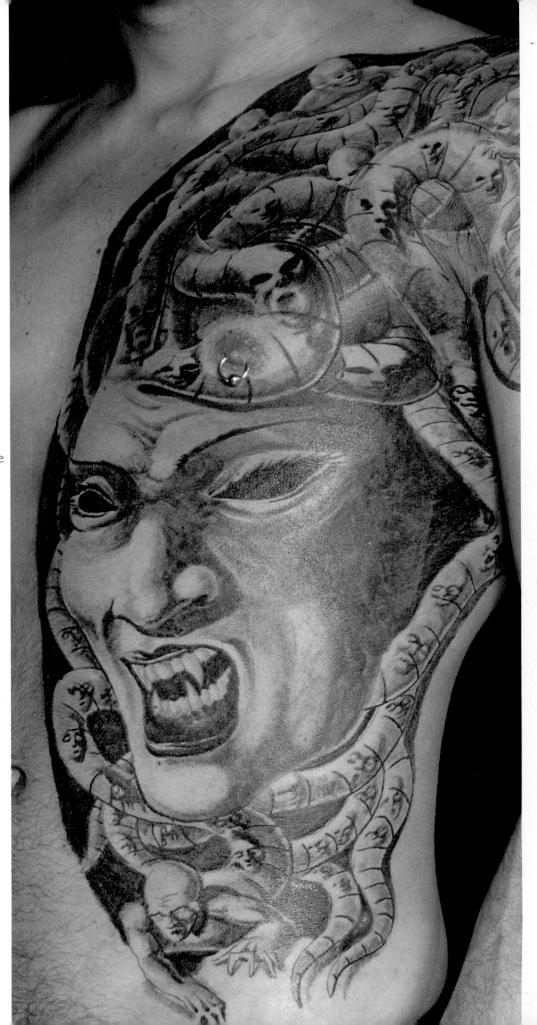

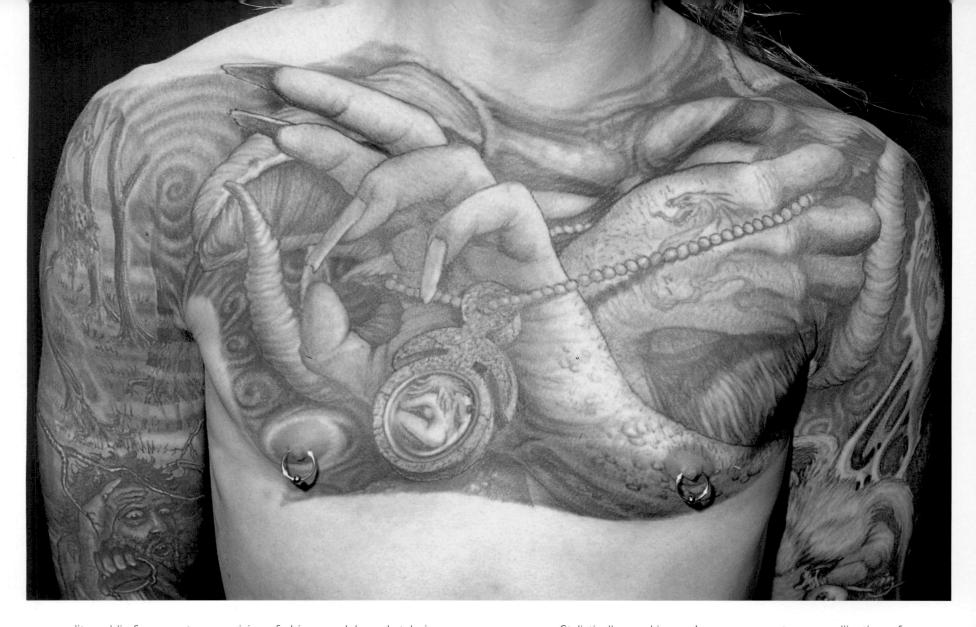

personality, public figures, actors, musicians, fashion models, and style icons adopted tattooing as badge of instant "cool." Today, more and more people from every walk of life are getting tattooed.

So where does the future of tattooing lie? Far from the ideals of the Modern Primitives we all in the West live under the shadow of global capitalism and its products. Body art has become commodified, a product, as much a fashion item as any item of clothing. In becoming so it has been divorced from its roots and connotations. In response many tattoo enthusiasts have taken the art ever further. Not since the days of the sideshows have we seen westerners exhibiting such extensive bodily

coverage. Stylistically speaking we've seen a great cross-pollination of tattooing styles. The West Coast new school is blending Japanese color and themes with old school traditional simplicity. Prison and criminal fraternity lettering and imagery is being used by gang members, rap stars, and R&B artists alike. Anything is possible as new technologies and techniques are developed and more and more young tattoo artists come to the fore. We are seeing whitework applied over blackwork and more and more studios are specializing in custom work. With styles unique to the client and artist, the days of the old "walk-in" flash-style studios are numbered.

44

Left: Arnult by Paul Booth. This cark but stunning tattoo is an excellent example of the artist's world-renowned work.

Right: Amber Hinojosa tattooed by Jimé Litwalk, Electric Superstition, Detroit, Michigan. Amber's fascination with the Mexican Day of the Dead led her to choose that as a subject, but for her the significance lies in who made the tattoo as opposed to what it depicts.

There are countless great tattooists at work today, but as in any other arena there are some real heavy hitters in the contemporary tattoo world. Known for his dark, black and gray tattoos, Paul Booth's work can also be considered "dark" on a spiritual level, espousing ant-Christian views that are reflected in some of his imagery. He started his career as a tattooist like many others; by getting tattooed himself. (Uncharacteristically sweet for a man known for tattooing demons and devils, his first tattoo was of his daughter's name.) Already being an inquisitive artist, always out to the challenge of trying something new, by the time he got his second tattoo, he was hooked. He got an apprenticeship at Ernie White's in New Jersey and

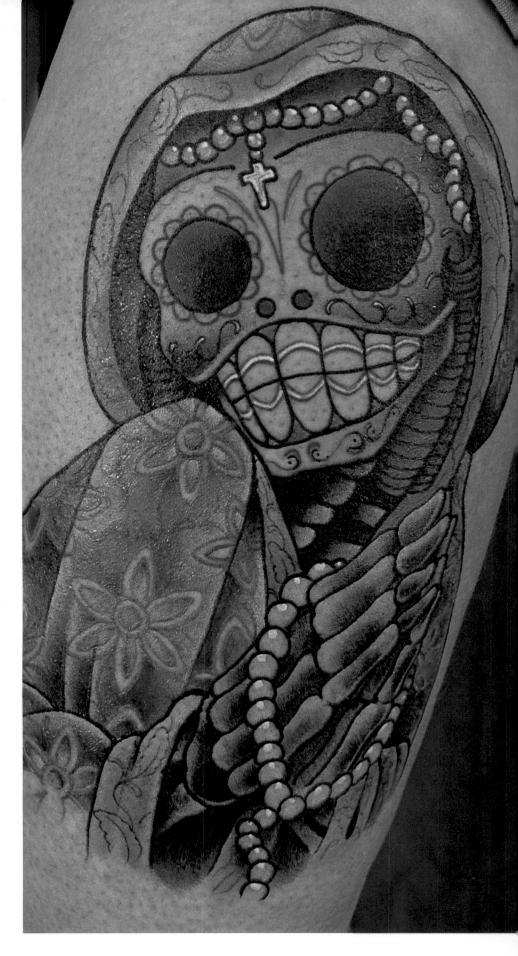

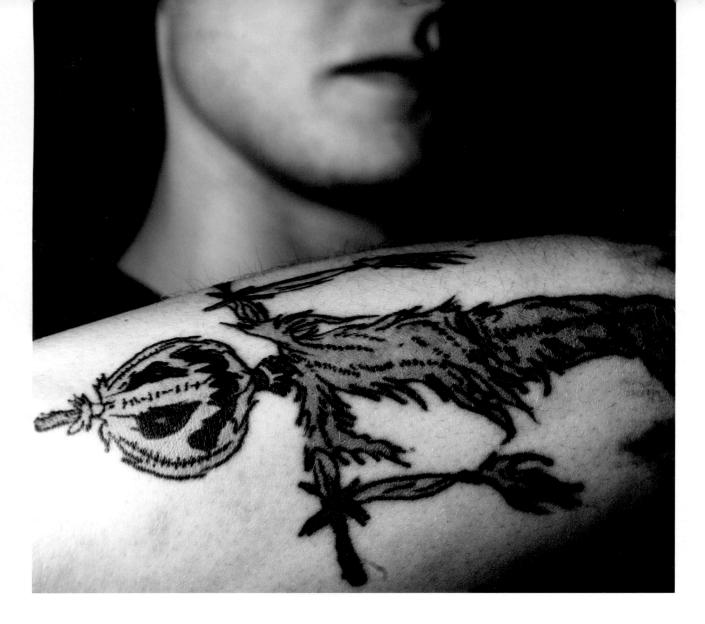

Left: A fascination with the macabre extends around the world. This simple scarecrow is in a much more traditional manner.

Right: Andrea by Pittan. An extensive tattoo with an unusual theme and style, which owes as much to comic books as it does to tattoo art.

spent two and a half years learning the ropes through a steady diet of eagles, hearts, and Tasmanian devils. His own artistic vision developed slowly, in the isolation of New Jersey in the 1980s, until he saw work by artists like Guy Aitchison in magazines and realized that tattooing could be taken to another level. As he started to attend conventions and come in contact with other tattooists who were doing full-on custom work, this belief strengthened and he began developing his personal style into what it is today. Whereas he will tattoo anyone who seeks him out, (usually being given full creative reign or working off a specific theme supplied by the client), Paul saves his spiritually heavy imagery for those he feels are up to

the task of wearing it; people who he feels are ready to deal with the hostility that goes along with sporting something that is considered negative by society. He weeds out those looking to become part of a trend, who would wear his anti-religious tattoos in the same way that they would wear a T-shirt.

It was his research into native American jewelry and garment design, while in art school, that led Leo Zulueta to start investigating indigenous tattooing. He realized that design motifs that recurred in various indigenous crafts formed a general aesthetic that intrigued him, and Leo soon found himself going to the library and photocopying everything

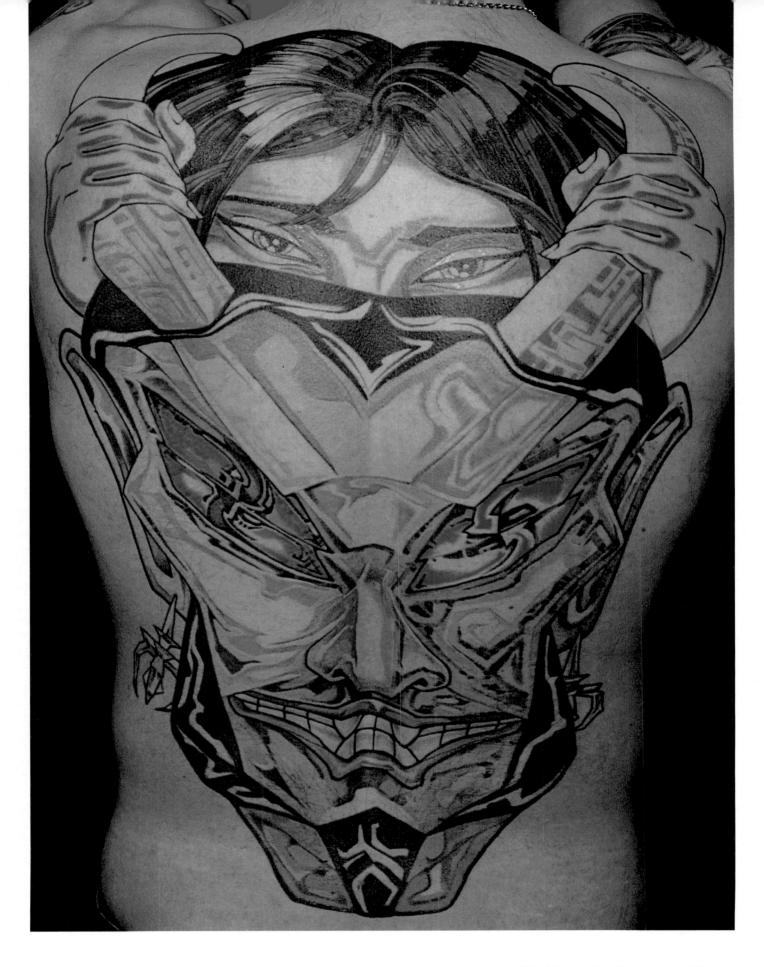

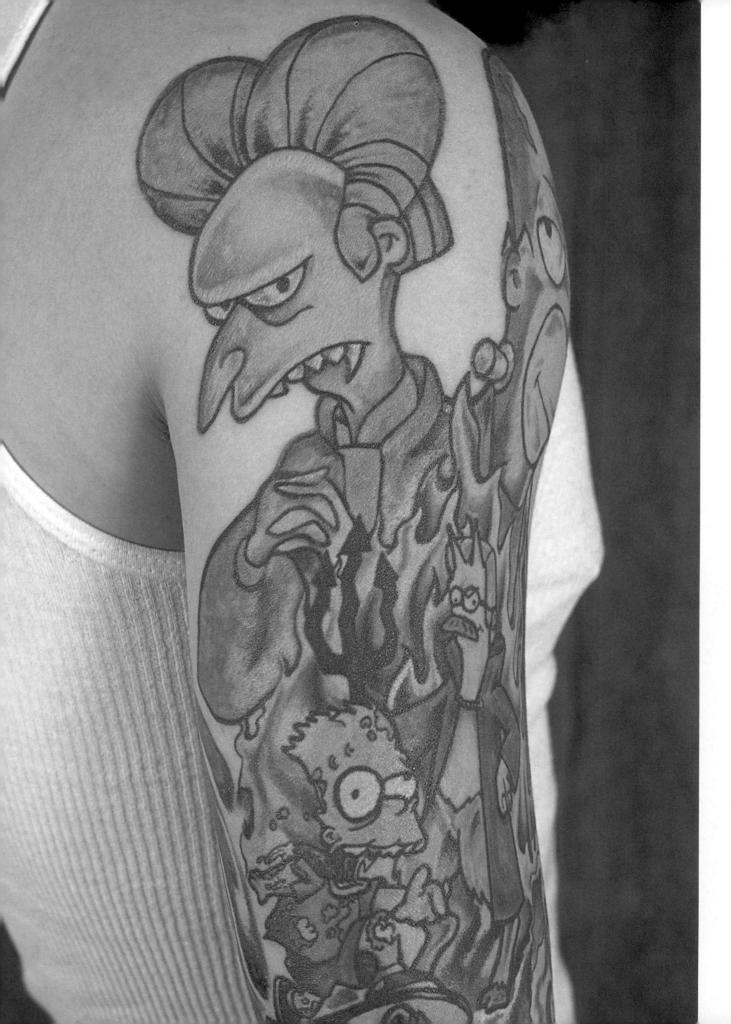

Left: Mike Kozlowski tattooed by Eamonn Carey. Among the many styles of tattooing that come and go in fashion there is always room for the less serious. This entire sleeve is based on T.V. cartoon family the Simpsons' "Treehouse of Horror' halloween specials.

Right: Steven Parker tattooed by Troll, Munkee Wrench Tattooz and Chad Lambert, Kustom Tattooz. This is another good example of incorporating imagery from popular culture (Star Wars) into a tattoo.

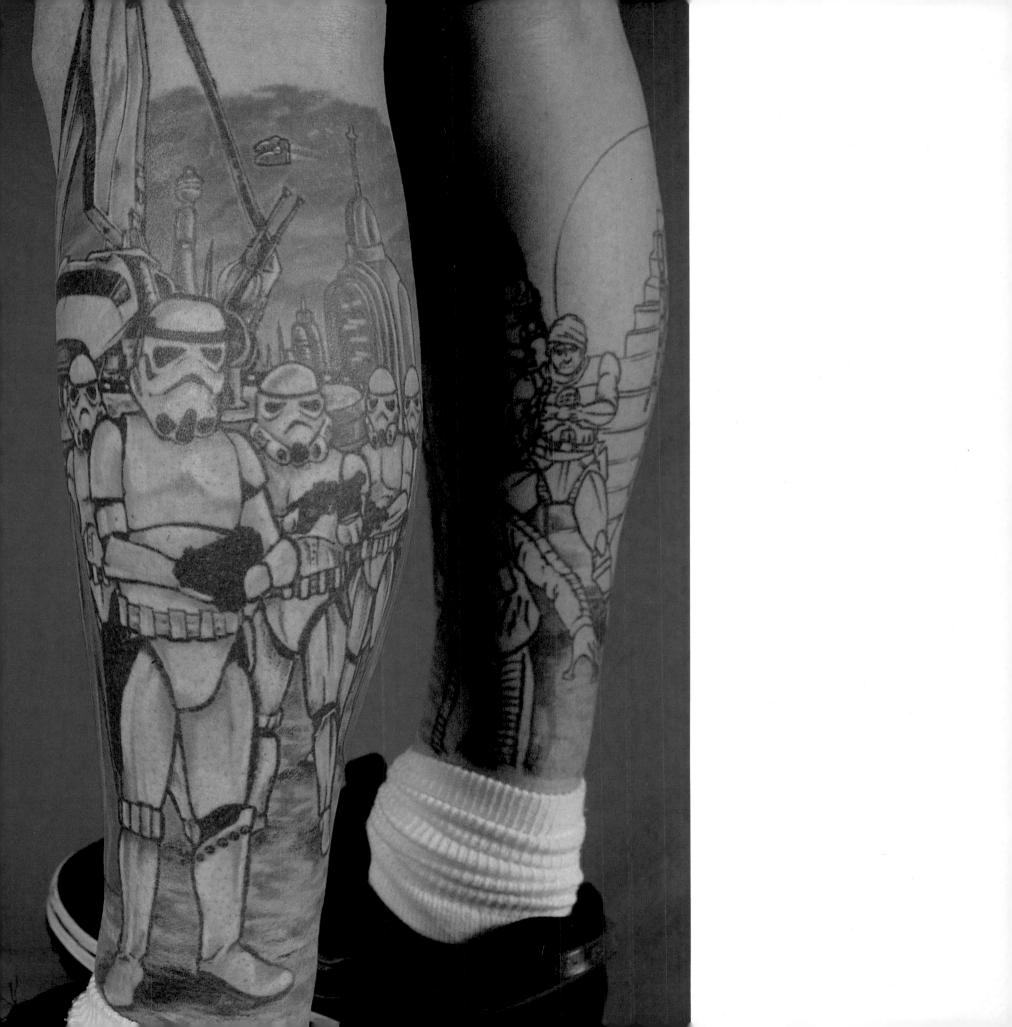

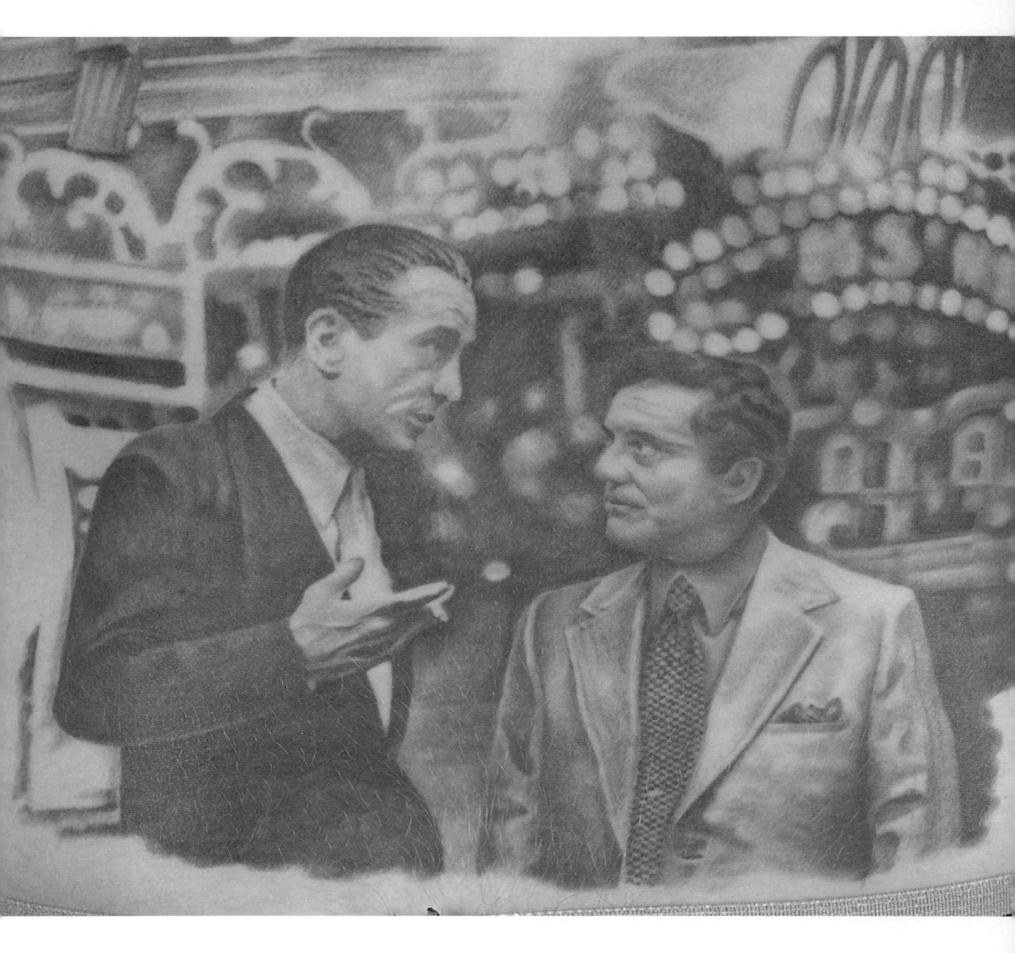

Left: Jeff Wilson tattooed by Tom Renshaw, Electric Superstition. An example of Tom's skills in the black and gray department.

Right: Benjamin T.Trayers tattooed by Jason McCarty. Another excellent example of a pop culture tattoo, this time comic book hero Wolverine.

he could on indigenous tattooing. Through his love of the tribal aesthetic, he met people who had similar interests. Don Ed Hardy, who encouraged Leo's personal research into this field, pushed him to start tattooing believing that with his vision and passion, Leo had something important to offer the tattoo world. Leo was hesitant at first about making a career change in his late twenties, but he realized the fortunate position he was in, having Hardy as his mentor and friend, and soon he made the plunge that would lead to a long career and the creation of a new style of tattooing.

When Leo first started out, the fineline style was very popular and at the complete opposite end of the spectrum from what he was doing, so he cherished every opportunity he had to meet people with similar interests, which, in turn, encouraged him to push himself even further. Borrowing graphic elements from different indigenous styles, Leo makes a distinction between a symbol and symbolism, seeing tattooing as not necessarily being visually symbolic in a literal manner, but rather as a means to express an idea or event in one's life in a personal, perhaps abstract, way. He therefore designs each piece to fit the particulars of his client's story, making highly customized, one-of-a-kind tattoos that are deeply meaningful to the people wearing them.

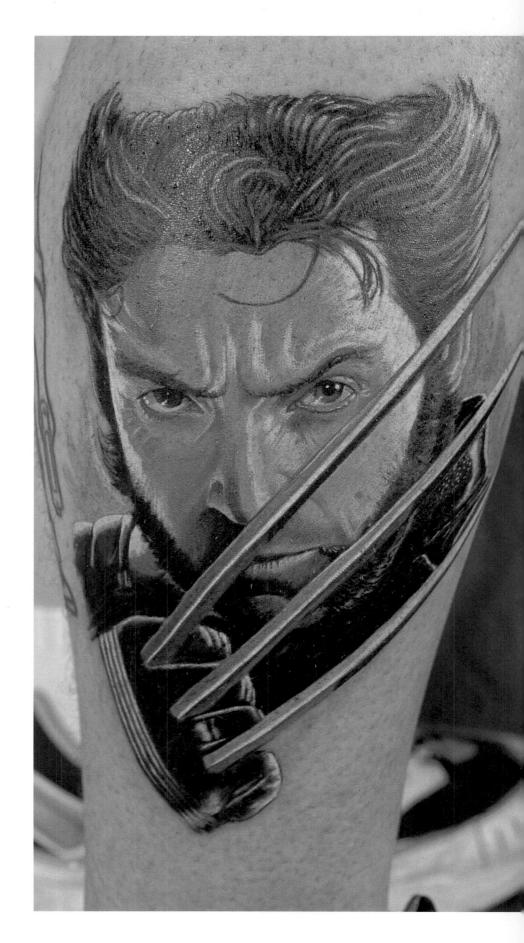

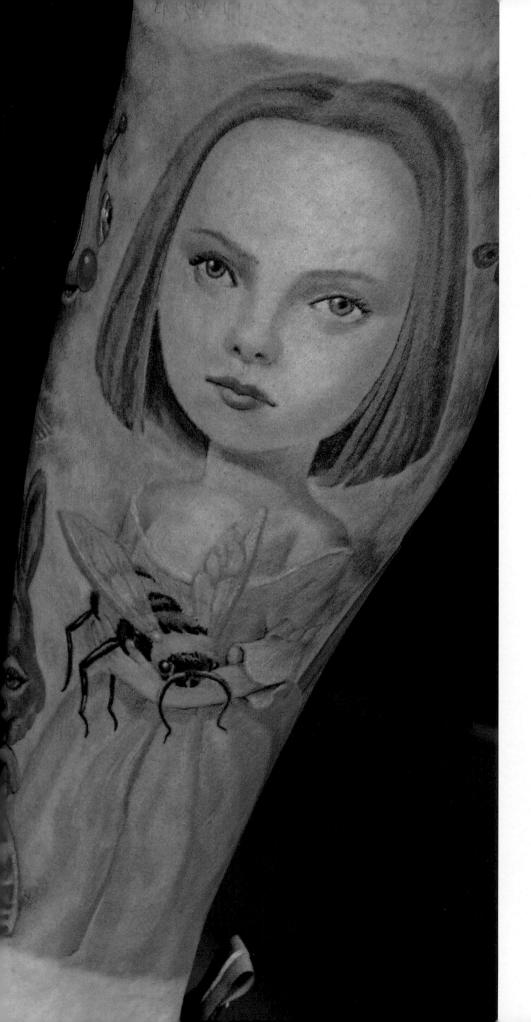

Left: Matt Scherran tattooed by Steve Morris, American Tattoo, Verona, Pennsylvania. This tattoo, and the one opposite are based on paintings by Californian Mark Ryden whose work is both enchanting and disturbing.

The contradictions between the history of the art form and its recent popularity are beginning to show. Some groups in society seek to appropriate the "anti-social" characteristics of body art to maintain their difference. Bikers, gangs, skinheads, and punks all use the "anti-establishment" connotations to establish their disaffiliation with the values of mainstream society. There are other groups who regard body art as just a fashion statement, but still revel in its "deviant" connotations, its potential for "shock." Others find body art to be "empowering," a "rite of passage," a return to "primitive" values. Such collectors commonly feel that elevating it to "art" status in the popular imagination will rid it

Right: Hope Davis tattooed by Mike Parsons. Also based on an oil painting by Mark Ryden these tattoos show how much closer the two worlds of high art and tattoo art are in the modern world.

of its negative attributes. Faced with the pressure to conform, to discipline one's body in order to meet social conventions, constructing an appearance becomes a way to upset normality. Everyone becomes an actor, capable of displaying their body in a unique way. Rather than sinking into the crowd, they spark a chain of reactions (grounded or not), from attraction and fascination to rejection and fear. The refusal to comply with social norms, the awareness that looking different has an impact, is all part of a battle against the creeping standard zation.

These collectors stand at opposite ends from those who undergo cosmetic surgery, drastic diets, and the like. Television and the Internet are

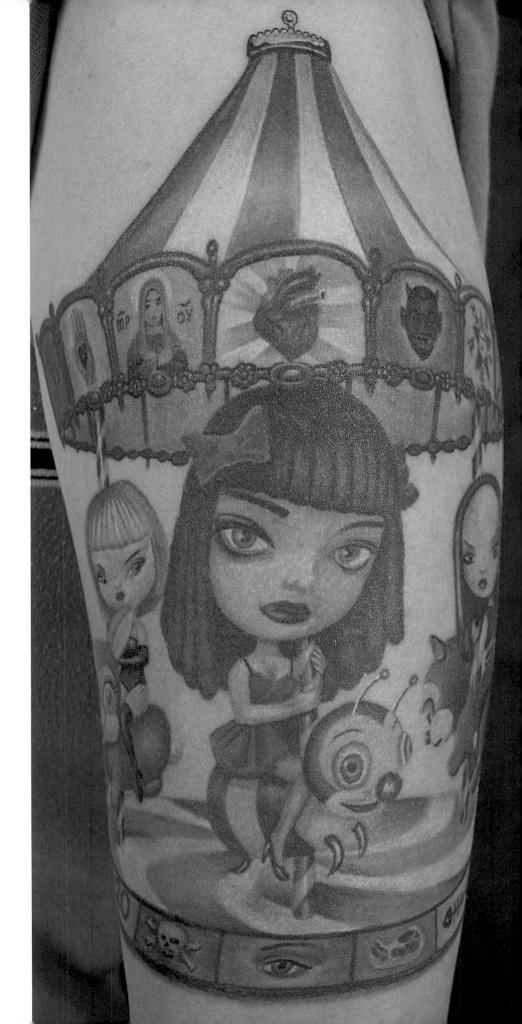

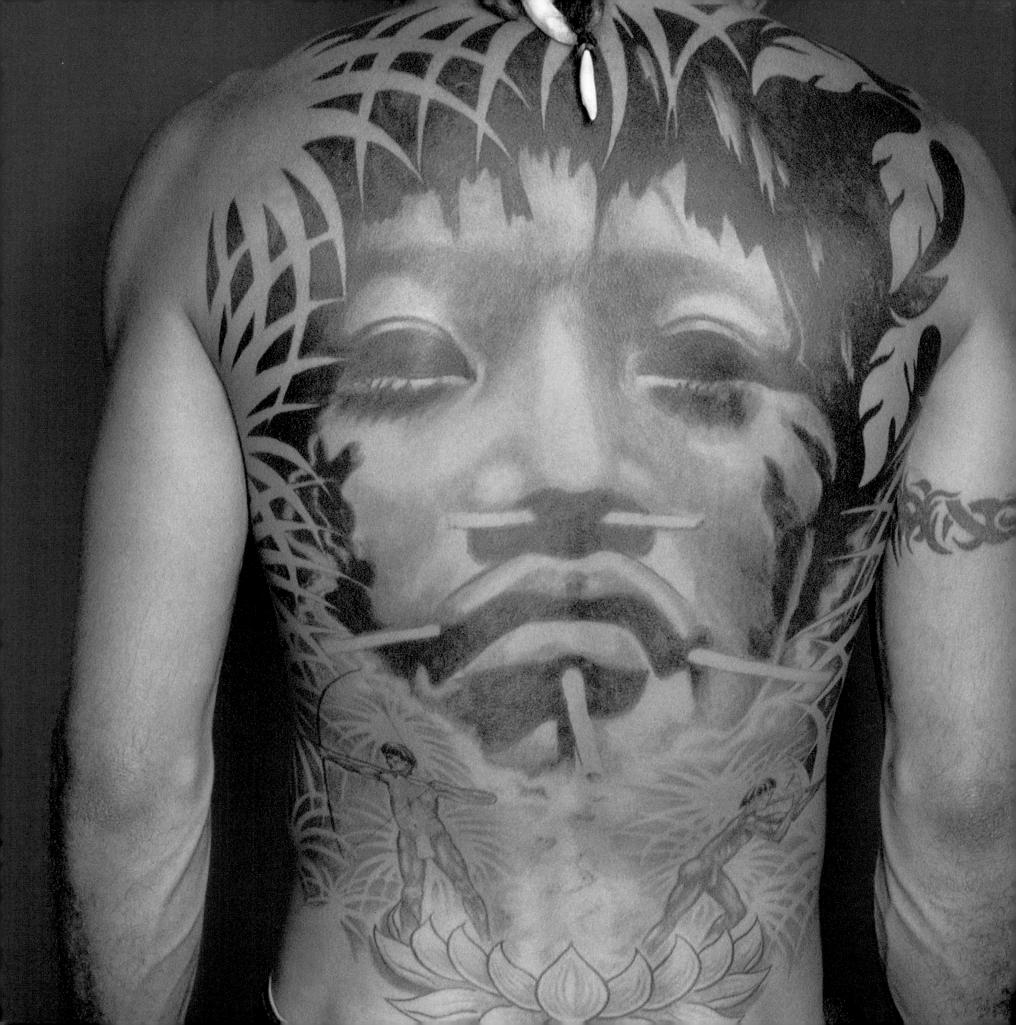

Left: Tuca by Tattoo Sauvage, France. This stunning piece of art signals a deep involvement in "primitive" values.

Right: Goska tattooed by Bugs. This example again reflects a recent trend toward tattoos that utilize styles historically reserved for fine art and are not usually found on skin. They challenge what is considered "acceptable" tattoo subject matter and style. One of the tattooists integral to this movement is Bugs, whose work is in the cubist vein.

giving play to all these trends. Day after day, we are exposed to a million ways of looking at the body, culled from past and present, from the imagination and real experiments. This should remind us that the body is not about a static anatomy, and that there is more than one way to signal membership to a group, which brings us again back round the very roots of tattoo culture.

Whatever the personal politics of the modern collector, and whatever society thinks of them, it cannot be denied that today's tattoos represent an amazing flowering of the art. And while there may be serious politics beneath the surface, not all tattoos are loaded with philosophy and deep thought. There is a playfulness in the tattoo community that is readily seen in the art. Cartoon characters are as popular as ever, though now they are likely to be more thoughtfully executed. Scenes from a favorite movie, animals, the fantastic and macabre—everything that a human can see and experience is on offer. It can be a vast piece or something tiny and beautiful that only a lover will ever see.

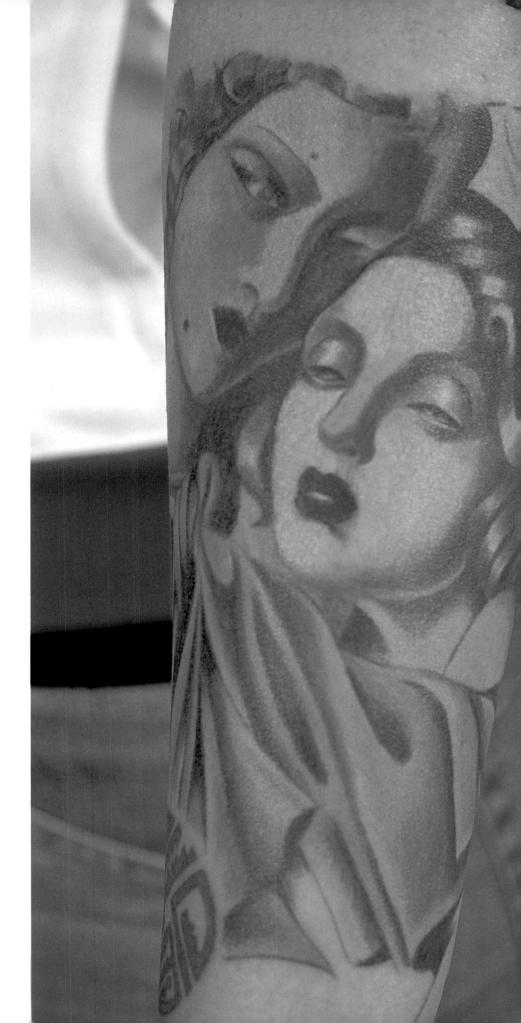

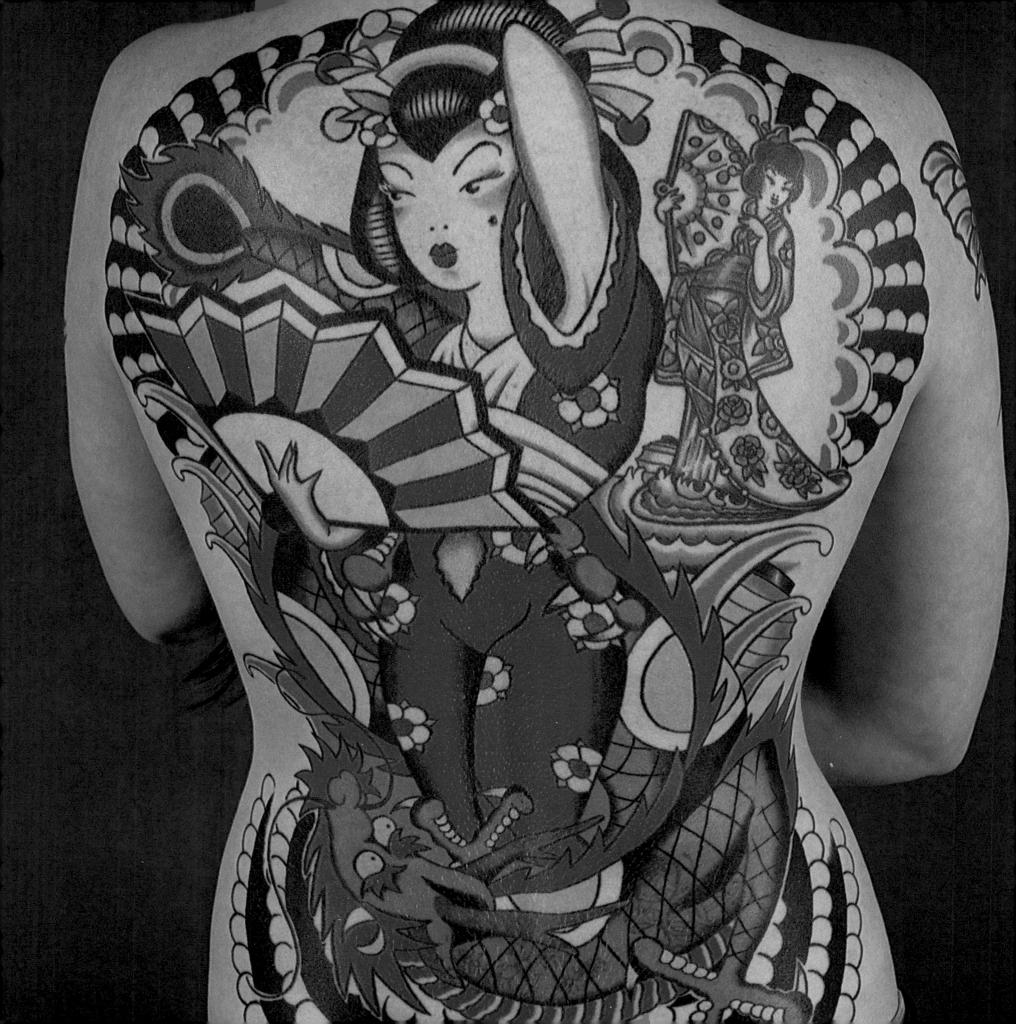

EASTERNINFLUENCES

Above: The dragon is a recurring motif in Japanese-style tattoos.

Left: Natalie Silverthorn tattooed by Luc Zietek, "What It Is," Clinton, Massachusetts. This tattoo takes Japanese themes and images and gives them a distinctly Western feel. The geisha owes as much to sailor-style tattooing as she does to traditional Japanese design.

The Japanese style of tattooing has probably had a more significant impact on our own tattooing culture than any other form or style. The image of the full body suit with its realistic detail, the skillfully executed shading and striking color, is forever locked into the Western idea of tattooing. As a result it has never really fallen in nor out of fashion. We have, it is true, seen more of a resurgence in its use over the last five or six years, but that is just part of the increased popularity of tattooing on the whole.

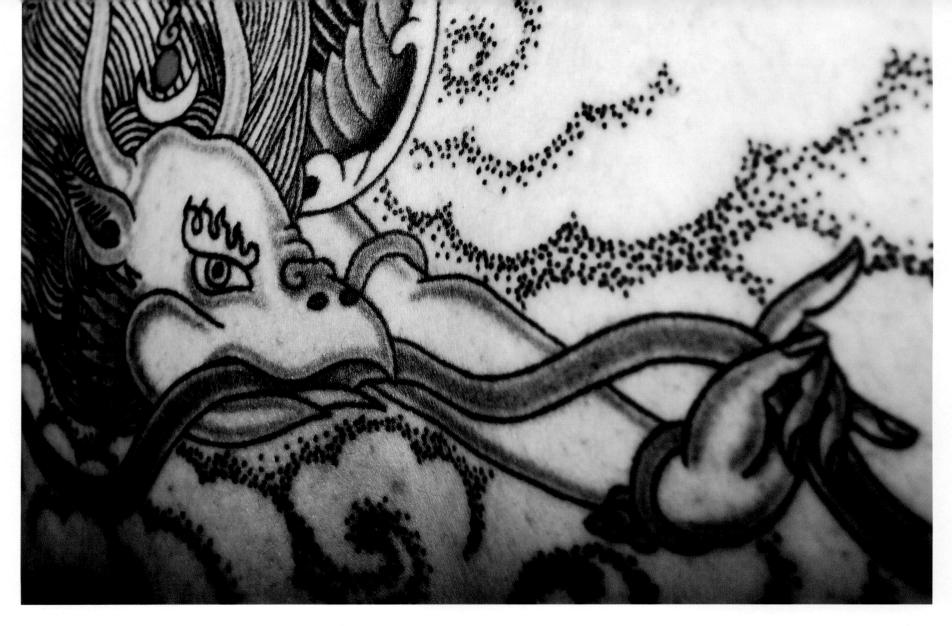

Japan's history of tattooing is extensive: the practice has been a part of their culture since at least 5,000 BC. In its earliest form, however, the designs were not what we associate with Japanese tattooing, but were more akin to those of ancient Egypt or Polynesia. Pictorial tattoos first appeared after the Horeki era (1751–1764). At this time tattoos were relatively small, and the designs were family crests or talismanic images, such as severed human heads. Even though people began to have a couple of tattoos on their body, each piece was scattered at random, not unified.

The development of the art of *ukiyo*-e fundamentally changed the style of Japanese tattooing. The *ukiyo*-e are pictures of "the floating world,"

mainly depicting the landscape and people's daily lives, including entertainment such as *kabuki* plays or the pleasure quarters. The images were first illustrated in color prints, but with the 1650s development of woodblock printing the *ukiyo*-e began to become widely available in books. The most significant development in Japanese tattooing came with the translation into Japanese of the Chinese legend, the *Suikoden*, the "Water Margin," by Okajima Kanzan in 1757. The heroic adventure stories of the *Suikoden* were illustrated in 1827 by Utagawa Kuniyoshi, the great *ukiyo*-e artist. Its popularity was such that it could almost be described as hysteria among townspeople. A genuine pop phenomenon with an unthought of

Left: While Japanese tattooing has distinct properties, such as shaded backgrounds, its iconography has long been purloined by flash artists to lesser or greater effect.

Right: Richard by Bob Hoyle, Halifax, U.K. Here the dragon is used in a very impressive manner, which is reminiscent old Japanese work in both subject matter and extent of coverage.

consequence—Kuniyoshi's prints inspired the development of a tattoo style that has been popular ever since. The tattooing term *wabori* meaning "Japanese style," refers to *ukiyo*-e pictures, including dragons, carp, Buddha, maple leaves, or peonies. These were the plueprints for a style that has become forever associated with Japan and many of the same images are still used today.

The idea of the full body tattoo originated with a part of the traditional samurai warrior costume called *jimbaori*—a sleeveless campaign coat. The samurai had their favorite patterns embroidered on the back of their *jimbaori* and tended to prefer heroic designs representing guardian

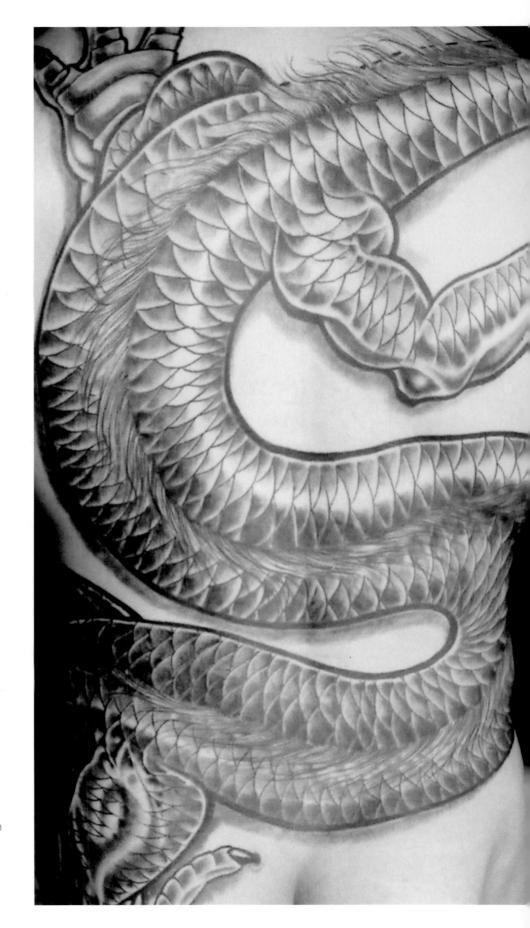

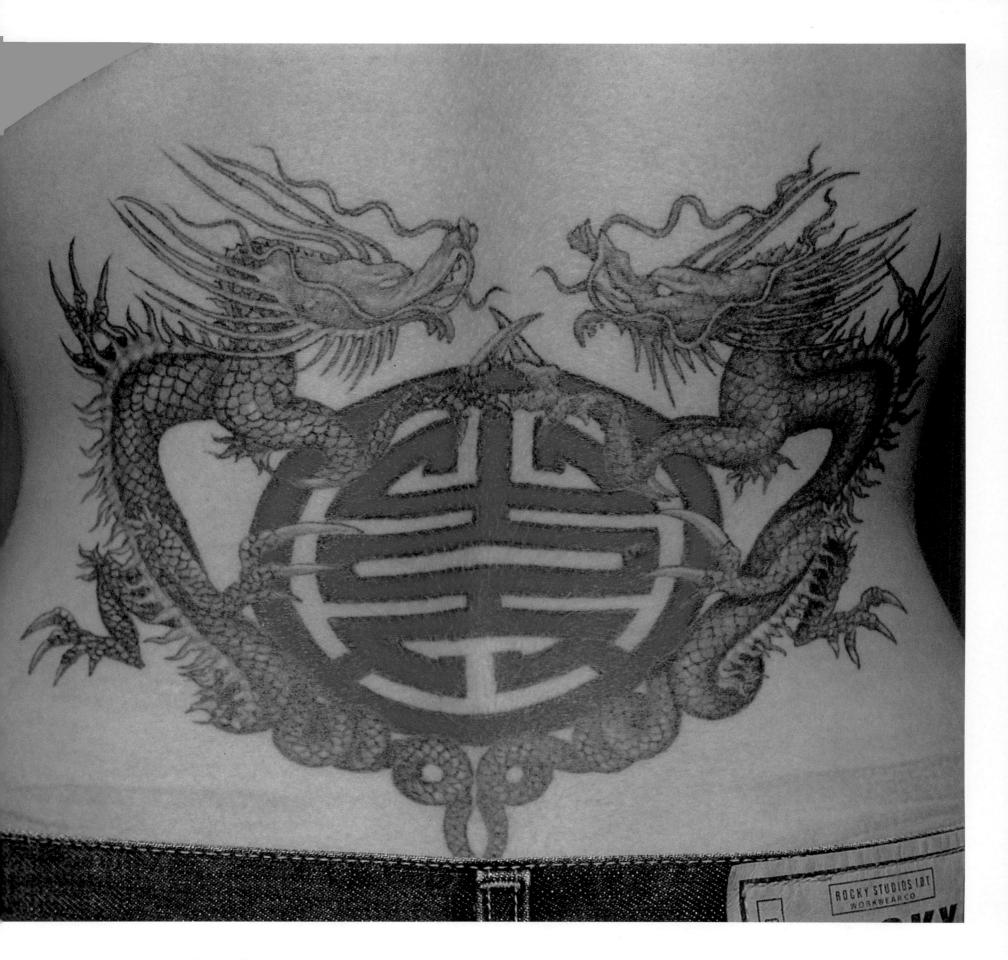

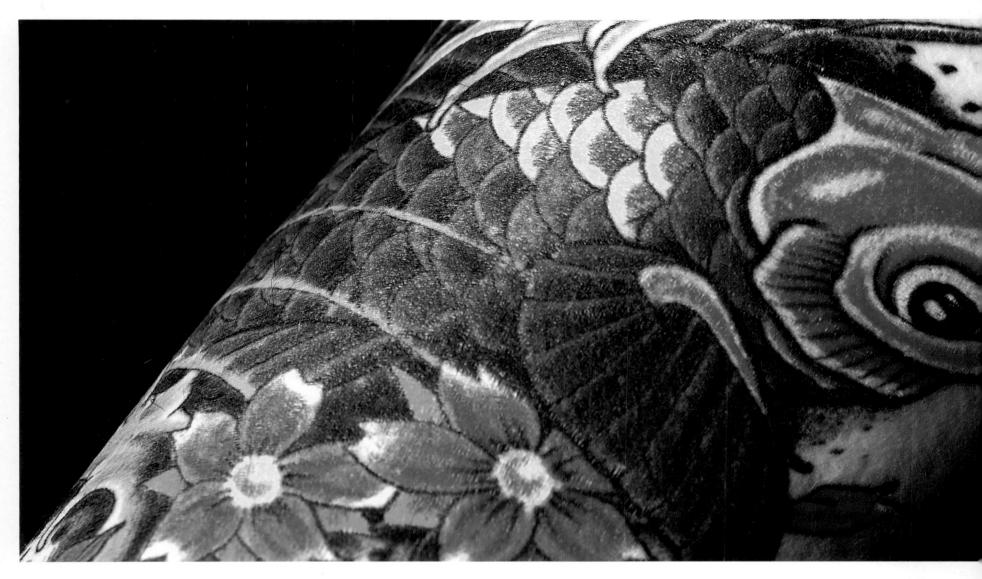

Above: A fine example of the traditional carp, which was originally inspired by *ukiyo*-e images and has remained a staple of the Japanese style ever since.

Left: Bianca by Yvonne Blut. Another example of Eastern art informing a Western tattooist.

deities, dragon, and suchlike to symbolize their own courage and pride. At first, tattooing was done only on the back, the designs extending to the shoulders, arms, and thighs. As time progressed, however, the tattooed pictures came to appear on the whole body, covering the entire front of the upper part of the torso with the exception of a vertical strip running from the chest to the abdomen, giving the effect of an unbuttoned vest. The tattoos were, of course, done by hand—the art of *tebori*. This is a special technique, and only a handful of traditional tattooists now offer it, and of these most also use tattooing machines, though in a traditional manner. It is important to note the main difference between traditional Western and

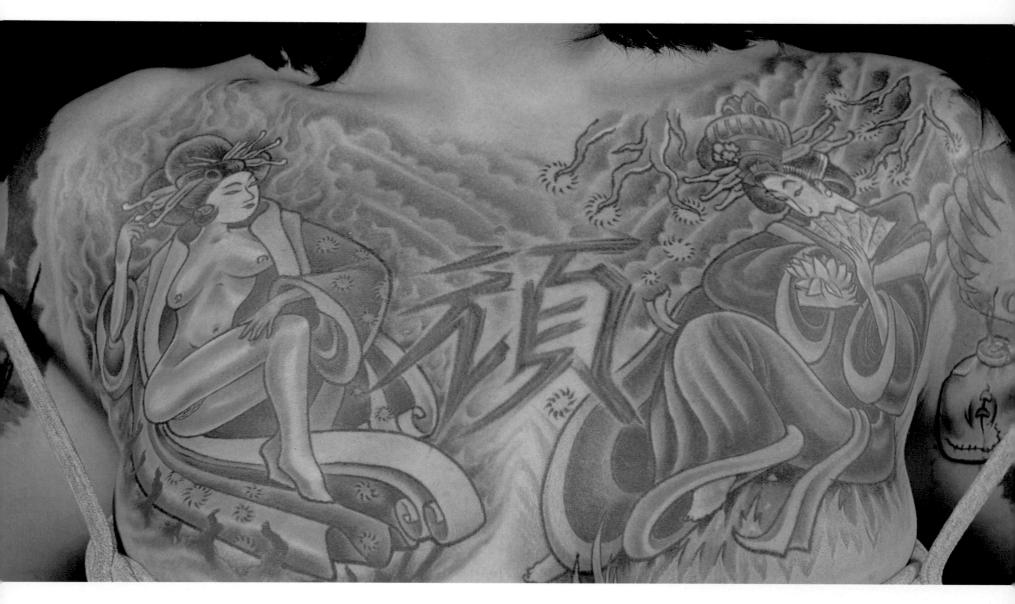

Japanese styles. In Western styles, the designs usually do not have the shaded background that are seen in tattoos influenced by the Japanese art.

The Japanese used tattooing to give personality to the naked body.

A nude to them had never been considered "divine" or even beautiful as it was in the West. The sight of the naked body did not have the slightest charm. If you look at antique Japanese erotic drawings you'll notice that they never depict naked people and the women are never nude—naked parts of the body are considered sexy only in the context of their

being coquettishly revealed, glimpsed beneath the clothing. From this point of view, a tattooed man or woman could never be entirely and defenselessly nude.

The art of tattooing flowered in Japan until the mid to late nineteenth century when the Japanese government began to strive toward becoming a member of the leading industrialized nations. In order to do so it was thought that the population should appear more "civilized" and "sophisticated." The government, in an effort to modernize, prohibited all tattooing. It was deemed a "barbarous and primitive act" and in 1872 it

Left: Michelle Corwin tattooed by Durb
Morrison, Stained Skin, Columbus, Ohio. Both
this tattoo and the one to the right are good
examples of how Japanese themes and
techniques have been appropriated by the West.
The colors are strong and the shading extens ve.
Of course, the influence can also be seen in
tattoos that do not have such an obvious
Eastern heritage.

Right: Christy LoPresti tattooed by Jim LoPresti, Lucky Soul Tattoo, Ansonia, Connecticut & Zee (tribal on lower back). This backpiece is of Kwan Yin, the goddess of mercy, compassion, and forgiveness. The faces on the backs of her arms are Bernini sculptures called "The Blessed and Damned Souls" representing the good and evil present in all of us.

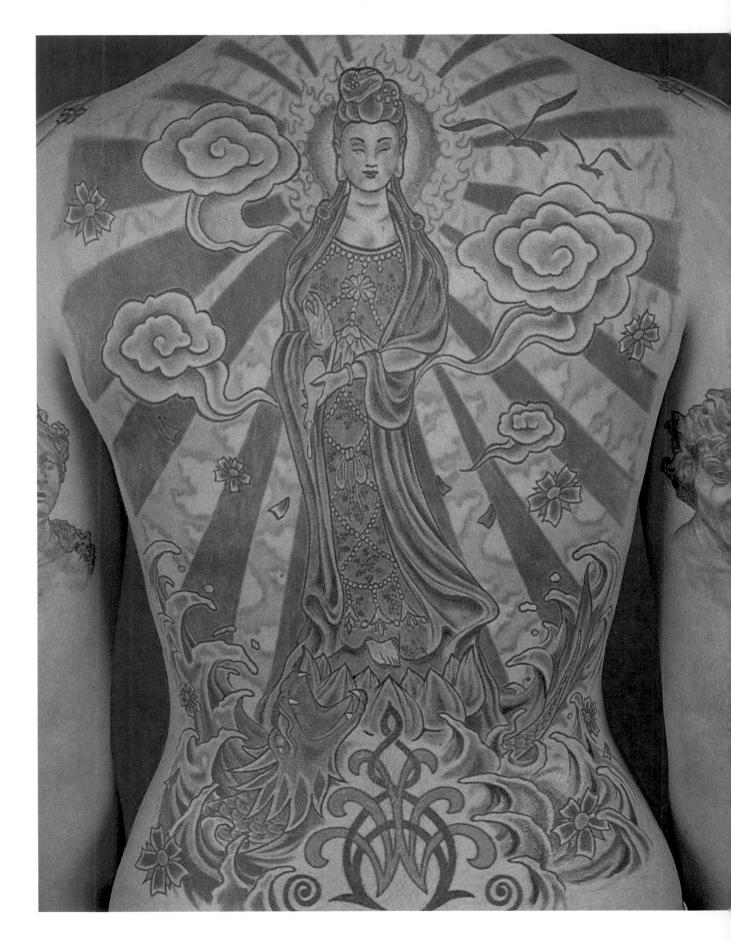

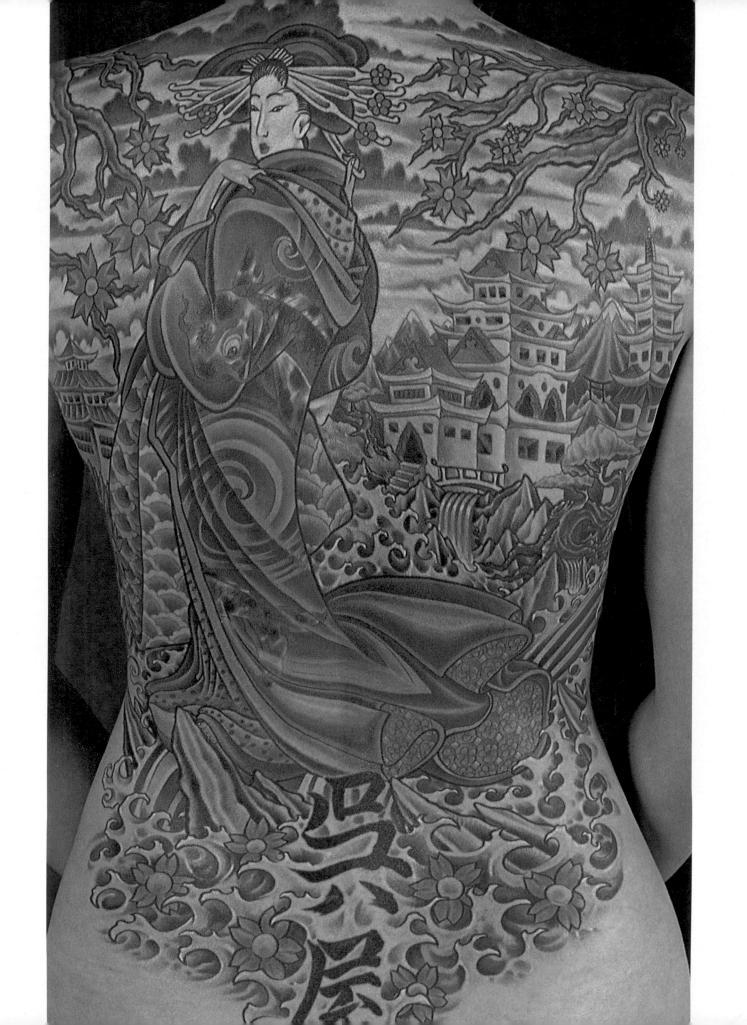

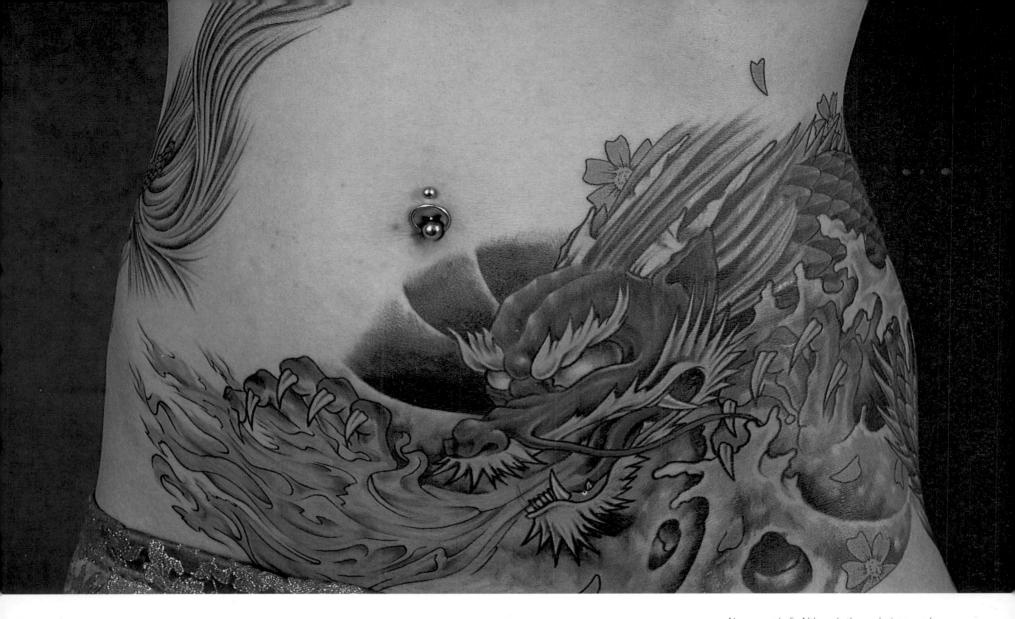

was banned. Thus, during the first half of the twentieth century, tattooing remained a forbidden art form. In 1948, however, the prohibition was officially lifted. One of the principle reasons for the change in law was the huge demand from soldiers of the occupying American forces for Japanese-style tattoos. Now legal, the art blossomed once more. As a direct result Japanese tattoos were exported to America and across the world, acquiring an international reputation for great beauty.

Although their style of work is highly regarded in the West, the Japanese themselves now generally have a somewhat different attitude. Since the advent of Confucianism and Buddhism, and partly due to the

Above and Left: Although these designs are by Western tattooists, they are much more traditionally Japanese in feel.

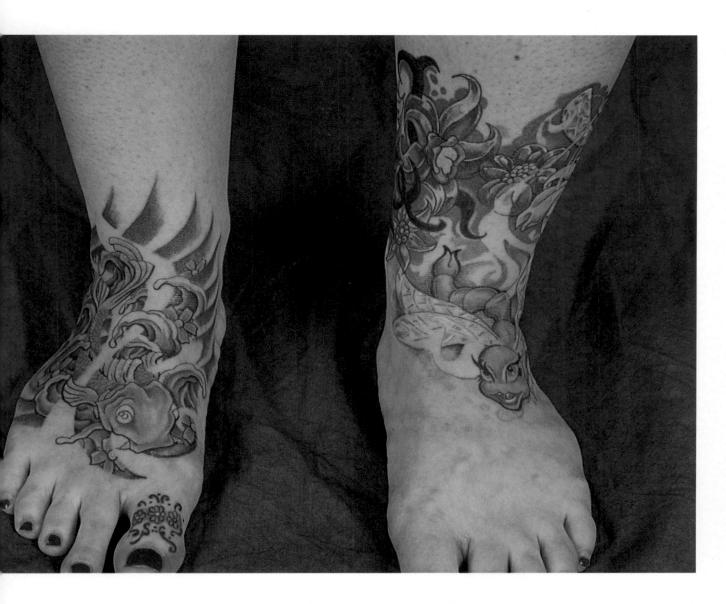

Left: Tiffany Krizmanich tattooed by Penny Schuhrke (right foot) and Jim Schuhrke (left foot). Tiffany's feet combine traditional Japanese tattoo iconography with a contemporary "cartoon" style.

Right: Marlon T. Hart tattooed by Marco Bratt. This is a Japanese backpiece of a dragon on an epic scale.

long prohibition, tattoo art has become anathema to the majority of the Japanese people. In the eyes of an average Japanese, a tattoo is a mark of a yakuza (a member of the Japanese mafia), a macho symbol for members of the lower classes, or the sign of a prostitute. The yakuza are notorious Japanese syndicate members and tattooing is their most famous trademark. However, in recent years, it has been reported that the number of yakuza with tattoos has been decreasing. The younger members are forsaking the full-body pictorial tattoos, opting instead for a simple line drawing or phrase on their upper arm, similar to the tattoos of Western youths. The reasons are simple; increased law enforcement has meant that their income

has been eroded and extensive tattooing is time consuming and painful. The traditional Japanese tattoo takes a long time to complete—to wear the full body tattoo, one needs patience to endure the time and pain. They also cost a fortune, and so are increasingly seen as being not worth either the physical or financial stress.

In an extraordinary exchange of styles, contemporary tattoos in Japan are typically in the Western style. While traditional designs are decreasing in popularity, "one-point tattooing" is gaining ground among young people. "One-point" means getting only one tattoo, and is trendy among young Japanese, who now often choose to wear skulls, roses, or

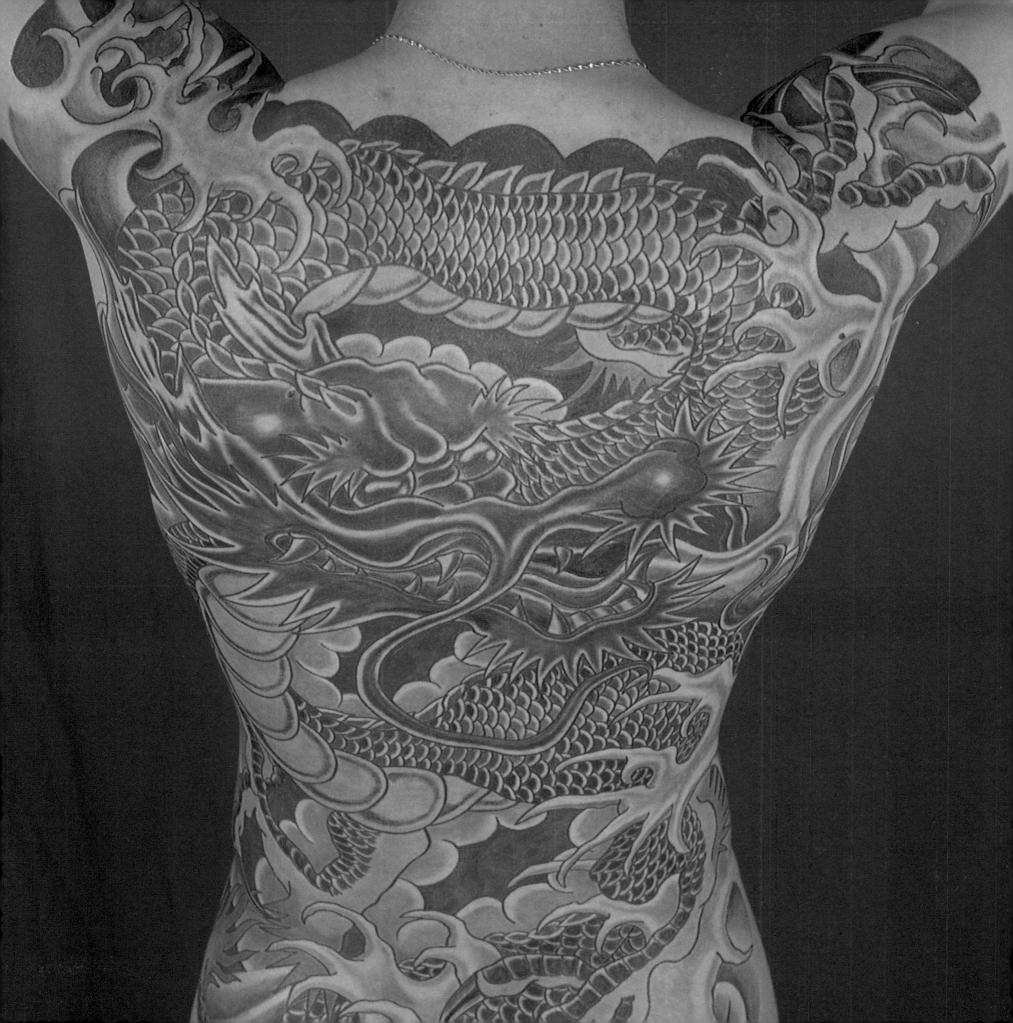

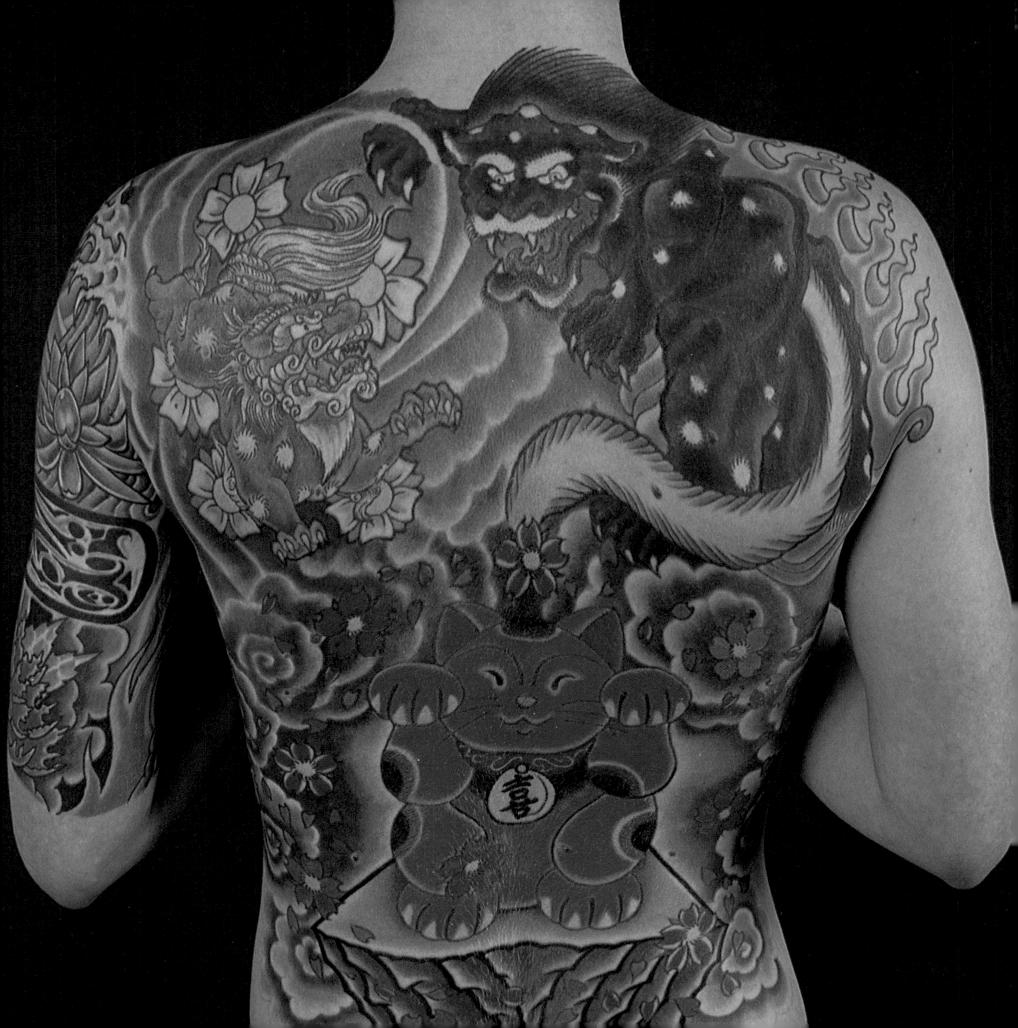

Left: Rebecca Russell tattooed by Mark Vigil, 4
Star Tattoo, Santa Fe, New Mexico. Rebecca
utilized the Chinese "good luck" cat to symbolize
health and prosperity, colored it pink to
represent love, and included two Japanese foo
dogs as guards.

Right: Jill Guarino tattooed by Litos. An excellent example of cultural mixing, here the Japanese style is used to illustrate Ganesh, the Hindu elephant-headed god who removes obstacles.

hearts. The cultural code is still a big part of Japanese society, but attitudes toward the one-point tattoo and the full body tattoo are much different. The one-point, having fewer connotations and involving much less coverage is gaining acceptability as a fashion trend among the young. It's also worth noting that the sales of temporary tattoos have skyrocketed—their impermanence means that young people can enjoy tattoos without any risk of breaking cultural code.

There is another twist—tattooing has become more popular among Japanese females than males. Where it was once dominated by males, the tattooed female population is increasing at a faster rate. The obvious reason for this is the prevalence of the fashion industry in Japan. As more and more models, singers, and other stars become tattooed so it is becoming increasingly established among Japanese women.

There cannot be many instances of such an artistic swap in history; the East now covets the traditions of the West, while the West bases ts own designs on those of the East. In this strange tangle of appreciation, the West has seemed to benefit the most. Tattoo designs imported from such a disciplined society bring an unrivaled level of artistry. Quite simply, Japan's inspiring images should forever be taken as a benchmark of quality.

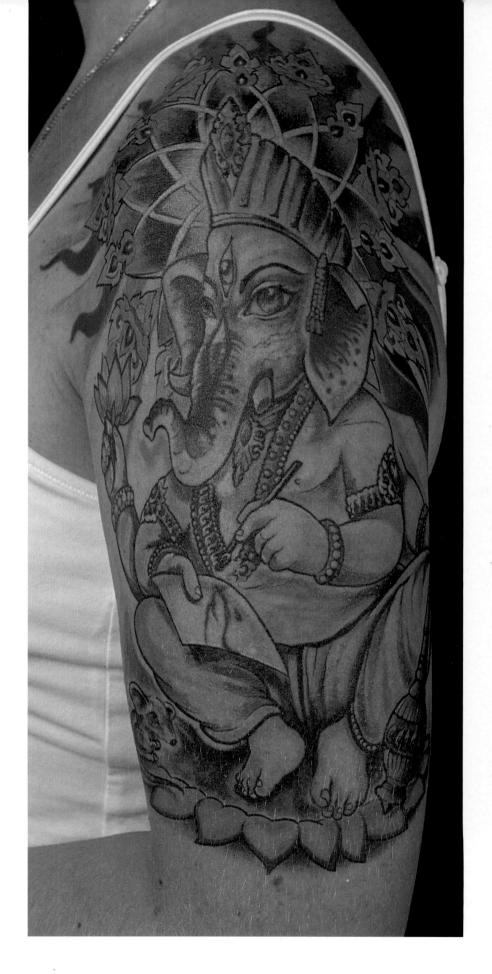

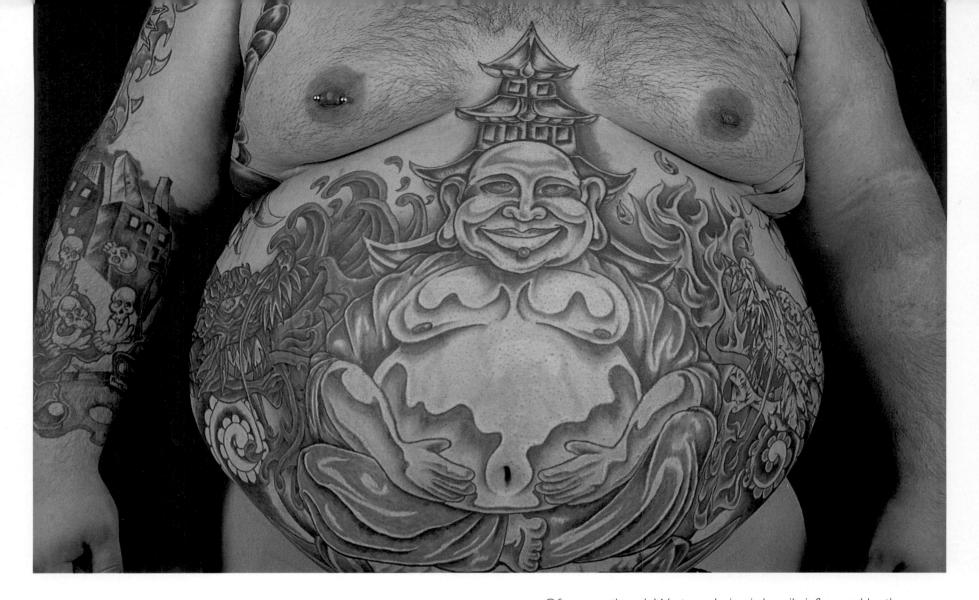

Above: Jeremy Renfro tattooed by Penny Schuhrke, China Doll, Hammond, Indiana. Jeremy's Buddha belly is probably the best example we've seen of working a tattoo into one's own body lines and shape.

Right: Bordering on the fantasy genre, this epic tattoo has the characteristic, winding, serpent-like body of a typical Eastern dragon figure.

Of course, though Western design is heavily influenced by the Japanese, the actual art is just as likely to be influenced by other Asian cultures. Recent times have seen many more people traveling to different parts of Asia as well as embracing the philosophies of Buddhism and practicing yoga and mediation. The fascination with these rich and colorful societies has introduced many different themes and perspectives to the Japanese palette. In overlapping Tibetan and Indian cultures, among others, with Japanese design, Western tattoo artists are creating a new style of tattooing of their own.

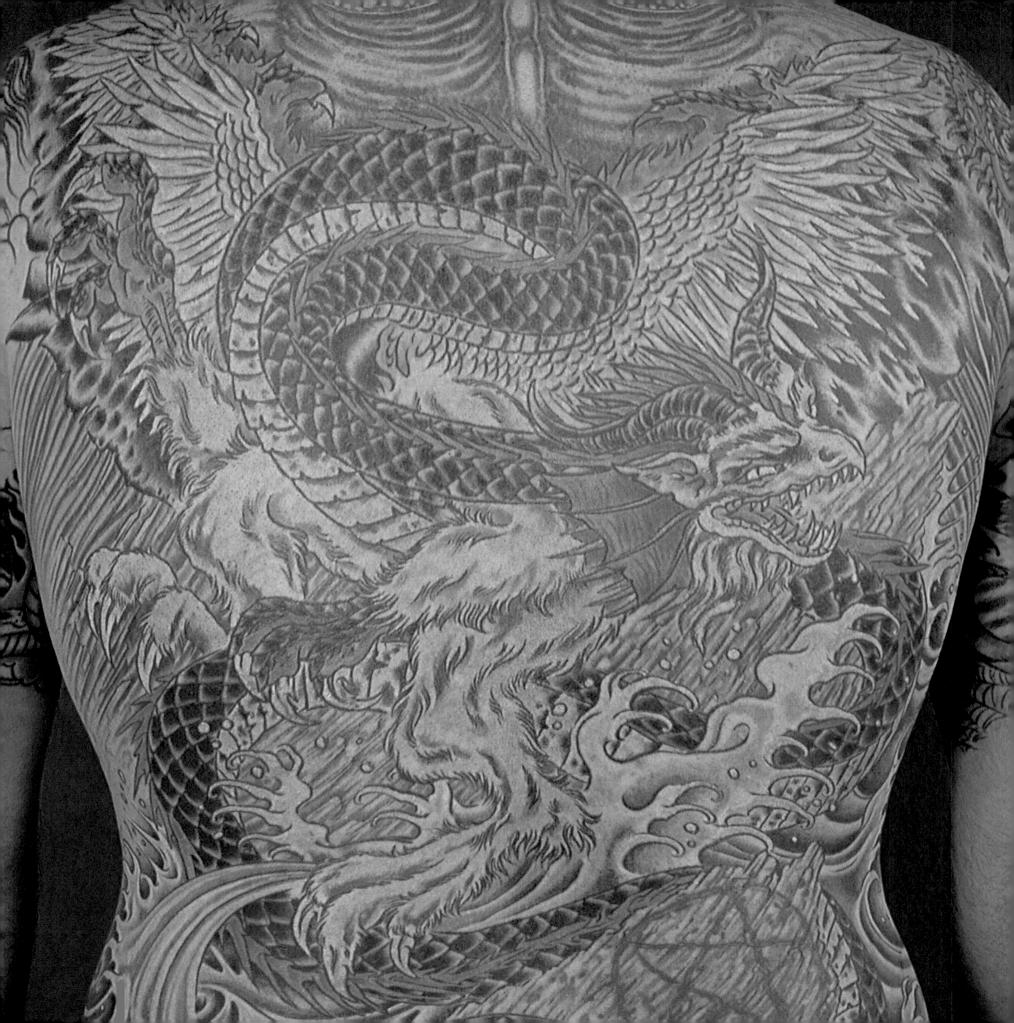

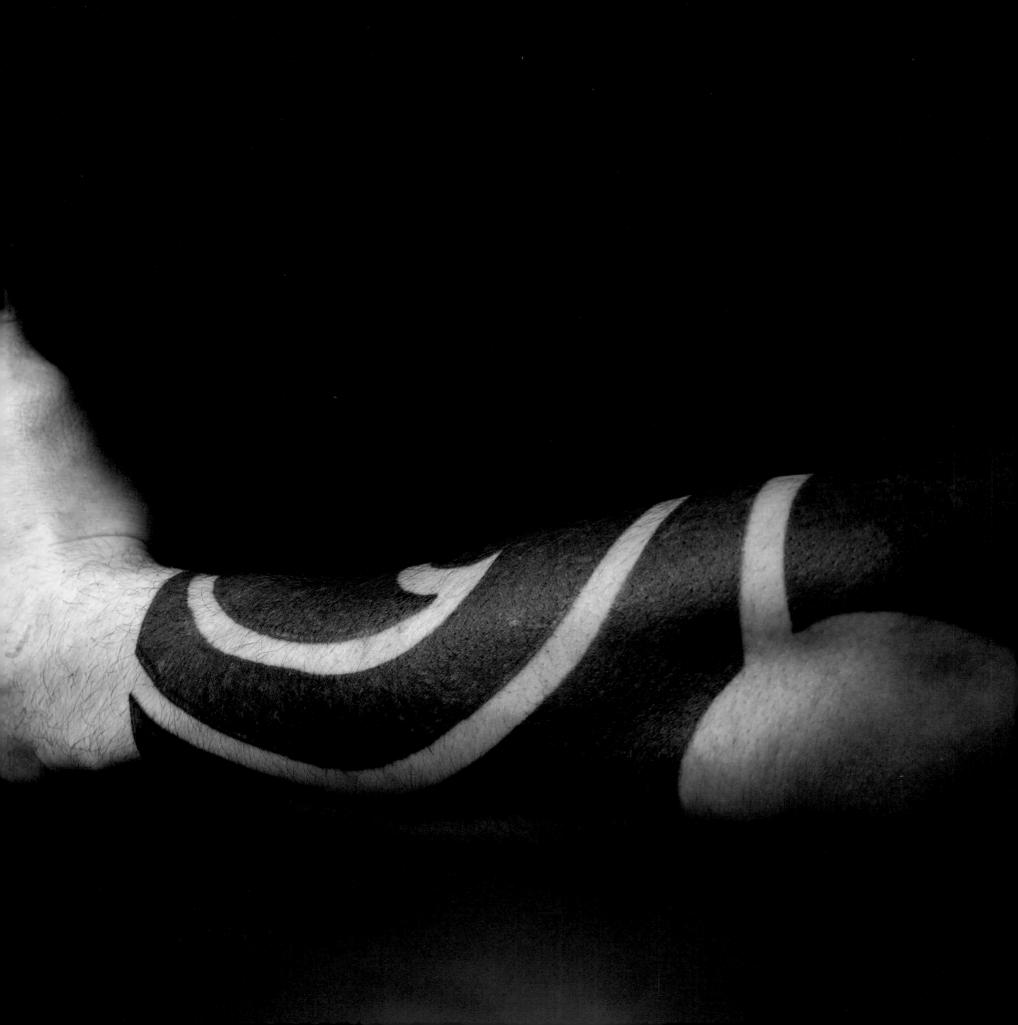

BLACKWORK

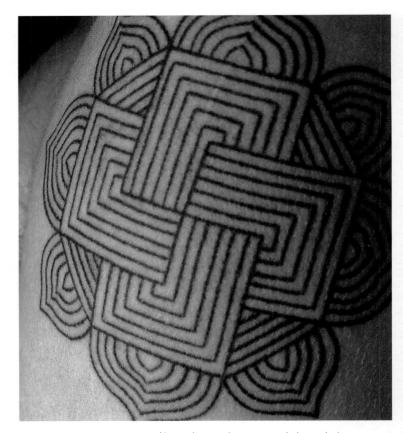

Above: A complex geometric knot design, inked solely in black. Such designs are very common today.

Left: The strong swirling lines of tribal tattooing adapt to the body in a striking fashion.

The terms "blackwork" and "tribal" tattooing are often taken to mean the same thing, and indeed tribal tattoos are so popular today that they form the majority of all blackwork. However, it is worth differentiating the two terms. Blackwork is a tattoo made using only, or primarily, black ink whereas tribal-style tattoos (which can be any number of established forms) are derived from designs originally worn by indigenous peoples for religious reasons, tribal identification, or folk superstition. What all these styles have in common is that they are primarily monochrome, being black and skin tone in nature.

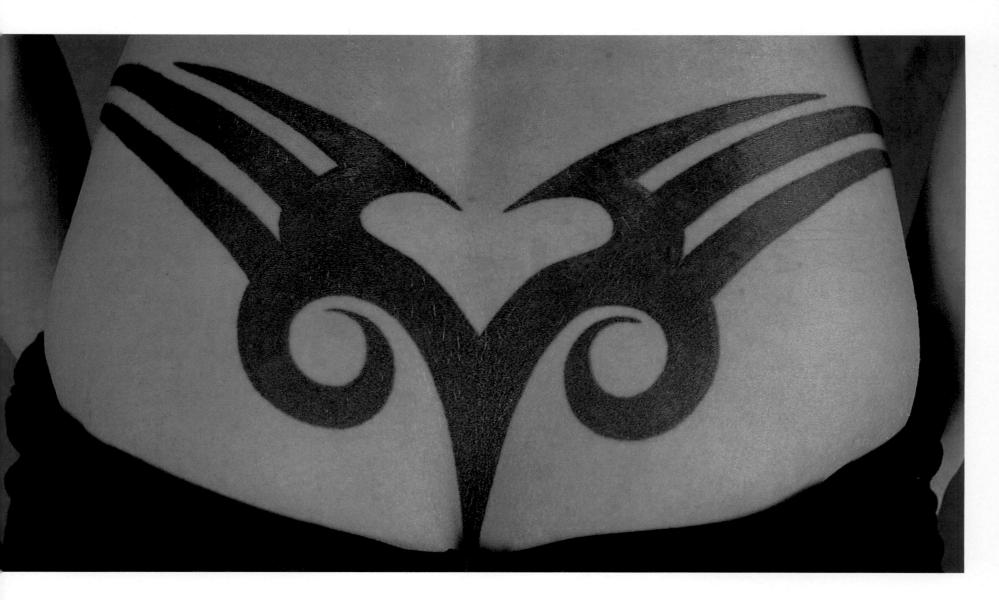

The scene for the phenomenon of black only tattoos was set by "Celtic" blackwork, which was popular across Britain and Scandinavia during the mid to late 80s. Though often intricately and beautifully designed, Celtic tattoos were adapted from other forms of art and not from a tattoo heritage, so cannot strictly speaking be regarded as a part of the tribal movement. Instead, they can be seen almost as a statement of intent for the intelligent option and a spark for the huge explosion in black tattooing that was to follow.

Although the Celtic style never really caught on in the U.S., this work had become the tattoo of choice for Goths, nouveau-hippies, and heavy

metal fans alike. The same people, in fact, who were the first across Europe to embrace the subsequent tribal style.

As mentioned in the first chapter, the earliest exponents of the tribal style were members of a particular subculture in San Francisco, who were looking for a stronger, more committed way of asserting their individuality and their rejection of the consumerist ideals that had developed during the previous decade. At the same time there was a growing awareness of ecological issues and a corresponding interest in "new age" ideas of living in harmony with the environment, as well as with older cultures and ancient civilizations that had seemed to achieve this. Inspired by the traditional

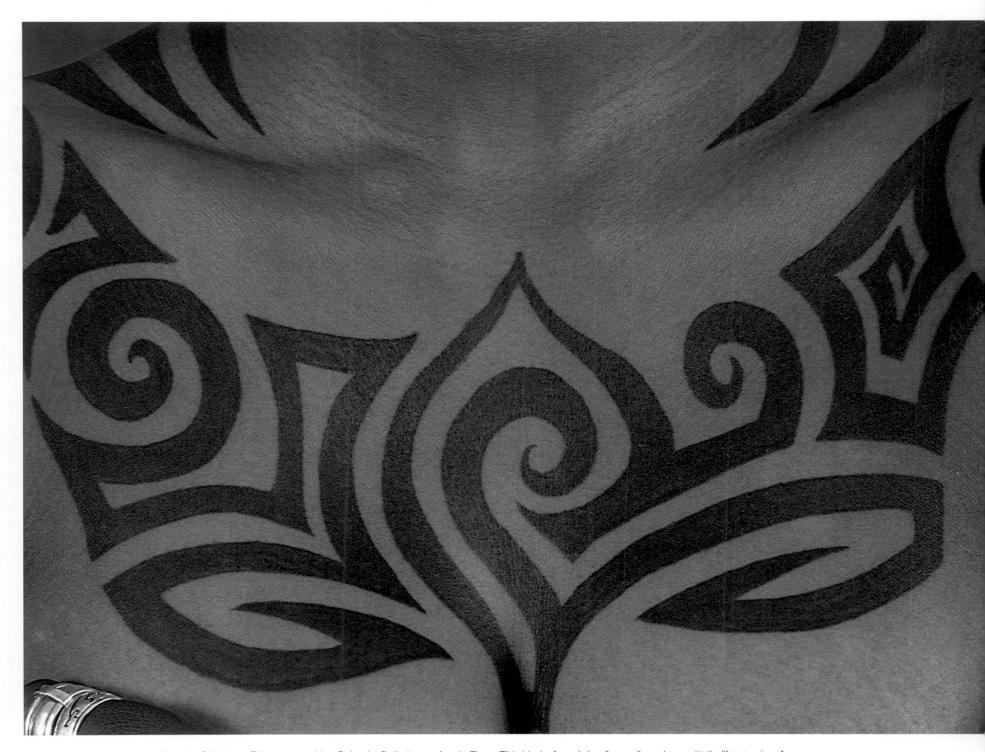

Above Left: Nad re Diaz tattooed by Orlando, Belladonna, Austin, Texas. This kind of work is often referred to as "tribal" tattooing. A more accurate description for this style is "blackwork," since it has no direct connection to any particular tribe or tribal peoples.

Above: Despite having no tribal connections, designs such as this are both striking and appealing. Though somewhat eclipsed by New School tattooirg, blackwork continues to make up a large proportion of all new tattoos commissioned.

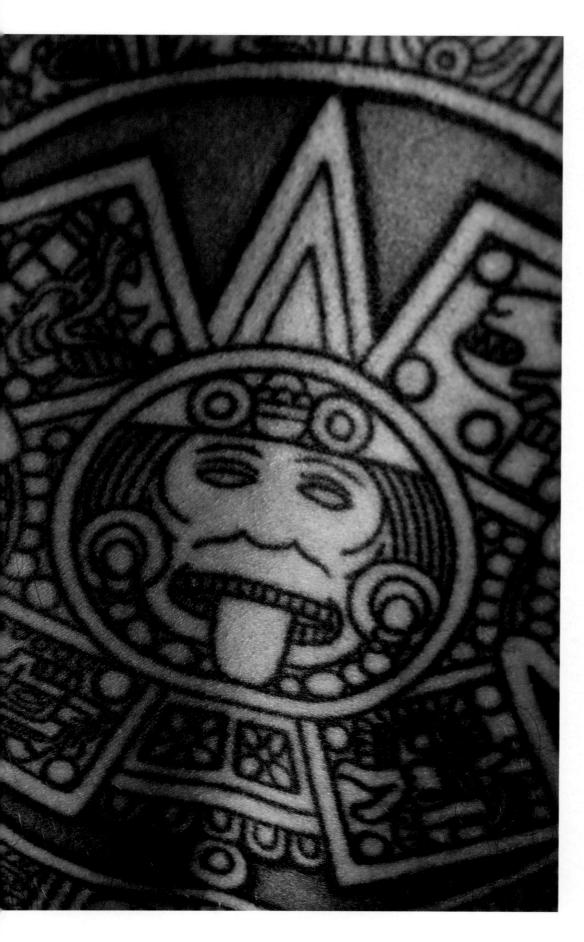

Left (detail) and Right: This tattoo has a more obvious lineage, being derived from hieroglyphs used by South American civilizations.

designs of the people of Samoa, Borneo, Marquesa, and New Zealand, artists like Leo Zulueta (who is credited with starting the modern Western tribal tattoo movement) began looking at the roots of the patterns, ultimately producing a contemporary form of work that took traditional designs and reworked them in highly personal ways for a modern clientele. The tribal style of tattooing was born. Its bold, swirling, black designs adapt onto the body well, and maintain a crisp appearance over time.

"Tatu" in Samoan means "to strike" and their traditional patterns are literally hammered into the skin. Areas of solid

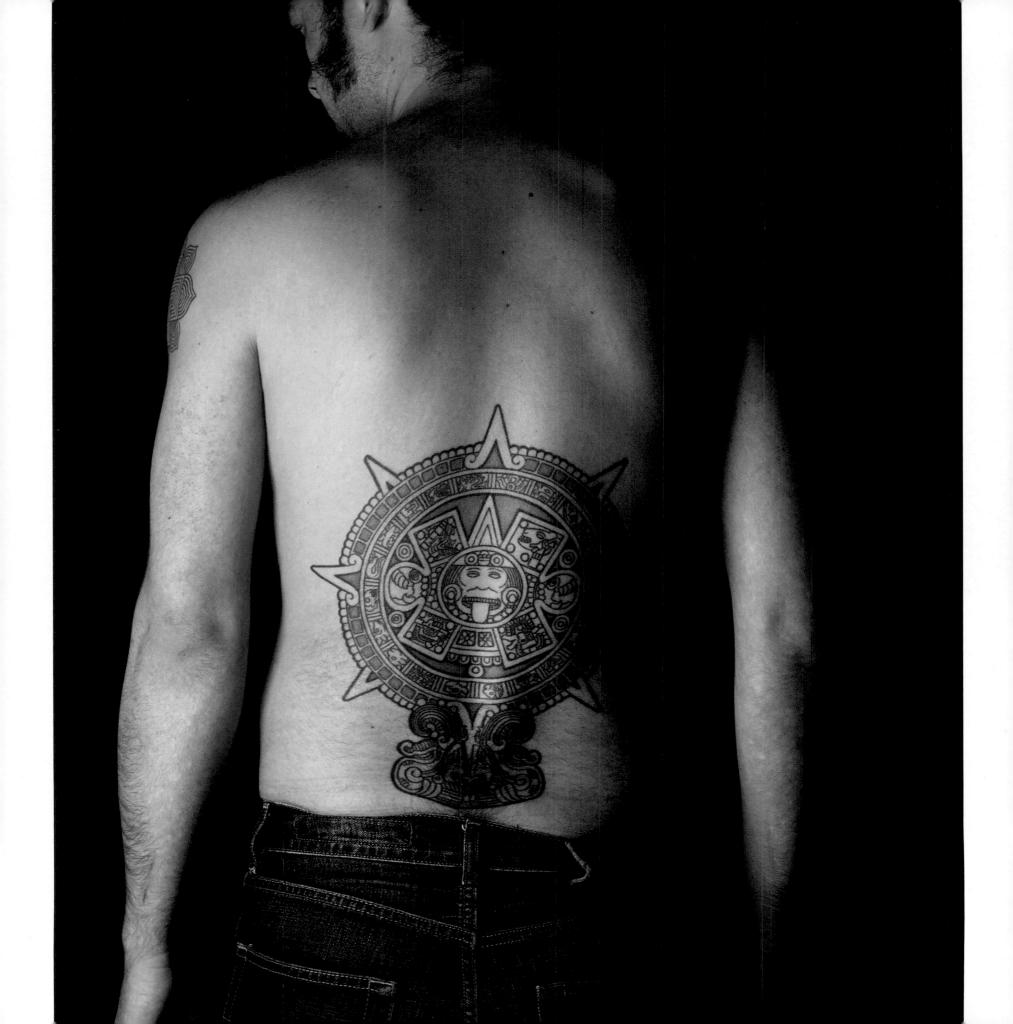

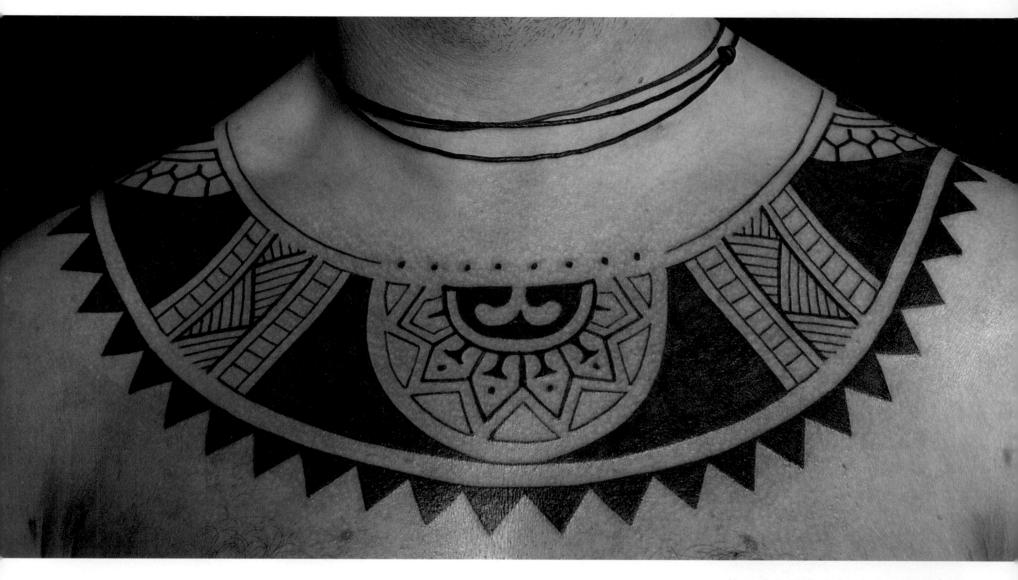

black intermix with delicate geometric designs across the lower abdomen and continue down the thighs to create the characteristic "britches" look. These patterns were, and sometimes still are, tattooed with a pair of wood-handled tools: a toothed "rake" and a slim stick that is used to strike the handle of the rake so that it punctures the skin. In fact, there is a traditional story that narrates the origins of these instruments. It says that tattoo designs were only painted upon the skin until a Samoan adventurer traveled to the kingdom of the spirits. He was treated very well by the inhabitants, but they found his painted body decorations a pale imitation of their own tattoos. He was taught the art of tattooing, and when he

Above: Carlo by Oogie Boogie. A stunning Mayan inspired collar that unusually uses red as a background color, giving the piece a little more depth and texture.

Right: Andre Munro tattooed by Nehe Ruben. This is a modern traditional Maori tattoo done by Nehe, who is part of the recent resurgence of Maori tattooing and traditional arts in New Zealand.

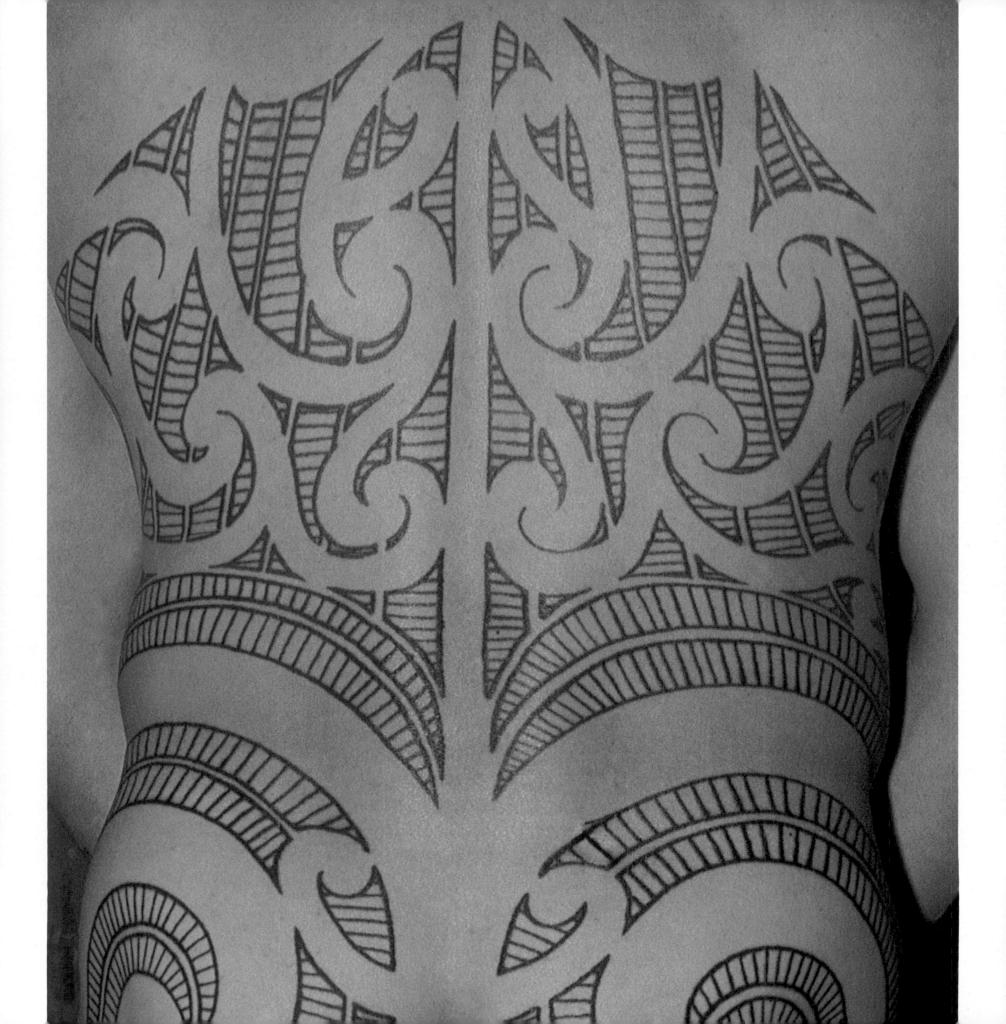

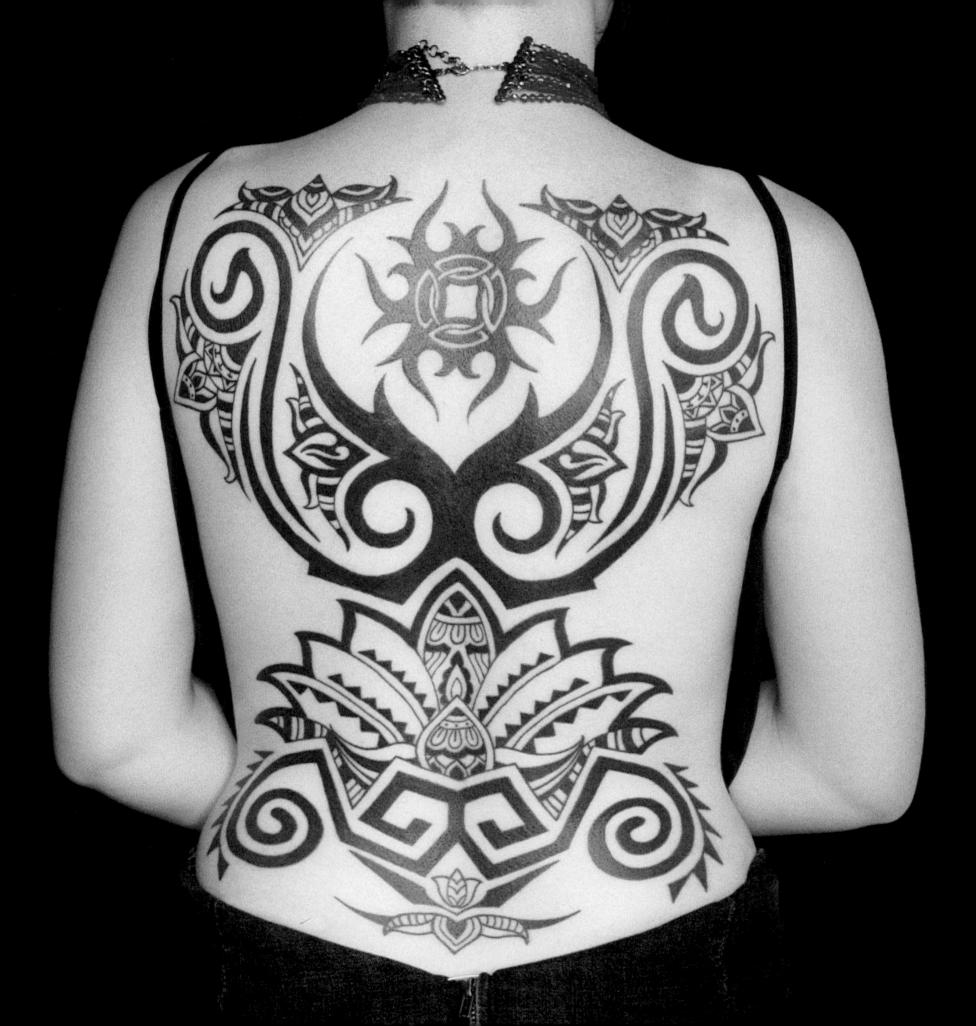

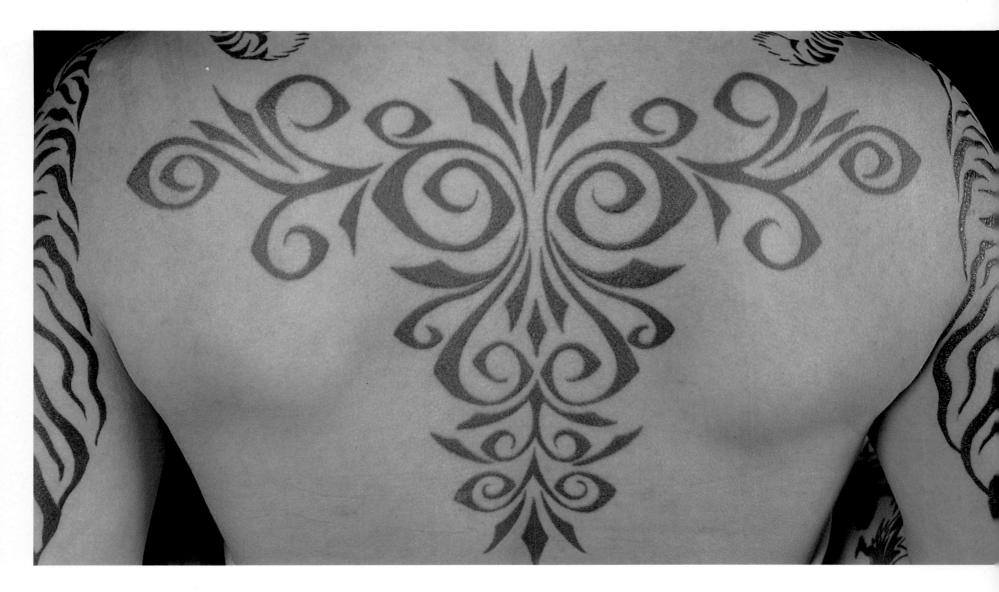

Above: The contours of the back adapt beautifully to black designs and patterns. This is the backpiece of Lisa M. Duhl. More detail of her tattoos can be seen on page 16.

Left: Marie by Calypso Tattoo. This tattoo parlor in Belgium specializes in transforming traditional Polynesian and African tribal art into stunning contemporary tattoo work with a Western interpretation.

returned to Samoa he introduced the use of hammers and sharpened bone or teeth. However it developed (its origins are lost in the very ancient past), tattooing was practiced in nearly all Pacific Island cultures and flourished over any other means of body modification or decoration, including clothing. The warmth of the tropics was the perfect climate for the development of the art of tattoo. In cooler climates, where protection from the elements was necessary, mode of dress was often the marker of status, age, or gender. In Polynesia, however, elaborate tattoos served this purpose instead. Over the centuries, tattooing has been a natural part of life in Polynesia since time immemorial; islanders

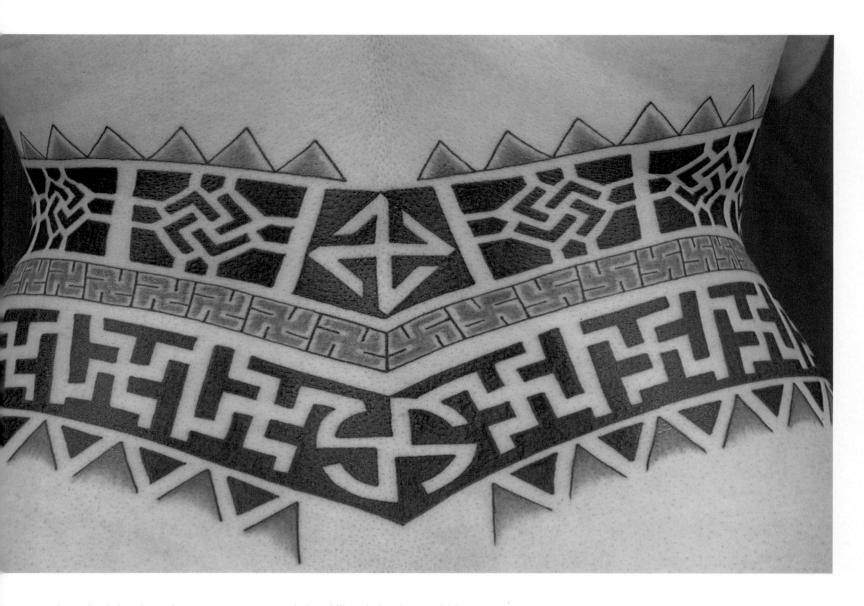

have had the time, the temperament, and the skill to bring it to a high pitch of perfection.

Naturally, for these people tattooing is far more than merely a bodily ornament. In the Marquesas, the art of tattooing has always been deeply linked to the ancient culture and traditions. Men's bodies here, including the face and even the tongue, can be entirely tattooed with geometrical signs. On the other hand, women only got the shoulders, the lower region of the back, the hands, and the border of their lips tattooed. The exceptional variety of designs are usually related to nature; animals (turtles, sharks, lizards, or tropical birds), plants (bamboo, cane sugar,

Left: Brett Jones tattooed by Adam Dutton. This beautiful piece places authentic tribal symbolism in a corset-type design that accentuates the waist.

Right: Neil Bass tattooed by Alex Nardini. This is a tribal-style tattoo based on Pacific Island shapes and design patterns.

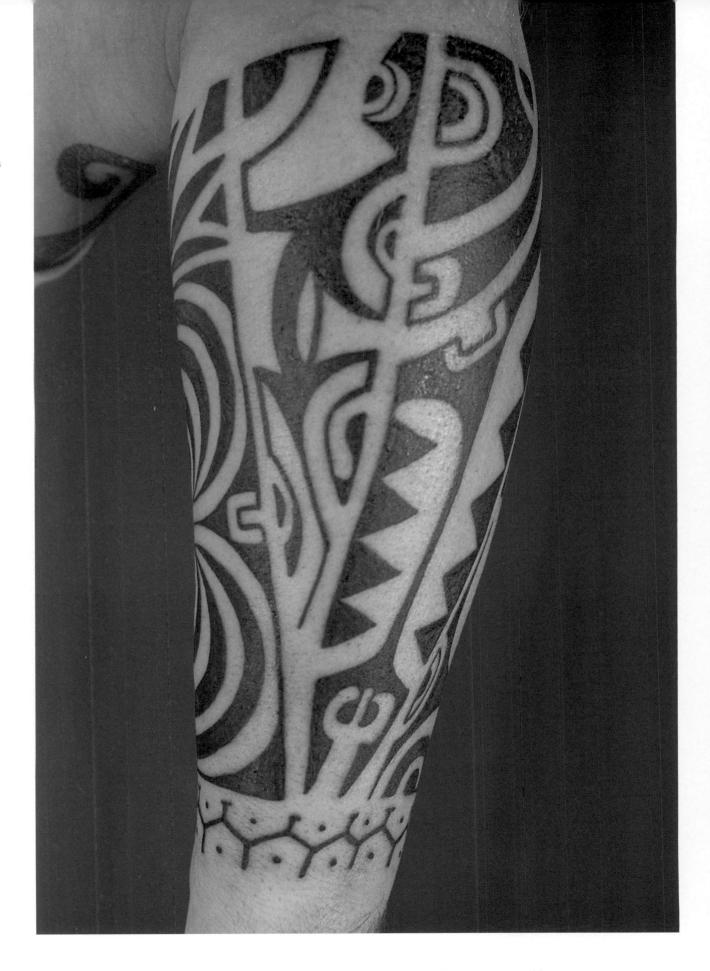

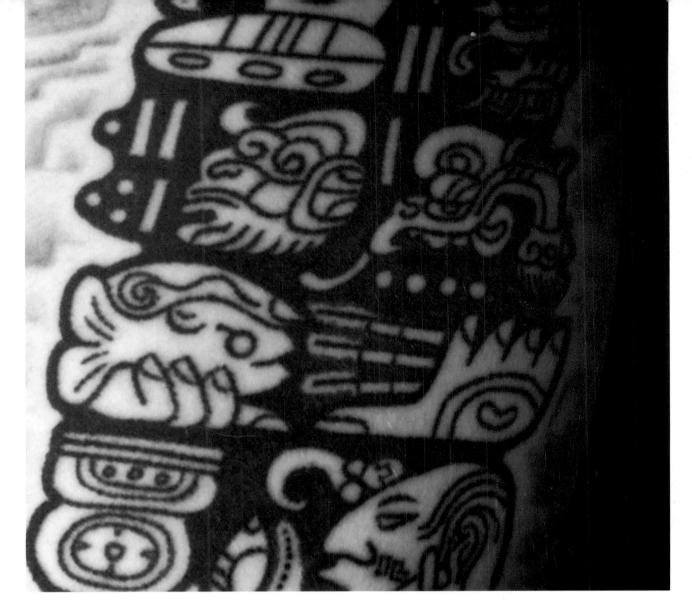

Above: A Mayan tattoo by PierTatu of Temple Tatu in Brighton, England. The top four symbols represent the date, while the bottom four show what is taking place along with the client's name, Tom. The hand holding the fish represents "to let blood" in Mayan and to the right there is a hand holding tattooing needles. Pier works in a hand-picking style with needles on chopsticks.

Left: Kirsty tattooed by Nigel Palmer of Temple
Tatu, showing dotwork or stippling around the
elbow, radiating out into an improvised "doodle."
The dotwork is a version of the pointillist style
that can be used to create 3D tattoos with few
or no lines.

coconut palm, pandanus leaves...), or sometimes to legends or activities like fishing. The most widely spread figure remains the *tiki* whose eyes, nose, or hands could be used separately in the design to obtain a more complicated and unique result.

In New Zealanc, Maori warriors were tattooed to appear more threatening. The spiralinear facial tattoos were as characteristic as a signature, and clan or tribal identification was indicated by tattoo motifs. Although the tattoos were mainly facial, the North Auckland warriors included swirling double spirals on both buttocks, often leading down their legs until the knee. As in the Marquesas the women were not as

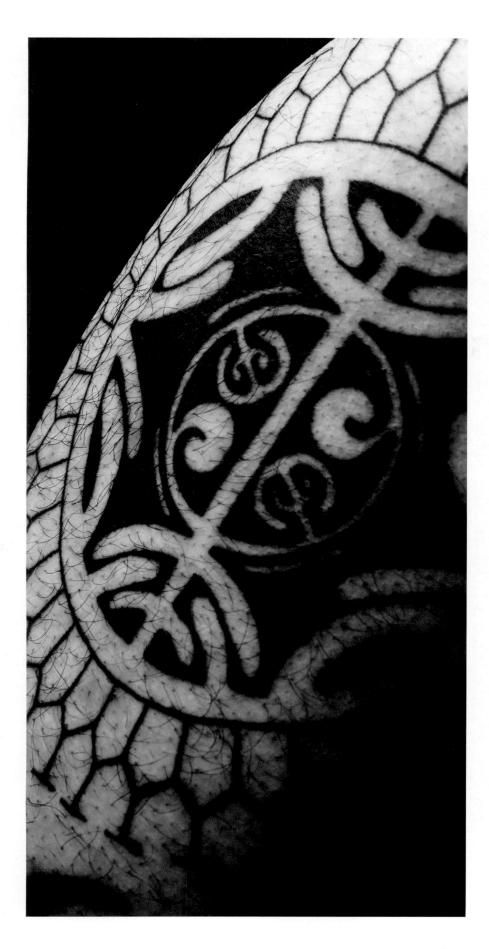

Left: Mathew tattooed by Simon Read at Scribe Tattooing, Bournemouth, England, showing distinctive, symmetrical blackwork.

Right: Christine, tattooed by Elisa and photographed in Milan 2003, demonstrates the use of whitework to enhance areas of gray shading, adding depth to the piece.

extensively tattooed as the men. Their upper lips were outlined, usually in dark blue and the nostrils were also very finely incised. However, the chin *Moko* was always the most popular design and continued to be practiced even into the 1970s.

In Hawaii, names of the deceased were inscribed on the body, and the tongue was tattooed as a sign of mourning. In many cultures, the chin of a woman was tattooed to denote marriage. On some islands, the vulva was tattooed on the chests of young men at marriage. Small facial tattoos often indicated the lower status of slaves, whereas elaborate full-body tattoos were a sign of wealth, strength, and endurance.

Today, Pacific Islanders are taking pride and interest in their cultural heritage, finding their identity in the revival of many lost traditions including the traditional tattoo. Once again, in the Pacific, the tattoo is recognized as a respectable art.

Back in the West the tribal movement, though still producing some wonderful tattoo work, is now regarded as somewhat less than cutting edge. Its place as the leader of tattoo fashion has been taken by more traditional old-school American styles and Japanese-inspired color work. Nevertheless, watered down flash versions of this most striking form of tattooing have become the choice of the masses. Where once the walk-in

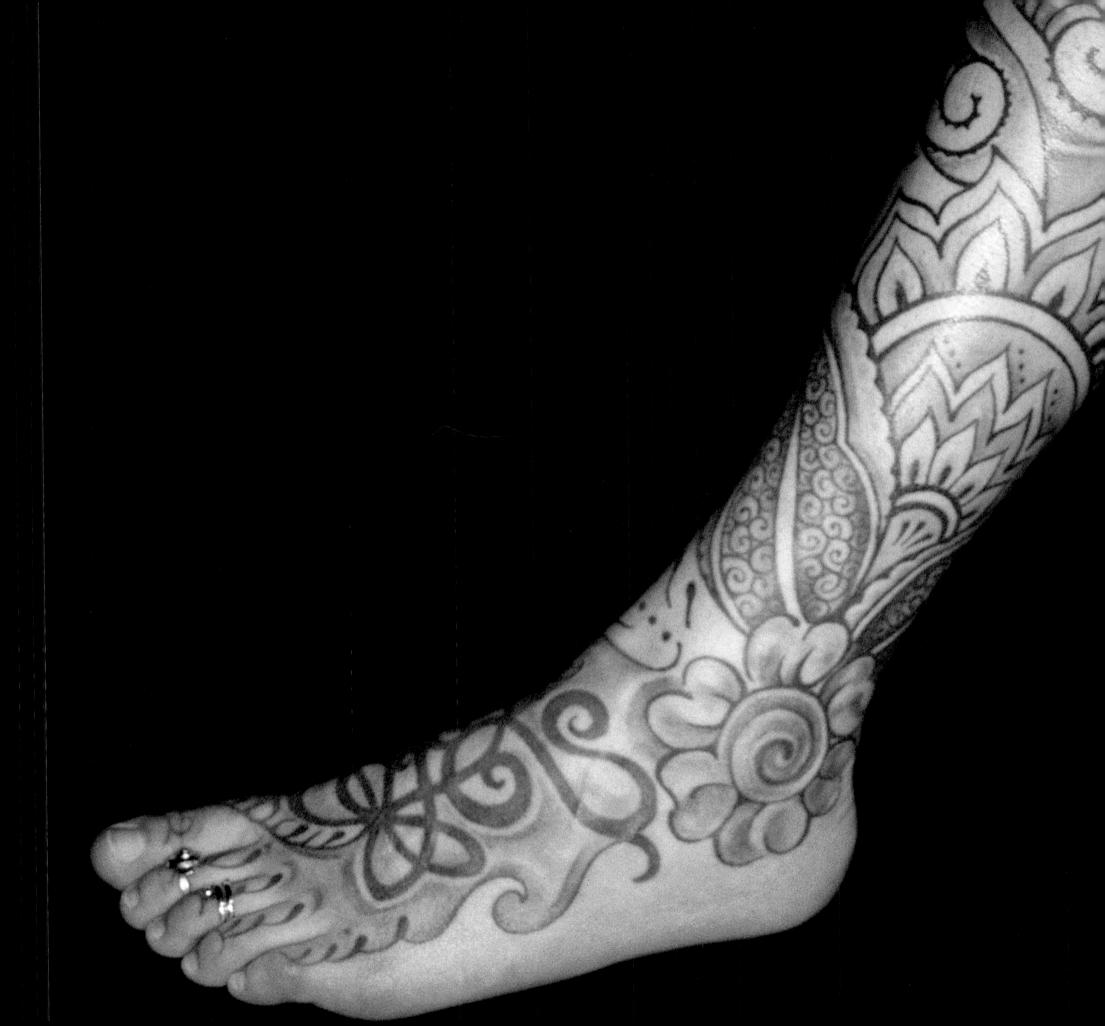

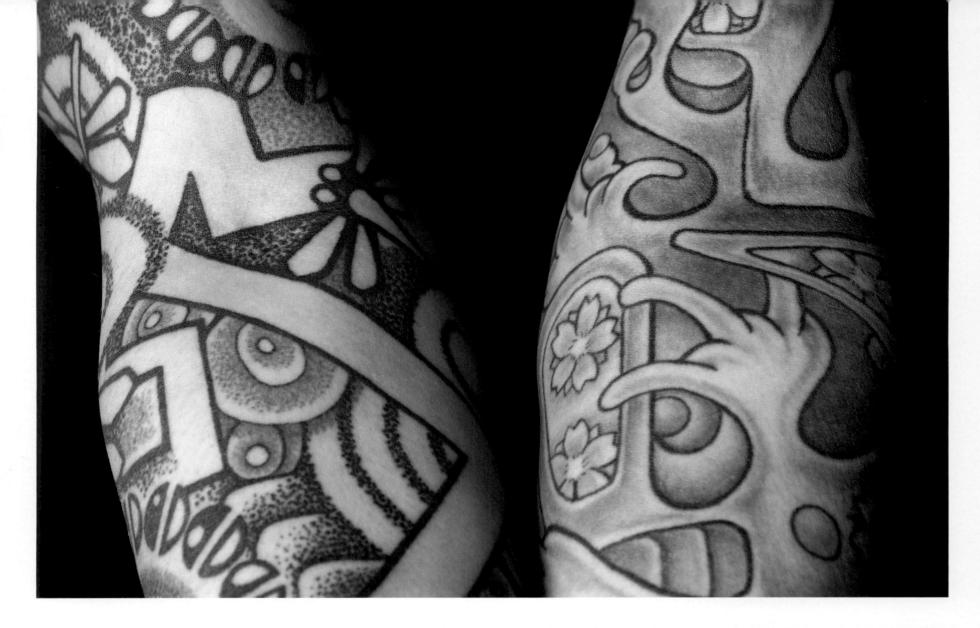

client would prevaricate over sheets of roses with raindrops, hearts 'n' daggers with "your name here," American eagles, British bulldogs, or the national equivalent, now the most popular flash art designs are more along the lines of the Celtic butterfly or the Sepultura tribal style "S."

Unfortunately, as with most forms of artistic expression what begins as something ground-breaking and avant-garde, eventually suffers from its own popularity. There are some excellent tribal tattooists out there, true devotees who are pushing the boundaries of their art and if this style appeals to you, it is worth seeking them out rather than picking a vaguely ethnic-looking picture on a flash sheet.

One such new style takes a mathematical approach, using this as the basis for a modern spirituality through science. Combining hand and machine techniques tattooists have created startling new designs—three-dimensional looking geometric shapes and ever-decreasing circles which are both beautiful and speak of new expressions and ideas about our changing relationship with our own universe. Notably, this type of work is being produced by British artist Xed Le Head, though there are others working with the same ideas.

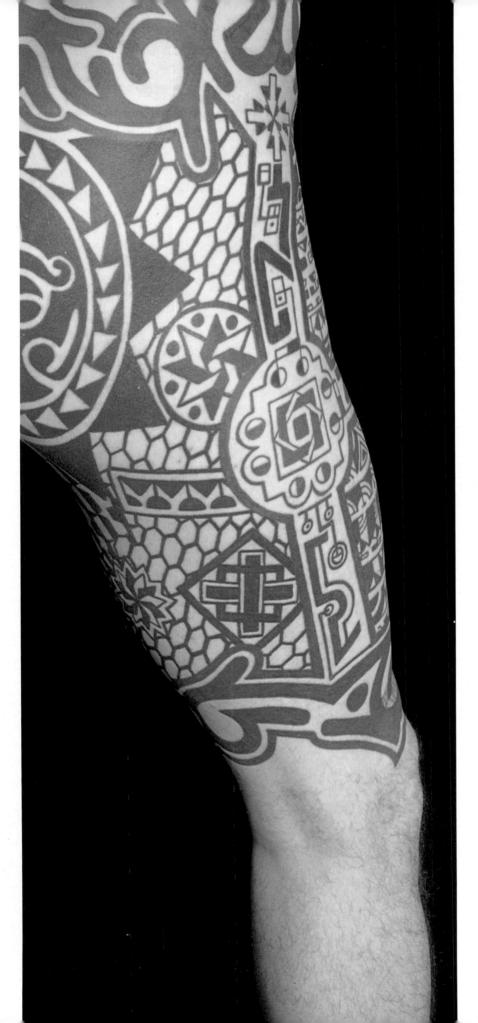

Far Left: Kirsty's forearms. The left is by Nigel
Palmer of Temple Tatu, showing traditional
katsumushi or "win bugs" that appear on
Japanese textiles and are associated with Samurai
iconography. The right arm is by Ade at Trollspile,
Guildford, England, which has elements of cherry
blossom and "abstract Japanese water."

Left: Laurent by Calypso of Belgium, a new interpretation of the traditional Samoan "britches" first recorded in eighteenth century ships' logs. The geometric patterns, however, are not traditional Polynesian.

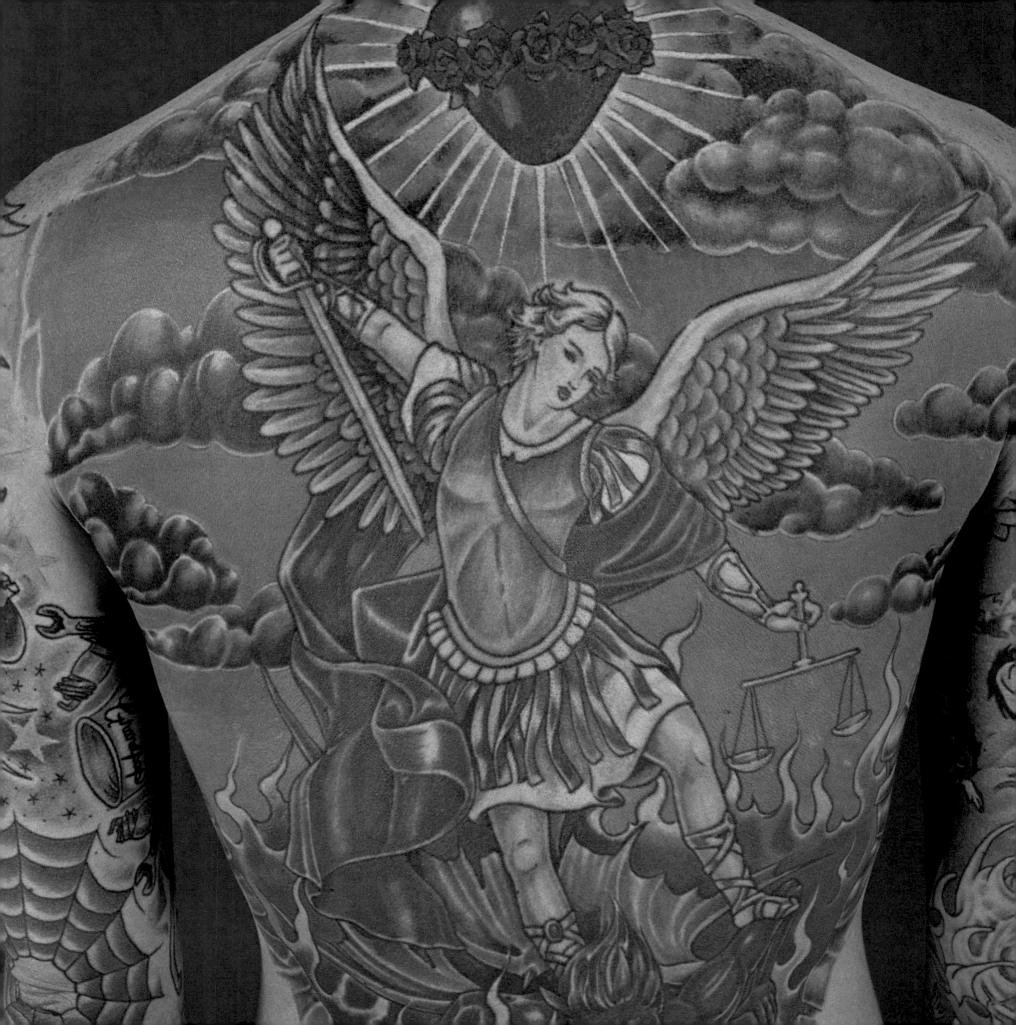

Above: Nina Jean tattooed by artists at Thinkin' Ink. New School tattooing encompasses a range of styles and sizes, but is most notable for its vibrant colors.

Left: Michelle Henry tattooed by Chris Henry. Michelle chose to depict St. Michael on her back because of her love of religious imagery and because she was named for him. While religious tattoos are not so popular as in the past, the New School movement makes great use of traditional tattoo subjects.

New School tattooing, as its name suggests, is at the forefront of a new wave in tattoo style. It developed on the West Coast of America and is, very broadly speaking, a combination of Japanese style and traditional old school tattoos; think sailor-style plus. Most significantly, and what sets it apart from either types of tattooing, is its bold use of color.

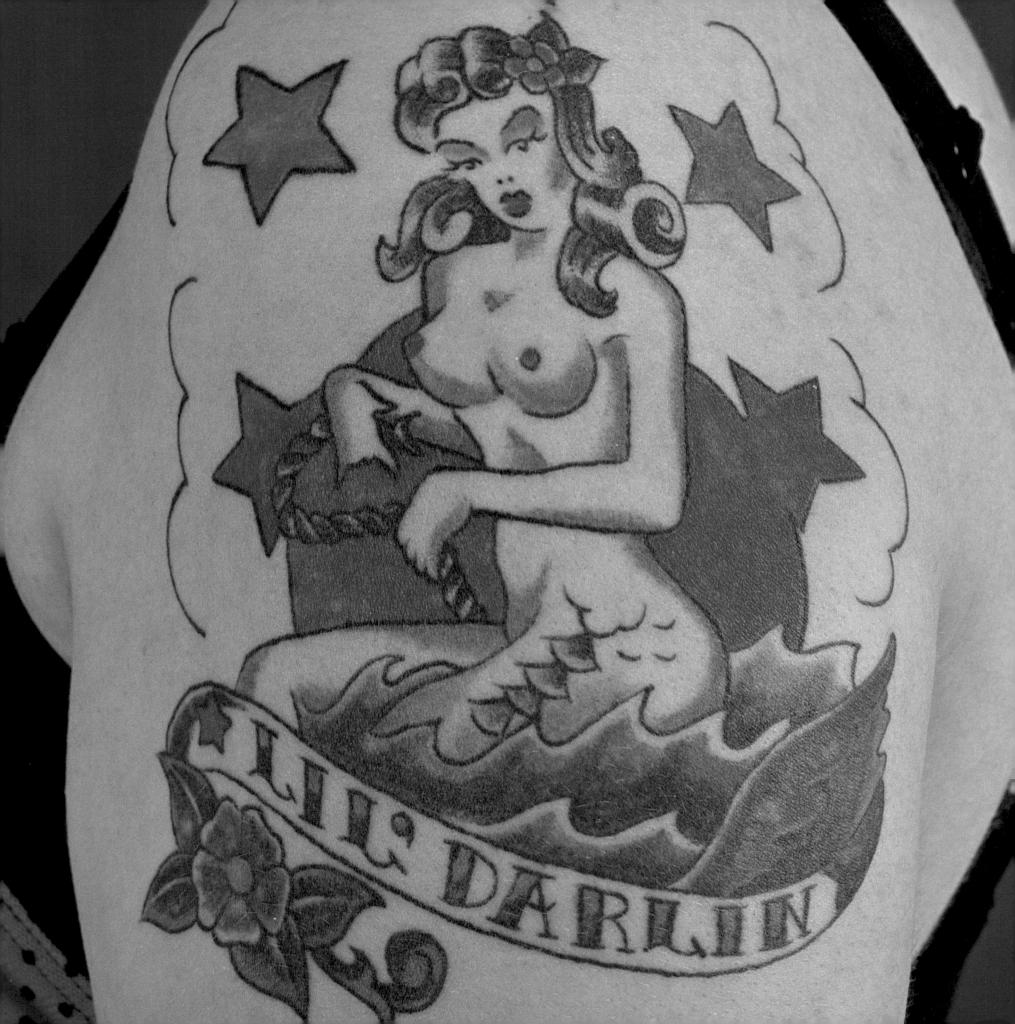

Left: Cheri Pafumi tattooed by Jim White, Modern Tribalism. This is a classic Sailor Jerrystyle pin-up reinterpreted by a new generation.

Right: Lucy by Simon Read at Scribe Tattooing. This sweet tattoo replicates a garter on Lucy's thigh.

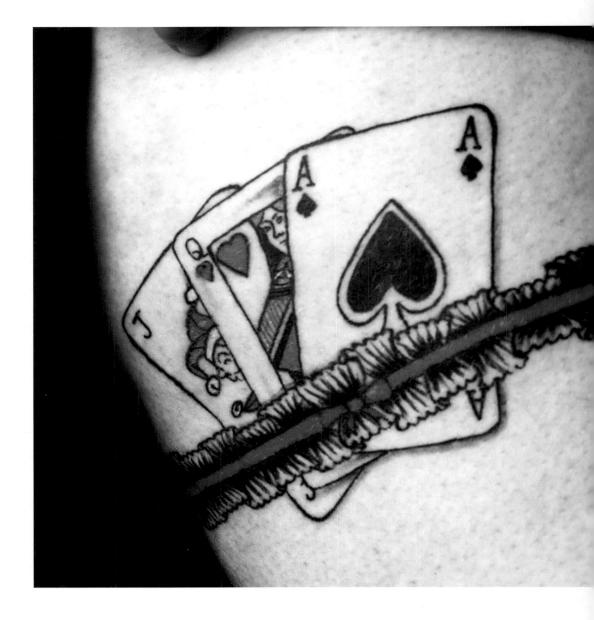

Although colored inks have been with us for generations, color work really began to come into its own in the late 60s and early 70s—the time of the psychedelic generation created by children of the 1950s who were raised under the sobriety and conformity that was the hangover from World War II. When the 1960s brought greater prosperity the time was ripe for teenage rock 'n' roll rebellion. As the decade progressed—with the new advancements in trave and communication—the exposure of the masses to the exotic, experimental and the avant-garde was much greater than in any previous decade. This together with the growing use of drugs, an increased

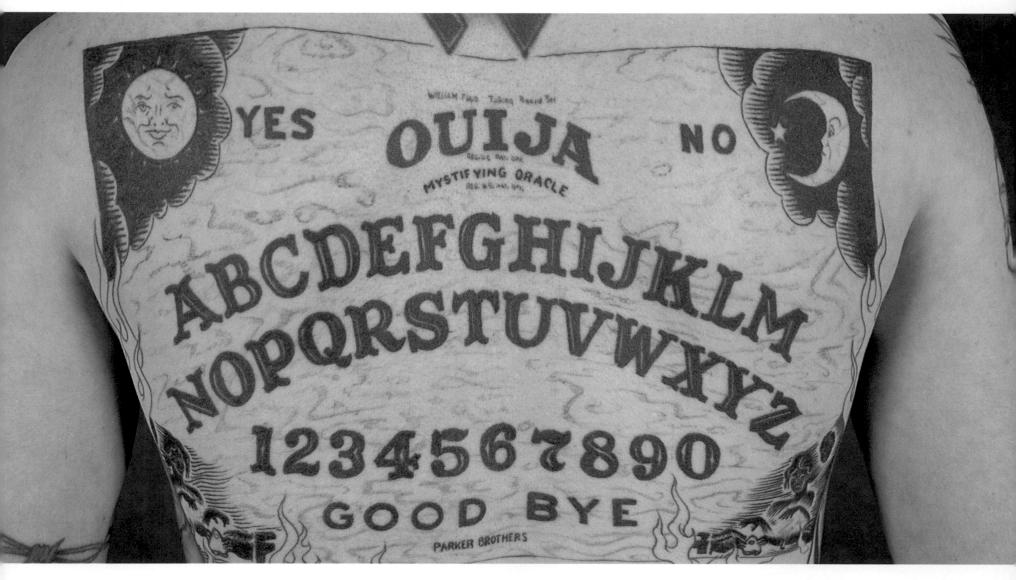

interest in mysticism, and the moon landings, all served to fuel imaginations. The psychedelic universe was born. First featured on album covers, the psychedelic influence was soon everywhere, and in tattooing it was pioneered in the work of the likes of San Francisco's Lyle Tuttle.

Although this was a period mostly associated with the strange and conceptual, it is at this point that advancements in tattooing techniques also made a degree of realism possible. Figures and portraits had always been a feature of traditional work, but it was only now that they began to resemble the ones we see today with their use of color and shading. Where previously the figures had been the familiar simple line-drawn

tattoo with perhaps some blocks of color, it was now almost possible for artists to draw in flesh as they would on paper. The popularity of this practice has its roots in the "remembrance" or "tribute" tattoo, where a likeness of a loved one (living or deceased) would be tattooed on to the body so that the wearer might always carry something of them to remember. Such tattoos are all about the protection that your loved one will give you and also create an illusion of togetherness. The same rationale accounts for the many images of Christ and the Virgin Mary that have been a staple of tattooing for generations. This type of work can be seen more extensively in times of war for obvious reasons. More recently, however,

Left: John Barrows Jr. tattooed by Al Benendetti, Julie Moon Designs, Seabrook, New Hampshire. John and his tattooist are both fascinated by horror movies and decided to tie his horror-themed tattoos together with a Ouija board backpiece. Despite the lack of color, this tattoo is a descendant of "American manner" tattooing which often used text in fancy scripts with decorated surrounding borders.

Right: Emily Roberts, artist unknown. This is an excellent example of a tattoo made solely with white ink, which is very uncommon. Drawing on tribal themes it is much more delicate and discreet than blackwork and is a very feminine tattoo.

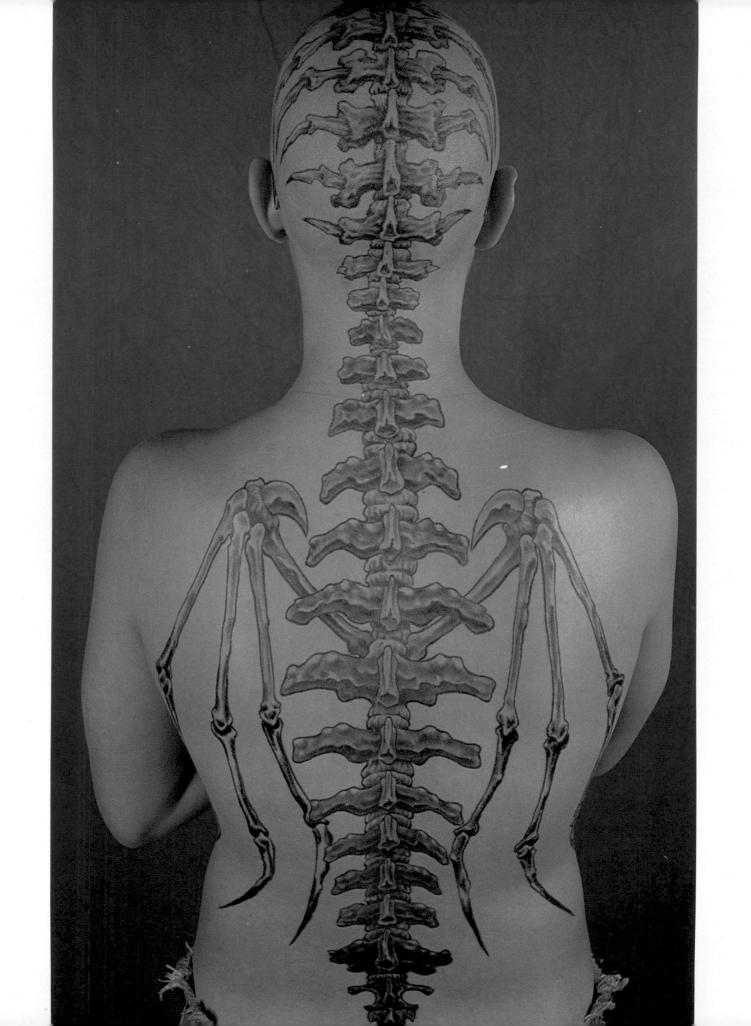

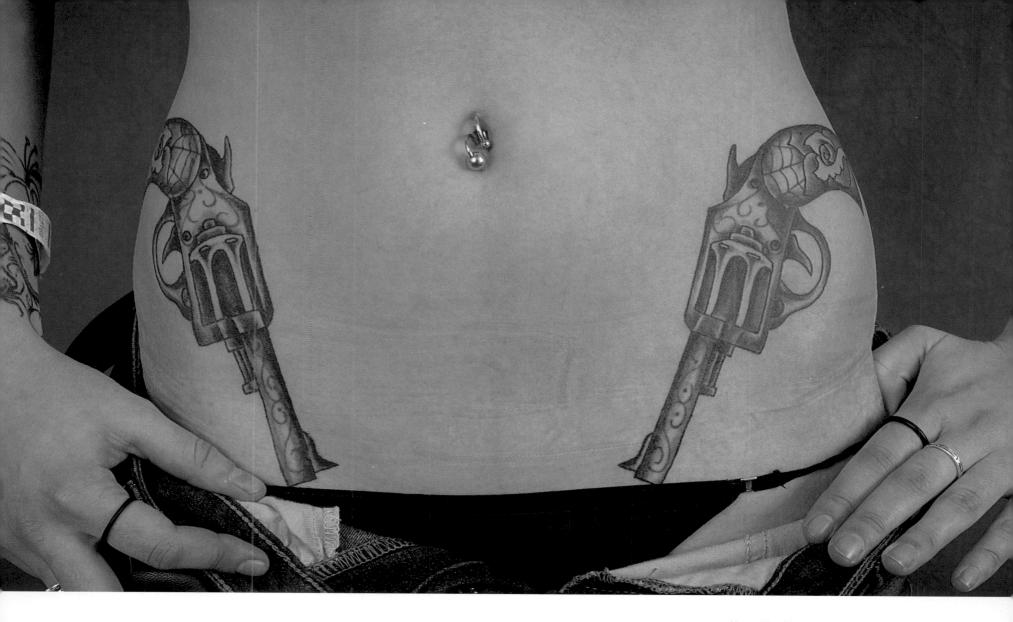

there has been less of a demand for religious tattoos or images of loved ones and more and more they might depict actors, actresses, musicians, and other celebrities—not entirely surprising with the almost religious fervor directed toward many stars. It is worth mentioning that however worthy or otherwise the subject of the tattoc might be, the skill involved in producing the best examples of this work is undeniable.

Following the revolution in color work of the 60s and 70s, the 1980s saw tattooing fall stylistically into a kind of norman's land. There was no dearth of new styles or techniques being worked at, but neither one was more prevalent than the next. However this decade is arguably where

Above: Kim Sikorsky tattooed by Rev. Bob Knox, Enigma Studios. Similar in feel to the garter on page 93, "holstered" pistols seem to be gaining popularity in the tattoo world. This pair of six shooters is a superbly executed example.

Left: Kim Stivers tattooed by Tim Kohtz. These skeletal demon wings were inspired by the 80s fashion for making a terrifying tattoo that appeared to be a part of the body.

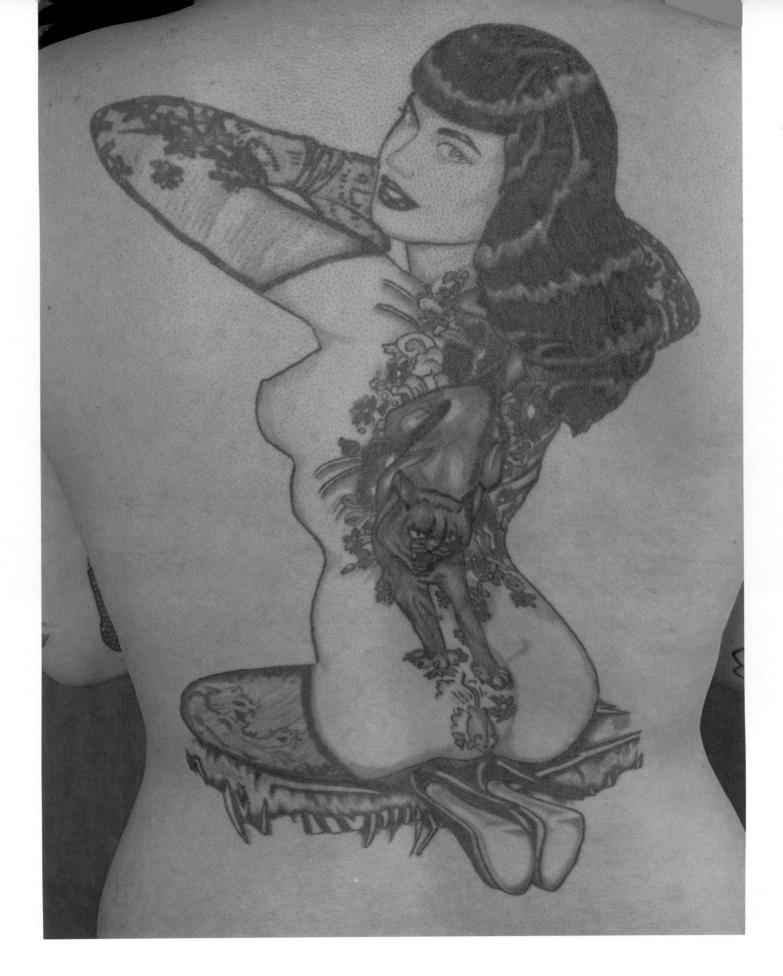

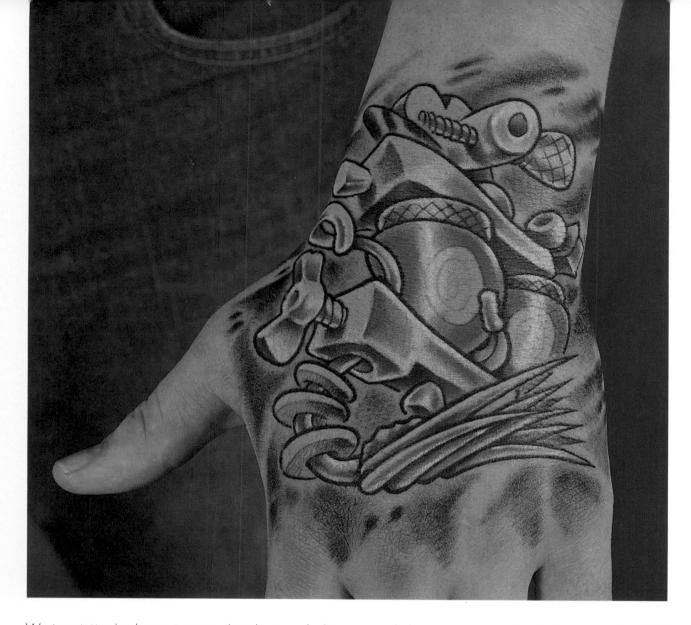

Far Left: Kymmburleigh Atherholt tattooed by Mike Oliver, Consolidated Ink & Steel, Flint, Michigan. Pin-up icon Bettie Page is a popular subject for tattoos. This bold tattoo is very much in the New School style, being a contemporary take on the Sailor Jerry erotic portrait, and also uses color in a simple but effective manner.

Left: Jason Tritten tattooed by Cleen Rock One, Chicago. This is a New School tattoo machine. Many tattooists will not tattoo hands as this is obviously an area that is not easy for the recipient to hide should they wish to at some future time. Hands are also quite technically difficult due to the amount of tendons, veins, and bones. Nevertheless, this tattoo is a good example of how graffiti art has been adopted by the tattoo world.

Western tattooing began to come into its cwn. Artists were quietly developing the skills that would make the following decade's explosion of style possible. If anything, this was the age of the heavy metal tattoo, with many requests for Iron Maiden's "Eddie." With the screening of H. R. Geiger's Alien, biomechanics was also born and the idea of integrating man and machine became a form of horror tattooing. New York's Paul Booth was one of the most successful at bringing a profound level of realism to this genre and images of peeled away flesh revealing mechanical workings beneath became quite popular during this period.

This brings us to the 1990s and the advent of the "modern primitive" movement discussed in the previous chapter, a term coined by cultural philosopher Levi Strauss in a book commenting on the trend for tribal tattooing and body modification. However popular though, strong expanses of black ink weren't for everyone. Also during this period the allure of rap and hip hop music had began to increase and with it graffiti art. So, while some disaffected youth were getting themselves inked like the Marquesians, stretching their ear piercings and hanging themselves from hooks, others were painting trains and tagging walls. Graffiti, once regarded as purely public nu sance and vandalism, was starting to be seen as an art form in its

Left: Mike by Simon Read at Scribe Tattooing. This vibrantly colored tattoo is reminiscent of street art in its colorful simplicity.

Right: Flowers are another popular traditional subject for tattoos. This floral design is a very modern take on the tradition with the flowers more naturally colored and rendered than would have been possible with the inks of the past.

own right and soon found its way into tattooing. To quote Alex Binnie, the tattoo artist: "Tattooing attracts the young, it's a vibrant street-art like graffiti. If kids can get a hold of start-up kits they are going to. I don't want to encourage that, but it's inevitable. Let's face it, some of the best tattooing is done in unlicensed conditions by young artists who are really passionate, tattooing away in someone's bedroom at three in the morning." Combine this creative passion with elements of traditional work and Japanese composition and you have something of the premise of New School tattooing. In short, it can be seen as a kind of Westernized take on Japanese tattooing. Developing in tandem with the tribal movement,

it is now the basis for many of the vast array of styles across the U.S. and Europe.

Although it has always been a part of the New School mix, more recently we have seen a stronger return to the Western traditions of tattooing. This type of traditional tattoo is very stylized, quite two dimensional, and often executed with little regard for art. The lines tend to be thick and bold, the colors are rarely shaded or lifelike, and the images tend toward iconic and cartoon-like with little effort made to make things look realistic. This was a relatively quick way to tattoo and came into its own in the 40s and 50s near military bases where, unlike the world at

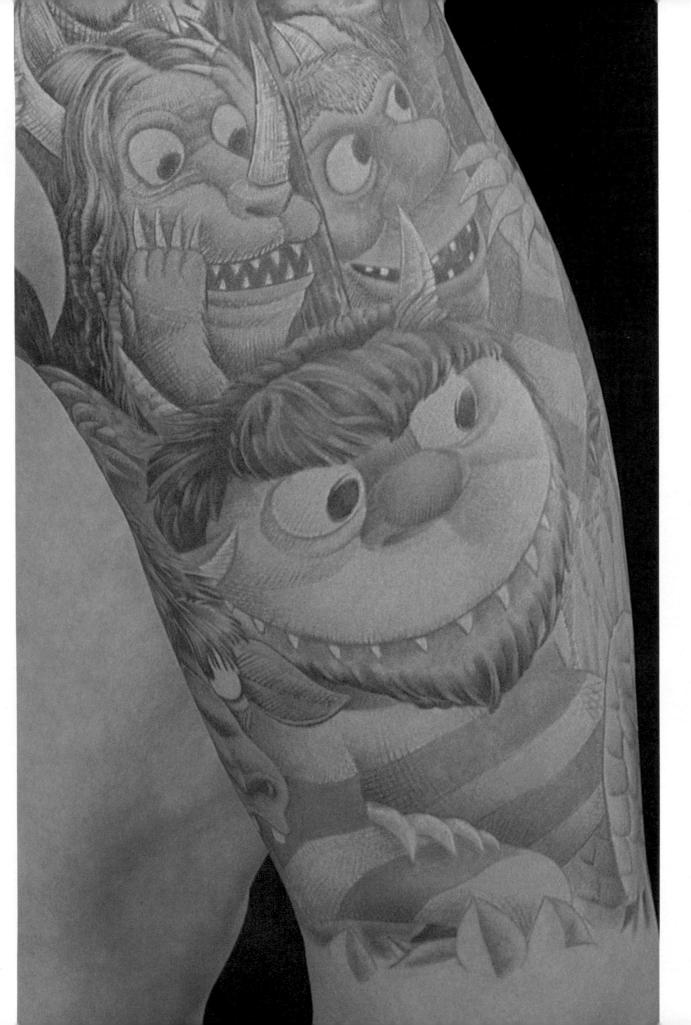

Left: Lyndsey Hahn tattooed by Monte, New Breed. This extensive tattoo is a depiction of Shel Silverstein's children's book Where The Wild Things Are. This is a work of considerable devotion and expense, but is notable for its dramatic use of color and amazing detail.

Right: Sharon A. Trainor tattooed by Dan Carroll, Masterpiece, Salem, New Hampshire. This tattoo depicts Sharon's grandmother reading to her granddaughters and how their imaginations interpreted the story. This is a modern example of the "remembrance" tattoo, which is an indelible reminder of a loved one. These days, however, the image is likely to be much more photo-realistic than in years past. To make an accurate portrait as a tattoo involves great skill, but the result is likely to be highly personal to the wearer.

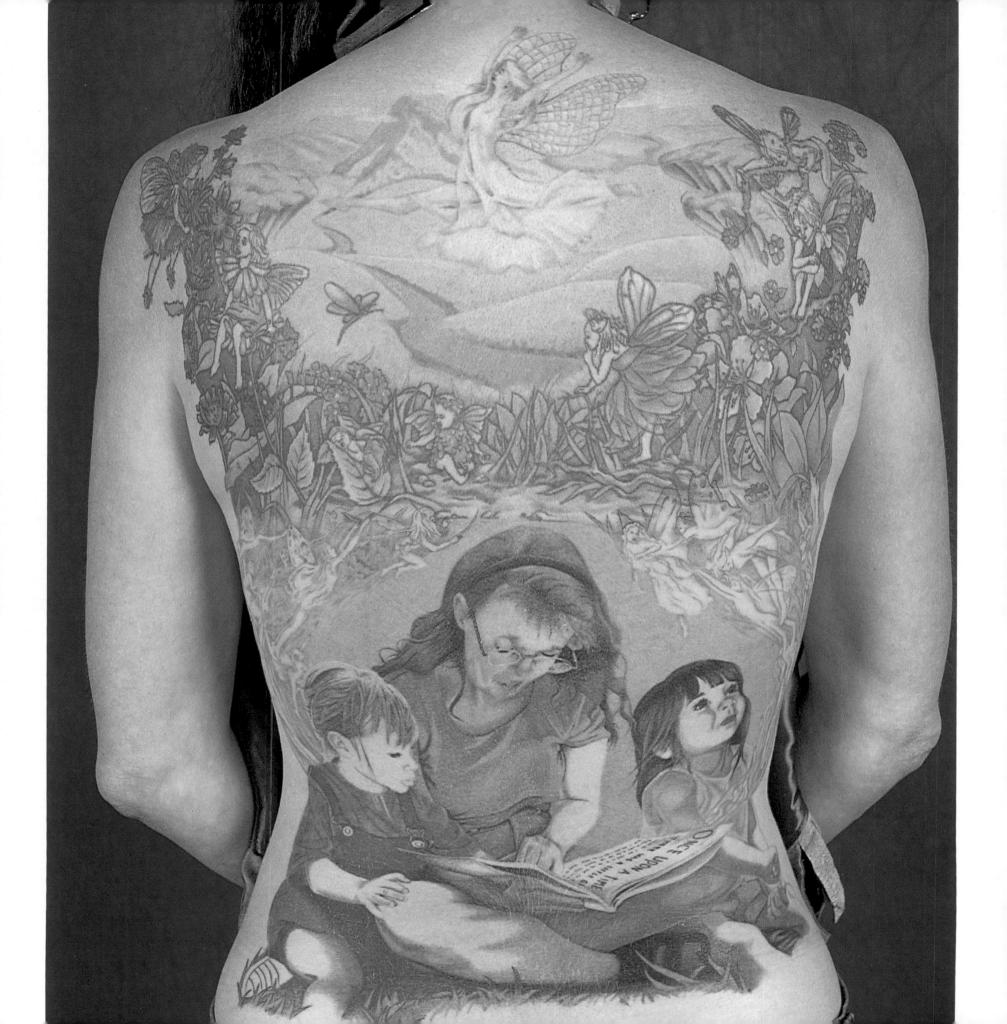

large, there was an unusually heavy demand at this time. The tattoos were colored using the limited palette then available, predominately black and red. Common design elements included arranging scrolls of words among decorative vignettes, flowers, anchors, hearts, birds, and animals. Originally the preserve of soldiers, sailors, criminals, and sideshow performers, today the proudest exponents of this kind of body art are punk kids and musicians. And, for a change, the movement is now taking its lead from the East Coast of the U.S. While it always comes down to personal choice, it is worth mentioning that among devotees there is also a move toward greater coverage—hand and neck work is no longer out of bounds.

Above: Clare Jordan tattooed by Eric Merrill. Both this tattoo and the one opposite are remarkable reworkings of traditional imagery by New School artists. Clare believes in tattoos that correspond with your life. The yellow roses in her chestpiece represent the last flowers that she gave her grandmother before she passed away in a hospital.

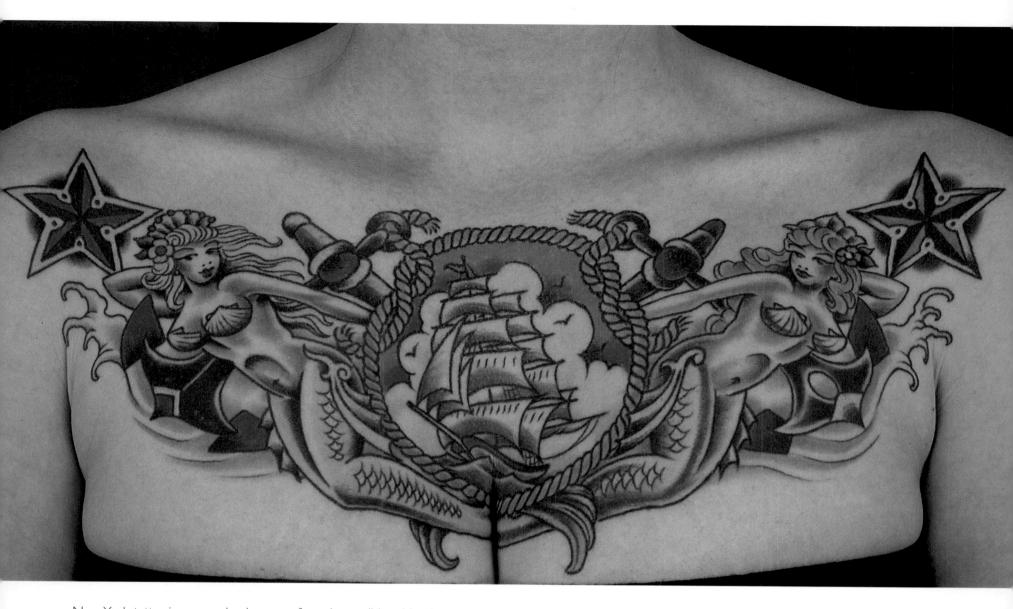

New York tattooing never broke away from its traditional beginnings completely. With the use of strong graphics often accompanying wording, for a time the New York artists were often accused of being gratuitously aesthetic with their bold use of heavy shading and strong color. But the best examples of this new style old school tattooing (so to speak) differ from their origins in that they are expertly executed with a highly considered appearance. The tattoos are largely of custom design. This can be seen as modern tattooists picking-up where the famous sailor Jerry Collins left off. Collins was noted for striving to introduce a greater level of quality to traditional style, bringing an element of Japanese quality

Above: This tattoo by an unknown artist takes traditional nautical themes of anchors and mermaids and gives them a modern twist, not least in the tattoo being worn by a woman. The coloring is also exceptional.

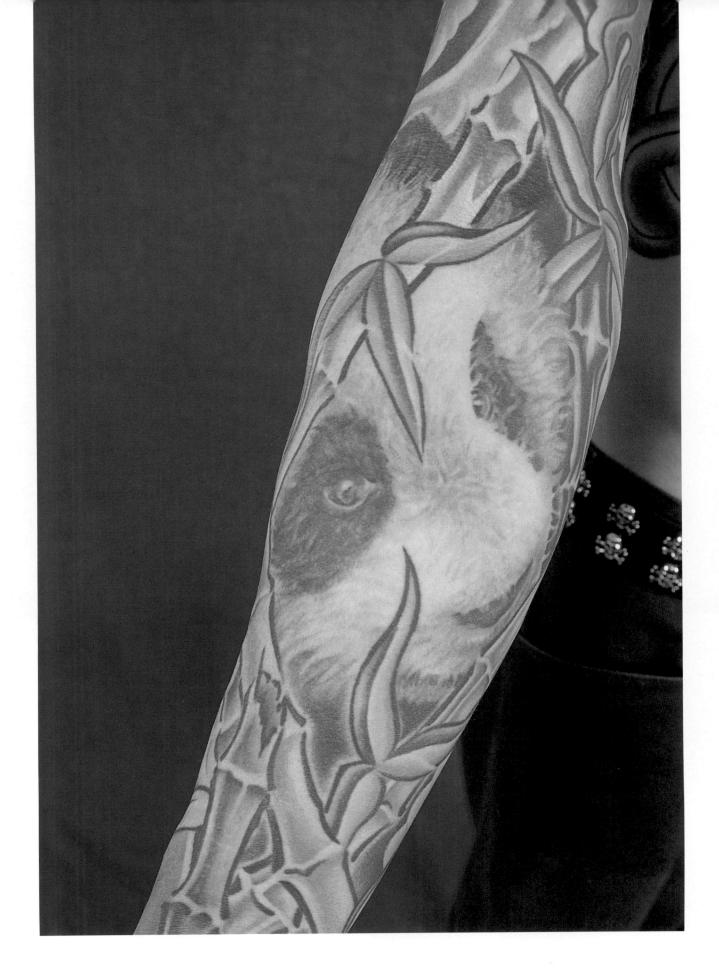

Left: J. Green tattooed by Dawn Purnell, Four Star Tattoo, Santa Fe, New Mexico. This photorealistic tattoo of a panda bear would have been impossible with the equipment available to previous generations of tattoo artists. With technology improving all the time, the future for tattooing is limited only by the skill of the artist and imagination of the client.

Right: Christina Richardson tattooed by Sarah Peacock, Jade Monkey Studios. Once a profession held mainly by men, more and more women are becoming tattooists today. Well able to hold her own against any man in the field, this tattoo is a good example of Sarah's big, bold work, combining mythological beings from varying cultures.

to the work. However, the return to the o'd school has not seen a return to flash work.

So where does tattooing go from here? Well frankly this is anybody's guess. There is a school of thought that believes that with the current trend toward greater coverage and an appreciation for traditional work, we'll see a more savage, less aesthetic style emerge, more akin to the old prison style or sideshow performer tattoos, and similar in style to some of the more extreme work of Mr. X. It would make sense given tattooings new face of acceptability. Having previously been the preserve of the outsider, what better way forward for those who want their tattoos to give them a little bit of

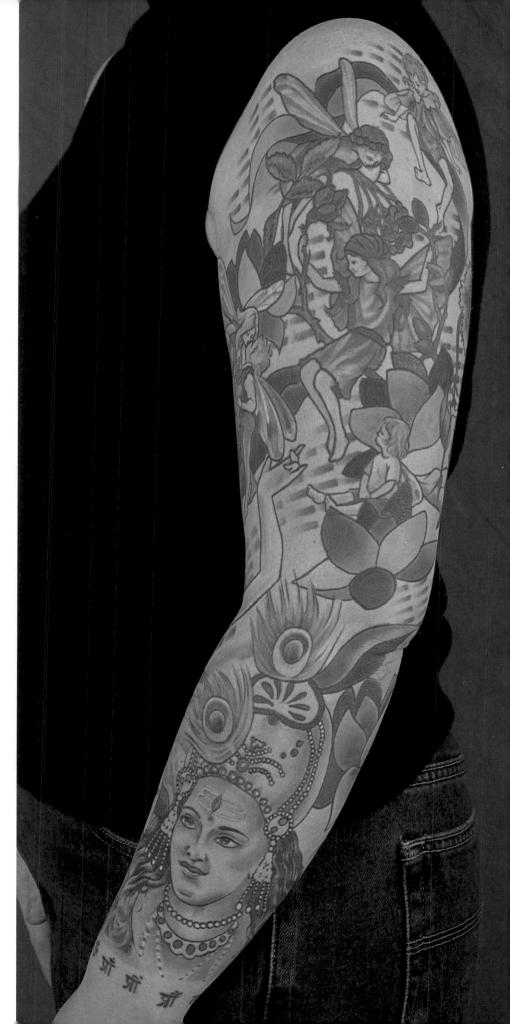

Above: A traditional theme in a modern style.

Right: Gil Blovin tattooed by Avashai Tene, Israel.

A strikingly individual backpiece in terms of both subject matter and use of color. It depicts

Alexander the Great.

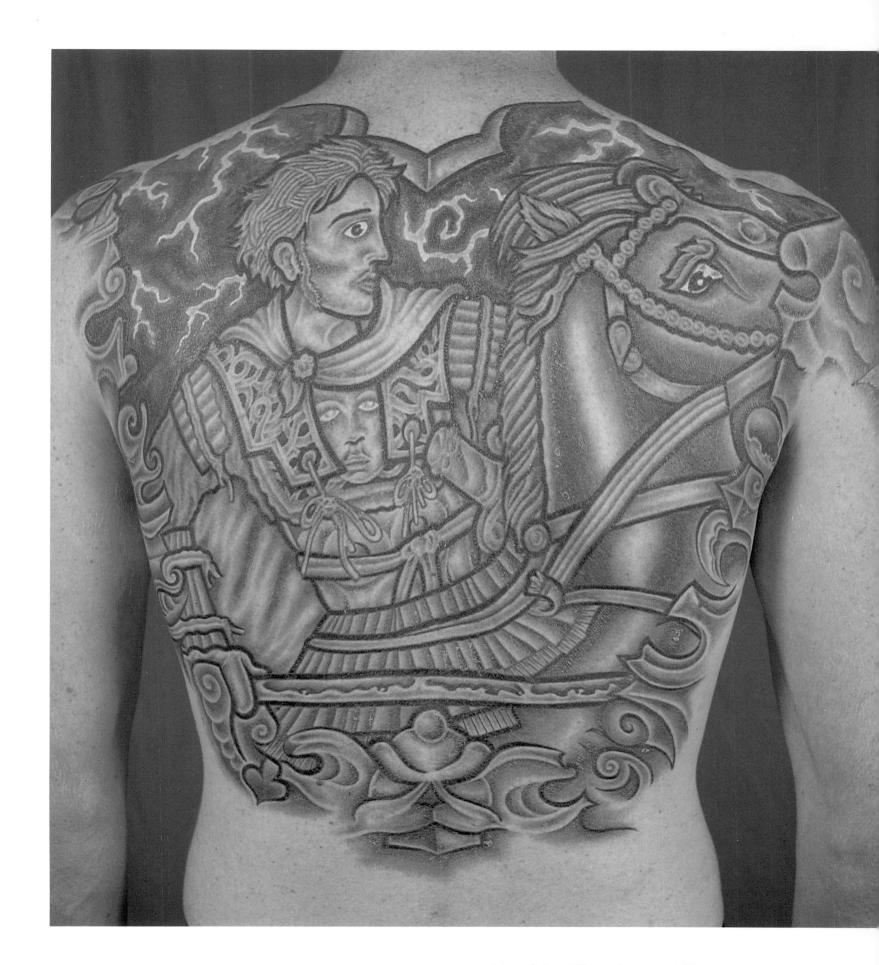

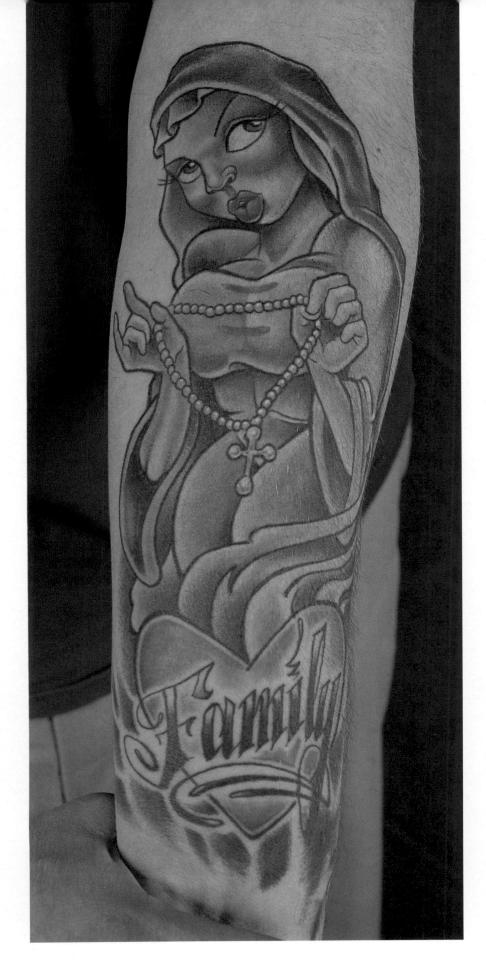

Left: Jason Tritten tattooed by Jim Litwalk, Electric Superstition. Jim is known for his New School cartoon style, which incorporates elements of street art and old style tattooing. This tattoo is a quirky take on old style religious tattoos.

danger than to add chaos to the mix? Just when we are becoming comfortable looking at tattooed skin and those exhibiting it then there are those that would continue to challenge the fashionable images and ideals that have recently been created, pushing tattooing back toward the peripheries of society.

To conclude it is worth mentioning just a few of those tattooists who have recently pushed the boundaries of their art. Although it is impossible to mention all of those who have helped to bring tattooing back into the public conciousness and make it the dynamic art form it now is, these brief biographies show just how diverse the tattooing world is and how very far the artists are from the old public perception of seedy tattooists in dirty parlors, tattooing worthless images onto social outcasts.

Whereas some tattooists focus almost exclusively on their tattoo work as their chosen form of artistic expression, Guy Aitchison moves in and out of different media as need be, whether it be tattooing, painting, or writing. He sees being an artist and getting tattooed as having almost unavoidable consequences, and from his own background painting record covers, Guy started apprenticing at Bob Olson's Custom

Left: Goska tattooed by Bugs, Juan from Angelic Hell, Matt from Tusk. This is traditional tattoo subject matter depicted in a style not often found outside of a canvas or subway wall.

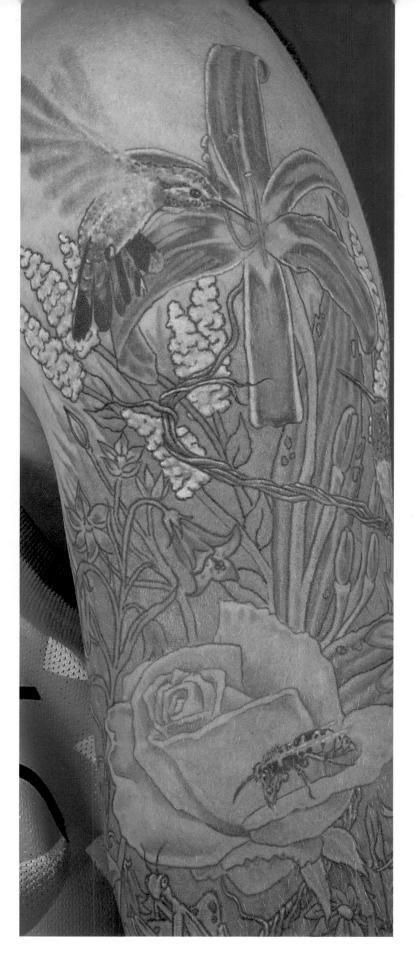

Far Left: Britt Davis tattooed by Mike Parsons. This is a realistic underwater scene that incorporates all of Britt's arm.

Left: Mike Racicot tattooed by Mike Andrews, Fantality Tattoos, Peterborough, U.K. An amazing wildlife scene with elements of the English garden (the rose and bee) as well as tropical flora and fauna. The overall result is colorful and beautiful.

Tattooing in Chicago in 1989. Two years later, he opened his own shop under the moniker Guilty and Innocent Productions, only to close his doors in the mid-nineties in order to move away from the urban environment and have the ability to pursue other means of expression. He sees the balance of different artistic media as an integral part of avoiding getting burnt out on any one medium. Still tattooing at home and on the road, he finds himself in a constant state of flux, learning from everyone he comes in contact with, regardless of their experience level. Although considered an innovator and master

of the tattoo medium, he sees himself rather as a catalyst for change; the driving force for that change comes from within the entire movement itself. He says that "...true mastery can exist only in theory, and... our limitations as human beings make us perpetual students." As a student of life and art, Guy's inspirations reflect his varied interests: Salvador Dali for his work ethic, high technical standards, and sense of humor, H.R. Giger for his organic forms, Alex Grey for a sacred presence, and M.C. Escher for his multi-dimentionality. These influences can be seen in his work; exploring the organic form, which he sees as both simple and infinitely complex, allowing an understanding of light, form, and composition.

Above: Debra Blue tattooed by Shane Watkins, BellaDonna Tattoo, Austin, Texas. Inspiration can be drawn from a myriad of artistic sources. This rose is in a style pioneered by the Arts and Crafts movement of the early twentieth century.

Right: Angie Mitchell tattooed Chad Wells, Glenn Scott's, Dayton, Ohio. This tattoo is a New School gambler's delight incorporating good luck symbols such as the horseshoe, dice, and number seven, as well as a sailor-style inspired pin-up girl.

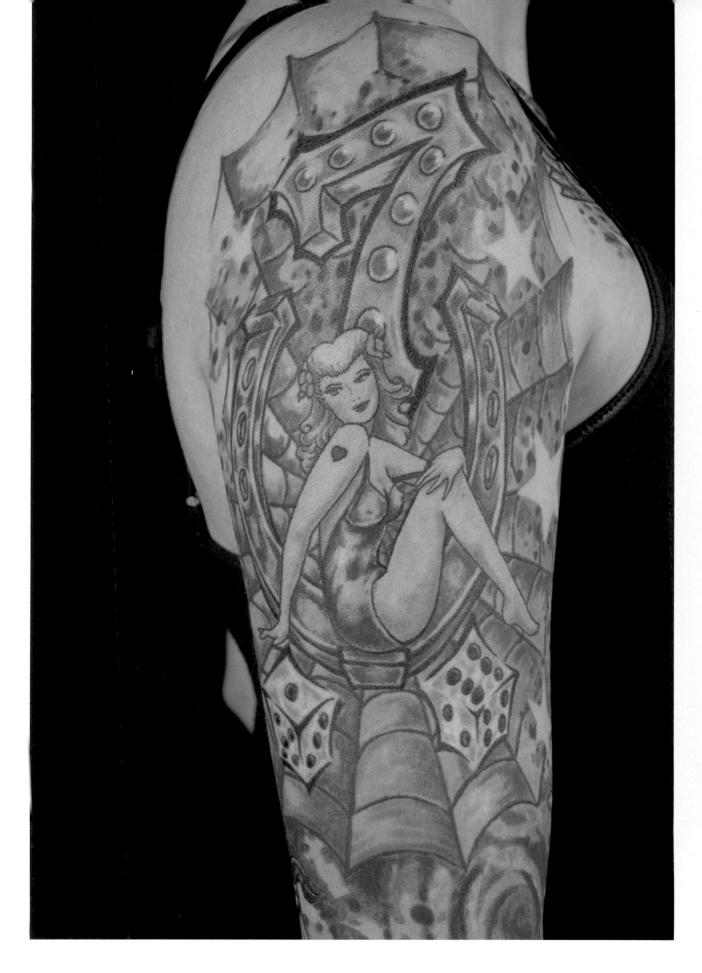

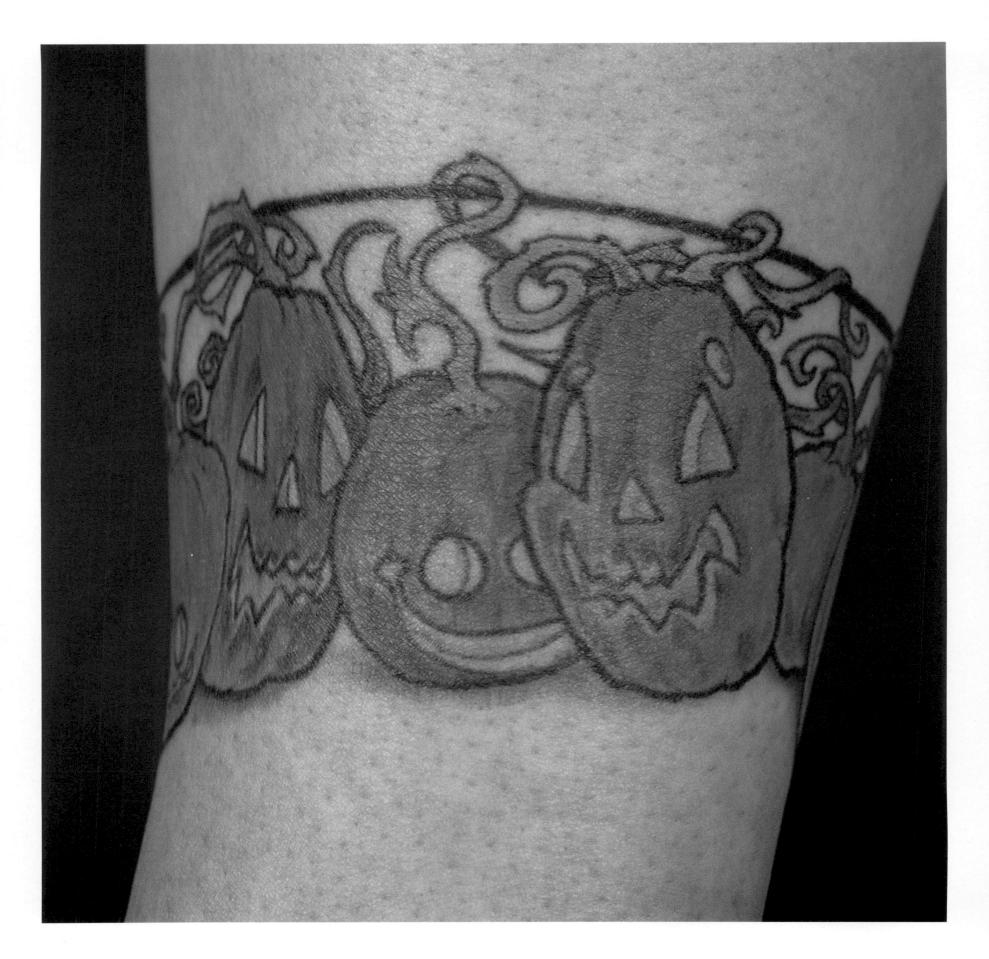

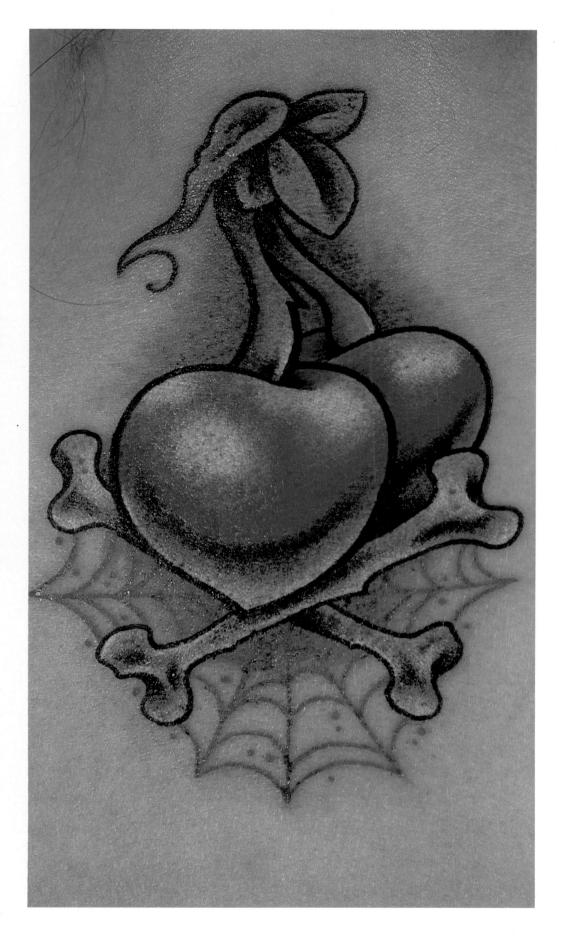

Far Left: Beth Dauria tattooed by Dirk. Bands around the arm are popular in Celtic and tribal tattooing, and this tattoo of Halloween pumpkins shows how such a tattoo can be just as effective in a pictorial style.

Left: This small tattoo by an unknown artist shows how amazing detail and shading can be achieved in a relatively tiny tattoo.

Having been raised in Perpignan, France, in the Catalan culture that influenced artists like Picasso and van Gogh, it's no surprise that Bugs (born Pascal Jarrion) has recently turned to art movements such as Cubism for inspiration. After attending art school and completing his compulsory service in France, Bugs moved to London, believing there to be more opportunities there as a professional tattooist than at home. This proved to be the case, and after two years of working for others, he opened his own shop while still in the process of refining his craft. After a period of constant drawing and creating custom designs, Bugs made a name for himself as the King of Celtic. Being highly in demand for years in this capacity, when he was finally able to find the time to pick up a paint brush, he felt it was a natural progression from the thick outlines and softly angular shapes of Celtic knotwork to parallel elements in Cubism. This exploration of painting techniques, in turn, influenced his tattoo work, and he started to incorporate a mix of Cubism, Art Deco, and Classical art into his designs. Like most artists of worth, Bugs is his own harshest critic,

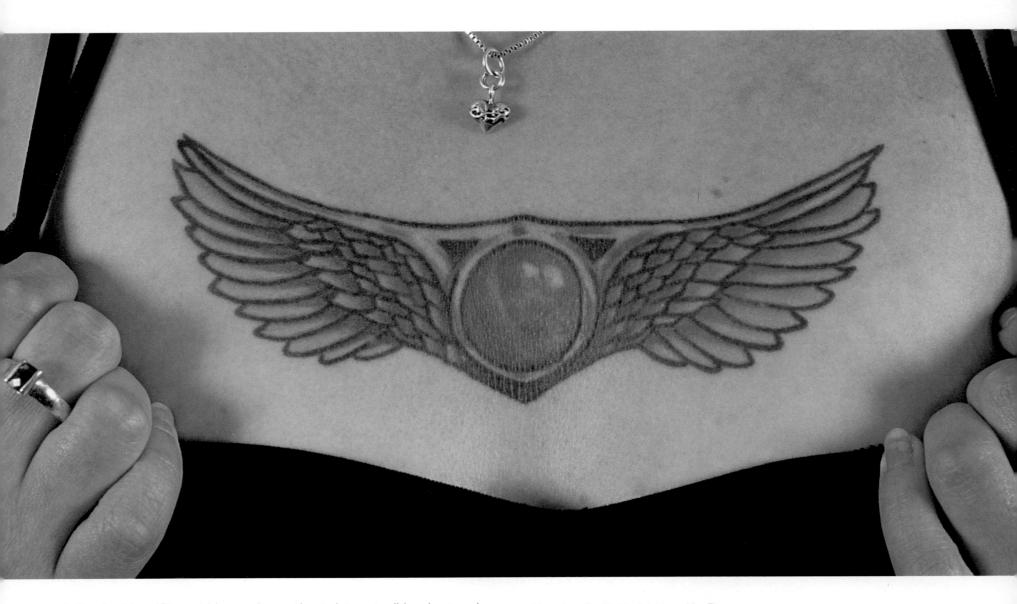

challenging himself to put his own innovative twist on traditional art, and finding inspiration from artists outside of the tattoo world, such as Picasso and Braque. Making inroads into the world of fine art, Bugs foresees himself in ten years doing just what he's doing now—remaining true to tattooing as his first love and what he sees as the best thing that's ever happened to him, as well as pursuing his painting as the logical progression of his artwork.

With a degree in criminal justice and a respectable career designing security programs for hotels, why would anyone take a chance on starting a new career as a tattooist? Well, that is just what Tom Renshaw did, and

Above: Jennifer DeNault tattooed by Dave Heroald. A simple design with an ancient Egyptian flavor, beautifully colored and shaded.

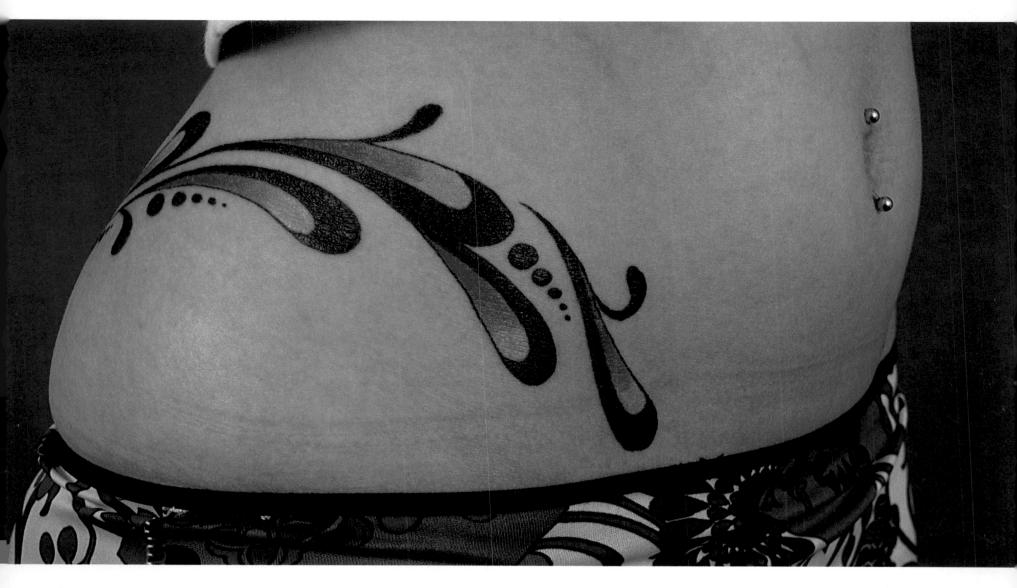

the gamble certainly paid off. Now known worldwide for his realistic portraits of people and animals, Tom got hooked when he took his former wife to get tattooed. It was time for him to trade in his suit and tie for a tattoo machine. Although he had no professional background as an artist, as a child he had had quite a talent for drawing and copying photographs that had laid dormant while he worked the nine-to-five grind as an adult. Luckily, like riding a bike, the talent was never quite lost and Tom found the same attraction to photorealism as a tattooist as he had as a kid. Having been tattooed by Brian Everett also informed his artistic direction, and he started out gravitating toward portraiture.

Above: Natalie Norbeck tattooed by Cory Ferguson, Way Cool Tattoos, Oakville, Ontario, Canada. This tattoo owes more to tribal tattooing than to traditional. However, its design is purely abstract, though this does not detract from its impact. The flowing, organic lines across the rounded hip make this a striking tattoo. Right: Marta by Lucky Bastard, photographed at a convention in Madrid 2001. Another excellent example of how modern tattooists are working with the same themes as their forebears. Again this tattoo is on the arm of a woman, which confuses the viewer's interpretation.

Far Right: Natalie Bousquet tattooed by Tom Renshaw. Renshaw is the final word in black and gray realistic tattoos.

Although he still does his fair share of portraits of people, he finds that the challenge in depicting the variety of skin and fur textures found in the animal kingdom serves to increase his flexibility as an artist and push the technical aspects of his craft. On the interpersonal side of his work, he feels that not only is the act of permanently altering one's physical self an emotionally and spiritually charged experience, but when a person requests a portrait of a loved one, whether man or beast, it adds another aspect of emotionality that binds him to his client. Even when someone asks for a tattoo of a wild animal, Tom encourages them to research that particular animal, bring him photos, and become part of the process that brings an exotic animal from the wild into the immediate proximity of their skin.

At age seven, Bob Tyrrell's future was starting to take shape, as he began to collect monster magazines such as *Creepy, Eerie, and Famous Monsters of Filmland*, as well as *Mad* magazine. With his artist father and fantasy artist Frank Franzetta as influences, you'd think Bob would have been off and running, but instead he picked up a guitar as a teenager and spent the next fifteen years playing rock and roll. At age thirty, after much deliberation, he got his first tattoo, and that experience reignited an early

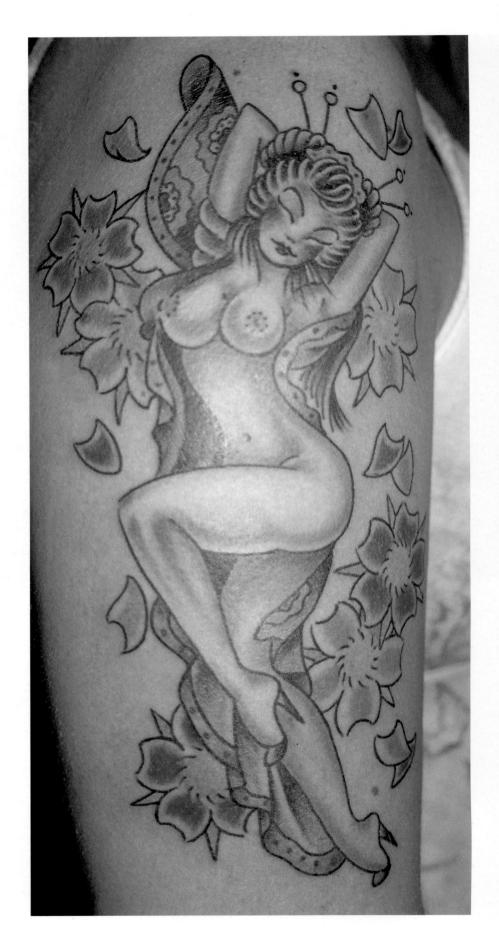

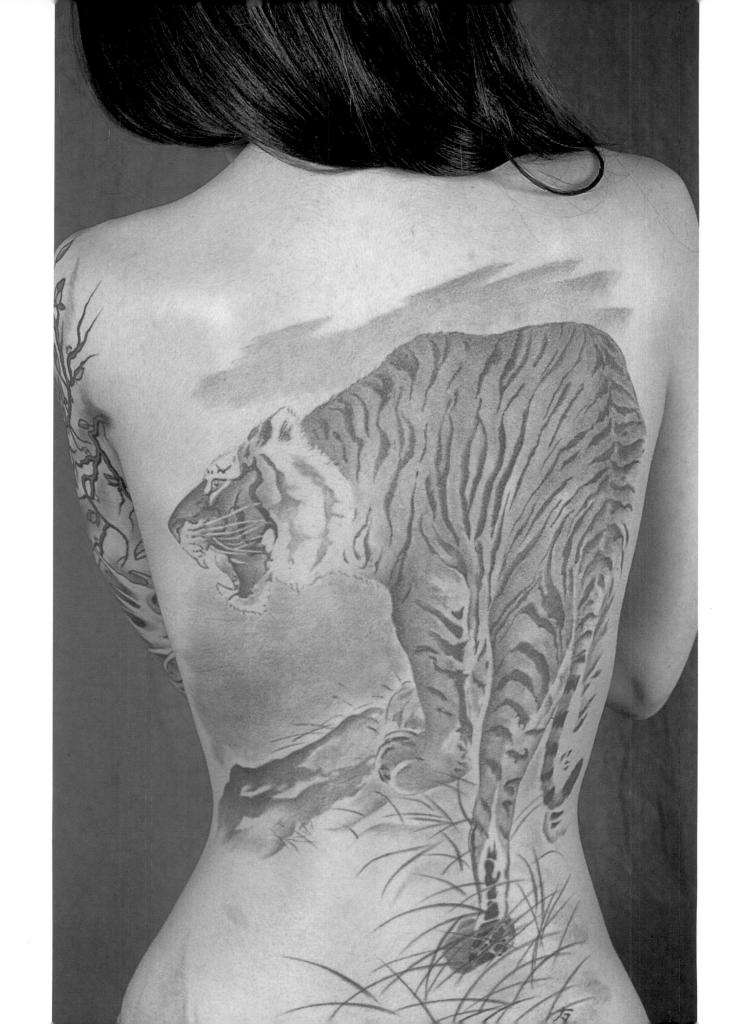

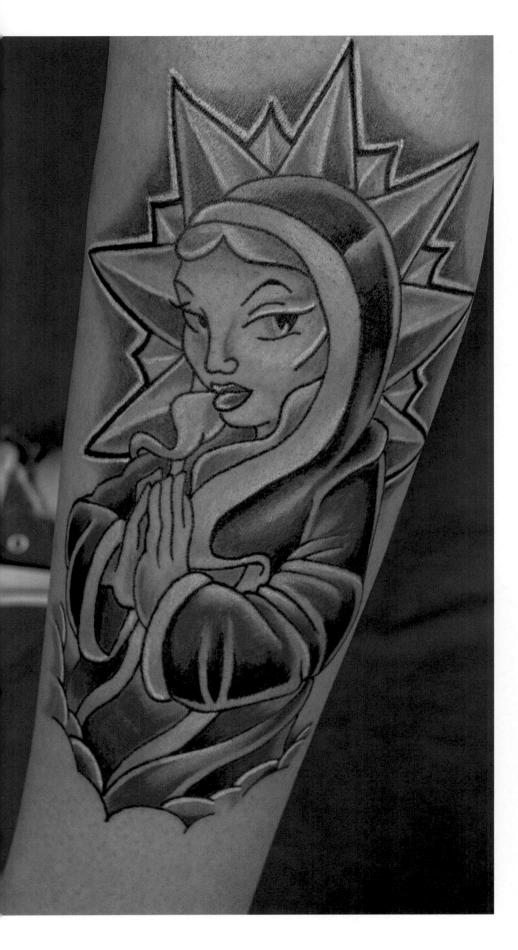

Left: In modern tattooing, traditional religious themes are subverted such as in this cartoon-style tattoo.

interest in drawing. Over the next few years, he took some art classes, and, at age thirty four, he acquired an apprenticeship at Brian Everett's Eternal Tattoo. Being taken under the wing of Tom Renshaw, (one of Bob's best friends and favorite artists), certainly had an influential on Bob as a fledgling tattooist, and he soon created his own niche tattooing black and gray work. Going full circle, back to his boyhood roots, his preference lies in portraiture, especially that of horror related subjects. He regards tattooing as a field where there is always room for improvement and evolution of both style and craft, and therefore tips his hat to artists like Guy Aitchison who are constantly evolving. And with talented newcomers nipping at the heels of established artists, he sees an unlimited potential in the future of tattooing, with the quality of work being steadily pushed to

Right: Amber Phebus tattooed by Kevin Johnson, Ramesses Shadow, Memphis, Tennessee. This is an interesting tattoo in that it consists entirely of color with no outline work at all. Such tattoos appear far more subtle and delicate.

higher and higher levels. Embracing such motivation, he also realizes the fortunate position he is in, being able to make a living from creating art without having an art education background, and doesn't take it for granted; he loves what he does and couldn't imagine doing anything else.

Those profiled here represent a mere fraction of what is happening in the tattoo world today. There are artists who made innovative inroads in tattooing a generation ago who are still around, plying their trade and influencing younger artists. And there are the younger artists themselves, respectful of their elders and the traditions that came along well before they did; learning lessons from the past, drawing inspiration from the world around them today, and laying a course for the future of tattooing.

BEFORE GETTING A TATTOO

"Tattooing is more interesting and beautifying than costly jewelry. It cannot be lost or stolen.

Tattooing is something you can keep through life and the only thing you can retain after death."

Brose E. Massy—tattoo artist

It's true, more and more people are getting tattooed each year and the one thing that can be said for all tattoo experiences is that it is a deeply personal event. Whether the design you have chosen is of great personal significance or just a fancy of a purely decorative nature, the result of the experience is with you forever.

Before getting your tattoo, ask yourself if you are positive that this is a commitment you are prepared to make. This may sound obvious but you would be wise to think about the ramifications of having a tattoo. It's not just getting a tattoo that you have to consider, it's the living with it subsequently. Hanging in his parlor, Sailor Jerry kept a list of reasons not to get a tattoo. Number five of seven advised, "people will know you are running your own life, instead of listening to them!"

There are a few points that anyone should consider before they take the first step toward a tattoo.

- Depending on where on the body you are going to place your design, every time you look in the mirror you will see it and it is going to be frequently looked at by others close to you.
- Tattoos commonly provoke adverse reactions from others. Some people will fell compelled to pass comment on your work and not everyone's reactions will be favorable. Not only this, they may make unfounded assumptions about your personality, intelligence, and background. It's human nature to be curious and you may attract unwelcome attention, though on a positive note tattoos are a great talking point and can be a good way to meet people.
- Having decided you want to get tattooed, in our experience you know what you want and where you want it, and no amount of pain,

money, time, or recriminations are going to dissuade you. However, take the time to find an artist that produces the style of work you are looking for. All reputable tattoo studios should be registered with the local authorities and should be a clean and sanitary environment. Personal recommendations are always a good start, but failing that, do your own research. Look at websites, magazines, visit studios, and trawl through as many artists' books as you can get your hands on. Discuss your planned design with the prospective artist, making sure they are comfortable with your requirements and that you in turn are comfortable with them and are confident of their abilities to produce what you want. Keep in mind that you will probably be spending several hours in very close contact with the tattooist and if you don't feel comfortable with them then these hours may feel like a lifetime.

- When discussing your design with a tattocist, if you don't have a specific idea of what you want, bring scurce material or pictures from books or magazines. This will give the artist a better idea of what you want and make it easier for you to be understood.
- When making an appointment, be aware that most good tattooists are booked weeks and sometimes morths in advance. Don't be frustrated or impatient—wait. A few weeks for something you'll have on your skin forever really is worth taking your time over.

• Don't be too specific or inflexible about your tattoo—you must appreciate that you are working with an artist who will interpret what you want to a certain degree from their own perspective and will put a little of themselves into the work. That said, if you are getting custom work done and the artwork is being created by the tattoo artist, do make

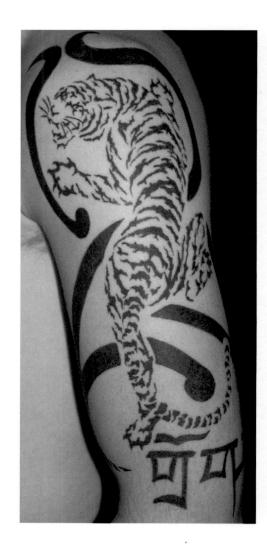

sure you approve the final draft and if you are not happy with t then feel free to say so.

• When going to get tattooed do make sure you are wearing suitable clothing, something that's not restrictive, bearing in mind you may have to remove some of it so that the artist can work on the area. Blood and ink will stain most fabrics and also you will probably be feeling quite sore by the time you leave the studio, so ensure you will be warm enough and comfortable in what you have to wear to travel home in and that it's not your favorite item of clothing.

• How you feel physically will determine how well you handle the tattooing process. If you are not your normal 100% due to a cold, fatigue, or medication you will feel more discomfort during the tattooing process. It will be better to reschedule an appointment than to go into

the shop for a tattoo with a migraine headache. The artist will also appreciate the fact that you decided not to come in with the flu.

- A part of that feeling 100% is your stomach. Many first timers are under the false impression that if you don't eat, you won't have anything to throw up if you get sick. Unfortunately this does more harm than good. Eating prior to getting a tattoo re-energizes your body. It puts back nutrients your body has depleted and returns your blood-sugar level back to normal. Having something in your stomach also helps to calm your nerves.
- Make sure you do not use alcohol or aspirin-based medication, this will thin the blood making you bleed more and thus difficult to tattoo.

- Don't get tattooed if you have a hangover.
- If you have a pre-existing condition, such as diabetes or heart problems, it would be wise for you to consult with your personal physician about your plans to get a tattoo. Don't risk your health.
- Everybody has a different threshold for pain. What will hurt one person can be simply annoying to someone else. How much a tattoo hurts is dependent on your individual tolerance for pain. Having said that there are areas more sensitive than others, and these are the same for everybody. Generally the "meatier" the area, the less it hurts. The closer to bone or tendons, the more it hurts. Likewise certain areas are more frequently exposed to the elements, such as the back and outside parts of the arm, and these tend to hurt less than more protected areas, like the inside of the arm, thigh, or stomach. Women also tend to be more tolerant of pain than men, especially around the stomach area, but be warned—if you are due to be menstruating when you have a tattoo appointment this can affect your usual pain threshold.
- The pain associated with tattooing has been described as feeling like

 a) a bad sunburn, b) a bee stinging several times, c) a cigarette burn, and d)

 a bad scrape. In most cases the pain diminishes after a few minutes when

your body's natural pain killers (endorphins) kick in, but be mentally prepared to bear some pain without wriggling.

• There are two generally accepted methods of pricing a tattoo—a flat fee and an hourly fee. Most tattoo studios will have both pricing methods in effect depending on what the shop's policies and requirements are. Here is a description of the two methods:

Flat fee: This is the preferred method of pricing flash and small standards like roses, hearts, and lettering. Pricing is estimated based on what it takes for an artist to complete the piece; length of time, complexity of design, number of colors, etc. Keep in mind that these prices are not set in stone and will fluctuate depending on other circumstances such as placement, resizing, adding and/or omitting elements from the design.

Hourly fee: Most custom artwork will be charged on a shop's hourly rate.

This is particularly true when the piece is large, takes more than one sitting to accomplish, or is freehanded on the client. What determines a shop's hourly rate is their operating cost, the artist's time, and the artist's quality and experience.

• However a tattoo is priced, be advised that once set, it is generally not a good idea to try to haggle down the price. It belittles the artist and it can make you look like a cheapskate. If you feel the price is genuinely too high, then talk to the artist. If your concerns are legitimate, he may reduce it for you—otherwise look for cheaper alternatives. Also most artists insist on being paid in cash with a deposit up front.

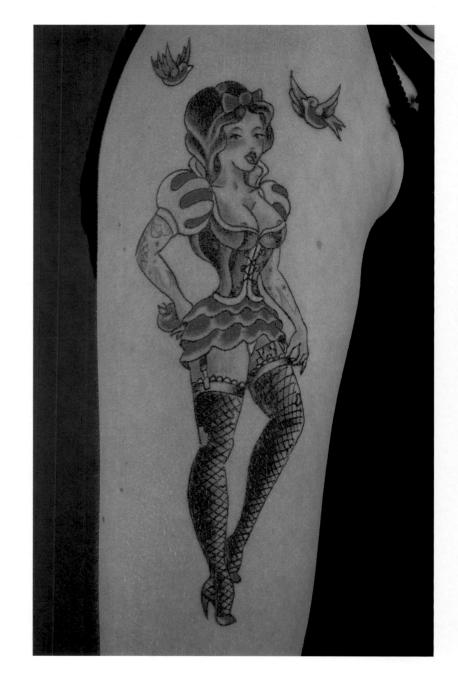

Ultimately, this is about you, and you have to live with the choices you've made... not all of which are so public or permanent. Getting tattooed should be an exciting and positive experience—a unique way of expressing yourself.

INDEX

roses 66, 88, 104, 113, 114, 127 devils 45 J dotwork 85 Japanese 10, 12, 13, 25, 27, 33, 44, 57, Rudy, Jack 14 Aitchison, Guy 14, 110, 113, 114, 122 58, 59, 61, 62, 63, 65, 66, 69, 70, 86, 89, dragons 57, 59, 61, 66, 70 American manner 36 91, 100, 105 S anchors 21, 104, 105 sailor style 8, 12, 21, 29, 30, 31, 57, 91, E animals 36, 82, 104, 120 93, 99, 104, 105, 115 arms 8, 61, 89, 113 eagles 46, 88 legs 7, 8, 61, 78, 85 shoulders 19, 61, 82 Egyptian 10, 23, 24, 58, 118 skulls 66 В M stomach 7 back 11, 40, 61, 81, 82, 95, 108 machine work 33, 40, 43, 61, 99, 119 swallow 8, 21 face 82, 85, 86 bikers 23, 39, 52 Manga 10 birds 104 fish 85 Т Maori 78, 85 black ink 10 flash designs 7, 10, 12, 15, 40, 44, 59, Tasmanian devils 46 86, 107, 127 Mayan 22, 78, 85 blackwork 17, 40, 44, 73-89, 95 Tibetan 27, 70 mermaids 29, 105 Booth, Paul 14, 45, 46, 99 flowers 7, 10, 11, 20, 36, 100, 104 Bugs 117, 118 Modern Primitive 40, 44, 99 torso 8, 61 tribal 7, 10, 12, 13, 14, 17, 19, 26, 27, G 39, 51, 63, 73, 74, 75, 76, 81, 83, 85, 86, N C gothic 39 neck 104 88, 95, 99, 100, 117, 119 carp 33, 61 graffiti 99, 100 New School 8, 75, 91–123 Tuttle, Lyle 94 cartoons 10, 48, 55, 66, 100, 110, 122 Tyrrell, Bob 120 Celtic 19, 39, 74, 88, 117 Н chests 86 hands 82, 99, 104 0 U circus 20, 36, 39, 104, 107 Hardy, Don Ed 51 one-point 66, 69 Ukiyo-e 58, 59, 61 comic books 46, 51 hearts 36, 46, 69, 88, 104, 127 horror 95, 99, 122 custom designs 12, 15, 31, 40, 44, 46, Polynesian 30, 31, 33, 58, 81, 89 51, 105, 117, 125, 127 ı whitework 44, 95 Indian 70 D Z indigenous 46,51 religious 45, 91, 97, 110, 122 daggers 88

Renshaw, Tom 14, 118, 120, 122

Zulueta, Leo 14, 46, 51, 76

demons 40, 45, 97

International Folk Style 36

A PRIVE BOX 4 &

GUSTAVE FLAUBERT

MADAME BOVARY

Translated by ELEANOR MARX AVELING

With an afterword by PETER HARNESS

First published 1857

This translation first published 1886

This edition first published by Collector's Library 2014

Reissued by Macmillan Collector's Library 2017 an imprint of Pan Macmillan 20 New Wharf Road, London N1 9RR Associated companies throughout the world www.panmacmillan.com

ISBN 978-1-5098-4288-9

All rights reserved. No part of this publication may be reproduced, stored in a retrieval system, or transmitted, in any form, or by any means (electronic, mechanical, photocopying, recording or otherwise) without the prior written permission of the publisher.

135798642

A CIP catalogue record for this book is available from the British Library.

Casing design and endpaper pattern by Andrew Davidson
Typeset by Antony Gray
Printed and bound in China by Imago

This book is sold subject to the condition that it shall not, by way of trade or otherwise, be lent, hired out, or otherwise circulated without the publisher's prior consent in any form of binding or cover other than that in which it is published and without a similar condition including this condition being imposed on the subsequent purchaser.

Visit www.panmacmillan.com to read more about all our books and to buy them. You will also find features, author interviews and news of any author events, and you can sign up for e-newsletters so that you're always first to hear about our new releases.

。 1. 其美國國際的第二個國際企業的經濟學

PART ONE

I am all and a line

We were in class when the headmaster came in, followed by a 'new boy', not wearing the school uniform, and a school servant carrying a large desk. Those who had been asleep woke up, and everyone rose as if just surprised at his work.

The headmaster made a sign to us to sit down. Then, turning to the class-master, he said to him in a low voice – 'Monsieur Roger, here is a pupil whom I recommend to your care; he'll be in the second. If his work and conduct are satisfactory, he will go into one of the upper classes, as becomes his age.'

The 'new boy', standing in the corner behind the door so that he could hardly be seen, was a country lad of about fifteen and taller than any of us. His hair was cut square on his forehead like a village chorister's; he looked reliable, but very ill at ease. Although he was not broad-shouldered, his short school jacket of green cloth with black buttons must have been tight about the armholes, and showed at the opening of the cuffs red wrists accustomed to being bare. His legs, in blue stockings, looked out from beneath yellow trousers, drawn tight by braces. He wore stout, ill-cleaned, hobnailed boots.

We began repeating the lesson. He listened with all his ears, as attentive as if at a sermon, not daring even to cross his legs or lean on his elbow; and when at two

o'clock the bell rang, the master was obliged to tell him to fall into line with the rest of us.

When we came back to work, we were in the habit of throwing our caps on the ground so as to have our hands more free; we used from the door to toss them under the form, so that they hit against the wall and made a lot of dust: it was 'the thing'.

But, whether he had not noticed the trick, or did not dare to attempt it, the 'new boy' was still holding his cap on his knees even after prayers were over. It was one of those head-gears of composite order, in which we can find traces of the bearskin, shako, billycock hat, sealskin cap, and cotton nightcap; one of those poor things, in fine, whose dumb ugliness has depths of expression, like an imbecile's face. Oval, stiffened with whalebone, it began with three round knobs; then came in succession lozenges of velvet and rabbit-skin separated by a red band; after that a sort of bag that ended in a cardboard polygon covered with complicated braiding, from which hung, at the end of a long, thin cord, small twisted gold threads in the manner of a tassel. The cap was new; its peak shone.

'Stand up,' said the master.

He stood up; his cap fell. The whole class began to laugh. He stooped to pick it up. A neighbour knocked it down again with his elbow; he picked it up once more.

'Get rid of your helmet,' said the master, who was a bit of a wag.

There was a burst of laughter from the boys, which so thoroughly put the poor lad out of countenance that he did not know whether to keep his cap in his hand, leave it on the ground, or put it on his head. He sat down again and placed it on his knee.

'Stand up,' repeated the master, 'and tell me your name.'

The new boy articulated in a stammering voice an unintelligible name.

'Say it again!'

The same spluttering of syllables was heard, drowned by the tittering of the class.

'Louder!' cried the master; 'louder!'

The 'new boy' then took a supreme resolution, opened an inordinately large mouth, and shouted at the top of his voice as if calling someone the word 'Charbovari'.

A hubbub broke out, rose in *crescendo* with burst of shrill voices (they yelled, barked, stamped, repeated 'Charbovari! Charbovari!'), then died away into single notes, growing quieter only with great difficulty, and now and again suddenly recommencing along the line of a form whence rose here and there, like a damp cracker going off, a stifled laugh.

However, amid a rain of impositions, order was gradually re-established in the class; and the master having succeeded in catching the name of 'Charles Bovary', having had it dictated to him, spelt out, and re-read, at once ordered the poor devil to go and sit down on the punishment form at the foot of the master's desk. He got up, but before going hesitated.

'What are you looking for?' asked the master.

'My c-a-p,' timidly said the 'new boy', casting troubled looks round him.

'Five hundred lines for all the class!' shouted in a furious voice stopped, like the *Quos ego*, a fresh outburst. 'Silence!' continued the master indignantly, wiping his brow with his handkerchief, which he had just taken from his cap. 'As for you, "new boy", you

will conjugate "ridiculus sum" twenty times.' Then, in a gentler tone, 'Come, you'll find your cap again; it hasn't been stolen.'

Quiet was restored. Heads bent over desks, and the 'new boy' remained for two hours in an exemplary attitude, although from time to time some paper pellet flipped from the tip of a pen came bang in his face. But he wiped his face with one hand and continued motionless, his eyes lowered.

In the evening, at preparation, he pulled out his pens from his desk, arranged his small belongings, and carefully ruled his paper. We saw him working conscientiously, looking up every word in the dictionary, and taking the greatest pains. Thanks, no doubt, to the willingness he showed, he had not to go down to the class below. But though he knew his rules passably, he had little finish in composition. It was the curé of his village who had taught him his first Latin; his parents, from motives of economy, having sent him to school as late as possible.

His father, Monsieur Charles Denis Bartholomé Bovary, retired assistant-surgeon-major, compromised about 1812 in certain conscription scandals, and forced at that time to leave the service, had taken advantage of his fine figure to get hold of a dowry of sixty thousand francs that offered in the person of a hosier's daughter who had fallen in love with his good looks. A fine man, a great talker, making his spurs ring as he walked, wearing whiskers that ran into his moustache, his fingers always garnished with rings and dressed in loud colours, he had the dash of a military man with the easy go of a commercial traveller. Once married, he lived for three or four years on his wife's fortune, dining well, rising late, smoking long porcelain pipes, not coming in

at night till after the theatre, and haunting cafés. The father-in-law died, leaving little; he was indignant at this, 'went in for business', lost some money in it, then retired to the country, where he thought he would make money. But, as he knew no more about farming than calico, as he rode his horses instead of sending them to plough, drank his cider in bottle instead of selling it in cask, ate the finest poultry in his farmyard, and greased his hunting-boots with the fat of his pigs, he was not long in finding out that he would do better to give up all speculation.

For two hundred francs a year he managed to rent on the border of the provinces of Caux and Picardy a kind of place half-farm, half-private-house; and here, soured, eaten up with regrets, cursing his luck, jealous of everyone, he shut himself up at the age of forty-five, sick of men, he said, and determined to live in peace.

His wife had once upon a time adored him; she had bored him with a thousand servilities that had only estranged him the more. Lively once, expansive and affectionate, in growing older she had become (after the fashion of wine that, exposed to air, turns to vinegar) ill-tempered, grumbling, irritable. She had suffered so much without complaint at first, until she had seen him going after all the village drabs, and until a score of bad houses sent him back to her at night, weary, stinking drunk. Then her pride revolted. After that she was silent, burying her anger in a dumb stoicism that she maintained till her death. She was constantly going about looking after business matters. She called on the lawyers, the president, remembered when bills fell due, got them renewed, and at home ironed, sewed, washed, looked after the workmen, paid the accounts, while he, troubling himself about noth-

ing, eternally besotted in a sleepy sulkiness, from which he only roused himself to say disagreeable things to her, sat smoking by the fire and spitting into the cinders.

When she had a child, it had to be sent out to nurse. When he came home, the lad was spoilt as if he were a prince. His mother stuffed him with jam; his father let him run about barefoot, and, playing the philosopher, even said he might as well go about quite naked like the young of animals. As opposed to the maternal ideas, he had a certain virile idea of childhood on which he sought to mould his son, wishing him to be brought up hardily, like a Spartan, to give him a strong constitution. He sent him to bed without any fire, taught him to drink off large draughts of rum and to jeer at religious processions. But, peaceable by nature, the lad answered only poorly to his notions. His mother always kept him near her; she cut out cardboard for him, told him tales, entertained him with endless monologues full of melancholy gaiety and charming nonsense. In her life's isolation she centred on the child's head all her shattered, broken little vanities. She dreamed of high station; already she saw him, tall, handsome, clever, well established as an engineer or in the law. She taught him to read, and even, on an old piano, she had taught him two or three little songs. But to all this Monsieur Bovary, caring little for letters, said, 'It was not worth while. Would they ever have the means to send him to the Government schools, to buy him a practice, or start him in business? Besides, with cheek a man always gets on in the world.' Madame Bovary bit her lips, and the child knocked about the village.

He followed the ploughboys, drove away with clods of earth the ravens that were flying about. He ate

blackberries along the hedges, minded the geese with a long switch, went haymaking during harvest, ran about in the woods, played hopscotch under the church porch on rainy days, and at great fêtes begged the beadle to let him pull the bells, that he might hang all his weight on the long rope and feel himself dragged upward in its swing. Meanwhile he grew like an oak; he grew strong of hand, fresh of colour.

When he was twelve years old his mother had her own way; he began his lessons. The curé took him in hand; but the lessons were so short and irregular that they could not be of much use. They were given at spare moments in the sacristy, standing up, hurriedly, between a baptism and a burial; or else the curé, if he had not to go out, sent for his pupil after the Angelus. They went up to his room and settled down; the flies and moths fluttered round the candle. It was close, the child fell asleep, and the good man, beginning to doze with his hands on his stomach, was soon snoring with his mouth wide open. On other occasions, when Monsieur le Curé, on his way back from taking the viaticum to some sick person in the neighbourhood, caught sight of Charles playing about the fields, he called him, lectured him for a quarter of an hour, and took advantage of the occasion to make him conjugate his verb at the foot of a tree. The rain interrupted them or an acquaintance passed. All the same he was always pleased with him, and even said the 'young man' had a very good memory.

Charles could not go on like this. Madame Bovary took strong steps. Ashamed, or rather tired out, Monsieur Bovary gave in without a struggle, and they waited one year longer, so that the lad should take his first communion.

Six months more passed, and the year after Charles was finally sent to school at Rouen, whither his father took him towards the end of October, at the time of the St Romain fair.

It would now be impossible for any of us to remember anything about him. He was a youth of even temperament, who played in playtime, worked in school-hours, was attentive in class, slept well in the dormitory, and ate well in the refectory. He had *in loco parentis* a wholesale ironmonger in the Rue Ganterie, who took him out once a month on Sundays after his shop was shut, sent him for a walk on the quay to look at the boats, and then brought him back to college at seven o'clock before supper. Every Thursday evening he wrote a long letter to his mother with red ink and three wafers; then he went over his history notebooks, or read an old volume of *Anacharsis* that was knocking about the study. When he went for walks he talked to the servant, who, like himself, came from the country.

By dint of hard work he kept always about the middle of the class; once even he got a certificate in natural history. But at the end of his third year his parents withdrew him from the school to make him study medicine, convinced that he could even take his degree by himself.

His mother chose a room for him on the fourth floor of a dyer's she knew, overlooking the Eau-de-Robec. She made arrangements for his board, got him furniture, a table and two chairs, sent home for an old cherry-wood bedstead, and bought besides a small cast-iron stove with the supply of wood that was to warm the poor child. Then at the end of a week she departed, after endless injunctions to be good now that he was going to be left to himself.

The syllabus that he read on the noticeboard stunned him: lectures on anatomy, lectures on pathology, lectures on physiology, lectures on pharmacy, lectures on botany and clinical medicine, and therapeutics, not to mention hygiene and *materia medica* all names of whose etymologies he was ignorant, and that were to him as so many doors to sanctuaries filled with awe-inspiring darkness.

He understood nothing of it all; it was in vain that he listened – he did not follow. Still he worked; he had bound notebooks, he attended all the courses, never missed a single lecture. He did his little daily task like a mill-horse, who goes round and round with his eyes bandaged, not knowing what work he is doing.

To spare him expense his mother sent him every week by the carrier a piece of veal baked in the oven, with which he lunched when he came back from the hospital, while he sat kicking his feet against the wall. After this he had to run off to lectures, to the operation-room, to the hospital, and return to his home at the other end of the town. In the evening, after the poor dinner of his landlord, he went back to his room and set to work again in his wet clothes, which smoked as he sat in front of the hot stove.

On the fine summer evenings, at the time when the close streets are empty, when the servants are playing shuttlecock at the doors, he opened his window and leaned out. The river, that makes of this quarter of Rouen a paltry little Venice, flowed beneath him, between the bridges and the railings, yellow, violet, or blue. Working men, kneeling on the banks, washed their bare arms in the water. On poles projecting from the attics, skeins of cotton were drying in the air. Opposite, beyond the roofs, spread the pure heaven

with the red sun setting. How pleasant it must be at home! How fresh under the beech tree! And he expanded his nostrils to breathe in those sweet country smells which did not come so far.

He grew thin, his figure became taller, his face took a saddened look that made it nearly interesting. Naturally, through indifference, he abandoned all the resolutions he had made. Once he missed a lecture: the next day all the lectures; and, enjoying his idleness, little by little, he gave up work altogether. He got into the habit of going to the café, and developed a passion for dominoes. To shut himself up every evening in the dirty public room, to push about on marble tables the small sheep-bones with black dots, seemed to him a fine proof of his freedom, which raised him in his own esteem. It was beginning to see life, the sweetness of stolen pleasures; and when he entered, he put his hand on the door-handle with an almost sensual joy. Then many things hidden within him came out; he learnt couplets by heart and sang them to his boon companions, became enthusiastic about Béranger, learnt how to make punch, and, finally, how to make love.

Thanks to these preparatory labours, he failed completely in his examination for an ordinary degree. He was expected home the same night to celebrate his success. He started on foot, stopped at the beginning of the village, sent for his mother, and told her all. She excused him, threw the blame of his failure on the injustice of the examiners, encouraged him a little, and took upon herself to set matters straight. It was only five years later that Monsieur Bovary knew the truth; it was old then, and he accepted it. Moreover, he could not believe that a man born of him could be a fool.

So Charles set to work again and crammed for his examination, ceaselessly learning all the old questions by heart. He passed pretty well. What a happy day for his mother! They gave a grand dinner.

Where should he go to practise? To Tostes, where there was only one old doctor. For a long time Madame Bovary had been on the look-out for his death, and the old fellow had barely been packed off when Charles was installed, opposite his place, as his successor.

But it was not everything to have brought up a son, to have had him taught medicine, and discovered Tostes, where he could practise it; he must have a wife. She found him one – the widow of a bailiff at Dieppe, – who was forty-five and had an income of twelve hundred francs. Though she was ugly, as dry as a bone, her face with as many pimples as the spring has buds, Madame Dubuc had no lack of suitors. To attain her ends Madame Bovary had to oust them all, and she even succeeded in very cleverly baffling the intrigues of a pork-butcher backed up by the priests.

Charles had seen in marriage the advent of an easier life, thinking he would be more free to do as he liked with himself and his money. But his wife was master; he had to say this and not say that in company, to fast every Friday, dress as she liked, harass at her bidding those patients who did not pay. She opened his letters, watched his comings and goings, and listened at the partition-wall when women came to consult him in his surgery.

She must have her chocolate every morning, attentions without end. She constantly complained of her nerves, her chest, her liver. The noise of footsteps made her ill; when people left her, solitude became

odious to her; if they came back, it was doubtless to see her die. When Charles returned in the evening, she stretched forth two long thin arms from beneath the sheets, put them round his neck, and having made him sit down on the edge of the bed, began to talk to him of her troubles: he was neglecting her, he loved another. She had been warned she would be unhappy; and she ended by asking him for a dose of medicine and a little more love.

One night towards eleven o'clock they were awakened by the noise of a horse pulling up outside their door. The servant opened the garret-window and parleyed for some time with a man in the street below. He came for the doctor; he had a letter for him. Nastasie came downstairs shivering and undid the bars and bolts one after the other. The man left his horse, and, following the servant, suddenly came in behind her. He pulled out from his wool cap with grey topknots a letter wrapped up in a rag and presented it gingerly to Charles, who rested on his elbow on the pillow to read it. Nastasie, standing near the bed, held the light. Madame in modesty had turned to the wall and showed only her back.

This letter, sealed with a small seal in blue wax, begged Monsieur Bovary to come immediately to the farm of the Bertaux to set a broken leg. Now from Tostes to the Bertaux was a good eighteen miles across country by way of Longueville and Saint-Victor. It was a dark night; young Madame Bovary was afraid of accidents for her husband. So it was decided the stable-boy should go on first; Charles would start three hours later when the moon rose. A boy was to be sent to meet him, to show him the way to the farm, and open the gates for him.

Towards four o'clock in the morning, Charles, well wrapped up in his cloak, set out for the Bertaux. Still sleepy from the warmtn of his bed, he let himself be lulled by the quiet trot of his horse. When it stopped of its own accord in front of those holes surrounded with

thorns that are dug on the edge of ploughland, Charles awoke with a start, suddenly remembered the broken leg, and tried to call to mind all the fractures he knew. The rain had stopped, day was breaking, and on the branches of the leafless trees birds roosted motionless, their little feathers bristling in the cold morning wind. The flat country stretched as far as eve could see, and the tufts of trees round the farms at long intervals seemed like dark violet stains on the vast grey surface, that on the horizon faded into the gloom of the sky. Charles from time to time opened his eyes, his mind grew weary, and, sleep coming upon him, he soon fell into a doze wherein, his recent sensations blending with memories, he became conscious of a double self, at once student and married man, lying in his bed as but now, and crossing the operation theatre as of old. The warm smell of poultices mingled in his brain with the fresh odour of dew; he heard the iron rings rattling along the curtain-rods of the bed and saw his wife sleeping. As he passed Vassonville he came upon a boy sitting on the grass at the edge of a ditch.

'Are you the doctor?' asked the child.

And on Charles's answer he took his wooden shoes in his hands and ran on in front of him.

The general practitioner, riding along, gathered from his guide's talk that Monsieur Rouault must be one of the most well-to-do farmers. He had broken his leg the evening before on his way home from a Twelfth-night feast at a neighbour's. His wife had been dead for two years. There was with him only his daughter, who helped him to keep house.

The ruts were becoming deeper; they were approaching the Bertaux. The little lad, slipping through a hole in the hedge, disappeared; then he came back to

the end of a courtyard to open the gate. The horse slipped on the wet grass; Charles had to stoop to pass under the branches. The watchdogs in their kennels barked, dragging at their chains. As he entered the Bertaux the horse took fright and stumbled.

It was a substantial-looking farm. In the stables, over the top of the open doors, one could see great cart-horses quietly feeding from new racks. Right along the outbuildings extended a large dunghill, from which manure liquid oozed, while amidst fowls and turkeys five or six peacocks, a luxury in the farmyards of Caux, were foraging on the top of it. The sheepfold was long, the barn high, with walls smooth as your hand. Under the cart-shed were two large carts and four ploughs, with their whips, shafts and harnesses complete, whose fleeces of blue wool were getting soiled by the fine dust that fell from the granaries. The courtyard sloped upwards, planted with trees set out symmetrically, and the chattering noise of a flock of geese was heard near the pond.

A young woman in a blue merino dress with three flounces came to the threshold of the door to receive Monsieur Bovary, whom she led to the kitchen, where a large fire was blazing. The servants' breakfast was boiling beside it in small pots of all sizes. Some damp clothes were drying inside the chimney-corner. The shovel, the tongs, and the nozzle of the bellows, all of colossal size, shone like polished steel, whilst along the walls hung numerous pots and pans in which the clear flame of the hearth, mingling with the first rays of the sun coming in through the window, was mirrored fitfully.

Charles went up to the first floor to see the patient. He found him in his bed, sweating under his bed-

clothes, having thrown his cotton nightcap right away from him. He was a short, stout man of fifty, with white skin and blue eyes, the forepart of his head bald, and he wore ear-rings. By his side on a chair stood a large decanter of brandy, whence he poured himself out a little from time to time to keep up his spirits; but as soon as he caught sight of the doctor his elation subsided, and instead of swearing, as he had been doing for the last twelve hours, began to groan feebly.

It was a simple fracture, with no kind of complication. Charles could not have hoped for an easier case. Then calling to mind the devices of his masters at the bedsides of patients, he comforted the sufferer with all sorts of kindly remarks, those caresses of the surgeon that are like the oil they put on bistouries. To make some splints, a bundle of laths was brought up from the cart-house. Charles selected one, cut it into two pieces and planed it with a fragment of windowpane, while the servant tore up sheets to make bandages, and Mademoiselle Emma tried to sew some pads. As she was a long time in finding her work-case, her father grew impatient; she did not answer, but as she sewed she pricked her fingers, which she then put to her mouth to suck them. Charles was surprised by the whiteness of her nails. They were shiny, delicate at the tips, more polished than Dieppe ivories, and almond-shaped. Yet her hand was not beautiful, perhaps not white enough, and a little hard at the knuckles; besides, it was too long, with no soft inflections in the outlines. Her real beauty was in her eyes. Although brown, they seemed black because of the lashes, and her look came at you frankly, with a candid boldness.

The bandaging over, the doctor was invited by Monsieur Rouault himself to 'have a bite of something' before he left.

Charles went down into the room on the ground-floor. Knives and forks and silver goblets were laid for two on a little table at the foot of a huge bed that had a canopy of printed cotton with figures representing Turks. There was an odour of iris-root and damp sheets that escaped from a tall oak cupboard facing the window. On the floor in corners were sacks of flour stuck upright in rows. These were the overflow from the neighbouring granary, to which three stone steps led. By way of decoration for the apartment, hanging to a nail in the middle of the wall, whose green paint scaled off from the effects of the saltpetre, was a crayon head of Minerva in a gold frame, underncath which was written in Gothic letters 'To my dear Papa'.

First they spoke of the patient, then of the weather, of the great cold, of the wolves that infested the fields at night. Mademoiselle Rouault did not at all like the country, especially now that she had to look after the farm almost alone. As the room was chilly, she shivered as she ate. This showed something of her full lips, that she had a habit of biting when silent.

Her neck rose from a white turned-down collar. Her hair, whose two black folds seemed each of a single piece, so smooth were they, was parted in the middle by a delicate line that curved slightly with the curve of the head; and, just showing the tip of the ear, it was joined behind in a thick *chignon*, with a wavy sweep towards the temples which the country doctor now saw for the first time in his life. There was a pink flush on her cheekbones. She had, like a man, thrust in

between two buttons of her bodice a tortoiseshell eyeglass.

When Charles, after bidding farewell to old Rouault, returned to the room before leaving, he found her standing, her forehead against the window, looking into the garden, where the bean props had been knocked down by the wind. She turned round. 'Are you looking for anything?' she asked.

'My whip, if you please,' he answered.

He began rummaging on the bed, behind the doors, under the chairs. It had fallen to the floor, between the sacks and the wall. Mademoiselle Emma saw it, and bent over the flour sacks. Charles out of politeness made a dash also, and as he stretched out his arm, at the same moment felt his breast brush against the back of the young girl bending beneath him. She drew herself up, scarlet, and looked at him over her shoulder as she handed him his whip of bull's sinew.

Instead of returning to the Bertaux in three days as he had promised, he went back the very next day, then regularly twice a week, without counting the visits he paid now and then as if by accident.

Everything, moreover, went well; the patient progressed favourably; and when, at the end of forty-six days, old Rouault was seen trying to walk alone in his 'den', Monsieur Bovary began to be looked upon as a man of great capacity. Old Rouault said that he could not have been cured better by the leading doctors of Yvetot, or even of Rouen.

As for Charles, he did not stop to wonder why it was a pleasure to him to go to the Bertaux. Had he done so, he would, no doubt, have attributed his zeal to the importance of the case, or perhaps to the money he hoped to make by it. Was it for this,

however, that his visits to the farm formed a delightful break in the meagre occupations of his life? On these days he rose early, set off at a gallop, urging on his horse, then got down to wipe his boots in the grass and put on black gloves before entering. He liked going into the courtyard, and noticing the gate turn against his shoulder, the cock crow on the wall, the lads come to meet him. He liked the granary and the stables; he liked old Rouault, who pressed his hand and called him his saviour; he liked the small wooden clogs of Mademoiselle Emma on the scoured flags of the kitchen – her high heels made her a little taller; and when she walked in front of him, the wooden soles springing up quickly struck with a sharp click against the leather of her boots.

She always accompanied him to the first step of the stairs. When his horse had not yet been brought round she stayed there. They had said goodbye; there was no more talking. The open air wrapped her round, playing with the soft down on the back of her neck, or blew to and fro on her hips her apronstrings, that fluttered like streamers. Once, during a thaw, the bark of the trees in the yard was oozing, the snow on the roofs of the outbuildings was melting; she stood on the threshold, and went to fetch her sunshade and opened it. The sunshade, of silk of the colour of pigeons' breasts, through which the sun shone, lit up with shifting hues the white skin of her face. She smiled under the tender warmth, and drops of water could be heard falling one by one on the stretched silk

During the first period of Charles's visits to the Bertaux, young Madame Bovary never failed to enquire after the invalid, and she had even chosen in the

book that she kept on a system of double-entry a clean blank page for Monsieur Rouault. But when she heard he had a daughter, she began to make enquiries, and she learnt the Mademoiselle Rouault brought up at the Ursuline Convent, had received what is called 'a good education'; and so knew dancing, geography, drawing, how to embroider and play the piano. That was the last straw.

'So it is for this,' she said to herself, 'that his face beams when he goes to see her, and that he puts on his new waistcoat at the risk of spoiling it with the rain. Ah! that woman! that woman!'

And instinctively she detested her. At first she solaced herself by allusions that Charles did not understand, then by casual observations that he let pass for fear of a storm, finally by open apostrophes to which he knew not what to answer. 'Why did he go back to the Bertaux now that Monsieur Rouault was cured and that these folks hadn't paid vet? Ah! it was because a young lady was there, someone who knew how to talk, to embroider, to be witty. That was what he cared about; he wanted town misses.' And she went on - 'The daughter of old Rouault a town miss! Come, come! Their grandfather was a shepherd, and they have a cousin who was almost had up at the assizes for a nasty blow in a quarrel. It is not worth while making such a fuss, or showing herself at church on Sundays in a silk gown like a countess. Besides, if it hadn't been for the colza last year, the poor old chap would have had much ado to pay up his arrears.'

For very weariness Charles left off going to the Bertaux. Héloïse made him swear, his hand on the prayer-book, that he would go there no more, after much sobbing and many kisses, in a great outburst of

love. He obeyed then, but the strength of his desire protested against the servility of his conduct; and he thought, with a kind of naïve hypocrisy, that this interdict to see her gave him a sort of right to love her. And then the widow was thin; she had long teeth; wore in all weathers a little black shawl, the edge of which hung down between her shoulder-blades; her bony figure was sheathed in her clothes as if they were a scabbard; they were too short, and displayed her ankles with the laces of her large boots crossed over grey stockings.

Charles's mother came to see them from time to time, but after a few days the daughter-in-law seemed to put her own edge on her, and then, like two knives, they scarified him with their reflections and observations. It was wrong of him to eat so much. Why did he always offer a glass of something to everyone who came? What obstinacy not to wear flannels!

In the spring it came about that a notary at Ingouville, the holder of the widow Dubuc's property, one fine day went off, taking with him all the money in his office. Héloïse, it is true, still possessed, besides a share in a boat valued at six thousand francs, her house in the Rue St François; and yet, with all this fortune that had been so trumpeted abroad, nothing, excepting perhaps a little furniture and a few clothes, had appeared in the household. The matter had to be gone into. The house at Dieppe was found to be eaten up with mortgages to its foundations; what she had placed with the notary God only knew, and her share in the boat did not exceed one thousand crowns. She had lied, the good lady! In his exasperation, Monsieur Bovary the elder, smashing a chair on the flags,

accused his wife of having caused misfortune to their son by harnessing him to such a harridan, whose harness wasn't worth her hide. They came to Tostes. Explanations followed. There were scenes. Héloïse in tears, throwing her arms about her husband, implored him to defend her from his parents. Charles tried to speak up for her. They grew angry and left the house.

But 'the blow had struck home'. A week after, as she was hanging up some washing in her yard, she was seized with a spitting of blood, and the next day, while Charles had his back turned to her drawing the window-curtain, she said, 'O God!' gave a sigh and fainted. She was dead! What a surprise!

When all was over at the cemetery Charles went home. He found no one downstairs; he went up to the first floor to their room; he saw her dress still hanging at the foot of the alcove; then, leaning against the writing-table, he stayed until the evening, buried in a sorrowful reverie. After all, she had loved him! One morning old Rouault brought Charles the money for setting his leg – seventy-five francs in forty-sou pieces, and a turkey. He had heard of his loss, and consoled him as well as he could.

'I know what it is,' said he, clapping him on the shoulder; 'I've been through it. When I lost my dear departed, I went into the fields to be quite alone. I fell at the foot of a tree; I cried; I called on God; I talked nonsense to Him. I wanted to be like the moles that I saw on the branches, their insides swarming with worms, dead, and an end of it. And when I thought that there were others at that very moment with their nice little wives holding them in their embrace, I struck great blows on the earth with my stick. I was pretty well mad with not eating; the very idea of going to a café disgusted me - you wouldn't believe it. Well, quite softly, one day following another, a spring on a winter, and an autumn after a summer, this wore away, piece by piece, crumb by crumb; it passed away, it went, it sank, I mean; for something always remains at the bottom, as one would say - a weight here, at one's heart. But since it is the lot of all of us, one must not give way altogether, and, because others have died, want to die too. You must pull vourself together, Monsieur Bovary. It will pass away. Come to see us; my daughter thinks of you now and again, d've know, and she says you are forgetting her. Spring will soon be here We'll have come rabbit cheeting in the warrens to amuse you a bit.'

Charles followed his advice. He went back to the

Bertaux. He found all as he had left it, that is to say, as it was five months ago. The pear trees were already in blossom, and Farmer Rouault, on his legs again, came and went, making the farm more full of life.

Thinking it his duty to heap the greatest attention upon the doctor because of his sad position, he begged him not to take his hat off, spoke to him in an undertone as if he had been ill, and even pretended to be angry because nothing rather lighter had been prepared for him than for the others, such as a little clotted cream or stewed pears. He told stories. Charles found himself laughing, but the remembrance of his wife suddenly coming back to him depressed him. Coffee was brought in; he thought no more about her.

He thought less of her as he grew accustomed to living alone. The new delight of independence soon made his loneliness bearable. He could now change his meal-times, go in or out without explanation, and when he was very tired stretch himself at full length on his bed. So he nursed and coddled himself and accepted the consolations that were offered him. On the other hand, the death of his wife had not served him ill in his business, since for a month people had been saying, 'The poor young man! what a loss!' His name had been talked about, his practice had increased; and, moreover, he could go to the Bertaux just as he liked. He had an aimless hope, and was vaguely happy; he thought himself better looking as he brushed his whiskers before the looking-glass.

One day he got there about three o'clock. Everybody was in the fields. He went into the kitchen, but did not at once catch sight of Emma; the outside shutters were closed. Through the chinks of the wood the sun sent across the flooring long fine rays that were

broken at the corners of the furniture and trembled along the ceiling. Some flies on the table were crawling up the glasses that had been used, and buzzing as they drowned themselves in the dregs of the cider. The daylight that came in by the chimney made velvet of the soot at the back of the fireplace, and touched with blue the cold cinders. Between the window and the hearth Emma was sewing; she wore no fichu; he could see small drops of perspiration on her bare shoulders.

After the fashion of country folks she asked him to have something to drink. He said no; she insisted, and at last laughingly offered to have a glass of liqueur with him. So she went to fetch a bottle of curaçoa from the cupboard, reached down two small glasses, filled one to the brim, poured scarcely anything into the other, and, after having clinked glasses, carried hers to her mouth. As it was almost empty she bent back to drink, head thrown back, lips thrust forward, throat drawn back. She laughed at getting none of it, while with the tip of her tongue passing between her small teeth she licked drop by drop the bottom of her glass.

She sat down again and took up her work, a white cotton stocking she was darning. She worked with her head bent down; she did not speak, nor did Charles. The air coming in under the door blew a little dust over the flags; he watched it drift along, and heard nothing but the throbbing in his head and the faint clucking of a hen that had laid an egg in the yard. Emma from time to time cooled her cheeks with the palms of her hands, and cooled these again on the knobs of the huge firedogs.

She complained of suffering since the beginning of the season from giddiness; she asked if sea-baths would do her any good; she began talking of her

convent, Charles of his school; words came to them. They went up into her bedroom. She showed him her old music-books, the little prizes she had won, and the oak-leaf crowns, left at the bottom of a cupboard. She spoke to him, too, of her mother, of the country, and even showed him the bed in the garden where, on the first Friday of every month, she gathered flowers to put on her mother's tomb. But the gardeners had never known anything about it; servants are so stupid! She would have dearly liked, if only for the winter, to live in town, although the length of the fine days made the country perhaps even more wearisome in the summer. And, according to what she was saying, her voice was clear, sharp, or, on a sudden all languor, drawn out in modulations that ended almost in murmurs as she spoke to herself, now joyous, opening big naïve eyes, then with her eyelids half closed, her look full of boredom, her thoughts wandering.

Going home at night, Charles went over her words one by one, trying to recall them, to fill out their sense, that he might piece out the life she had lived before he knew her. But he never saw her in his thoughts other than he had seen her the first time, or as he had just left her. Then he asked himself what would become of her - if she would be married, and to whom? Alas! old Rouault was rich, and she! - so beautiful! But Emma's face always rose before his eyes, and a monotone, like the humming of a top, sounded in his ears, 'If you should marry after all! if you should marry!' At night he could not sleep; his throat was parched; he was athirst. He got up to drink from the water-bottle and opened the window. The night was covered with stars, a warm wind blowing in the distance; the dogs were barking. He turned his head towards the Bertaux.

Thinking that, after all, he should lose nothing, Charles promised himself to ask her in marriage as soon as occasion offered, but, whenever occasion did offer, his lips were sealed by the fear of not finding the right words.

Old Rouault would not have been sorry to be rid of his daughter, who was of no use to him in the house. In his heart he excused her, thinking her too clever for farming, a calling under the ban of Heaven, since one never saw a millionaire in it. Far from having made a fortune by it, the good man was losing every year; for if he was good in bargaining, in which he enjoyed the dodges of the trade, on the other hand, agriculture properly so called, and the internal management of the farm, suited him less than most people. He did not willingly take his hands out of his pockets, and did not spare expense in all that concerned himself, liking to eat well, to have good fires, and to sleep well. He liked old cider, underdone legs of mutton, glorias [a mixture of coffee and spirits] well beaten up. He took his meals in the kitchen alone, opposite the fire, on a little table brought to him all ready laid as on the stage.

When, therefore, he perceived that Charles's cheeks grew red if near his daughter, which meant that he would propose for her one of these days, he chewed the cud of the matter beforehand. He certainly thought him a little meagre, and not quite the son-in-law he would have liked, but he was said to be well brought-up, economical, very learned, and no doubt would not make too many difficulties about the dowry. Now, as old Rouault would soon be forced to sell twenty-two acres of 'his property', as he owed a good deal to the mason, to the harnessmaker, and as

the shaft of the cider-press wanted renewing, 'If he asks for her,' he said to himself, 'I'll give her to him.'

At Michaelmas Charles went to spend three days at the Bertaux. The last had passed like the others in procrastinating from hour to hour. Old Rouault was seeing him off; they were walking along the road full of ruts; they were about to part. This was the time. Charles gave himself as far as to the corner of the hedge, and at last, when past it – 'Monsieur Rouault,' he murmured, 'I should like to say something to you.'

They stopped. Charles was silent.

'Well, tell me your story. Don't I know all about it?' said old Rouault, laughing kindly.

'Monsieur Rouault - Monsieur Rouault,' stammered Charles.

'I ask nothing better,' the farmer went on. 'Although, no doubt, the little one is of my mind, still we must ask her opinion. So you get off – I'll go back home. If it is "yes", you needn't return because of all the people about, and besides it would upset her too much. But so that you mayn't be eating your heart, I'll open wide the outer shutter of the window against the wall; you can see it from the back by leaning over the hedge.'

And he went off.

Charles fastened his horse to a tree; he ran into the road and waited. Half an hour passed, then he counted nineteen minutes by his watch. Suddenly a noise was heard against the wall; the shutter had been thrown back; the hook was still swinging.

The next day by nine o'clock he was at the farm. Emma blushed as he entered, and she gave a little forced laugh to keep herself in countenance. Old Rouault embraced his future son-in-law. The discussion of money matters was put off: moreover, there

was plenty of time before them, as the marriage could not decently take place till Charles was out of mourning, that is to say, about the spring of the next year.

The winter passed waiting for this. Mademoiselle Rouault was busy with her trousseau. Part of it was ordered at Rouen, and she made herself chemises and nightcaps after fashion-plates that she borrowed. When Charles visited the farmer, the preparations for the wedding were talked over; they wondered in what room they should have dinner; they dreamed of the number of dishes that would be wanted, and what should be the entrées.

Emma, on the contrary, would have preferred a midnight wedding with torches, but old Rouault could not understand such an idea. So there was a wedding at which forty-three persons were present, at which they remained sixteen hours at table, began again the next day, and to some extent on the days following.

The guests arrived early in carriages, in one-horse chaises, two-wheeled cars, old open gigs, wagonettes with leather hoods, and the young people from the nearer villages in carts, in which they stood up in rows, holding on to the sides so as not to fall, going at a trot and getting well shaken up. Some came from a distance of thirty miles, from Goderville, from Normanville, and from Cany. All the relatives of both families had been invited, quarrels between friends arranged, acquaintances long since lost sight of written to.

From time to time was heard the crack of a whip behind the hedge; then the gates opened, a chaise entered. Galloping up to the foot of the steps, it stopped there dead and emptied its load. They got down from all sides, rubbing knees and stretching arms. The ladies, wearing bonnets, had on dresses in the town fashion, gold watch chains, pelerines with the ends tucked into belts, or little coloured fichus fastened down behind with a pin, and that left the back of the neck bare. The lads, dressed like their papas, seemed uncomfortable in their new clothes (many that day handselled their first pair of boots), and by their sides, speaking never a word, wearing the white dress of their first communion lengthened for the occasion, were some big girls of fourteen or sixteen, cousins or elder sisters no doubt, rubicund, bewildered, their hair greasy with rose-pomade, and very much afraid of dirtying their gloves. As there were not enough stable-boys to unharness all the carriages,

the gentlemen turned up their sleeves and set about it themselves. According to their different social positions they wore tail-coats, overcoats, shootingjackets, cutaway-coats: finc tail-coats, redolent of family respectability, that only came out of the wardrobe on state occasions; overcoats with long tails flapping in the wind and round capes and pockets like sacks; shooting-jackets of coarse cloth, generally worn with a cap with a brass-bound peak; very short cutaway-coats with two small buttons in the back, close together like a pair of eyes, and the tails of which seemed cut out of one piece by a carpenter's hatchet. Some, too (but these, you may be sure, would sit at the bottom of the table), wore their best blouses - that is to say, with collars turned down to the shoulders, the back gathered into small plaits and the waist fastened very low down with a worked belt.

And the shirts stood out from the chests like cuirasses! Everyone had just had his hair cut; ears stood out from the heads; they had been close-shaved; a few, even, who had had to get up before daybreak, and not been able to see to shave, had diagonal gashes under their noses or cuts the size of a three-franc piece along the jaws, which the fresh air *en route* had inflamed, so that the great white beaming faces were mottled with red dabs.

The mairie was a mile and a half from the farm, and they went thither on foot, returning in the same way after the ceremony in the church. The procession, first united like one long coloured scarf undulating across the fields, along the narrow path winding amid the green corn, soon lengthened out, and broke up into different groups that loitered to talk. The fiddler walked in front with his violin, gay with ribbons at its

pegs. Then came the wedded pair, with relations, and friends all following pell-mell; the children staved behind amusing themselves plucking the bell-flowers from oat-ears, or playing amongst themselves unseen. Emma's dress, too long, trailed a little on the ground; from time to time she stopped to pull it up, and then delicately, with her gloved hands, she picked off the coarse grass and the thistledowns, while Charles, empty handed, waited till she had finished. Old Rouault, with a new silk hat and the cuffs of his black coat covering his hands up to the nail gave his arm to Madame Boyary, senior. As to Monsieur Boyary, senior, who, heartily despising all these folk, had come simply in a frock-coat of military cut with one row of buttons - he was passing compliments of the bar to a fair young peasant. She bowed, blushed, and did not know what to say. The other wedding guests talked of their business or played tricks behind each other's backs, egging one another on in advance to be jolly. Those who listened could always catch the squeaking of the fiddler, who went on playing across the fields. When he saw that the rest were far behind he stopped to take breath, slowly rosined his bow, so that the strings should sound more shrilly, then set off again, by turns lowering and raising his neck, the better to mark time for himself. The noise of the instrument drove away the little birds from afar.

The table was laid under the cart-shed. On it were four sirloins, six chicken fricassees, stewed veal, three legs of mutton, and in the middle a fine roast suckingpig, flanked by four chitterlings with sorrel. At the corners were decanters of brandy. Sweet bottled cider frothed round the corks, and all the glasses had been filled to the brim with wine beforehand. The large

dishes of yellow cream trembling with the least shake of the table, had designed on their smooth surface the initials of the newly-wedded pair in nonpareil arabesques. A confectioner of Yvetot had been entrusted with the tarts and sweets. As he had only just set up in the place, he had taken a lot of trouble, and at dessert he himself brought in a set dish that evoked loud cries of wonderment. To begin with, at its base there was a square of blue cardboard, representing a temple with porticoes, colonnades, and stucco statuettes all round, and in the niches constellations of gilt paper stars; then on the second stage was a dungeon of Savoy cake, surrounded by many fortifications in candied angelica, almonds, raisins, and quarters of oranges; and finally, on the upper platform a green field with rocks set in lakes of jam, nutshell boats, and a small Cupid balancing himself in a chocolate swing whose two uprights ended in real roses for balls at the top.

Until nightfall the eating went on. When any of them were tired of sitting, they went out for a stroll in the yard, or for a game with corks in the granary, and then returned to table. Some towards the finish went to sleep and snored. But with the coffee everyone woke up. Then they began songs, showed off tricks, raised heavy weights, performed feats with their fingers, then tried lifting carts on their shoulders, made broad jokes, kissed the women. At night when they left, the horses, stuffed up to the nostrils with oats, could hardly be got into the shafts; they kicked, reared, the harness broke, their masters laughed or swore; and all night in the light of the moon along country roads there were runaway carts at full gallop plunging into the ditches, jumping over yard after yard

of stones, clambering up the hills, with women leaning out from the tilt to catch hold of the reins.

Those who stayed at the Bertaux spent the night drinking in the kitchen. The children had fallen asleep under the benches.

The bride had begged her father to be spared the usual marriage pleasantries. However, a fishmonger, one of their cousins (who had actually brought a couple of soles as his wedding-present), began to squirt water from his mouth through the keyhole, when old Rouault came up just in time to stop him, and explain to him that the distinguished position of his son-in-law would not allow of such liberties. The cousin all the same did not give in to these reasons readily. In his heart he accused old Rouault of being proud, and he joined four or five other guests in a corner, who having, through mere chance, been several times running served with the worst helps of meat, also were of opinion they had been badly used, and were whispering about their host, and with covered hints hoping he would ruin himself.

Madame Bovary, senior, had not opened her mouth all day. She had been consulted neither as to the dress of her daughter-in-law nor as to the arrangement of the feast; she went to bed early. Her husband, instead of following her, sent to Saint-Victor for some cigars, and smoked till daybreak, drinking kirsch-punch, a mixture unknown to the company. This added greatly to the consideration in which he was held.

Charles, who was not of a facetious turn, did not shine at the wedding. He answered feebly to the puns, doubles entendres, compliments, and chaff that it was felt a duty to let off at him as soon as the soup appeared.

The next day, on the other hand, he seemed another man. It was he who might rather have been taken for the virgin of the evening before, whilst the bride gave not one sign that could have revealed anything. The shrewdest did not know what to make of it, and they looked at her when she passed near them with an unbounded concentration of mind. But Charles concealed nothing. He called her 'my wife', tutoyêd her, asked for her of everyone, looked for her everywhere, and often he dragged her into the yards, where he could be seen from far between the trees, putting his arm round her waist, and walking half-bending over her, ruffling the chemisette of her bodice with his head.

Two days after the wedding the married pair left. Charles, on account of his patients, could not be away longer. Old Rouault had them driven back in his cart, and himself accompanied them as far as Vassonville. Here he embraced his daughter for the last time, got down, and went his way. When he had gone about a hundred paces he stopped, and as he saw the cart disappearing, its wheels turning in the dust, he gave a deep sigh. Then he remembered his wedding, the old times, the first pregnancy of his wife; he, too, had been very happy the day when he had taken her from her father to his home, and had borne her off on his pillion, trotting through the snow, for it was near Christmas-time and the country was all white. She held on to him with one arm, her basket hanging from the other; the wind blew the long lace of her Cauchois headdress so that it sometimes flapped across his mouth, and when he turned his head he saw near him, on his shoulder, her little rosy face, smiling silently under the gold bands of her cap. To warm her hands

she put them against his chest from time to time. How long ago it all was! Their son would have been thirty by now. Then he looked back and saw nothing on the road. He felt dreary as an empty house; and tender memories mingling with the sad thoughts in his brain, addled by the fumes of the feast, he felt inclined for a moment to take a turn towards the church. As he was afraid, however, that this sight would make him yet more sad, he went right away home.

Monsieur and Madame Charles arrived at Tostes about six o'clock. The neighbours came to the windows to see their doctor's new wife.

The old servant presented herself, curtsied to her, apologised for not having dinner ready, and suggested that Madame should meantime look over her house.

The brick front was just in a line with the street, or rather the road. Behind the door hung a cloak with a small collar, a bridle, and a black leather cap, and on the floor, in a corner, were a pair of leggings, still covered with dry mud. On the right was the one apartment, that was both dining and sitting-room. A canary-yellow paper, relieved at the top by a garland of pale flowers, was puckered everywhere over the badlystretched canvas; white calico curtains with a red border hung crossways the length of the window; and on the narrow mantelpiece a clock with a head of Hippocrates shone resplendent between two plate candlesticks under oval shades. On the other side of the passage was Charles's consulting-room, a little room about six paces wide, with a table, three chairs, and an office-chair. Volumes of the Dictionary of Medical Science, uncut, but the binding rather the worse for the successive sales through which they had gone, occupied almost alone the six shelves of a deal bookcase. The smell of melted butter penetrated through the walls when he saw patients, just as in the kitchen one could hear the people coughing in the consulting-room and recounting their whole histories. Then, opening on the yard, where the stable was, came a large dilapidated room with a stove, now used as a wood-house, cellar, and pantry, full of old rubbish, of empty casks, agricultural implements past service, and a mass of dusty things whose use it was impossible to guess.

The garden, longer than wide, ran between two

mud walls with espaliered apricots, to a hawthorn hedge that separated it from the field. In the middle was a slate sundial on a brick pedestal; four flowerbeds with eglantines surrounded symmetrically the more useful kitchen-garden bed. Right at the bottom, under the spruce bushes, was a curé in plaster reading his breviary.

Emma went upstairs. The first room was not furnished, but in the second, which was their bedroom, was a mahogany bedstead in an alcove with red drapery. A shell box adorned the chest of drawers, and on the secretary-table near the window a bouquet of orange blossoms tied with white satin ribbons stood in a bottle. It was a bride's bouquet; it was the other one's. She looked at it. Charles noticed it; he took it and carried it up to the attic, while Emma seated in an armchair (they were putting her things down around her) thought of her bridal flowers packed up in a bandbox, and wondered, dreaming, what would be done with them if she were to die.

During the first days she occupied herself in thinking about changes in the house. She took the shades off the candlesticks, had new wallpaper put up, the staircase repainted and seats made in the garden round the sundial; she even enquired how she could get a basin with a jet fountain and fishes. Finally her husband, knowing that she liked to drive out, picked up a second-hand dogcart, which, with new lamps and a splash-board in striped leather, looked almost like a tilbury.

He was happy then, and without a care in the world. A meal together, a walk in the evening on the high-road, a gesture of her hands over her hair, the sight of

her straw hat hanging from the window-fastener, and many another thing in which Charles had never dreamed of pleasure, now made up the endless round of his happiness. In bed, in the morning, by her side, on the pillow, he watched the sunlight sinking into the down on her fair cheek, half hidden by the lappets of her nightcap. Seen thus closely, her eyes looked to him enlarged, especially when, on waking up, she opened and shut them rapidly many times. Black in the shade, dark blue in broad daylight, they had, as it were, depths of different colours, that, darker in the centre, grew paler towards the surface of the eye. His own eyes lost themselves in these depths; he saw himself in miniature down to the shoulders, with his handkerchief round his head and the top of his shirt open. He rose. She came to the window to see him off, and staved leaning on the sill between two pots of geranium, clad in her dressing-gown hanging loosely about her. Charles, in the street, buckled his spurs, his foot on the mounting stone, while she talked to him from above, picking with her mouth some scrap of flower or leaf that she blew out at him. Then this, eddying, floating, described semicircles in the air like a bird, and was caught before it reached the ground in the ill-groomed mane of the old white mare standing motionless at the door. Charles threw her a kiss from his mount; she answered with a nod; she closed the window, and he set off. And then along the highroad, spreading out its long ribbon of dust, along the deep lanes that the trees bent over as in arbours, along paths where the corn reached to the knees, with the sun on his back and the morning air in his nostrils, his heart full of the joys of the past night, his mind at rest, his flesh at ease, he went off, chewing the cud of his

happiness, like those who after dinner taste again the truffles which they are digesting.

Until now what good had he had of his life? His time at school, when he remained shut up within the high walls, alone, in the midst of companions richer than he or cleverer at their work, who laughed at his accent, who jeered at his clothes, and whose mothers came to the school with cakes in their muffs? Later on, when he studied medicine, and never had his purse full enough to treat some little work-girl who would have become his mistress? Afterwards, he had lived fourteen months with the widow, whose feet in bed were cold as icicles. But now he had for life this beautiful woman whom he adored. For him the universe did not extend beyond the circumference of her petticoat, and he reproached himself with not loving her. He wanted to see her again; he turned back quickly, ran up the stairs with a beating heart. Emma, in her room, was dressing; he came up on tiptoe, kissed her between the shoulders; she gave a cry.

He could not keep from constantly touching her comb, her rings, her fichu; sometimes he gave her great sounding kisses with all his mouth on her cheeks, or else little kisses in a row all along her bare arm from the tip of her fingers up to her shoulder, and she put him away half-smiling, half-vexed, as you do a child who hangs about you.

Before marriage she thought herself in love; but the happiness that should have followed this love not having come, she must, she thought, have been mistaken. And Emma tried to find out what one meant exactly in life by the words, *felicity*, *passion*, *rapture*, that had seemed to her so beautiful in books.

She had read *Paul et Virginie*, and had dreamed of the little bamboo-house, the negro Domingo, the dog Fidéle, but above all of the sweet friendship of some dear little brother, who seeks red fruit for you on trees taller than steeples, or who runs barefoot over the sand, bringing you a bird's nest.

When she was thirteen, her father himself took her to town to place her in the convent. They stopped at an inn in the St Gervais quarter, where, at their supper, they used painted plates that set forth the story of Mademoiselle de la Vallière. The explanatory legends, chipped here and there by the scratching of knives, all glorified religion, the tendernesses of the heart, and the pomps of court.

Far from being bored at first at the convent, she took pleasure in the society of the good sisters, who, to amuse her, took her to the chapel, which one entered from the refectory by a long corridor. She played very little during recreation hours, knew her catechism well, and it was she who always answered her parish priest's most difficult questions. Living thus, without ever leaving the warm atmosphere of the classrooms, and amid these pale-faced women wearing rosaries with brass crosses, she was softly lulled by the mystic languor exhaled in the perfumes of the altar, the freshness of the holy water, and the lights of the tapers. Instead of attending to mass, she looked at the pious vignettes with their azure borders in her book, and she loved the sick lamb, the sacred heart pierced with sharp arrows, or the poor Jesus sinking beneath the

cross he carries. She tried, by way of mortification, to eat nothing a whole day. She puzzled her head to find some vow to fulfil.

When she went to confession, she invented little sins in order that she might stay there longer, kneeling in the shadow, her hands joined, her face against the grating beneath the whispering of the priest. The comparisons of betrothed, husband, celestial lover, and eternal marriage, that recur in sermons, stirred within her soul depths of unexpected sweetness.

In the evening, before prayers, there was some religious reading in the study. On week-nights it was some abstract of sacred history or the addresses of the Abbé Frayssinous, and on Sundays passages from the Gênie du Christianisme, as a recreation. How she listened at first to the sonorous lamentations of its romantic melancholies re-echoing through the world and eternity! If her childhood had been spent in the shop-parlour of some business quarter, she might perhaps have opened her heart to those lyrical invasions of Nature, which usually come to us only through translation in books. But she knew the country too well; she knew the lowing of cattle, the milking, the ploughs. Accustomed to calm aspects of life, she turned, on the contrary, to those of excitement. She loved the sea only for the sake of its storms, and the green fields only when broken up by ruins. She wanted to get some personal profit out of things, and she rejected as useless all that did not contribute to the immediate desires of her heart, being of a temperament more sentimental than artistic, looking for emotions, not landscapes.

At the convent there was an old maid who came for a week each month to mend the linen. Patronised by

the clergy, because she belonged to an ancient family of noblemen ruined by the Revolution, she dined in the refectory at the table of the good sisters, and after the meal had a bit of chat with them before going back to her work. The girls often slipped out from the study to go and see her. She knew by heart the love songs of the last century, and sang them in a low voice as she stitched away. She told stories, gave them news, Wellt estateds in the town, and on the sly lent the hig girls some novel, that she always carried in the pockets of her apron, and of which the good lady herself swallowed long chapters in the intervals of her work. They were all love, lovers, sweethearts, persecuted ladies fainting in lonely pavilions, postilions killed at every stage, horses ridden to death on every page, sombre forests, heartaches, vows, sobs, tears and kisses, little skiffs by moonlight, nightingales in shady groves, 'gentlemen' brave as lions, gentle as lambs, virtuous as no one ever was, always well dressed, and weeping like fountains. For six months, then, Emma, at fifteen years of age, made her hands dirty with books from old lending libraries. Through Walter Scott, later on, she fell in love with historical events, dreamed of old chests, guardrooms, and minstrels. She would have liked to live in some old manor-house, like those long-waisted chatelaines who, in the shade of pointed arches, spent their days leaning on the stone, chin in hand, watching a cavalier with white plume galloping on his black horse from the distant fields. At this time she had a cult for Mary Stuart and enthusiastic veneration for illustrious or unhappy women. Joan of Arc, Héloïse, Agnès Sorel, the beautiful Ferronière, and Clémence Isaure stood out to her like comets in the dark immensity of heaven,

where also were seen, lost in shadow, and all unconnected, St Louis with his oak, the dying Bayard, some cruelties of Louis XI, a little of St Bartholomew's Day, the plume of the Béarnais, and always the remembrance of the plates painted in honour of Louis XIV.

In the music-class, in the ballads she sang, there was nothing but little angels with golden wings, madonnas, lagunes, gondoliers – mild compositions that allowed her to catch a glimpse athwart the obscurity of style and the weakness of the music of the attractive phantasmagoria of sentimental realities. Some of her companions brought 'keepsakes' given them as new year's gifts to the convent. These had to be hidden; it was quite an undertaking; they were read in the dormitory. Delicately handling the beautiful satin bindings, Emma looked with dazzled eyes at the names of the unknown authors, who had signed their verses for the most part as counts or viscounts.

She trembled as she blew back the tissue paper over the engraving, and saw it folded in two and fall gently against the page. Here behind the balustrade of a balcony was a young man in a short cloak, holding in his arms a young girl in a white dress wearing an almsbag at her belt; or there were nameless portraits of English ladies with fair curls, who looked at you from under their round straw hats with their large clear eyes. Some there were lounging in their carriages, gliding through parks, a greyhound bounding along in front of this equipage driven at a trot by two midget postilions in white breeches. Others, dreaming on sofas with an open letter, gazed at the moon through a slightly open window half draped by a black curtain. The naïve ones, a tear on their cheeks, were kissing doves through the bars of a Gothic cage, or, smiling,

their heads on one side, were plucking the leaves of a marguerite with their taper fingers, that curved at the tips like peaked shoes. And you, too, were there, Sultans with long pipes reclining beneath arbours in the arms of Bayadères; Djiaours, Turkish sabres, Greek caps; and you especially, pale landscapes of dithyrambic lands, that often show us at once palm trees and firs, tigers on the right, a lion to the left, tartar militarets on the lionizon, the whole funned by a very neat virgin forest, and with a great perpendicular sunbeam trembling in the water, where, standing out in relief like white excoriations on a steel-grey ground, swans are swimming about.

And the shade of the argand lamp fastened to the wall above Emma's head lighted up all these pictures of the world, that passed before her one by one in the silence of the dormitory, and to the distant noise of some belated carriage rolling over the Boulevards.

When her mother died she cried much the first few days. She had a funeral picture made with the hair of the deceased, and, in a letter sent to the Bertaux full of sad reflections on life, she asked to be buried later on in the same grave. The good man thought she must be ill, and came to see her. Emma was secretly pleased that she had reached at a first attempt the rare ideal of pale lives, never attained by mediocre hearts. She let herself glide along with Lamartine meanderings, listened to harps on lakes, to all the songs of dying swans, to the falling of the leaves, the pure virgins ascending to heaven, and the voice of the Eternal discoursing down the valleys. She wearied of it, would not confess it, continued from habit, and at last was surprised to feel herself soothed, and with no more sadness at heart than wrinkles on her brow.

The good nuns, who had been so sure of her vocation, perceived with great astonishment that Mademoiselle Rouault seemed to be slipping from them. They had indeed been so lavish to her of prayers, retreats, novenas, and sermons, they had so often preached the respect due to saints and martyrs, and given so much good advice as to the modesty of the body and the salvation of her soul, that she did as tightly reigned horses: she pulled up short and the bit slipped from her teeth. This nature, positive in the midst of its enthusiasms, that had loved the church for the sake of the flowers, and music for the words of the songs, and literature for its passional stimulus, rebelled against the mysteries of faith as it grew irritated by discipline, a thing antipathetic to her constitution. When her father took her from school, no one was sorry to see her go. The Lady Superior even thought that she had latterly been somewhat irreverent to the community.

Emma, at home once more, first took pleasure in looking after the servants, then grew disgusted with the country and missed her convent. When Charles came to the Bertaux for the first time, she thought herself quite disillusioned, with nothing more to learn, and nothing more to feel.

But the uneasiness of her new position, or perhaps the disturbance caused by the presence of this man, had sufficed to make her believe that she at last felt that wondrous passion which, till then, like a great bird with rose-coloured wings, hung in the splendour of the skies of poesy; and now she could not think that the calm in which she lived was the happiness she had dreamed. She thought, sometimes, that, after all, this was the happiest time of her life - the honeymoon, as people called it. To taste its full sweetness, it would have been necessary doubtless to fly to those lands of resounding names where marriage brings morrows of the most languorous ease! In post-chaises behind blue silken curtains to ride slowly up steep roads, listening to the song of the postilion re-echoed by the mountains, along with the bells of goats and the muffled sound of a waterfall; at sunset on the shores of gulfs to breathe in the perfume of lemon trees; then in the evening on the villa-terraces above, hand in hand to look at the stars, making plans for the future. It seemed to her that certain places on earth must bring happiness, as a plant peculiar to the soil, and that cannot thrive elsewhere. Why could not she lean over balconies in Swiss chalets, or enshrine her melancholy in a Scotch cottage, with a husband dressed in a black velvet coat with long tails, and thin shoes, a pointed hat and frills?

Perhaps she would have liked to confide all these things to someone. But how tell an undefinable uneasiness, variable as the clouds, unstable as the winds? Words failed her – the opportunity, the courage.

If Charles had but wished it, if he had guessed it, if his look had but once met her thought, it seemed to her that a sudden plenty would have gone out from her heart, as the fruit falls from a tree when shaken by a hand. But as the intimacy of their life became deeper, the greater became the gulf that separated her from him.

Charles's conversation was commonplace as a street pavement, and everyone's ideas trooped through it in their everyday garb, without exciting emotion, laughter, or thought. He had never had the curiosity, he said, while he lived at Rouen, to go to the theatre to see the actors from Paris. He could neither swim, nor fence, nor shoot, and one day he could not explain to her some term of horsemanship which she had come across in a novel.

A man, on the contrary, should he not know everything, excel in manifold activities, initiate you into the energies of passion, the refinements of life, all mysteries? But this one taught nothing, knew nothing, wished nothing. He thought her happy; and she resented this easy calm, this serene heaviness, the very happiness she gave him.

Sometimes she would draw; and it was great amusement to Charles to stand there bolt upright and watch her bend over her cardboard, with eyes half-closed the better to see her work, or rolling, between her fingers, little bread-pellets. As to the piano, the more quickly her fingers glided over it the more he wondered. She struck the notes with aplomb, and ran from top to bottom of the keyboard without a break. Thus shaken up, the old instrument, whose strings buzzed, could be heard at the other end of the village when the window was open, and often the bailiff's clerk, passing along the highroad bareheaded and in list slippers, stopped to listen, his sheet of paper in his hand.

Emma, on the other hand, knew how to look after her house. She sent the patients' accounts in wellphrased letters that had no suggestion of a bill. When they had a neighbour to dinner on Sundays, she managed to have some tasty dish – piled up pyramids of

greengages on vine leaves, served up preserves turned out into plates – and even spoke of buying finger-glasses for dessert. From all this much consideration was extended to Bovary.

Charles finished by rising in his own esteem for possessing such a wife. He showed with pride in the sitting-room two small pencil sketches by her that he had had framed in very large frames, and hung up against the wallpaper by long green cords. People returning from mass saw him at his door in his wool-work slippers.

He came home late – at ten o'clock, at midnight sometimes. Then he asked for something to eat, and, as the servant had gone to bed, Emma waited on him. He took off his coat to dine more at his ease. He told her, one after the other, the people he had met, the villages where he had been, the prescriptions he had written, and, well pleased with himself, he finished the remainder of the boiled beef and onions, picked pieces off the cheese, munched an apple, emptied his waterbottle, and then went to bed, and lay on his back and snored.

As he had been for a time accustomed to wearing nightcaps, his handkerchief would not keep down over his ears, so that his hair in the morning was all tumbled pell-mell about his face and whitened with the feathers of the pillow, whose strings came untied during the night. He always wore thick boots that had two long creases over the instep running obliquely towards the ankle, while the rest of the upper continued in a straight line as if stretched on a wooden foot. He said that was 'quite good enough for the country.'

His mother approved of his economy, for she came

to see him as formerly when there had been some violent row at her place; and yet Madame Bovary, senior, seemed prejudiced against her daughter-in-law. She thought 'her ways too fine for their position'; the wood, the sugar, and the candles disappeared 'as if in a big house,' and the amount of firing in the kitchen would have been enough for twenty-five courses. She put her linen in order for her in the presses, and taught her to keep an eye on the butcher when he brought the meat. Emma put up with these lessons. Madame Bovary was lavish of them; and the words 'daughter' and 'mother' were exchanged all day long, accompanied by little quiverings of the lips, each one uttering gentle words in a voice trembling with anger.

In Madame Dubuc's time the old woman felt that she was still the favourite; but now the love of Charles for Emma seemed to her a desertion from her tenderness, an encroachment upon what was hers, and she watched her son's happiness in sad silence, as a ruined man looks through the windows at people dining in his old house. She recalled to him as remembrances her troubles and her sacrifices, and, comparing these with Emma's negligence, came to the conclusion that it was not reasonable to adore her so exclusively.

Charles knew not what to answer; he respected his mother, and he loved his wife infinitely; he considered the judgement of the one infallible and yet he thought the conduct of the other irreproachable. When Madame Bovary had gone, he tried timidly and in the same terms to hazard one or two of the more anodyne observations he had heard from his mamma. Emma proved to him with a word that he was mistaken, and sent him off to his patients.

And yet, in accord with theories she believed right, she wanted to make herself in love with him. By moonlight in the garden she recited all the passionate rhymes she knew by heart, and, sighing, sang melancholy adagios to him; but she found herself as calm after this as before, and Charles seemed neither more amorous nor more stirred.

When she had thus for a while struck the flint on her heart without getting a spark, incapable, moreover, of understanding what she did not experience as of believing anything that did not present itself in conventional forms, she persuaded herself without difficulty that Charles's passion was nothing very exorbitant. His outbursts became regular; he embraced her at certain fixed times. It was one habit among other habits, and, like a dessert, looked forward to after the monotony of dinner.

A gamekeeper, cured by the doctor of inflammation of the lungs, had given madame a little Italian greyhound; she took her out walking, for she went out sometimes in order to be alone for a moment, and not to see before her eyes the eternal garden and the dusty road. She went as far as the beeches of Banneville, near the deserted pavilion which forms an angle of the wall on the side of the country. Amidst the vegetation of the ditch there are long reeds with leaves that cut you.

She began by looking round her to see if nothing had changed since last she had been there. She found again in the same places the foxgloves and wall-flowers, the bed of nettles growing round the big stones, and the patches of lichen along the three windows, whose shutters, always closed, were rotting away on their rusty iron bars. Her thoughts, aimless at first, wandered at random, like her greyhound, who

ran round and round in the fields, yelping after the yellow butterflies, chasing the shrew-mice, or nibbling the poppies on the edge of a cornfield. Then gradually her ideas took definite shape, and, sitting on the grass that she dug up with little prods of her sunshade, Emma repeated to herself, 'Good heavens! why did I marry?'

She asked herself if by some other chance combination it would not have been possible to meet another man; and she tried to imagine what would have been these unrealised events, this different life, this unknown husband. All, surely, could not be like this one. He might have been handsome, witty, distinguished, attractive, such as, no doubt, her old companions of the convent had married. What were they doing now? In town, with the noise of the streets, the buzz of the theatres, and the lights of the ballroom. they were living lives where the heart expands, the senses bourgeon out. But she - her life was cold as a garret whose dormer-window looks on the north, and ennui, the silent spider, was weaving its web in the darkness in every corner of her heart. She recalled the prize days, when she mounted the platform to receive her little crowns, with her hair in long plaits. In her white frock and open prunella shoes she had a pretty way, and when she went back to her seat, the gentlemen bent over her to congratulate her; the courtvard was full of carriages; farewells were called to her through their windows; the music-master with his violin-case bowed in passing by. How far off all this! How far away!

She called Djali, took her between her knees, and smoothed the long, delicate head, saying, 'Come, kiss mistress; you have no troubles.'

Then noting the melancholy face of the graceful animal, who yawned slowly, she softened, and comparing her to herself, spoke to her aloud as to somebody in trouble whom one is consoling.

Occasionally there came gusts of wind, breezes from the sea rolling in one sweep over the whole plateau of the Gaux country, which brought even to these fields a salt freshness. The rushes, close to the ground, whistled; the branches trembled in a swift rustling, while their summits, ceaselessly swaying, kept up a deep murmur. Emma drew her shawl round her shoulders and rose.

In the avenue a green light dimmed by the leaves lit up the short moss that crackled softly beneath her feet. The sun was setting; the sky showed red between the branches, and the trunks of the trees, uniform, and planted in a straight line, seemed a brown colonnade standing out against a background of gold. A fear took hold of her; she called Djali, and hurriedly returned to Tostes by the highroad, threw herself into an armchair, and for the rest of the evening did not speak.

But towards the end of September an extraordinary event broke into her life; she was invited by the Marquis d'Andervilliers to Vaubyessard.

Secretary of State under the Restoration, the Marquis, anxious to re-enter political life, set about preparing for his candidature to the Chamber of Deputies long beforehand. In the winter he distributed a great deal of wood, and in the Conseil General was always enthusiastically demanding new roads for his arrondissement. During the dog-days he had suffered from an abscess, which Charles had cured as if by miracle with a timely touch of the

lancet. The steward sent to Tostes to pay for the operation reported in the evening that he had seen some superb cherries in the doctor's little garden. Now cherry trees did not thrive at Vaubyessard; the Marquis asked Bovary for some slips; made it his business to thank him personally; saw Emma; thought she had a pretty figure, and that she did not bow like a peasant, so that he did not think he was going beyond the bounds of condescension, nor, on the other hand, making a mistake, in inviting the young couple.

One Wednesday at three o'clock, Monsieur and Madame Bovary, seated in their dogcart, set out for Vaubyessard, with a great trunk strapped on behind and a bonnet-box in front on the apron. Besides these Charles held a bandbox between his knees.

They arrived at nightfall, just as the lamps in the park were being lit to show the way for the carriages. The château, a modern building in the Italian style, with two projecting wings and three flights of steps, lay at the foot of an immense greensward, on which some cows were grazing among groups of large trees set out at regular intervals, while large beds of arbutus, rhododendron, syringas, and guelder roses bulged out their irregular clusters of green along the curve of the gravel path. A river flowed under a bridge; through the mist one could distinguish buildings with thatched roofs scattered over the field bordered by two gently-sloping, well-timbered hillocks, and in the background amid the trees rose in two parallel lines the coach-houses and stables, all that was left of the ruined old château.

Charles's dogcart pulled up before the middle flight of steps; servants appeared; the Marquis came forward, and, offering his arm to the doctor's wife, conducted her to the vestibule.

It was paved with marble slabs, was very lofty, and the sound of footsteps and that of voices re-echoed through it as in a church. Opposite rose a straight staircase, and on the left a gallery overlooking the garden led to the billiard-room, through whose door one could hear the click of the ivory balls. As she crossed it to go to the drawing-room, Emma saw standing round the table men with grave faces, their chins resting on high cravats. They were all wearing orders, and smiled silently as they made their strokes. On the dark wainscoting of the walls large gold frames bore at the bottom names written in black letters. She

read; 'Jean-Antoine d'Andervilliers d'Yverbonville, Count de la Vaubvessard and Baron de la Fresnave. killed at the battle of Coutras on the 20th of October. 1587'. And on another: 'Jean-Antoine-Henry-Guy d'Andervilliers de la Vaubyessard, Admiral of France and Chevalier of the Order of St Michael, wounded at the battle of the Hougue-Saint-Vaast on the 29th of May, 1692; died at Vaubvessard on the 23rd of January, 1693'. One could hardly make out those that followed, for the light of the lamps lowered over the green cloth threw a dim shadow round the room. Burnishing the horizontal pictures, it broke up against these in delicate lines where there were cracks in the varnish, and from all these great black squares framed in with gold stood out here and there some lighter portion of the painting - a pale brow, two eves that looked at you, perukes flowing over and powdering red-coated shoulders, or the buckle of a garter above a well-rounded calf.

The Marquis opened the drawing-room door; one of the ladies (the Marchioness herself) came to meet Emma. She made her sit down by her on an ottoman, and began talking to her as amicably as if she had known her a long time. She was a woman of about forty, with fine shoulders, a hook nose, a drawling voice, and on this evening she wore over her brown hair a simple guipure fichu that fell in a point at the back. A fair young woman sat in a high-backed chair in a corner; and gentlemen with flowers in their buttonholes were talking to the ladies round the fire.

At seven dinner was served. The men, who were in the majority, sat down at the first table in the vestibule; the ladies at the second in the dining-room with the Marquis and Marchioness.

Emma, on entering, felt herself wrapped round by the warm air, a blending of the perfume of flowers and of the fine linen, of the fumes of the viands, and the odour of the truffles. The silver dish-covers reflected the lighted wax candles in the candelabra, the cut crystal covered with light steam reflected from one to the other pale rays; bouquets were placed in a row the whole length of the table; and in the large-bordered plates each napkin, arranged after the fashion of a bishop's mitre, held between its two gaping folds a small oval-shaped roll. The red claws of lobsters hung over the dishes; rich fruit in open baskets was piled up on moss; there were quails in their plumage; smoke was rising; and in silk stockings, knee-breeches, white crayat, and frilled shirt, the steward, grave as a judge, offering ready-carved dishes between the shoulders of the guests, with a touch of the spoon gave you the piece chosen. On the large stove of porcelain inlaid with copper baguettes the statue of a woman, draped to the chin, gazed motionless on the room full of life.

Madame Bovary noticed that many ladies had not

put their gloves in their glasses.

But at the upper end of the table, alone amongst all these women, bent over his full plate, and his napkin tied round his neck like a child, an old man sat eating, letting drops of gravy drip from his mouth. His eyes were bloodshot, and he wore a little queue tied with a black ribbon. He was the Marquis's father-in-law, the old Duke de Laverdière, once on a time favourite of the Count d'Artois, in the days of the Vaudreuil hunting-parties at the Marquis de Conflans', and had been, it was said, the lover of Queen Marie Antoinette, between Monsieur de Coigny and Monsieur de Lauzun. He had lived a life of noisy debauch, full

of duels, bets, elopements; he had squandered his fortune and frightened all his family. A servant behind his chair named aloud to him in his ear the dishes that he pointed to stammering, and constantly Emma's eyes turned involuntarily to this old man with hanging lips, as to something extraordinary. He had lived at Court and slept in the bed of queens!

Iced champagne was poured out. Emma shivered all over as she felt it cold in her mouth. She had never seen pomegranates nor tasted pineapples. The powdered sugar even seemed to her whiter and finer than elsewhere.

The ladies afterwards went to their rooms to prepare for the ball.

Emma made her toilet with the fastidious care of an actress on her début. She did her hair according to the directions of the hairdresser, and put on the barège dress spread out upon the bed. Charles's trousers were tight across the belly.

'My trouser-straps will be awkward for dancing,' he said.

'Dancing?' repeated Emma.

'Yes!

'Why, you must be mad! They would laugh at you; keep your place. Besides, it is more becoming for a doctor,' she added.

Charles was silent. He walked up and down waiting for Emma to finish dressing.

He saw her from behind in the glass between two lights. Her black eyes seemed blacker than ever. Her hair, undulating towards the ears, shone with a blue lustre; a rose in her *chignon* trembled on its mobile stalk, with artificial dewdrops on the tip of the leaves. She wore a gown of pale saffron trimmed with three

bouquets of pompon roses mixed with green.

Charles came and kissed her on her shoulder.

'Let me alone!' she said; 'you'll have me in rags.'

One could hear the flourish of the violin and the notes of a horn. She went downstairs restraining herself from running.

Dancing had begun. Guests were arriving. There was some crushing. She sat down on a form near the door.

The quadrille over, the floor was occupied by groups of men standing up and talking and servants in livery bearing large trays. Along the line of seated women painted fans were fluttering, bouquets half hid smiling faces, and gold-stoppered scent-bottles were turned in partly-closed hands, whose white gloves outlined the nails and tightened on the flesh at the wrists. Lace trimmings, diamond brooches, medallion bracelets trembled on bodices, gleamed on breasts, clinked on bare arms. The hair, well smoothed over the temples and knotted at the nape, bore crowns, or bunches, or sprays of myosotis, jasmine, pomegranate blossoms, ears of corn, and cornflowers. Calmly seated in their places, mothers with forbidding countenances were wearing red turbans

Emma's heart beat rather faster when, her partner holding her by the tips of the fingers, she took her place in a line with the dancers, and waited for the first note to start. But her emotion soon vanished, and, swaying to the rhythm of the orchestra, she glided forward with slight movements of the neck. A smile rose to her lips at certain delicate phrases of the violin, that sometimes played alone while the other instruments were silent; one could hear the clear clink

of the louis d'or that were being thrown down upon the card-tables in the next room; then all struck in again, the cornet-a-piston uttered its sonorous note, feet marked time, skirts swelled and rustled, hands touched and parted; the same eyes falling before you met yours again.

A few men (some fifteen or so), of twenty-five to forty, scattered among the dancers or talking at the doorways, stood out among the crowd by a certain air of breeding, whatever their differences in age, dress or face.

Their clothes, better made, seemed of finer cloth, and their hair, brought forward in curls towards the temples, glossy with more delicate pomades. They had the complexion of wealth - that clear complexion that is heightened by the pallor of porcelain, the shimmer of satin, the veneer of old furniture, and that an ordered regimen of exquisite nurture maintains at its best. Their necks moved easily in their low cravats, their long whiskers fell over their turned-down collars, they wiped their lips upon handkerchiefs with embroidered initials that gave forth a subtle perfume. Those who were beginning to grow old had an air of youth, while there was something mature in the faces of the young. In their unconcerned looks was the calm of passions daily satiated, and through all their gentleness of manner pierced that peculiar brutality, the result of a command of half-easy things, in which force is exercised and vanity amused - the management of thoroughbred horses and the society of loose women.

A few steps from Emma a gentleman in a blue coat was talking of Italy with a pale young woman wearing a parure of pearls.

They were praising the breadth of the columns of St

Peter's, Tivoli, Vesuvius, Castellamare, and Cassines, the roses of Genoa, the Coliseum by moonlight. With her other ear Emma was listening to a conversation full of words she did not understand. A circle gathered round a very young man who the week before had beaten 'Miss Arabella' and 'Romolus', and won two thousand louis jumping a ditch in England. One complained that his racehorses were growing fat; another of the printers' errors that had distorted the name of his horse.

The atmosphere of the ball was heavy; the lamps were growing dim. Guests were flocking to the billiardroom. A servant got upon a chair and broke the windowpanes. At the crash of the glass Madame Boyary turned her head and saw in the garden the faces of peasants pressed against the window looking in at them. Then the memory of the Bertaux came back to her. She saw the farm again, the muddy pond, her father in a blouse under the apple trees, and she saw herself again as formerly, skimming with her finger the cream off the milk pans in the dairy. But in the refulgence of the present hour her past life, so distinct until then, faded away completely, and she almost doubted having lived it. She was there; beyond the ball was only shadow overspreading all the rest. She was just eating a maraschino ice that she held with her left hand in a silver-gilt cup, her eyes half-closed, and the spoon between her teeth.

A lady near her dropped her fan. A gentleman was passing.

'Would you be so good,' said the lady, 'as to pick up my fan that has fallen behind the sofa?'

The gentleman bowed, and as he moved to stretch out his arm, Emma saw the hand of the young woman

throw something white, folded in a triangle, into his hat. The gentleman, picking up the fan, offered it to the lady respectfully; she thanked him with an inclination of the head, and began smelling her bouquet.

After supper, where were plenty of Spanish and Rhine wines, soups à la bisque and au lait d'amandes, puddings à la Trafalgar, and all sorts of cold meats with jellies that trembled in the dishes, the carriages one after the other began to drive off. Raising the corners of the muslin curtain, one could see the light of their lanterns glimmering through the darkness. The seats began to empty, some card-players were still left; the musicians were cooling the tips of their fingers on their tongues. Charles was half asleep, his back propped against a door.

At three o'clock the cotillion began. Emma did not know how to waltz. Everyone was waltzing, Mademoiselle d'Andervilliers herself and the Marquis; only the guests staying at the castle were still there, about a dozen persons.

One of the waltzers, however, who was familiarly called 'Viscount', and whose low-cut waistcoat seemed moulded to his chest, came a second time to ask Madame Bovary to dance, assuring her that he would guide her, and that she would get through it very well.

They began slowly, then went more rapidly. They turned; all around them was turning – the lamps, the furniture, the wainscoting, the floor, like a disc on a pivot. On passing near the doors the bottom of Emma's dress caught against his trousers. Their legs met in the steps; he looked down at her; she raised her eyes to his. A torpor seized her; she stopped. They started again, and with a more rapid movement; the

Viscount, dragging her along, disappeared with her to the end of the gallery, where, panting, she almost fell, and for a moment rested her head upon his breast. And then, still turning, but more slowly, he guided her back to her seat. She leaned back against the wall and covered her eyes with her hands.

When she opened them again, in the middle of the drawing-room, three waltzers were kneeling before a lady sitting on a stool. She chose the Viscount, and the violin struck up once more.

Everyone looked at them. They passed and repassed, she with rigid body, her chin bent down, and he always in the same pose, his figure curved, his elbow rounded, his chin thrown forward. That woman knew how to waltz! They kept up a long time, and tired out all the others.

Then they talked a few moments longer, and after the nights, or rather mornings, the guests of the château retired to bed.

Charles dragged himself up by the balusters. His 'knees were going up into his body.' He had spent five consecutive hours standing bolt upright at the cardtables, watching them play whist, without understanding anything about it, and it was with a deep sigh of relief that he pulled off his boots.

Emma threw a shawl over her shoulders, opened the window, and leant out.

The night was dark; some drops of rain were falling. She breathed in the damp wind that refreshed her eyelids. The music of the ball was still murmuring in her ears, and she tried to keep herself awake in order to prolong the illusion of this luxurious life that she would soon have to give up.

Day began to break. She looked long at the windows

of the château, trying to guess which were the rooms of all those she had noticed the evening before. She would fain have known their lives, have penetrated, blended with them. But she was shivering with cold. She undressed, and cowered down between the sheets against Charles, who was asleep.

There were a great many people to luncheon. The repast lasted ten minutes; no liqueurs were served, which astonished the doctor. Next, Mademoiselle d'Andervilliers collected some pieces of roll in a small basket to take them to the swans on the ornamental waters, and they went to walk in the hothouses, where strange plants, bristling with hairs, rose in pyramids under hanging vases, whence, as from overfilled nests of serpents, fell long green cords interlacing. The orangery, which was at the other end, led by a covered way to the outhouses of the château. The Marquis, to amuse the young woman, took her to see the stables. Above the basket-shaped racks porcelain slabs bore the names of the horses in black letters. Each animal in its stall whisked its tail when anyone went near and said 'Tchk! tchk!' The boards of the harness-room shone like the flooring of a drawing-room. The carriage harness was piled up in the middle against two twisted columns, and the bits, the whips, the spurs, the curbs, were ranged in a line all along the wall.

Charles, meanwhile, went to ask a groom to put his horse to. The dogcart was brought to the foot of the steps, and, all the parcels being crammed in, the Bovarys paid their respects to the Marquis and Marchioness and set out again for Tostes.

Emma watched the turning wheels in silence.

Charles, on the extreme edge of the seat, held the reins with his two arms wide apart, and the little horse ambled along in the shafts that were too big for him. The loose reins hanging over his crupper were wet with foam; the box fastened behind the dogcart bumped heavily and regularly against it.

They were on the heights of Thibourville when suddenly some horsemen with cigars between their lips passed laughing. Emma thought she recognised the Viscount, turned back, and caught on the horizon only the movement of the heads rising or falling with the unequal cadence of trot or gallop.

A mile farther on they had to stop to mend with

some string the traces that had broken.

But Charles, giving a last look to the harness, saw something on the ground between his horse's legs, and he picked up a cigar-case with a green silk border and beblazoned in the centre like the door of a carriage.

'There are even two cigars in it,' said he; 'they'll do

for this evening after dinner.'

'Why, do you smoke?' she asked.

'Sometimes, when I get a chance.'

He put his find in his pocket and whipped up the nag.

When they reached home the dinner was not ready. Madame lost her temper. Nastasie answered rudely.

'Leave the room!' said Emma. 'You are forgetting yourself. I give you notice.'

For dinner there was onion soup and a piece of veal with sorrel. Charles, seated opposite Emma, rubbed his hands gleefully.

'How good it is to be at home again!'

Nastasie could be heard crying. He was rather fond

of the poor girl. She had formerly, during the wearisome time of his widowhood, kept him company many an evening. She had been his first patient, his oldest acquaintance in the place.

'Have you given her notice for good?' he asked at last.

'Yes. Who's to prevent me?' she replied.

Then they warmed themselves in the kitchen while their room was being made ready. Charles began to smoke. He smoked with lips protruded, spitting every moment, recoiling at every puff.

'You'll make yourself ill,' she said scornfully.

He put down his cigar and ran to swallow a glass of cold water at the pump. Emma seizing hold of the cigar-case threw it quickly to the back of the cupboard.

The next day was a long one. She walked about her little garden, up and down the same walks, stopping before the beds, before the espalier, before the plaster curé, looking with amazement at all these things of once-on-a-time that she knew so well. How far off the ball seemed already! What was it that thus set so far asunder the morning of the day before yesterday and the evening of today? Her journey to Vaubyessard had made a hole in her life, like one of those great crevices that a storm will sometimes make in one night in mountains. Still she was resigned. She devoutly put away in her drawers her beautiful dress, down to the satin shoes whose soles were yellowed with the slippery wax of the dancing floor. Her heart was like these. In its friction against wealth something had come over it that could not be effaced.

The memory of this ball, then, became an occupation for Emma. Whenever the Wednesday came

round she said to herself as she awoke, 'Ah! I was there a week – a fortnight – three weeks ago.' And little by little the faces grew confused in her remembrance. She forgot the tune of the quadrilles; she no longer saw the liveries and appointments so distinctly; some details escaped her, but the regret remained.

Often when Charles was out she took from the cupboard, between the folds of the linen where she had left it, the green silk cigar-case. She looked at it, opened it and even smelt the odour of the lining - a mixture of verbena and tobacco. Whose was it? The Viscount's? Perhaps it was a present from his mistress. It had been embroidered on some rosewood frame, a pretty little thing, hidden from all eyes, that had occupied many hours, and over which had fallen the soft curls of the pensive worker. A breath of love had passed over the stitches on the canvas; each prick of the needle had fixed there a hope or a memory, and all those interwoven threads of silk were but the continuity of the same silent passion. And then one morning the Viscount had taken it away with him. Of what had they spoken when it lay upon the wide-mantelled chimneys between flower-vases and Pompadour clocks? She was at Tostes; he was at Paris now, far away! What was Paris really like? What a vague name! She repeated it in a low voice, for the mere pleasure of it; it rang in her ears like a great cathedral bell; it shone before her eyes, even on the labels of her pomade-pots.

At night, when the carriers passed under her windows in their carts singing the 'Marjolaine', she awoke, and listened to the noise of the iron-bound wheels, which, as they gained the country road, was soon deadened by the soil. 'They will be there tomorrow!' she said to herself.

And she followed them in thought up and down the

hills, traversing villages, gliding along the highroads by the light of the stars. At the end of some indefinite distance there was always a confused spot, into which her dream died.

She bought a plan of Paris, and with the tip of her finger on the map she walked about the capital. She went up the boulevards, stopping at every turning, between the lines of the streets, in front of the white squares that represented the houses. At last she would close the lids of her weary eyes, and see in the darkness the gas jets flaring in the wind and the steps of carriages lowered with much noise before the peristyles of theatres.

She took in La Corbeille, a lady's journal, and the Sylphe des Salons. She devoured, without skipping a word, all the accounts of first-nights, races, and soirées, took an interest in the début of a singer, in the opening of a new shop. She knew the latest fashions, the addresses of the best tailors, the right days for the Bois and the Opera. In Eugène Sue she studied descriptions of furniture; she read Balzac and George Sand, seeking imaginary satisfaction for her own desires. Even at table she had her book by her, and turned over the pages while Charles ate and talked to her. The memory of the Viscount always returned as she read. Between him and the imaginary personages she made comparisons. But the circle of which he was the centre gradually widened round him, and the aureole that he bore fading from his form, broadened out beyond, lighting up her other dreams.

Paris, something vaster than the ocean, glimmered before Emma's eyes in a rosy haze. The many lives that stirred amid this tumult were, however, divided into parts, classed as distinct pictures. Emma perceived

only two or three that hid from her all the rest, and in themselves represented all humanity. The world of ambassadors moved over polished floors in drawingrooms lined with mirrors, round oval tables covered with velvet and gold-fringed cloths. There were dresses with trains, deep mysteries, anguish hidden beneath smiles. Then came the society of the duchesses; all were pale; all got up at four o'clock; the women, poor angels, wore English point on their petticoats; and the men, unappreciated geniuses under a frivolous outward seeming, rode horses to death at pleasure parties, spent the summer season at Baden, and towards the forties married heiresses. In the private rooms of restaurants, where one sups after midnight by the light of wax candles, laughed the motley crowd of men of letters and actresses. They were prodigal as kings, full of ideal, ambitious, fantastic frenzy. This was an existence outside that of all others, between heaven and earth, in the midst of storms, having something of the sublime. For the rest of the world it was lost, with no particular place and as if nonexistent. The nearer things were, moreover, the more her thoughts turned away from them. All her immediate surroundings, the wearisome country, the middle-class imbeciles, the mediocrity of existence, seemed to her exceptional, a peculiar chance that had caught hold of her, while beyond stretched, as far as eye could see, an immense land of joys and passions. She confused in her desire the sensualities of luxury with the delights of the heart, elegance of manners with delicacy of sentiment. Did not love, like Indian plants, need a special soil, a particular temperature? Sighs by moonlight, long embraces, tears flowing over vielded hands, all the fevers of the flesh and the languors of tenderness could

not be separated from the balconies of great castles full of indolence, from boudoirs with silken curtains and thick carpets, well-filled flower-stands, a bed on a raised daïs, nor from the flashing of precious stones and the shoulder-knots of liveries.

The lad from the posting-house who came to groom the mare every morning passed through the passage with his heavy clogs; there were holes in his blouse; his feet were bare in list slippers. And this was the groom in knee-breeches with whom she had to be content! His work done, he did not come back again all day, for Charles on his return put up his horse himself, unsaddled him and put on the halter, while the servant-girl brought a bundle of straw and threw it as best she could into the manger.

To replace Nastasie (who left Tostes shedding torrents of tears) Emma took into her service a young girl of fourteen, an orphan with a sweet face. She forbade her wearing cotton caps, taught her to address her in the third person, to bring a glass of water on a plate, to knock before coming into a room, to iron, starch, and to dress her – wanted to make a lady's maid of her. The new servant obeyed without a murmur, so as not to be sent away; and as madame usually left the key in the sideboard, Félicité every evening took a small supply of sugar that she ate alone in bed after she had said her prayers.

Sometimes in the afternoon she went to chat with the postilions. Madame was in her room upstairs. She wore an open dressing-gown that showed between the shawl facings of her bodice a pleated chemisette with three gold buttons. Her belt was a corded girdle with great tassels, and her small garnet-coloured slippers had a large knot of ribbon that fell over her instep. She

had bought herself a blotting-book, writing-case, penholder, and envelopes, although she had no one to write to; she dusted her what-not, looked at herself in the glass, picked up a book, and then, dreaming between the lines, let it drop on her knees. She longed to travel or to go back to her convent. She wished at the same time to die and to live in Paris.

In snow and in rain Charles trotted across country. He ate omelettes on farmhouse tables, poked his arm into damp beds, received the tepid spurt of bloodlettings in his face, listened to death-rattles, examined basins, turned over a good deal of dirty linen; but every evening he found a blazing fire, his dinner ready, easy-chairs, and a well-dressed woman, charming with an odour of freshness, though one could not say whence the perfume came, or if it were not her skin that made odorous her chemise.

She charmed him by numerous attentions; now it was some new way of arranging paper sconces for the candles, a flounce that she altered on her gown, or an extraordinary name for some very simple dish that the servant had spoilt, but that Charles swallowed with pleasure to the last mouthful. At Rouen she saw some ladies who wore a bunch of charms on their watchchains; she bought some charms. She wanted two large blue glass vases for her mantelpiece, and some time after an ivory nécessaire with a silver-gilt thimble. The less Charles understood these refinements the more they seduced him. They added something to the pleasure of the senses and to the comfort of his fireside. It was like a golden dust sanding all along the narrow path of his life.

He was well, looked well; his reputation was firmly established. The country-folk loved him because he

was not proud. He petted the children, never went to the public-house, and, moreover, his morals inspired confidence. He was specially successful with catarrhs and chest complaints. Being much afraid of killing his patients, Charles, in fact, only prescribed sedatives, from time to time an emetic, a footbath, or leeches. It was not that he was afraid of surgery; he bled people copiously like horses, and for the taking out of teeth he had the 'devil's own wrist'.

Finally, to keep up with the times, he took in La Ruche Médicale, a new journal whose prospectus had been sent him. He read it a little after dinner, but in about five minutes the warmth of the room added to the effect of his dinner sent him to sleep; and there he sat, his chin on his two hands and his hair spreading like a mane to the foot of the lamp. Emma looked at him and shrugged her shoulders. Why, at least, was not her husband one of those men of taciturn passions who work at their books all night, and at last, when about sixty, the age of rheumatism sets in, wear a string of orders on their ill-fitting black coat? She could have wished this name of Bovary, which was hers, had been illustrious, to see it displayed at the booksellers', repeated in the newspapers, known to all France. But Charles had no ambition. An Yvetot doctor whom he had lately met in consultation had somewhat humiliated him at the very bedside of the patient, before the assembled relatives. When, in the evening, Charles told her this anecdote, Emma inveighed loudly against his colleague. Charles was much touched. He kissed her forehead with a tear in his eyes. But she was angered with shame; she felt a wild desire to strike him; she went to open the window in the passage and breathed in the fresh air to calm herself.

'What a poor fellow! what a poor fellow!' she murmured, biting her lips.

Besides, she was becoming more irritated with him. As he grew older his manner grew heavier; at dessert he cut the corks of the empty bottles; after eating he cleaned his teeth with his tongue; in taking soup he made a gurgling noise with every spoonful; and, as he was getting fatter, the puffed-out cheeks seemed to push the eyes, always small, up to the temples.

Sometimes Emma tucked the red borders of his under-vest into his waistcoat, rearranged his cravat, and threw away the dirty gloves he was going to put on; and this was not, as he fancied, for himself; it was for herself, by a diffusion of egotism, of nervous irritation. Sometimes, too, she told him of what she had read, such as a passage in a novel, of a new play, or an anecdote of the 'upper ten' that she had seen in a feuilleton; for, after all, Charles was something, an ever-open ear, an ever-ready approbation. She confided many a thing to her greyhound. She would have done so to the logs in the fireplace or to the pendulum of the clock.

Her inmost heart, however, was waiting for something to happen. Like shipwrecked sailors, she turned a despairing gaze over the solitude of her life, seeking some white sail in the far mists of the horizon. She did not know what this chance would be, what wind would bring it her, towards what shore it would drive her, if it would be a sloop or a three-decker, laden with anguish or crammed to the scuppers with bliss. But each morning, as she woke, she hoped it would come that day; she listened to every sound, sprang up with a start, wondered that it did not come; then at sunset, always more saddened, she longed for the morrow.

Spring came round. With the first warm weather, when the pear trees began to blossom, she suffered from dyspnoea.

From the beginning of July she counted how many weeks there were to October, thinking that perhaps the Marquis d'Andervilliers would give another ball at Vaubyessard. But all September passed without letters or visits.

After the ennui of this disappointment her heart once more remained empty, and then the same series of days recommenced. So now they would thus follow one another, always the same, immovable, and bringing nothing. Other lives, however flat, had at least the chance of some event. One adventure sometimes brought with it infinite consequences and the scene changed. But nothing happened to her; God had willed it so! The future was a dark corridor, with its door at the end shut fast.

She gave up music. What was the good of playing? Who would hear her? Since she could never, in a velvet gown with short sleeves, striking with her light fingers the ivory keys of an Erard at a concert, feel the murmur of ecstasy envelope her like a breeze, it was not worth while boring herself with practising. Her drawing cardboard and her embroidery she left in the cupboard. What was the good? What was the good? Sewing irritated her. 'I have read everything,' she said to herself. And she sat there making the tongs red-hot, or looked at the rain falling.

How sad she was on Sundays when vespers sounded! She listened with dull attention to each stroke of the cracked bell. A cat slowly walking over some roof put up his back in the pale rays of the sun. The wind on the highroad blew up clouds of dust.

Afar off a dog sometimes howled; and the bell, keeping time, continued its monotonous ringing that died away over the fields.

But the people came out from church. The women in waxed clogs, the peasants in new blouses, the little bareheaded children skipping along in front of them, all were going home. And till nightfall, five or six men, always the same, stayed playing at corks in front of the large door of the inn.

The winter was severe. The windows every morning were covered with rime, and the light shining through them, dim as through ground-glass, sometimes did not change the whole day long. At four o'clock the lamp had to be lighted.

On fine days she went down into the garden. The dew had left on the cabbages a silver lace with long, transparent threads spreading from one to the other. No birds were to be heard; everything seemed asleep, the espalier covered with straw, and the vine, like a great sick serpent under the coping of the wall, along which, on drawing near, one saw the many-footed woodlice crawling. Under the spruce by the hedgerow, the curé in the three-cornered hat reading his breviary had lost his right foot, and the very plaster, scaling off with the frost, had left white scabs on his face.

Then she went up again, shut her door, put on coals, and fainting with the heat of the hearth, felt her boredom weigh more heavily than ever. She would have liked to go down and talk to the servant, but a sense of shame restrained her.

Every day at the same time the schoolmaster in a black skullcap opened the shutters of his house, and the rural policeman, wearing his sabre over his blouse, passed by. Night and morning the post-horses, three by three, crossed the street to water at the pond. From time to time the bell of a public house door rang, and when it was windy one could hear the little brass basins that served as signs for the hairdresser's shop creaking on their two rods. As decoration this shop had an old engraving of a fashion-plate stuck against a windowpane and the wax bust of a woman with yellow hair. He, too, the hairdresser, lamented his wasted calling, his hopeless future, and dreamed of some shop in a big town - at Rouen, for example, overlooking the harbour, near the theatre - walking up and down all day from the mairie to the church, sombre and waiting for customers. When Madame Bovary looked up, she always saw him there, like a sentinel on duty, with his skullcap over his ears and his vest of lasting.

Sometimes in the afternoon, outside the window of her room, the head of a man appeared, a swarthy head with black whiskers, smiling slowly, with a broad, gentle smile that showed his white teeth. A waltz immediately began, and on the organ, in a little drawing-room, dancers the size of a finger, women in pink turbans, Tyrolians in jackets, monkeys in frockcoats, gentlemen in knee-breeches, turned and turned between the sofas, the consoles, multiplied in the bits of looking-glass held together at their corners by a piece of gold paper. The man turned his handle, looking to the right and left, and up at the windows. Now and again, while he shot out a long squirt of brown saliva against the milestone, with his knee he raised his instrument, whose hard straps tired his shoulder; and now, doleful and drawling, or gay and hurried, the music escaped from the box, droning through a curtain of pink taffeta under a brass claw in arabesque. They were airs played in other places at the theatre, sung in drawing-rooms, danced to at night under lighted lustres, echoes of the world that reached even to Emma. Through her head ran endless sarabands, and like an Indian dancing-girl on the flowers of a carpet, her thoughts leapt with the notes, swung from dream to dream, from sadness to sadness. When the man had caught some coppers in his cap, he drew down an old cover of blue cloth, hitched his organ on to his back, and went off with a heavy tread. She watched him going.

But it was above all the meal-times that were unbearable to her, in this small room on the ground-floor, with its smoking stove, its creaking door, the walls that sweated, the damp flags; all the bitterness in life seemed served up on her plate, and with the smoke of the boiled beef there rose from her secret soul whiffs of sickliness. Charles was a slow eater; she played with a few nuts, or, leaning on her elbow, amused herself with drawing lines along the oilcloth table-cover with the point of her knife.

She now let everything in her household take care of itself, and Madame Bovary, senior, when she came to spend part of Lent at Tostes, was much surprised at the change. She who was formerly so careful, so dainty, now passed whole days without dressing, wore grey cotton stockings, and burnt tallow candles. She kept saying they must be economical since they were not rich, adding that she was very contented, very happy, that Tostes pleased her very much, with other speeches that closed the mouth of her mother-in-law. Besides, Emma no longer seemed inclined to follow her advice; once even, Madame Bovary having thought fit to maintain that mistresses ought to keep

an eye on the religion of their servants, she had answered with so angry a look and so cold a smile that the good woman did not interfere again.

Emma was growing difficile, capricious. She ordered dishes for herself, then she did not touch them; one day drank only pure milk, and the next cups of tea by the dozen. Often she persisted in not going out, then, stifling, threw open the windows and put on light dresses. After she had well scolded her servant she gave her presents or sent her out to see neighbours, just as she sometimes threw beggars all the silver in her purse, although she was by no means tenderhearted or easily accessible to the feelings of others, like most country-bred people, who always retain in their souls something of the horny hardness of the paternal hands.

Towards the end of February old Rouault, as a memento of his cure, himself brought his son-in-law a superb turkey, and stayed three days at Tostes. Charles being with his patients, Emma kept him company. He smoked in the room, spat on the firedogs, talked farming, calves, cows, poultry, and municipal council, so that when he left she closed the door on him with a feeling of satisfaction that surprised even herself. Moreover she no longer concealed her contempt for anything or anybody, and at times she set herself to express singular opinions, finding fault with that which others approved, and approving things perverse and immoral, all of which made her husband open his eyes widely.

Would this misery last for ever? Would she never issue from it? Yet she was as good as all the women who were living happily. She had seen duchesses at Vaubyessard with clumsier waists and commoner ways, and she execrated the injustice of God. She

leant her head against the walls to weep; she envied lives of stir; longed for masked balls, for violent pleasures, with all the wildness that she did not know, but that these must surely yield.

She grew pale and suffered from palpitations of the heart. Charles prescribed valerian and camphor baths. Everything that was tried only seemed to irritate her the more.

On certain days she chattered with feverish rapidity, and this over-excitement was suddenly followed by a state of torpor, in which she remained without speaking, without moving. What then revived her was pouring a bottle of eau-de-cologne over her arms.

As she was constantly complaining about Tostes, Charles fancied that her illness was no doubt due to some local cause, and, fixing on this idea, began to think seriously of setting up elsewhere.

From that moment she drank vinegar, contracted a sharp little cough, and completely lost her appetite.

It cost Charles much to give up Tostes after living there four years and 'when he was beginning to get on there'. Yet if it must be! He took her to Rouen to see his old master. It was a nervous complaint: change of air was needed.

After looking about him on this side and on that, Charles learnt that in the Neufchâtel arrondissement there was a considerable market-town called Yonville-l'Abbaye, whose doctor, a Polish refugee, had decamped a week before. Then he wrote to the chemist of the place to ask the number of the population, the distance from the nearest doctor, what his predecessor had made a year, and so forth; and the answer being satisfactory, he made up his mind to move towards the spring, if Emma's health did not improve.

One day, when in view of her departure, she was tidying a drawer, something pricked her finger. It was a wire of her wedding-bouquet. The orange blossoms were yellow with dust and the silver-bordered satin ribbons frayed at the edges. She threw it into the fire. It flared up more quickly than dry straw. Then it was, like a red bush in the cinders, slowly devoured. She watched it burn. The little pasteboard berries burst, the wire twisted, the gold lace melted; and at the last the shrivelled paper corollas, fluttering like black butterflies at the back of the stove, flew up the chimney.

When they left Tostes in the month of March, Madame Bovary was pregnant. Several terms of the control of the

Trible to company of the series while works my the series of the series

PART TWO

Ι

Yonville-L'Abbaye (so called from an old Capuchin abbey of which not even the ruins remain) is a markettown twenty-four miles from Rouen, between the Abbeville and Beauvais roads, at the foot of a valley watered by the Rieule, a little river that runs into the Andelle after turning three water-mills near its mouth, where there are a few trout which the lads amuse themselves by fishing for on Sundays.

Leaving the highroad at La Boissière, one keeps straight on to the top of the Leux hill, whence the valley is seen. The river that runs through it makes of it, as it were, two regions with distinct physiognomies – all on the left is pasture land, all on the right arable. The meadow stretches under a bulge of low hills to join at the back with the pasture land of the Bray country, while on the eastern side, the plain, gently rising, broadens out, showing as far as eye can follow its blond cornfields. The water, flowing by the grass, divides with a white line the colour of the roads and of the plains, and the country is like a great unfolded mantle with a green velvet cape bordered with a fringe of silver.

Before us, on the verge of the horizon, lie the oaks of the forest of Argueil, with the steeps of the Saint-Jean hills scarred from top to bottom with red irregular lines; they are rain-tracks, and these brick-tones

standing out in narrow streaks against the grey colour of the mountain are due to the quality of iron springs that flow beyond in the neighbouring country.

Here we are on the confines of Normandy, Picardy, and the Ile-de-France, a bastard land, whose language is without accent as its landscape is without character. It is there that they make the worst Neufchâtel cheeses of all the arrondissement, and, moreover, farming is costly because so much manure is needed to enrich this friable sandy, flinty soil.

Up to 1835 there was no practicable road for getting to Yonville, but about this time a crossroad was made which joins that of Abbeville to that of Amiens, and is occasionally used by the Rouen wagoners on their way to Flanders. Yonville-l'Abbaye has remained stationary in spite of its 'new outlet'. Instead of improving the soil, they persist in keeping up the pasture lands, however depreciated they may be in value, and the lazy borough, growing away from the plain, has naturally spread riverwards. It is seen from afar sprawling along the banks like a cowherd taking a siesta by the waterside.

At the foot of the hill beyond the bridge begins a roadway, planted with young aspens, that leads in a straight line to the first houses in the place. These, fenced in by hedges, are in the middle of courtyards full of straggling buildings, winepresses, cart-sheds, and distilleries scattered under thick trees, with ladders, poles, or scythes hung on to the branches. The thatched roofs, like fur caps drawn over eyes, reach down over about a third of the low windows, whose coarse convex glasses have knots in the middle like the bottoms of bottles. Against the plaster wall diagonally crossed by black joists, a meagre pear tree sometimes

leans, and the ground-floors have at their door a small swing-gate, to keep out the chicks that come pilfering crumbs of bread steeped in cider on the threshold. But the courtyards grow narrower, the houses closer together, and the fences disappear; a bundle of ferns swings under a window from the end of a broomstick; there is a blacksmith's forge and then a wheelwright's, with two or three new carts outside partly blocking the way. Then across an open space appears a white house beyond a grass mound ornamented by a Cupid, finger on lips; two brass vases are at each end of a flight of steps; the gilt notary's plaques blaze upon the door. It is the notary's house, the finest in the place.

The church is on the other side of the street, twenty paces farther down, at the entrance of the square. The little cemetery that surrounds it, closed in by a wall breast high, is so full of graves that the old stones, level with the ground, form a continuous pavement, on which the grass of itself has marked out regular green squares. The church was rebuilt during the last years of the reign of Charles X. The wooden roof is beginning to rot from the top, and here and there has black hollows in its blue colour. Over the door, where the organ should be, is a loft for the men, with a spiral staircase that reverberates under their wooden shoes.

The daylight coming through the plain glass windows falls obliquely upon the pews ranged along the walls, which are adorned here and there with a straw mat bearing beneath it the words in large letters, 'Mr So-and-so's pew'. Farther on, at a spot where the building narrows, the confessional forms a pendant to a statuette of the Virgin, clothed in a satin robe, coifed with a tulle veil sprinkled with silver stars, and with red cheeks, like an idol of the Sandwich Islands; and,

finally, a copy of the "Holy Family", presented by the Minister of the Interior', overlooking the high altar, between four candlesticks, closes in the perspective. The choir stalls, of deal wood, have been left unpainted.

The market, that is to say, a tiled roof supported by some twenty posts, occupies of itself about half the public square of Yonville. The town hall, constructed 'from the designs of a Paris architect', is a sort of Greek temple that forms the corner next to the chemist's shop. On the ground-floor are three Ionic columns and on the first floor a semicircular gallery, while the dome that crowns it is occupied by a Gallic cock, resting one foot upon the Charter and holding the scales of Justice in the other.

But what chiefly attracts the eye is the chemist's shop of Monsieur Homais, opposite the Lion d'Or inn. In the evening especially its argand lamp is lit up and the red and green jars embellishing his shop-front throw their two streams of colour far across the street; then across them, as if with Bengal lights, is seen the shadow of the chemist leaning over his desk. His house from top to bottom is placarded with inscriptions written in large hand, round hand, printed hand: 'Vichy, Seltzer, Barège waters, blood purifiers, Raspail patent medicine, Arabian racahout, Darcet lozenges, Regnault paste, trusses, baths, hygienic chocolate', etc. And the signboard, which takes up all the breadth of the shop, bears in gold letters, 'Homais, Chemist'. Then at the back of the shop, behind the great scales fixed to the counter, the word 'Laboratory' appears on a scroll above a glass door, which about halfway up once more repeats 'Homais' in gold letters on a black ground.

Beyond this there is nothing to see at Yonville. The street (the only one) a gunshot in length and flanked by a few shops on either side stops short at the turn of the highroad. If it is left on the right hand and the foot of the Saint-Jean hills followed the cemetery is soon reached.

In order to enlarge this, at the time of the cholera, a piece of wall was pulled down, and three acres of land beside it purchased; but all the new portion is almost tenantless; the tombs, as heretofore, continue to crowd together towards the gate. The keeper, who is at once gravedigger and church beadle (thus making a double profit out of the parish corpses), has taken advantage of the unused plot of ground to plant potatoes there. From year to year, however, his small field grows smaller, and when there is an epidemic, he does not know whether to rejoice at the deaths or regret the burials.

'You get your daily bread from the dead, Lestiboudois!' the curé at last said to him one day. This grim remark made him reflect; it checked him for some time; but to this day he carries on the cultivation of his little tubers, and will even stoutly maintain that they grow naturally.

Since the events about to be narrated, nothing in fact has changed at Yonville. The tin tricolour flag still swings at the top of the church-steeple; the two chintz streamers still flutter in the wind from the linendraper's; the chemist's foetuses, like lumps of white amadou, rot more and more in their turbid alcohol, and above the big door of the inn the old golden lion, faded by rain, still shows passers-by its poodle mane.

On the evening when the Bovarys were to arrive at Yonville, Widow Lefrançois, the landlady of this inn, was so very busy that she sweated generously as she stirred her saucepans. Tomorrow was market-day. The meat had to be cut beforehand, fowls drawn, soup and coffee made. Moreover, she had the boarders' meal to see to, and that of the doctor, his wife, and their servant; the billiard-room was ringing with bursts of laughter; three millers in a small parlour were calling for brandy; the wood was blazing, the brazen pan was hissing, and on the long kitchen-table, amid the quarters of raw mutton, rose piles of plates that rattled with the shaking of the block on which spinach was being chopped. From the poultry-yard was heard the screaming of the fowls which the servant was chasing to wring their necks.

A man slightly marked with smallpox, in green leather slippers, and wearing a velvet cap with a gold tassel, was warming his back at the chimney. His face expressed nothing but self-satisfaction, and he appeared to take life as calmly as the goldfinch suspended over his head in its wicker cage: this was the chemist.

'Artémise!' shouted the landlady, 'chop some wood, fill the water bottles, bring some brandy, look sharp! If only I knew what dessert to offer the guests you are expecting! Good heavens! Those furniture-movers are beginning their racket in the billiard-room again; and their van has been left before the front door! The "Hirondelle" might run into it when it draws up. Call Polyte and tell him to put it up. Only think, Monsieur Homais, that since morning they have had about fifteen games, and drunk eight jars of cider! Why, they'll tear my cloth for me,' she went on, looking at them from a distance, her strainer in her hand.

'That wouldn't be much of a loss,' replied Monsieur Homais. 'You would buy another.'

'Another billiard-table!' exclaimed the widow.

'Since that one is coming to pieces, Madame Lefrançois. I tell you again you are doing yourself harm, much harm! And besides, players now want narrow pockets and heavy cues. Hazards arcn't played now; everything is changed! One must keep pace with the times! Just look at Tellier!'

The hostess reddened with vexation. The chemist went on – 'You may say what you like; his table is better than yours; and if one were to think, for example, of getting up a patriotic pool for Poland or the sufferers from the Lyons floods – '

'It isn't beggars like him that'll frighten us,' interrupted the landlady, shrugging her fat shoulders. 'Come, come, Monsieur Homais; as long as the Lion d'Or exists people will come to it. We've feathered our nest; while one of these days you'll find the Café Français closed, with a big placard on the shutters. Change my billiard-table!' she went on, speaking to herself, 'the table that comes in so handy for folding the washing, and which I have slept six visitors on in the shooting season! But that dawdler, Hivert, isn't here yet!'

'Are you waiting for him for your gentlemen's dinner?'

'Wait for him! And what about Monsieur Binet? As the clock strikes six you'll see him come in, for he hasn't his equal under the sun for punctuality. He must always have his seat in the small parlour. He'd rather die than dine anywhere else. And so squeamish he is, and so particular about the cider! Not like Monsieur Léon: he sometimes comes at seven, or even half-past, and he doesn't so much as look at what he eats. Such a nice young man! Never speaks a rough word!'

'Well, you see, there's a great difference between an educated man and an old carabineer who is now a tax-collector.

Six o'clock struck. Binet came in.

He wore a blue frock-coat falling in a straight line round his thin body, and his leather cap, with its lappets knotted over the top of his head with string, showed under the turned-up peak a bald forehead, flattened by the constant wearing of a helmet. He wore a black cloth waistcoat, a hair collar, grey trousers, and, all the year round, well-blacked boots, that had two parallel swellings due to the sticking out of his big toes. Not a hair stood out from the regular line of fair whiskers, which, encircling his jaws, framed, after the fashion of a garden border, his long, wan face, whose eyes were small and the nose hooked. Clever at all games of cards, a good sportsman with the gun, and writing a fine hand, he had a lathe at home, and amused himself by turning napkin-rings, with which he cluttered up his house, with all the jealousy of an artist and the egotism of a bourgeois.

He went to the small parlour, but the three millers had to be got out first, and during the whole time necessary for laying the cloth, Binet remained silent in his place near the stove. Then he shut the door and took off his cap in his usual way.

'It isn't with saying civil things that he'll wear out his tongue,' said the chemist, as soon as he was alone with the landlady.

'He never talks more,' she replied. 'Last week two travellers in the cloth line were here – such clever chaps, who told such jokes in the evening, that I fairly cried with laughing; and he stood there like a dab fish and never said a word.'

'Yes,' observed the chemist; 'no imagination, no sallies, nothing that makes the society-man.'

'Yet they say he has parts,' objected the landlady.

'Parts!' replied Monsieur Homais; 'he parts! In his own line it is possible,' he added in a calmer tone. And he went on—'Ah! that a merchant, who has large connections, a jurisconsult, a doctor, a chemist, should be thus absent-minded, that they should become whimsical or even peevish, I can understand; such cases are cited in history. But at least it is because they are thinking of something. Myself, for example, how often has it happened to me to look on the bureau for my pen to write a label, and to find, after all, that I had put it behind my ear?'

Madame Lefrançois just then went to the door to see if the 'Hirondelle' were not coming. She started. A man dressed in black suddenly came into the kitchen. By the last gleam of the twilight one could see that his face was rubicund and his form athletic.

'What can I do for you, Monsieur le Curé?' asked the landlady, as she reached down from the chimney one of the copper candlesticks placed with their candles in a row. 'Will you take something? A thimbleful of Cassis? A glass of wine?'

The priest declined very politely. He had come for his umbrella, that he had forgotten the other day at the Ernemont convent, and after asking Madame Lefrançois to have it sent to him at the presbytery in the evening, he left for the church, from which the Angelus was ringing.

When the chemist no longer heard the noise of his boots along the square, he thought the priest's behaviour just now very unbecoming. This refusal to take any refreshment seemed to him the most odious hypocrisy; all priests tippled on the sly, and were trying to bring back the days of the tithe.

The landlady took up the defence of her curé.

'Besides, he could double up four men like you over his knee. Last year he helped our people to bring in the straw; he carried as many as six trusses at once, he is so strong.'

'Bravo!' said the chemist. 'Now just send your daughters to confess to fellows with such a temperament! I, if I were the Government, I'd have the priests bled once a month. Yes, Madame Lefrançois, every month – a good phlebotomy – in the interests of the police and morals.'

'Be quiet, Monsieur Homais. You are an infidel; you've no religion.'

The chemist answered: 'I have a religion, my religion, and I even have more than all these others with their mummeries and their juggling. I adore God, on the contrary. I believe in the Supreme Being, in a Creator, whatever he may be. I care little who has placed us here below to fulfil our duties as citizens and fathers of families; but I don't need to go to church to kiss silver-plates, and fatten, out of my pocket, a lot of for-nothings who live better than we do. For one can know him as well in a wood, in a field, or even contemplating the eternal vault like the ancients. My God! mine is the God of Socrates, of Franklin, of Voltaire, and of Béranger! I am for the profession of faith of the "Savoyard Vicar," and the immortal principles of '89! And I can't admit of an old boy of a God who takes walks in his garden with a cane in his hand, lodges his friends in the belly of whales, dies uttering a cry, and rises again at the end of three days; things absurd in themselves, and

completely opposed, moreover, to all physical laws, which proves to us, by the way, that priests have always wallowed in turbid ignorance, in which they would fain engulf the people with them.'

He ceased, looking round for an audience, for in his bubbling over the chemist had for a moment fancied himself in the midst of the town council. But the landlady no longer heeded him; she was listening to a distant rolling. One could distinguish the noise of a carriage mingled with the clattering of loose horseshoes that beat against the ground, and at last the 'Hirondelle' stopped at the door.

A great yellow box on two large wheels, which, reaching to the tilt, prevented travellers from seeing the road and dirtied their shoulders. The small panes of the narrow windows rattled in their sashes when the coach was closed, and retained here and there patches of mud amid the old layers of dust, that not even storms of rain had altogether washed away. It was drawn by three horses, the first a leader, and when it came downhill its bottom jolted against the ground.

Some of the inhabitants of Yonville came out into the square; they all spoke at once, asking for news, for explanations, for hampers. Hivert did not know whom to answer. It was he who did the errands of the place in town. He went to the shops and brought back rolls of leather for the shoemaker, old iron for the farrier, a barrel of herrings for his mistress, caps from the milliner's, locks from the hairdresser's, and all along the road on his return journey he distributed his parcels, which he threw, standing upright on his seat and shouting at the top of his voice, over the enclosures of the yards.

An accident had delayed him. Madame Bovary's

greyhound had run across the field. They had whistled for him a quarter of an hour; Hivert had even gone back a mile and a half expecting every moment to catch sight of her; but it had been necessary to go on. Emma had wept, grown angry; she had accused Charles of this misfortune. Monsieur Lheureux, a draper, who happened to be in the coach with her, had tried to console her by a number of examples of lost dogs recognising their masters at the end of long years. One, he said, had been told of, who had come back to Paris from Constantinople. Another had gone one hundred and fifty miles in a straight line, and swum four rivers; and his own father had possessed a poodle, which, after twelve years of absence, had all of a sudden jumped on his back in the street as he was going to dine in town.

Emma got out first, then Félicité, Monsieur Lheureux, and a nurse, and they had to wake up Charles in his corner, where he had slept soundly since night set in.

Homais introduced himself; he offered his homages to madame and his respects to monsieur; said he was charmed to have been able to render them some slight service, and added with a cordial air that he had ventured to invite himself, his wife being away.

When Madame Bovary was in the kitchen she went up to the chimney. With the tips of her fingers she caught her dress at the knee, and having thus pulled it up to her ankle, held out her foot in its black boot to the fire above the revolving leg of mutton. The flame lit up the whole of her, penetrating with a crude light the woof of her gowns, the fine pores of her fair skin, and even her eyelids, which she blinked now and again. A great red glow passed over her with the blowing of the wind through the half-open door. On the other side of the chimney a young man with fair hair watched her silently.

As he was a good deal bored at Yonville, where he was a clerk at the notary's, Monsieur Guillaumin, Monsieur Léon Dupuis (it was he who was the second habitué of the Lion d'Or) frequently put back his dinner-hour in the hope that some traveller might come to the inn, with whom he could chat in the evening. On the days when his work was done early, he had, for want of something else to do, to come punctually, and endure from soup to cheese a tête-à-

tête with Binet. It was therefore with delight that he accepted the landlady's suggestion that he should dine in company with the new-comers, and they passed into the large parlour where Madame Lefrancois, for the purpose of showing off, had had the table laid for four.

Homais asked to be allowed to keep on his skullcap, for fear of coryza; then, turning to his neighbour – 'Madame is no doubt a little fatigued; one gets jolted so abominably in our "Hirondelle".'

'That is true,' replied Emma; 'but moving about always amuses me. I like change of place.'

'It is so tedious,' sighed the clerk, 'to be always riveted to the same places.'

'If you were like me,' said Charles, 'constantly obliged to be in the saddle -'

'But,' Léon went on, addressing himself to Madame Bovary, 'nothing, it seems to me, is more pleasant – when one can,' he added.

'Moreover,' said the druggist, 'the practice of medicine is not very hard work in our part of the world, for the state of our roads allows us the use of gigs, and generally, as the farmers are prosperous, they pay pretty well. We have, medically speaking, besides the ordinary cases of enteritis, bronchitis, bilious affections, etc., now and then a few intermittent fevers at harvest-time; but, on the whole, little of a serious nature, nothing special to note, unless it be a great deal of scrofula, due, no doubt, to the deplorable hygienic conditions of our peasant dwellings. Ah! you will find many prejudices to combat, Monsieur Bovary, much obstinacy of routine, with which all the efforts of your science will daily come into collision; for people still have recourse to novenas, to relics, to the priest, rather than come straight to the doctor or the chemist. The climate, however, is not, truth to tell, bad, and we even have a few nonagenarians in our parish. The thermometer (I have made some observations) falls in winter to 4 degrees, and in the hottest season rises to 25 or 30 degrees Centrigade at the outside, which gives us 24 degrees Réaumur as the maximum, or otherwise 54 degrees Fahrenheit (English scale), not more. And, as a matter of fact, we are sheltered from the north winds by the forest of Argueil on the one side, from the west winds by the St Jean range on the other; and this heat, moreover, which on account of the aqueous vapours given off by the river and the considerable number of cattle in the fields, which, as you know, exhale much ammonia, that is to say, nitrogen, hydrogen, and oxygen (no, nitrogen and hydrogen alone), and which sucking up into itself the humus from the ground, mixing together all those different emanations, unites them into a stack, so to say, and combining with the electricity diffused through the atmosphere, when there is any, might in the long run, as in tropical countries, engender insalubrious miasmata, - this heat, I say, finds itself perfectly tempered on the side whence it comes, or rather whence it should come - that is to say, the southern side - by the southeastern winds, which, having cooled themselves passing over the Seine, reach us sometimes all at once like breezes from Russia.'

'But I suppose you have some walks in the neighbourhood?' continued Madame Bovary, addressing the young man.

'Oh, very few,' he answered. 'There is a place they call La Pâture, on the top of the hill, on the edge of the forest. Sometimes, on Sundays, I go and stay there with a book, watching the sunset.'

'I think there is nothing so admirable as sunsets,' she resumed; 'but especially by the side of the sea.'

'Oh, I adore the sea!' said Monsieur Léon.

'Then do you not think,' continued Madame Bovary, 'that the mind travels more freely on this limitless expanse, the contemplation of which elevates the soul and gives ideas of the infinite, the ideal?'

'It is the same with mountainous landscapes,' continued Léon. 'A cousin of mine who travelled in Switzerland last year told me that one could not conceive the poetry of the lakes, the charm of the waterfalls, the gigantic effect of the glaciers. One sees pines of incredible size hanging over torrents, cottages suspended over precipices, and, when the clouds open, whole valleys a thousand feet below. Such spectacles must stir one to enthusiasm, incline one to prayer, or ecstasy; and I no longer marvel at that celebrated musician who, the better to inspire his imagination, was in the habit of playing the piano before some imposing site.'

'You play?' she asked.

'No, but I am very fond of music,' he replied.

'Ah! don't you listen to him, Madame Bovary,' interrupted Homais, bending over his plate. 'That's sheer modesty. Why, my dear fellow, the other day in your room you were singing "L'Ange Gardien" ravishingly. I heard you from the laboratory. You gave it like an actor.'

Léon, in fact, lodged at the chemist's, where he had a small room on the second floor, overlooking the Place. He blushed at the compliment of his landlord, who had already turned to the doctor, and was enumerating to him, one after the other, all the principal inhabitants of Yonville. He was telling

anecdotes, giving information; the fortune of the notary was not known exactly, and 'there was the Tuvache household', who made a good deal of show.

Emma continued, 'And what music do you prefer?'
'Oh, German music; the music that makes you dream.'

'Have you been to the opera?'

'Not yet; but I shall go next year, when I am living at Paris to finish reading for the bar.'

'As I had the honour of putting it to your husband,' said the chemist, 'with regard to this poor Yanoda who has run away, you will find yourself, thanks to his extravagance, in the possession of one of the most comfortable houses of Yonville. Its greatest convenience for a doctor is a door giving on the Walk, where one can go in and out unseen. Moreover, it contains everything that is agreeable in a household—a laundry, kitchen with offices, sitting-room, fruitroom, etc. He was a gay dog, who didn't care what he spent. At the end of the garden, by the side of the water, he had an arbour built just for the purpose of drinking beer in summer; and if madame is fond of gardening she will be able—'

'My wife doesn't care about it,' said Charles; 'although she has been advised to take exercise, she prefers always sitting in her room reading.'

'Like me,' replied Léon. 'And indeed, what is better than to sit by one's fireside in the evening with a book, while the wind beats against the window and the lamp is burning?'

'What, indeed?' she said, fixing her large black eyes wide open upon him.

'One thinks of nothing,' he continued; 'the hours slip by. Motionless we traverse countries we fancy we

see, and your thought, blending with the fiction, playing with the details, follows the outline of the adventures. It mingles with the characters, and it seems as if it were yourself palpitating beneath their costumes.'

'That is true! that is true!' she said.

'Has it ever happened to you,' Léon went on, 'to come across some vague idea of one's own in a book, some dim image that comes back to you from afar, and as the completest expression of your own slightest sentiment?'

'I have experienced that,' she replied.

'That is why I especially love the poets,' he said. 'I think verse more tender than prose, and that it moves far more easily to tears.'

'Still it is tiring, in the long run,' continued Emma. 'Now I, on the contrary, adore stories that rush breathlessly along, and frighten one. I detest commonplace heroes and moderate sentiments, such as there are in nature.'

'In fact,' observed the clerk, 'these works, not touching the heart, miss, it seems to me, the true end of art. It is so sweet, amid all the disenchantments of life, to be able to dwell in thought upon noble characters, pure affections, and pictures of happiness. For myself, living here far from the world, this is my one distraction; but Yonville affords so few resources.'

'Like Tostes, no doubt,' replied Emma; 'and so I always subscribed to a lending library.'

'If madame will do me the honour of making use of it,' said the chemist, who had just caught the last words, 'I have at her disposal a library composed of the best authors, Voltaire, Rousseau, Delille, Walter Scott, the *Echo des Feuilletons*; and in addition I receive

various periodicals, among them the Fanal de Rouen daily, having the advantage to be its correspondent for the districts of Buchy, Forges, Neufchâtel, Yonville, and vicinity.'

For two hours and a half they had been at table; for the servant Artémise, carelessly dragging her old list slippers over the flags, brought one plate after the other, forgot everything, and constantly left the door of the billiard-room half open, so that it beat against the wall with its hooks.

Unconsciously, Léon, while talking, had placed his foot on one of the bars of the chair on which Madame Bovary was sitting. She wore a small blue silk necktie, that kept up like a ruff a gauffered cambric collar, and with the movements of her head the lower part of her face gently sunk into the linen or came out from it. Thus side by side, while Charles and the chemist chatted, they entered into one of those vague conversations where the hazard of all that is said brings you back to the fixed centre of a common sympathy. The Paris theatres, titles of novels, new quadrilles, and the world they did not know; Tostes, where she had lived, and Yonville, where they were; they examined all, talked of everything till to the end of dinner.

When coffee was served Félicité went away to get ready the room in the new house, and the guests soon raised the siege. Madame Lefrançois was asleep near the cinders, while the stable-boy, lantern in hand, was waiting to show Monsieur and Madame Bovary the way home. Bits of straw stuck in his red hair, and he limped with his left leg. When he had taken in his other hand the curé's umbrella, they started.

The town was asleep; the pillars of the market threw great shadows; the earth was all grey as on a summer's

night. But as the doctor's house was only some fifty paces from the inn, they had to say night almost immediately and the company dispersed.

As soon as she entered the passage, Emma felt the cold of the plaster fall about her shoulders like damp linen. The walls were new and the wooden stairs creaked. In their bedroom, on the first floor, a whitish light passed through the curtainless windows. She could catch glimpses of treetops, and beyond, the fields, half-drowned in the fog that lay reeking in the moonlight along the course of the river. In the middle of the room, pell-mell, were scattered drawers, bottles, curtain-rods, gilt poles, with mattresses on the chairs and basins on the ground, – the two men who had brought the furniture had left everything about carelessly.

This was the fourth time that she had slept in a strange place. The first was the day of her going to the convent; the second, of her arrival at Tostes; the third, at Vaubyessard; and this was the fourth. And each one had marked, as it were, the inauguration of a new phase in her life. She did not believe that things could present themselves in the same way in different places, and since the portion of her life lived had been bad, no doubt that which remained to be lived would be better.

Next day, when getting up, she saw the clerk on the Place. She had on a dressing-gown. He looked up and bowed. Nodding quickly, she closed the window again.

Léon waited all day for six o'clock in the evening to come, but on going to the inn, he found no one but Monsieur Binet, already at table. The dinner of the evening before had been a considerable event for him; he had never till then talked for two hours consecutively to a 'lady'. How then had he been able to explain, and in such language, the number of things that he could not have said so well before? He was usually shy, and maintained that reserve which partakes at once of modesty and dissimulation. At Yonville he was considered 'well-bred'. He listened to the arguments of the older people, and did not seem hot about politics - a remarkable thing for a young man. Then he had some accomplishments; he painted in watercolours, could read music in the key of G, and readily talked literature after dinner when he did not play cards. Monsieur Homais respected him for his education; Madame Homais liked him for his nature, for he often took the little Homais into the garden - little brats who were always dirty, very much spoilt, and somewhat lymphatic, like their mother. Besides the servant to look after them, they had Justin, the chemist's apprentice, a second cousin of Monsieur Homais, who had been taken into the house from charity, and who was useful at the same time as a servant.

The druggist proved the best of neighbours. He gave Madame Bovary information as to the tradespeople, sent expressly for his own cider merchant, tasted the drink himself, and saw that the casks were properly placed in the cellar; he explained how to set about getting in a supply of butter cheap, and made an arrangement with Lestiboudois, the sacristan, who, besides his sacerdotal and funeral functions, looked after the principal gardens at Yonville by the hour or the year, according to the taste of the customers.

The need of looking after others was not the only thing that urged the chemist to such obsequious cordiality; there was a plan underneath it all.

He had infringed the law of the 19th Ventôse, year XI, article I, which forbade all persons not having a diploma to practise medicine; so that, after certain anonymous denunciations, Homais had been summoned to Rouen to see the Procureur du Roi in his own private room; the magistrate receiving him standing up, ermine on shoulder and cap on head. It was in the morning, before the court opened. In the corridors one heard the heavy boots of the gendarmes walking past, and like a far-off noise great locks that were shut. The druggist's ears tingled as if he were about to have an apoplectic stroke; he had visions of the depths of dungeons, his family in tears, his shop sold, all the jars dispersed; and he was forced to enter a café and take a glass of rum and seltzer to recover his spirits.

Little by little the memory of this reprimand grew fainter, and he continued, as heretofore, to give anodyne consultations in his back-parlour. But the mayor resented it, his colleagues were jealous, everything was to be feared; to win Monsieur Bovary by his attentions

was to earn his gratitude, and prevent his speaking out later on, should he notice anything. So every morning Homais brought him 'the paper', and often in the afternoon left his shop for a few moments to have a chat with the Doctor.

Charles was gloomy: patients did not come. He remained seated for hours without speaking, went into his consulting-room to sleep, or watched his wife sewing. Then for diversion he employed himself at home as a workman; he even tried to do up the attic with some paint which had been left behind by the painters. But money matters worried him. He had spent so much for repairs at Tostes, for madame's toilette, and for the moving, that the whole dowry, over three thousand crowns, had slipped away in two years. Then how many things had been spoilt or lost during their carriage from Tostes to Yonville, without counting the plaster curé, who, falling out of the coach at an over-severe jolt, had been dashed into a thousand fragments on the payement of Quincampoix!

A pleasanter trouble came to distract him, namely, the pregnancy of his wife. As the time of her confinement approached he cherished her the more. It was another bond of the flesh establishing itself, and, as it were, a continuous sentiment of a more complex union. When from afar he saw her languid walk, and her figure without stays turning softly on her hips; when he looked over towards her at his ease, as she sat limply in her armchair, then his happiness knew no bounds; he rose and embraced her, passed his hands over her face, called her little mamma, wanted to make her dance, and, half-laughing, half-crying, uttered all kinds of caressing pleasantries that came into his head. The idea of having begotten a child

delighted him. Now he wanted nothing. He knew human life from end to end, and he sat down to it with serenity.

Emma at first felt a great astonishment; then was anxious to be delivered that she might know what it was to be a mother. But not being able to spend as much as she would have liked, to have a swing-bassinette with rose silk curtains, and embroidered caps, in a fit of bitterness she gave up looking after the trousseau, and ordered the whole of it from a village needlewoman, without choosing or discussing anything. Thus she did not amuse herself with those preparations that stimulate the tenderness of mothers – so her affection was from the very outset, perhaps, to some extent attenuated.

As Charles, however, spoke of the boy at every meal, she soon began to think of him more consecutively.

She hoped for a son; he would be strong and dark; she would call him George; and this idea of having a male child was like an expected revenge for all her impotence in the past. A man, at least, is free; he may travel over passions and over countries, overcome obstacles, taste of the most far-away pleasures. But a woman is always hampered. At once inert and flexible, she has against her the weakness of the flesh and legal dependence. Her will, like the veil of her bonnet, held by a string, flutters in every wind; there is always some desire pulling at her, some conventionality holding her back

She was delivered of the child on a Sunday about six o'clock, as the sun was rising.

'It is a girl!' said Charles.

She turned away her head and fainted.

Madame Homais, as well as Madame Lefrançois of

the Lion d'Or, almost immediately came running in to embrace her. The chemist, as a man of discretion, only offered a few provisional felicitations through the halfopened door. He wished to see the child and thought it well made.

Whilst she was getting well she occupied herself much in seeking a name for her daughter. First she went over all those that have Italian endings, such as Clara, Louisa, Amanda, Atala; she liked Galsuinde pretty well, and Yseult or Léocadie still better. Charles wanted the child to be called after her mother; Emma opposed this. They ran over the calendar from end to end, and then consulted outsiders.

'Monsieur Léon,' said the chemist, 'with whom I was talking about it the other day, wonders you do not choose Madeleine. It is very much in fashion just now.'

But Madame Boyary, senior, cried out loudly against this name of a sinner. As to Monsieur Homais, he had a preference for all those that recalled some great man, an illustrious fact, or a generous idea and it was on this system that he had baptised his four children. Thus Napoleon represented glory and Franklin liberty; Irma was perhaps a concession to romanticism, but Athalie was a homage to the greatest masterpiece of the French stage. For his philosophical convictions did not interfere with his artistic tastes; in him the thinker did not stifle the man of sentiment; he could make distinctions, make allowances for imagination and fanaticism. In this tragedy, for example, he found fault with the ideas, but admired the style; he detested the conception, but applauded all the details, and loathed the characters while he grew enthusiastic over their dialogue. When he read the fine passages he was transported, but when he thought that mummers would get something out of

them for their show, he was disconsolate; and in this confusion of sentiments in which he was involved he would have liked at once to crown Racine with both his hands and discuss with him for a good quarter of an hour.

At last Emma remembered that at the château of Vaubvessard she had heard the Marchioness call a young lady Berthe; from that moment this name was chosen; and as old Rouault could not come, Monsieur Homais was requested to stand godfather. His gifts were all products from his establishment, to wit: six boxes of jujubes, a whole jar of racahout, three cakes of marshmallow paste, and six sticks of sugar-candy into the bargain that he had come across in a cupboard. On the evening of the ceremony there was a grand dinner; the curé was present; there was much excitement. Monsieur Homais towards liqueur-time began singing 'Le Dieu des bonnes gens'. Monsieur Léon sang a barcarolle, and Madame Bovary, senior, who was godmother, a romance of the Empire period; finally M. Bovary, senior, insisted on having the child brought down, and began baptising it with a glass of champagne which he poured over its head. This mockery of the first of the sacraments angered the Abbé Bournisien; old Bovary replied by a quotation from La Guerre des Dieux; the curé wanted to leave; the ladies implored, Homais interfered; and they succeeded in making the priest sit down again, and he quietly went on with the half-finished coffee in his saucer.

Monsieur Bovary, senior, stayed at Yonville a month, dazzling the natives by a superb policeman's cap with silver tassels that he wore in the morning when he smoked his pipe in the square. Being also in the habit of drinking a good deal of brandy, he often

sent the servant to the Lion d'Or to buy him a bottle, which was put down to his son's account, and to perfume his handkerchiefs he used up his daughter-in-law's whole supply of eau-de-Cologne.

The latter did not at all dislike his company. He had knocked about the world, he talked about Berlin, Vienna, and Strasbourg, of his soldier times, of the mistresses he had had, the grand luncheons of which he had partaken; then he was amiable, and sometimes even, either on the stairs, or in the garden, would seize hold of her waist, crying, 'Charles, look out for yourself.'

Then Madame Bovary, senior, became alarmed for her son's happiness, and fearing that her husband might in the long-run have an immoral influence upon the ideas of the young woman, took care to hurry their departure. Perhaps she had more serious reasons for uneasiness. Monsieur Bovary was not the man to respect anything.

One day Emma was suddenly seized with the desire to see her little girl, who had been put to nurse with the carpenter's wife, and, without looking at the calendar to see whether the six weeks of the Virgin were yet passed, she set out for the Rollets' house, situated at the extreme end of the village, between the highroad and the fields.

It was midday, the shutters of the houses were closed, and the slate roofs glittering beneath the fierce light of the blue sky seemed to strike sparks from the crests of their gables. A heavy wind was blowing; Emma felt weak as she walked; the stones of the pavement hurt her; she was doubtful whether she would not go home again, or go in somewhere to rest.

At this moment Monsieur Léon came out from a

neighbouring door with a bundle of papers under his arm. He came to greet her, and stood in the shade in front of Lheureux's shop under the projecting grey awning.

Madame Bovary said she was going to see her baby, but that she was beginning to grow tired.

'If - ' said Léon, not daring to go on.

'Have you any business to attend to?' she asked.

And on the clerk's answer, she begged him to accompany her. That same evening this was known in Yonville, and Madame Tuvache, the mayor's wife, declared in the presence of her servant that 'Madame Bovary was compromising herself.'

To get to the nurse's it was necessary to turn to the left on leaving the street, as if making for the cemetery, and to follow between little houses and yards a small path bordered with privet hedges. They were in bloom, and so were the speedwells, eglantines, thistles, and the sweetbriar that sprang up from the thickets. Through openings in the hedges one could see into the huts, some pigs on a dung-heap, or tethered cows rubbing their horns against the trunk of trees. The two, side by side, walked slowly, she leaning upon him, and he restraining his pace, which he regulated by hers; in front of them a swarm of midges fluttered, buzzing in the warm air.

They recognised the house by an old walnut tree which shaded it. Low and covered with brown tiles, there hung outside it, beneath the dormer-window of the garret, a string of onions. Faggots upright against a thorn fence surrounded a bed of lettuce, a few square feet of lavender, and sweet peas strung on sticks. Dirty water was running here and there on the grass, and all round were several indefinite rags, knitted stockings, a

red calico jacket, and a large sheet of coarse linen spread over the hedge. At the noise of the gate the nurse appeared with a baby she was suckling on one arm. With her other hand she was pulling along a poor puny little fellow, his face covered with scrofula, the son of a Rouen hosier, whom his parents, too taken up with their business, left in the country.

'Go in,' she said; 'your little one is there asleep.'

The room on the ground-floor, the only one in the dwelling, had at its farther end, against the wall, a large bed without curtains, while a kneading-trough took up the side by the window, one pane of which was mended with a piece of blue paper. In the corner behind the door, shining hobnailed shoes stood in a row under the slab of the washstand, near a bottle of oil with a feather stuck in its mouth; a *Mathieu Laensberg* lay on the dusty mantelpiece amid gunflints, candle-ends, and bits of amadou. Finally, the last luxury in the apartment was a 'Fame' blowing her trumpets, a picture cut out, no doubt, from some perfumer's prospectus and nailed to the wall with six wooden shoe-pegs.

Emma's child was asleep in a wicker-cradle. She took it up in the wrapping that enveloped it and began singing softly as she rocked herself to and fro.

Léon walked up and down the room; it seemed strange to him to see this beautiful woman in her nankeen dress in the midst of all this poverty. Madame Bovary reddened; he turned away, thinking perhaps there had been an impertinent look in his eyes. Then she put back the little girl, who had just been sick over her collar. The nurse at once came to dry her, protesting that it wouldn't show.

'She gives me other doses,' she said: 'I am always

a-washing of her. If you would have the goodness to order Camus, the grocer, to let me have a little soap, it would really be more convenient for you, as I needn't trouble you then.'

'Very well! very well!' said Emma. 'morning, Madame Rollet,' and she went out, wiping her shoes at the door.

The good woman accompanied her to the end of the garden, talking all the time of the trouble she had getting up of nights.

'I'm that worn out sometimes as I drop asleep on my chair. I'm sure you might at least give me just a pound of ground coffee; that'd last me a month, and I'd take it of a morning with some milk.'

After having submitted to her thanks, Madame Bovary left. She had gone a little way down the path when, at the sound of wooden shoes, she turned round. It was the nurse.

'What is it?'

Then the peasant woman, taking her aside behind an elm tree, began talking to her of her husband, who with his trade and six francs a year that the captain – 'Oh, come to the point!' said Emma.

'Well,' the nurse went on, heaving sighs between each word, 'I'm afraid he'll be put out seeing me have coffee alone, you know men – '

'But you are to have some,' Emma repeated; 'I will give you some. You bother me!'

'Oh, dear! my poor, dear lady! you see, in consequence of his wounds he has terrible cramps in the chest. He even says that cider weakens him.'

'Do make haste, Mére Rollet!'

'Well,' the latter continued, making a curtsey, 'if it weren't asking too much,' and she curtsied once more,

'if you would' – and her eyes begged – 'a jar of brandy,' she said at last, 'and I'd rub your little one's feet with it; they're as tender as one's tongue.'

Once rid of the nurse, Emma again took Monsieur Léon's arm. She walked fast for some time, then more slowly, and looking straight in front of her, her eyes rested on the shoulder of the young man, whose frock-coat had a black-velvet collar. His brown hair fell over it, straight and carefully arranged. She noticed his nails which were longer than one wore them at Yonville. It was one of the clerk's chief occupations to trim them, and for this purpose he kept a special knife in his writing-desk.

They returned to Yonville by the waterside. In the warm season the bank, wider than at other times, showed to their foot the garden wells whence a few steps led to the river. It flowed noiselessly, swift, and cold to the eye; long, thin grasses huddled together in it as the current drove them, and spread themselves upon the limpid water like streaming hair; sometimes at the top of the reeds or on the leaf of a water-lily an insect with fine legs crawled or rested. The sun pierced with a ray the small blue bubbles of the waves that, breaking, followed each other; branchless old willows mirrored their grey backs in the water; beyond, all around, the meadows seemed empty. It was the dinner hour at the farms, and the young woman and her companion heard nothing as they walked but the fall of their steps on the earth of the path, the words they spoke, and the sound of Emma's dress rustling round her

The walls of the gardens with pieces of bottle on their coping were hot as the glass windows of a conservatory. Wallflowers had sprung up between the

bricks, and with the tip of her open sunshade Madame Bovary, as she passed, made some of their faded flowers crumble into a yellow dust, or a spray of overhanging honeysuckle and clematis caught in its fringe and dangled for a moment over the silk.

They were talking of a troupe of Spanish dancers who were expected shortly at the Rouen theatre.

'Are you going?' she asked.

'If I can,' he answered.

Had they nothing else to say to one another? Yet their eyes were full of more serious speech, and while they forced themselves to find trivial phrases, they felt the same languor stealing over them both. It was the whisper of the soul, deep, continuous, dominating that of their voices. Surprised with wonder at this strange sweetness, they did not think of speaking of the sensation or of seeking its cause. Coming joys, like tropical shores, throw over the immensity before them their inborn softness, an odorous wind, and we are lulled by this intoxication without a thought of the horizon that we do not even know.

In one place the ground had been trodden down by the cattle; they had to step on large green stones put here and there in the mud. She often stopped a moment to look where to place her foot, and tottering on the stone that shook, her arms outspread, her form bent forward with a look of indecision, she would laugh, afraid of falling into the puddles of water.

When they arrived in front of her garden, Madame Bovary opened the little gate, ran up the steps and disappeared.

Léon returned to his office. His chief was away; he just glanced at the briefs, then cut himself a pen, and at last took up his hat and went out.

He went to La Pâture at the top of the Argueil hills at the beginning of the forest; he threw himself upon the ground under the pines and watched the sky through his fingers.

'How bored I am!' he said to himself, 'how bored I am!'

He thought he was to be pitied for living in this village, with Homais for a friend and Monsieur Guillaumin for master. The latter, entirely absorbed by his business, wearing gold-rimmed spectacles and red whiskers over a white cravat, understood nothing of mental refinements, although he affected a stiff English manner, which in the beginning had impressed the clerk.

As for the chemist's spouse, she was the best wife in Normandy, gentle as a sheep, loving her children, her father, her mother, her cousins, weeping for others' woes, letting everything go in her household, and detesting corsets; but so slow of movement, such a bore to listen to, so common in appearance, and of such restricted conversation, that although she was thirty, he only twenty, although they slept in adjoining rooms and he spoke to her daily, he never thought that to someone else she might be a woman, or that she possessed anything of her sex beyond the gown.

And what else was there? Binet, a few shopkeepers, two or three publicans, the curé, and, finally, Monsieur Tuvache the mayor, with his two sons, rich, crabbed, obtuse persons, who farmed their own lands and had feasts among themselves, bigoted to boot, and quite unbearable companions.

But from the general background of all these human faces Emma's stood out isolated and yet farthest off; for between her and him he seemed to see a vague abyss.

In the beginning he had called on her several times along with the druggist. Charles had not appeared particularly anxious to see him again, and Léon did not know what to do between his fear of being indiscreet and the desire for an intimacy that seemed almost impossible.

When the first cold days set in Emma left her bodroom for the sitting-room, a long apartment with a low ceiling, in which there was on the mantelpiece a large bunch of coral spread out against the looking-glass. Seated in her armchair near the window, she could see the villagers pass along the pavement.

Twice a day Léon went from his office to the Lion d'Or. Emma could hear him coming from afar; she leant forward listening, and the young man glided past the curtain, always dressed in the same way, and without turning his head. But in the twilight, when, her chin resting on her left hand, she let the embroidery she had begun fall on her knees, she often shuddered at the apparition of this shadow suddenly gliding past. She would get up and order the table to be laid.

Monsieur Homais called at dinner-time. Skullcap in hand, he came in on tiptoe, in order to disturb no one, always repeating the same phrase, 'evening, everybody.' Then, when he had taken his seat at the table between the pair, he asked the doctor about his patients, and the latter consulted him as to the probability of their payment. Next they talked of 'what was in the paper.' Homais by this hour knew it almost by heart, and he repeated it from end to end, with the reflections of the penny-a-liners, and all the stories of individual catastrophes that had occurred in France or abroad. But the subject becoming exhausted, he was not slow in throwing out some remarks on the dishes before him. Sometimes even, half-rising, he delicately pointed out to madame the

tenderest morsel, or turning to the servant, gave her some advice on the manipulation of stews and the hygiene of seasoning. He talked aroma, osmazome, juices, and gelatine in a bewildering manner. Moreover, Homais, with his head fuller of recipes than his shop of jars, excelled in making all kinds of preserves, vinegars, and sweet liqueurs; he knew also all the latest inventions in economic stoves, together with the art of preserving cheeses and of curing sick wines.

At eight o'clock Justin came to fetch him to shut up the shop. Then Monsieur Homais gave him a sly look, especially if Félicité was there, for he half noticed that his apprentice was fond of the doctor's house.

'The young dog,' he said, 'is beginning to have ideas, and the devil take me if I don't believe he's in love with your servant!'

But a more serious fault with which he reproached Justin was his constantly listening to conversation. On Sunday, for example, one could not get him out of the drawing-room, whither Madame Homais had called him to fetch the children, who were falling asleep in the armchairs, and dragging down with their backs calico chair-covers that were too large.

Not many people came to these soirées at the chemist's, his scandal-mongering and political opinions having successfully alienated various respectable persons from him. The clerk never failed to be there. As soon as he heard the bell he ran to meet Madame Bovary, took her shawl, and put away under the shop counter the thick list shoes that she wore over her boots when there was snow.

First they played some hands at trente-et-un; next Monsieur Homais played écarté with Emma; Léon behind her gave her advice. Standing up with his

hands on the back of her chair he saw the teeth of her comb that bit into her chignon. With every movement that she made to throw her cards the right side of her dress was drawn up. From her turned-up hair a dark colour fell over her back, and growing gradually paler, lost itself little by little in the shade. Then her dress fell on both sides of her chair, puffing out full of folds, and reached the ground. When Léon occasionally felt the sole of his boot resting on it, he drew back as if he had trodden upon someone.

When the game of cards was over, the druggist and the Doctor played dominoes, and Emma, changing her place, leant her elbow on the table, turning over the leaves of L'Illustration. She had brought her ladies' journal with her. Léon sat down near her; they looked at the engravings together, and waited for one another at the bottom of the pages. She often begged him to read her the verses; Léon declaimed them in a languid voice, to which he carefully gave a dying fall in the love passages. But the noise of the dominoes annoved him. Monsieur Homais was strong at the game; he could beat Charles and give him a doublesix. Then the three hundred finished, they both stretched themselves out in front of the fire, and were soon asleep. The fire was dying out in the cinders; the teapot was empty, Léon was still reading. Emma listened to him, mechanically turning round the lampshade, on the gauze of which were painted clowns in carriages, and tightrope dancers with their balancing-poles. Léon stopped, pointing with a gesture to his sleeping audience; then they talked in low tones, and their conversation seemed the more sweet to them because it was unheard

Thus a kind of bond was established between them,

a constant commerce of books and of romances. Monsieur Bovary, little given to jealousy, did not trouble himself about it.

On his birthday he received a beautiful phrenological head, all marked with figures to the thorax and painted blue. This was an attention of the clerk's. He showed him many others, even to doing errands for him at Rouen; and the book of a novelist having made the mania for cactuses fashionable, Léon bought some for Madame Bovary, bringing them back on his knees in the 'Hirondelle', pricking his fingers with their hard hairs.

She had a board with a balustrade fixed against her window to hold the pots. The clerk, too, had his small hanging garden; they saw each other tending their flowers at their windows.

Of the windows of the village there was one yet more often occupied; for on Sundays from morning to night, and every morning when the weather was bright, one could see at the dormer-window of a garret the profile of Monsieur Binet bending over his lathe, whose monotonous humming could be heard at the Lion d'Or.

One evening on coming home Léon found in his room a rug in velvet and wool with leaves on a pale ground. He called Madame Homais, Monsieur Homais, Justin, the children, the cook; he spoke of it to his chief; everyone wanted to see this rug. Why did the doctor's wife give the clerk presents? It looked queer. They decided that she must be his lover.

He made this seem likely, so ceaselessly did he talk of her charms and of her wit; so much so, that Binet once roughly answered him – 'What does it matter to me since I'm not in her set?'

He tortured himself to find out how he could make his declaration to her, and always halting between the fear of displeasing her and the shame of being such a coward, he wept with discouragement and desire. Then he took energetic resolutions, wrote letters that he tore up, put it off to times that he again deferred. Often he set out with the determination to dare all; but this resolution soon deserted him in Emma's presence, and when Charles, dropping in, invited him to jump into his chaise to go with him to see some patient in the neighbourhood, he at once accepted, bowed to madame, and went out. Her husband, was he not something belonging to her?

As to Emma, she did not ask herself whether she loved. Love, she thought, must come suddenly, with great outbursts and lightnings, – a hurricane of the skics, which falls upon life, revolutionises it, roots up the will like a leaf, and sweeps the whole heart into the abyss. She did not know that on the terrace of houses it makes lakes when the pipes are choked, and she would thus have remained in her security when she suddenly discovered a rent in the wall of it.

It was a Sunday in February, an afternoon of falling snow.

Monsieur and Madame Bovary, Homais, and Monsieur Léon had all gone to see a yarn-mill that was being built in the valley a mile and a half from Yonville. The druggist had taken Napoléon and Athalie to give them some exercise, and Justin accompanied them, carrying the umbrellas on his shoulder.

Nothing, however, could be less curious than this curiosity. A great piece of waste ground, on which pell-mell, amid a mass of sand and stones, were a few break-wheels, already rusty, surrounded by a quadrangular building pierced by a number of little windows. The building was unfinished; the sky could be seen through the joists of the roofing. Attached to the stop-plank of the gable a bunch of straw mixed with corn-ears fluttered its tricoloured ribbons in the wind

Homais was talking. He explained to the company the future importance of this establishment, computed the strength of the floorings, the thickness of the walls, and regretted extremely not having a yardstick such as Monsieur Binet possessed for his own special use.

Emma, who had taken his arm, bent lightly against his shoulder, and she looked at the sun's disc shedding afar through the mist his pale splendour. She turned. Charles was there. His cap was drawn down over his eyebrows, and his two thick lips were trembling, which added a look of stupidity to his face; his very

back, his calm back, was irritating to behold, and she saw written upon his coat all the platitude of the bearer.

While she was considering him thus, tasting in her irritation a sort of depraved pleasure, Léon made a step forward. The cold that made him pale seemed to add a more gentle languor to his face; between his cravat and his neck the somewhat loose collar of his shirt showed the skin; the lobe of his ear looked out from beneath a lock of hair, and his large blue eyes, raised to the clouds, seemed to Emma more limpid and more beautiful than those mountain lakes where the heavens are mirrored.

'Wretched boy!' suddenly cried the chemist.

And he ran to his son, who had just precipitated himself into a heap of lime in order to whiten his boots. At the reproaches with which he was being overwhelmed Napoléon began to roar, while Justin dried his shoes with a wisp of straw. But a knife was wanted; Charles offered his.

'Ah!' she said to herself, 'he carries a knife in his pocket, like a peasant.'

The hoarfrost was falling, and they turned back to Yonville.

In the evening Madame Bovary did not go to her neighbour's, and when Charles had left and she felt herself alone, the comparison re-began with the clearness of a sensation almost actual, and with that lengthening of perspective which memory gives to things. Looking from her bed at the clean fire that was burning, she still saw, as she had down there, Léon standing up with one hand bending his cane, and with the other holding Athalie, who was quietly sucking a piece of ice. She thought him charming;

she could not tear herself away from him; she recalled his other attitudes on other days, the words he had spoken, the sound of his voice, his whole person; and she repeated, pouting out her lips as if for a kiss – 'Yes, charming! charming! Is he not in love?' she asked herself; 'but with whom? With me?'

All the proofs arose before her at once; her heart leapt. The flame of the fire threw a joyous light upon the ceiling; she turned on her back, stretching out her arms.

Then began the eternal lamentation: 'Oh, if only Heaven had willed it! And why not? What prevented it?'

When Charles came home at midnight, she seemed to have just awakened, and as he made a noise undressing, she complained of a headache, then asked carelessly what had happened that evening.

'Monsieur Léon,' he said, 'went to his room early.'

She could not help smiling, and she fell asleep, her soul filled with a new delight.

The next day, at dusk, she received a visit from Monsieur Lheureux, the draper. He was a man of ability, was this shopkeeper. Born a Gascon but bred a Norman, he grafted upon his southern volubility the cunning of the Cauchois. His fat, flabby, beardless face seemed dyed by a decoction of liquorice, and his white hair made even more vivid the keen brilliance of his small black eyes. No one knew what he had been formerly; a pedlar, said some, a banker at Routot according to others. One thing certain was that he made complex calculations in his head, enough to frighten Binet himself. Polite to the point of obsequiousness, he always held himself with his back bent in the position of one bowing or who is inviting.

After leaving at the door his hat surrounded with crape, he put down a green bandbox on the table, and began by complaining to madame, with many civilities, that he should have remained till that day without gaining her confidence. A poor shop like his was not made to attract a 'fashionable lady'; he emphasised the words; yet she had only to command, and he would undertake to provide her with anything she might wish, either in haberdashery or linen, millinery or fancy goods, for he went to town regularly four times a month. He was connected with the best houses. You could speak of him at the 'Trois Frères', at the 'Barbe d'Or', or at the 'Grand Sauvage'; all these gentlemen knew him as well as the insides of their pockets. Today, then, he had come to show madame, in passing, various articles he happened to have, thanks to the most rare opportunity. And he pulled out half a dozen embroidered collars from the box.

Madame Bovary examined them. 'I do not require anything,' she said.

Then Monsieur Lheureux delicately exhibited three Algerian scarves, several packets of English needles, a pair of straw slippers, and, finally, four egg-cups in cocoanut wood, carved in open work by convicts. Then, with both hands on the table, his neck stretched out, his figure bent forward, open-mouthed, he watched Emma's look, who was walking up and down undecided amid these goods. From time to time, as if to remove some dust, he flicked the silk of the outspread scarves with his nail, and they rustled a little, making the gold spangles of their tissue scintillate in the green twilight like tiny stars.

'How much are they?'

'A mere nothing,' he replied, 'a mere nothing. But

there's no hurry; whenever it's convenient. We are not Jews.'

She reflected for a few moments, and ended by again declining Monsieur Lheureux's offer. He replied quite unconcernedly – 'Very well. We shall understand one another by and by. I have always got on with ladies – if I didn't with my own!'

Emma smiled.

'I wanted to tell you,' he went on good-naturedly, after his joke, 'that it isn't the money I should trouble about. Why, I could give you some, if need be.'

She made a gesture of surprise.

'Ah!' said he quickly and in a low voice, 'I shouldn't have to go far to find you some, rely on that.'

And he began asking after old Tellier, the proprietor of the Café Français, whom Monsieur Bovary was then attending.

'What's the matter with old Tellier? He coughs so that he shakes his whole house, and I'm afraid he'll soon want a deal covering rather than a flannel vest. He was such a rake as a young man! Those sort of people, madame, have not the least regularity; he's burnt up with brandy. Still, it's sad, all the same, to see an acquaintance go off.'

And while he fastened up his box he chatted about the doctor's patients.

'It's the weather, no doubt,' he said, looking frowningly at the floor, 'that causes these illnesses. I, too, don't feel the thing. One of these days I shall even have to consult the doctor for a pain I have in my back. Well, goodbye, Madame Bovary. At your service; your very humble servant.' And he closed the door gently.

Emma had her dinner served in her bedroom on a

tray by the fireside; she was a long time over it; everything was well with her.

'How good I was!' she said to herself, thinking of the scarves.

She heard some steps on the stairs. It was Léon. She got up and took from the chest of drawers the first pile of dusters to be hemmed. When he came in she seemed very busy.

The conversation languished; Madame Bovary gave it up every few minutes, whilst he himself seemed quite embarrassed. Seated on a low chair near the fire, he turned round in his fingers the ivory thimble-case. She stitched on, or from time to time turned down the hem of the cloth with her nail. She did not speak; he was silent, captivated by her silence, as he would have been by her speech.

'Poor fellow!' she thought.

'How have I displeased her?' he asked himself.

At last, however, Léon said that he should have, one of these days, to go to Rouen on some office business.

'Your music subscription is out; am I to renew it?'

'No,' she replied.

'Why?'

'Because - '

And pursing her lips she slowly drew a long stitch of grey thread.

This work irritated Léon. It seemed to roughen the ends of her fingers. A gallant phrase came into his head, but he did not risk it.

'Then you are giving it up?' he went on.

'What?' she asked hurriedly. 'Music? Ah! yes! Have I not my house to look after, my husband to attend to, a thousand things, in fact, many duties that must be considered first?'

She looked at the clock. Charles was late. Then she affected anxiety. Two or three times she even repeated, 'He is so good!'

The clerk was fond of Monsieur Bovary. But this tenderness on his behalf astonished him unpleasantly; nevertheless he took up his praises, which he said everyone was singing, especially the chemist.

'Ah! he is a good fellow,' continued Emma.

'Certainly,' replied the clerk.

And he began talking of Madame Homais, whose very untidy appearance generally made them laugh.

'What does it matter?' interrupted Emma. 'A good housewife does not trouble about her appearance.'

Then she relapsed into silence.

It was the same on the following days; her talks, her manners, everything changed. She took interest in the housework, went to church regularly, and looked after her servant with more severity.

She took Berthe from nurse. When visitors called, Félicité brought her in, and Madame Bovary undressed her to show off her limbs. She declared she adored children; this was her consolation, her joy, her passion, and she accompanied her caresses with lyrical outbursts which would have reminded anyone but the Yonville people of Sachette in *Notre-Dame de Paris*.

When Charles came home he found his slippers put to warm near the fire. His waistcoat now never wanted lining, nor his shirt buttons, and it was quite a pleasure to see in the cupboard the nightcaps arranged in piles of the same height. She no longer grumbled as formerly at taking a turn in the garden; what he proposed was always done, although she did not understand the wishes to which she submitted without

a murmur; and when Léon saw him by his fireside after dinner, his two hands on his stomach, his two feet on the fender, his cheeks red with feeding, his eyes moist with happiness, the child crawling along the carpet, and this woman with the slender waist who came behind his armchair to kiss his forehead: 'What madness!' he said to himself. 'And how to reach her!'

And thus she seemed so virtuous and inaccessible to him that he lost all hope, even the faintest. But by this renunciation he placed her on an extraordinary pinnacle. To him she stood outside those fleshly attributes from which he had nothing to obtain, and in his heart she rose ever, and became farther removed from him after the magnificent manner of an apotheosis that is taking wing. It was one of those pure feelings that do not interfere with life, that are cultivated because they are rare, and whose loss would afflict more than their passion rejoices.

Emma grew thinner, her cheeks paler, her face longer. With her black hair, her large eyes, her aquiline nose, her birdlike walk, and always silent now, did she not seem to be passing through life scarcely touching it, and to bear on her brow the vague impress of some divine destiny? She was so sad and so calm, at once so gentle and so reserved, that near her one felt oneself seized by an icy charm, as we shudder in churches at the perfume of the flowers mingling with the cold of the marble. The others even did not escape from this seduction. The chemist said – 'She is a woman of great parts, who wouldn't be out of place in a sub-prefecture.'

The housewives admired her economy, the patients her politeness, the poor her charity.

But she was eaten up with desires, with rage, with

hate. That dress with the narrow folds hid a distracted heart, of whose torment those chaste lips said nothing. She was in love with Léon, and sought solitude that she might with the more ease delight in his image. The sight of his form troubled the voluptuousness of this meditation. Emma thrilled at the sound of his step; then in his presence the emotion subsided, and afterwards there remained to her only an immense astonishment that ended in sorrow.

Léon did not know that when he left her in despair she rose after he had gone to see him in the street. She concerned herself about his comings and goings; she watched his face; she invented quite a history to find an excuse for going to his room. The chemist's wife seemed happy to her to sleep under the same roof, and her thoughts constantly centred upon this house, like the Lion d'Or pigeons, who came there to dip their red feet and white wings in its gutters. But the more Emma recognised her love, the more she crushed it down, that it might not be evident, that she might make it less. She would have liked Léon to guess it, and she imagined chances, catastrophes that should facilitate this. What restrained her was, no doubt, idleness and fear, and a sense of shame also. She thought she had repulsed him too much, that the time was past, that all was lost. Then, pride, the joy of being able to say to herself, 'I am virtuous,' and to look at herself in the glass taking resigned poses, consoled her a little for the sacrifice she believed she was making.

Then the lusts of the flesh, the longing for money, and the melancholy of passion all blended themselves into one suffering, and instead of turning her thoughts from it, she clave to it the more, urging herself to pain, and seeking everywhere occasion for it. She was irritated by an ill-served dish, or by a half-open door; bewailed the velvets she had not, the happiness she had missed, her too exalted dreams, her narrow home.

What exasperated her was that Charles did not seem to notice her anguish. His conviction that he was making her happy seemed to her an imbecile insult, and his sureness on this point ingratitude. For whose sake, then, was she virtuous? Was it not for him, the obstacle to all felicity, the cause of all misery, and, as it were, the sharp clasp of that complex strap that buckled her in on all sides?

On him alone, then, she concentrated all the various hatreds that resulted from her boredom, and every effort to diminish only augmented it; for this useless trouble was added to the other reasons for despair, and contributed still more to the separation between them. Her own gentleness to herself made her rebel against him. Domestic mediocrity drove her to lewd fancies, marriage tenderness to adulterous desires. She would have liked Charles to beat her, that she might have a better right to hate him, to revenge herself upon him. She was surprised sometimes at the atrocious conjectures that came into her thoughts, and she had to go on smiling, to hear repeated to her at all hours that she was happy, to pretend to be happy, to let it be believed.

Yet she had loathing of this hypocrisy. She was seized with the temptation to flee somewhere with Léon to try a new life; but at once a vague chasm full of darkness opened within her soul.

'Besides, he no longer loves me,' she thought. 'What is to become of me? What help is to be hoped for, what consolation, what solace?'

She was left broken, breathless, inert, sobbing in a low voice, with flowing tears.

'Why don't you tell master?' the servant asked her when she came in during these crises.

'It is nerves,' said Emma. 'Don't speak to him about this; it would worry him.'

'Ah! yes,' Félicité went on, 'you are just like La Guérine, old Guérin's daughter, the fisherman at Pollet, whom I used to know at Dieppe before I came to you. She was so sad, so sad, that to see her standing on the threshold of her house, she seemed like a shroud spread out against the door. Her illness, it seemed, was a kind of fog that she had in her head, and the doctors could do nothing, nor the priest either. When she was taken too bad she went off quite alone to the seashore, so that the coastguard on his rounds often found her lying flat on her face, crying on the shingle. Then, after her marriage, it went off, they say.'

'But with me,' replied Emma, 'it was after marriage that it began.'

One evening, while sitting at the open window, she had been watching Lestiboudois, the beadle, trimming the box-hedge, she suddenly heard the *Angelus* ringing.

It was the beginning of April, when the primroses are in bloom, and a warm wind blows over the flowerbeds newly turned, and the gardens, like women, seem to be getting ready for the summer fêtes. Through the bars of the arbour and away beyond, the river seen in the fields, meandering through the grass in wandering curves. The evening vapours rose between the leafless poplars, touching their outlines with a violet tint, paler and more transparent than a subtle gauze caught athwart their branches. In the distance cattle moved about; neither their steps nor their lowing could be heard; and the bell, still ringing through the air, kept up its peaceful lamentation.

With this repeated tinkling the thoughts of the young woman lost themselves in old memories of her youth and schooldays. She remembered the great candlesticks that rose above the vases full of flowers on the altar, and the tabernacle with its small columns. She would have liked to be once more lost in the long line of white veils, marked off here and there by the stiff black hoods of the good sisters bending over their prie-dieu. At mass on Sundays, when she looked up, she saw the gentle face of the Virgin amid the blue smoke of the rising incense. Then she was moved; she felt herself weak and quite deserted, like the down of a bird whirled by the tempest, and it was unconsciously

that she went towards the church, inclined to no matter what devotions, so that her soul was absorbed and all existence lost in it.

On the Place she met Lestiboudois on his way back, for, in order not to shorten his day's labour, he preferred interrupting his work, then beginning it again, so that he rang the *Angelus* to suit his own convenience. Besides, the ringing over a little earlier warned the lads of catechism hour.

A few had already arrived and were playing marbles on the stones of the cemetery. Others, astride the wall, swung their legs, kicking with their clogs the large nettles growing between the little enclosure and the newest graves. This was the only green spot. All the rest was but stones, always covered with a fine powder, despite the vestry broom.

The children in list shoes ran about there as if it were an enclosure made for them. The shouts of their voices could be heard through the humming of the bell. This grew less and less with the swinging of the great rope that, hanging from the top of the belfry, dragged its end on the ground. Swallows flitted to and fro uttering little cries, cut the air with the edge of their wings, and swiftly returned to their yellow nests under the tiles of the coping. At the end of the church a lamp was burning, the wick of a night-light in a glass hung up. Its light from a distance looked like a white stain trembling in the oil. A long ray of the sun fell across the nave and seemed to darken the lower sides and the corners.

'Where is the curé?' asked Madame Bovary of one of the lads, who was amusing himself by shaking a swivel in a hole too large for it.

'He is just coming,' he answered.

And in fact the door of the presbytery grated; Abbé Bournisien appeared; the children, pell-mell, fled into the church.

'These young scamps!' murmured the priest, 'always the same!' Then, picking up a catechism all in rags that he had struck with his foot, 'They respect nothing!' But as soon as he caught sight of Madame Bovary, 'Excuse me,' he said; 'I did not recognise you.'

He thrust the catechism into his pocket, and stopped short, balancing the heavy vestry key between his two fingers.

The light of the setting sun that fell full upon his face paled the lasting of his cassock, shiny at the elbows, unravelled at the hem. Grease and tobacco stains followed along his broad chest the lines of the buttons, and grew more numerous the farther they were from his neckcloth, in which the massive folds of his red chin rested; this was dotted with yellow spots, that disappeared beneath the coarse hair of greyish beard. He had just dined, and was breathing noisily.

'How are you?' he added.

'Not well,' replied Emma; 'I am ill.'

'Well, and so am I,' answered the priest. 'These first warm days weaken one most remarkably, don't they? But, after all, we are born to suffer, as St Paul says. But what does Monsieur Bovary think of it?'

'He!' she said with a gesture of contempt.

'What!' replied the good fellow, quite astonished, 'doesn't he prescribe something for you?'

'Ah!' said Emma, 'it is no earthly remedy I need.'

But the curé from time to time looked into the church, where the kneeling boys were shouldering one another and tumbling over like packs of cards.

'I should like to know - 'she went on.

'You look out, Riboudet,' cried the priest in an angry voice; 'I'll warm your ears, you imp!' Then turning to Emma. 'He's Boudet the carpenter's son; his parents are well off, and let him do just as he pleases. Yet he could learn quickly if he would, for he is very sharp. And so sometimes for a joke I call him Riboudet (like the road one takes to go to Maromme) and I even say "Mon Riboudet". Ha! ha! "Mont Riboudet". The other day I repeated that jest to Monsignor, and he laughed at it; he condescended to laugh at it. And how is Monsieur Bovary?'

She seemed not to hear him. And he went on – 'Always very busy, no doubt; for he and I are certainly the busiest people in the parish. But he is a doctor of the body,' he added with a thick laugh, 'and I of the soul.'

She fixed her pleading eyes upon the priest. 'Yes,' she said, 'you solace all sorrows.'

'Ah! don't talk to me of it, Madame Bovary. This morning I had to go to the Bas-Diauville for a cow that was ill; they thought it was under a spell. All their cows, I don't know how it is – But pardon me! Longuemarre and Boudet! Bless me! will you leave off?'

And with a bound he ran into the church.

The boys just then were jostling round the large desk, climbing over the precentor's footstool, opening the missal; and others on tiptoe were just about to venture into the confessional. But the priest suddenly distributed a shower of cuffs among them. Seizing them by the collars of their coats he lifted them from the ground and deposited them on their knees on the stones of the choir, firmly, as if he meant planting them there.

'Yes,' said he, when he returned to Emma, unfolding his large cotton handkerchief, one corner of which he put between his teeth, 'farmers are much to be pitied.'

'Others too,' she replied.

'Assuredly. Town-labourers, for example.'

'It is not they - '

'Pardon! I've there known poor mothers of families, virtuous women, I assure you, real saints, who lacked even bread.'

'But those,' replied Emma, and the corners of her mouth twitched as she spoke, 'those, Monsieur le Curé, who have bread and have no –'

'Fire in the winter,' said the priest.

'Oh, what does that matter?'

'What! What does it matter? It seems to me that when one has firing and food – for, after all – '

'My God! my God!' she sighed.

'It is indigestion, no doubt? You must get home, Madame Bovary; drink a little tea, that will strengthen you, or else a glass of fresh water with a little moist sugar.'

'Why?' And she looked like one awaking from a dream.

'Well, you see, you were putting your hand to your forehead. I thought you felt faint.' Then, bethinking himself, 'But you were asking me something? What was it? I really don't remember.'

'I? Nothing! nothing!' repeated Emma.

And the glance she cast round her slowly fell upon the old man in the cassock. They looked at one another face to face without speaking.

'Then, Madame Bovary,' he said at last, 'excuse me, but duty first, you know; I must look after my goodfor-nothings. The first communion will soon be upon us, and I fear we shall be behind after all. So after Ascension Day I keep them *recta* an extra hour every Wednesday. Poor children! One cannot lead them too soon into the path of the Lord, as, moreover, He has Himself recommended us to do by the mouth of His Divine Son. Good health to you, madame; my respects to your husband.'

And he went into the church, making a genuflexion as he reached the door.

Emma saw him disappear between the double row of forms, walking with heavy tread, his head a little bent over his shoulder, and with his two hands halfopen behind him.

Then she turned on her heel all of one piece, like a statue on a pivot, and went homewards. But the loud voice of the priest, the clear voices of the boys still reached her ears, and went on behind her.

'Are you a Christian?'

'Yes, I am a Christian.'

'What is a Christian?'

'He who, being baptised - baptised - baptised - '

She went up the steps of the staircase holding on to the banisters, and when she was in her room threw herself into an armchair.

The whitish light of the windowpanes fell with soft undulations. The furniture in its place seemed to have become more immobile, and to lose itself in the shadow as in an ocean of darkness. The fire was out, the clock went on ticking, and Emma vaguely marvelled at this calm of all things, while within herself was such a tumult. But little Berthe was there, between the window and the work-table, tottering on her knitted shoes, and trying to come to her mother to catch hold of the ends of her apron-strings.

'Leave me alone,' said the latter, putting her from her with her hand.

The little girl soon came up closer against her knees, and leaning on them with her arms, she looked up with her large blue eyes, while a small thread of pure saliva dribbled from her lips on to the silk apron.

'Leave me alone,' repeated the young woman quite irritably.

Her face frightened the child, who began to scream. 'Will you leave me alone?' she said, pushing her with her elbow.

Berthe fell at the foot of the drawers against the brass handle, cutting her cheek, which began to bleed, against it. Madame Bovary sprang to lift her up, broke the bell-rope, called for the servant with all her might, and she was just going to curse herself when Charles appeared. It was the dinner-hour; he had come home.

'Look, dear!' said Emma, in a calm voice, 'the little one fell down while she was playing, and has hurt herself.'

Charles reassured her; the case was not a serious one, and he went for some sticking-plaster.

Madame Bovary did not go downstairs to the dining-room; she wished to remain alone to look after the child. Then watching her sleep, the little anxiety she felt gradually wore off, and she seemed very stupid to herself, and very good to have been so worried just now at so little. Berthe, in fact, no longer sobbed. Her breathing now imperceptibly raised the cotton covering. Big tears lay in the corner of the half-closed eyelids, through whose lashes one could see two pale sunken pupils; the plaster stuck on her cheek drew the skin obliquely.

'It is very strange,' thought Emma, 'how ugly this child is!'

When at eleven o'clock Charles came back from the chemist's shop, whither he had gone after dinner to return the remainder of the sticking-plaster, he found his wife standing by the cradle.

'I assure you it's nothing,' he said, kissing her on the forehead. 'Don't worry, my poor darling; you will make yourself ill.'

He had stayed a long time at the chemist's. Although he had not seemed much moved, Homais, nevertheless, had exerted himself to buoy him up, to 'keep up his spirits.' Then they had talked of the various dangers that threaten childhood, of the carelessness of servants. Madame Homais knew something of it, having still upon her chest the marks left by a basin full of soup that a cook had once dropped on her pinafore, and her good parents took no end of trouble for her. The knives were not sharpened, nor the floors waxed; there were iron gratings to the windows and strong bars across the fireplace; the little Homais, in spite of their spirit, could not stir without someone watching them; at the slightest cold their father stuffed them with pectorals; and until they were turned four they all, without pity, had to wear wadded head-protectors. This, it is true, was a fancy of Madame Homais'; her husband was inwardly afflicted by it. Fearing the possible consequences of such compression to the intellectual organs, he even went so far as to say to her, 'Do you want to make Caribs or Botocudos of them?'

Charles, however, had several times tried to interrupt the conversation. 'I should like to speak to you,' he had whispered in the clerk's ear, who went upstairs in front of him.

'Can he suspect anything?' Léon asked himself. His heart beat, and he racked his brain with surmises.

At last, Charles, having shut the door, asked him to see himself what would be the price at Rouen of a fine daguerreotype. It was a sentimental surprise he intended for his wife, a delicate attention – his portrait in a frock-coat. But he wanted first to know 'how much it would be.' The enquiries would not put Monsieur Léon out, since he went to town almost every week.

Why? Monsieur Homais suspected some 'young man's affair' at the bottom of it, an intrigue. But he was mistaken. Léon was after no love-making. He was sadder than ever, as Madame Lefrançois saw from the amount of food he left on his plate. To find out more about it she questioned the tax-collector. Binet answered roughly that he 'wasn't in the pay of the police'.

All the same, his companion seemed very strange to him, for Léon often threw himself back in his chair, and stretching out his arms, complained vaguely of life.

'It's because you don't take enough recreation,' said the collector.

'What recreation?'

'If I were you I'd have a lathe.'

'But I don't know how to turn,' answered the clerk.

'Ah! that's true,' said the other, rubbing his chin with an air of mingled contempt and satisfaction.

Léon was weary of loving without any result; moreover he was beginning to feel that depression caused by the repetition of the same kind of life, when no interest inspires and no hope sustains it. He was so bored with Yonville and its inhabitants, that the sight of certain persons, of certain houses, irritated him beyond endurance; and the chemist, good fellow though he was, was becoming absolutely unbearable to him. Yet the prospect of a new condition of life frightened as much as it seduced him.

This apprehension soon changed into impatience, and then Paris from afar sounded its fanfare of masked balls with the laugh of grisettes. As he was to finish reading there, why not set out at once? What prevented him? And he began by making home-preparations; he arranged his occupations beforehand. He furnished in his head an apartment. He would lead an artist's life there! He would take lessons on the guitar! He would have a dressing-gown, a Basque cap, blue velvet slippers! He even already was admiring two crossed foils over his chimney-piece, with a death's-head on the guitar above them.

The difficulty was the consent of his mother; nothing, however, seemed more reasonable. Even his employer advised him to go to some other chambers where he could advance more rapidly. Taking a middle course, then, Léon looked for some place as second clerk at Rouen; found none, and at last wrote his mother a long letter full of details, in which he set forth the reasons for going to live at Paris immediately. She consented.

He did not hurry. Every day for a month Hivert carried boxes, valises, parcels for him from Yonville to Rouen and from Rouen to Yonville; and when Léon had packed up his wardrobe, had his three armchairs restuffed, bought a stock of neckties, in a word, had made more preparations than for a voyage around the world, he put it off from week to week, until he received a second letter from his mother urging him to

leave, since he wanted to pass his examination before the vacation.

When the moment for the farewells had come, Madame Homais wept, Justin sobbed; Homais, as a man of nerve, concealed his emotion; he wished to carry his friend's overcoat himself as far as the gate of the notary, who was taking Léon to Rouen in his carriage. The latter had just time to bid farewell to Monsieur Bovary.

When he reached the head of the stairs he stopped, he was so out of breath. As he came in, Madame Bovary arose hurriedly.

'It is I again!' said Léon.

'I was sure of it!'

She bit her lips, and a rush of blood flowing under her skin made her red from the roots of her hair to the top of her collar. She remained standing, leaning with her shoulder against the wainscot.

'The doctor is not here?' he went on.

'He is out.' She repeated, 'He is out.'

Then there was silence. They looked one at the other and their thoughts, confounded in the same agony, clung close together like two throbbing breasts.

'I should like to kiss Berthe,' said Léon.

Emma went down a few steps and called Félicité.

He threw one long look around him that took in the walls, the decorations, the fireplace, as if to penetrate everything, carry away everything. But she returned, and the servant brought Berthe, who was swinging a windmill roof downwards at the end of a string. Léon kissed her several times on the neck.

'Goodbye, poor child! goodbye, dear little one! goodbye!' And he gave her back to her mother.

'Take her away,' she said.

They remained alone – Madame Bovary, her back turned, her face pressed against a windowpane; Léon held his cap in his hand, striking it lightly against his thigh.

'It is going to rain,' said Emma.

'I have a cloak,' he answered.

'Ah!'

She turned around, her chin lowered, her forehead bent forward. The light fell on it as on a piece of marble, to the curve of the eyebrows, without one's being able to guess what Emma was seeing on the horizon or what she was thinking within herself.

'Well, goodbye,' he sighed.

She raised her head with a quick movement.

'Yes goodbye - go!'

They advanced towards each other; he held out his hand; she hesitated.

'In the English fashion, then,' she said, giving her own hand wholly to him, and forcing a laugh.

Léon felt it between his fingers, and the very essence of all his being seemed to pass down into that moist palm. Then he opened his hand; their eyes met again, and he disappeared.

When he reached the marketplace, he stooped and hid behind a pillar to look for the last time at this white house with the four green blinds. He thought he saw a shadow behind the window in the room; but the curtain, sliding along the pole as though no one were touching it, slowly opened its long oblique folds, that spread out with a single movement, and thus hung straight and motionless as a plaster wall. Léon set off running.

From afar he saw his employer's gig in the road, and by it a man in a coarse apron holding the horse.

Homais and Monsieur Guillaumin were talking. They were waiting for him.

'Embrace me,' said the druggist with tears in his eyes. 'Here is your coat, my good friend. Mind the cold; take care of yourself; look after yourself.'

'Come, Léon, jump in,' said the notary.

Homais bent over the splash-board, and in a voice broken by sobs uttered these three sad words – 'A pleasant journey!'

'Good-night,' said Monsieur Guillaumin. 'Give him his head.' They set out, and Homais went back.

Madame Bovary had opened her window overlooking the garden and watched the clouds. They gathered around the sunset on the side of Rouen, and then swiftly rolled back their black columns, behind which the great rays of the sun looked out like the golden arrows of a suspended trophy, while the rest of the empty heavens was white as porcelain. But a gust of wind bowed the poplars, and suddenly the rain fell; it pattered against the green leaves. Then the sun reappeared, the hens clucked, sparrows shook their wings in the damp thickets, and the pools of water on the gravel as they flowed away carried off the pink flowers of an acacia.

'Ah! how far off he must be already!' she thought.

Monsieur Homais, as usual, came at half-past six during dinner.

'Well,' said he, 'so we've sent off our young friend!'
'So it seems,' replied the doctor. Then turning on his chair: 'Any news at home?'

'Nothing much. Only my wife was a little moved this afternoon. You know women – a nothing upsets them, especially my wife. And we should be wrong to object to that, since their nervous organisation is much more malleable than ours.'

'Poor Léon!' said Charles. 'How will he live at Paris? Will he get used to it?'

Madame Bovary sighed.

'Get along!' said the chemist, smacking his lips. 'The outings at restaurants, the masked balls, the champagne – all that'll be jolly enough, I assure you.'

'I don't think he'll trouble about all that,' objected Bovary.

'Nor do I,' continued Monsieur Homais quickly; 'although he'll have to do like the rest for fear of passing for a Jesuit. And you don't know what a life those dogs lead in the Latin quarter with actresses. Besides, students are thought a great deal of in Paris. Provided they have a few accomplishments, they are received in the best society; there are even ladies of the Faubourg Saint-Germain who fall in love with them, which subsequently furnishes them with opportunities for making very good matches.'

'But,' said the doctor, 'I fear for him that down there - '

'You are right,' interrupted the chemist; 'that is the reverse of the medal. And one is constantly obliged to keep one's hand in one's pocket there. For instance, suppose you are in a public garden. An individual presents himself well dressed, even wearing an order, and whom one would take for a diplomatist. He approaches you, he insinuates himself; offers you a pinch of snuff, or picks up your hat. Then you become more intimate; he takes you to a café, invites you to his country-house, introduces you, between two drinks, to all sorts of people; and three-fourths of the time it's

only to plunder your watch or lead you into some pernicious step.'

'That is true,' said Charles; 'but I was thinking especially of illnesses – of typhoid fever, for example, that attacks students from the provinces.'

Emma shuddered.

'Because of the change of regimen,' continued the chemist, 'and of the perturbation that results therefrom in the whole system. And then the water at Paris, don't you know! The dishes at restaurants, all the spiced food, end by heating the blood, and are not worth, whatever people may say of them, an honest soup. For my own part, I have always preferred plain living; it is more healthy. So when I was studying pharmacy at Rouen, I boarded in a boarding-house; I dined with the professors.'

And thus he went on, expounding his opinions generally and his personal likings, until Justin came to fetch him for a mulled egg that was wanted.

'Not a moment's peace!' he cried; 'always at it! I can't go out for a minute! Like a plough-horse, I have always to be moiling and toiling. What drudgery!' Then, when he was at the door, 'By the way, do you know the news?'

'What news?'

'That it is very likely,' Homais went on, raising his eyebrows and assuming one of his most serious expressions, 'that the agricultural meeting of the Seine-Inférieure will be held this year at Yonville-l'Abbaye. The rumour, at all events, is going the round. This morning the paper alluded to it. It would be of the utmost importance for our district. But we'll talk it over later on. I can see, thank you; Justin has the lantern.'

The next day was a dreary one for Emma. Everything seemed to her enveloped in a black atmosphere floating confusedly over the exterior of things, and sorrow was engulfed within her soul with soft shrieks such as the winter wind makes in ruined castles. It was that reverie which we give to things that will not return, the lassitude that seizes you after everything was done; that pain, in fine, that the interruption of every wonted movement, the sudden cessation of any prolonged vibration, brings on.

As on the return from Vaubyessard, when the quadrilles were running in her head, she was full of a gloomy melancholy, of a numb despair. Léon reappeared, taller, handsomer, more charming, more vague. Though separated from her, he had not left her; he was there, and the walls of the house seemed to hold his shadow. She could not detach her eyes from the carpet where he had walked, from those empty chairs where he had sat. The river still flowed on, and slowly drove its ripples along the slippery banks. They had often walked there to the murmur of the waves over the moss-covered pebbles. How bright the sun had been! What happy afternoons they had seen alone in the shade at the end of the garden! He read aloud, bareheaded, sitting on a footstool of dry sticks; the fresh wind of the meadow set trembling the leaves of the book and the nasturtiums of the arbour. Ah! he was gone, the only harm of her life, the only possible hope of joy. Why had she not seized this happiness when it came to her? Why not have kept

hold of it with both hands, with both knees, when it was about to flee from her? And she cursed herself for not having loved Léon. She thirsted for his lips. The wish took possession of her to run after him and rejoin him, throw herself into his arms and say to him, 'It is I; I am yours.' But Emma recoiled beforehand at the difficulties of the enterprise and her desires, increased by regret, became only the more acute.

Henceforth the memory of Léon was the centre of her boredom; it burnt there more brightly than the fire travellers have left on the snow of a Russian steppe. She sprang towards him, she pressed against him, she stirred carefully the dying embers, sought all around her anything that could revive it; and the most distant reminiscences, like the most immediate occasions, what she experienced as well as what she imagined, her voluptuous desires that were unsatisfied, her projects of happiness that crackled in the wind like dead boughs, her sterile virtue, her lost hopes, the domestic *tête-à-tête* – she gathered it all up, took everything, and made it all serve as fuel for her melancholy.

The flames, however, subsided, either because the supply had exhausted itself, or because it had been piled up too much. Little by little love was quelled by absence; regret stifled beneath habit; and this incendiary light that had empurpled her pale sky was overspread and faded by degrees. In the supineness of her conscience she even took her repugnance towards her husband for aspirations towards her lover, the burning of hate for the warmth of tenderness; but as the tempest still raged, and as passion burnt itself down to the very cinders, and no help came, no sun rose, there was night on all sides, and she was lost in the terrible cold that pierced her.

Then the evil days of Tostes began again. She now thought herself far more unhappy; for she had the experience of grief, with the certainty that it would not end.

A woman who had lain on herself such sacrifices could well allow herself certain whims. She bought a gothic prie-dieu, and in a month spent fourteen francs on lemons for polishing her nails; she wrote to Rouen for a blue cashmere gown; she chose one of Lheureux's finest scarves, and wore it knotted around her waist over her dressing-gown; and, in this garb, with closed blinds and a book in her hand, she lay stretched on a couch.

She often changed her coiffure; she did her hair à la Chinoise, in flowing curls, in plaited coils; she parted it on one side and rolled it under like a man's.

She wanted to learn Italian; she bought dictionaries, a grammar, and a supply of blank paper. She tried serious reading, history, and philosophy. Sometimes in the night Charles woke up with a start, thinking he was being called to a patient. 'I'm coming,' he stammered; and it was the noise of a match Emma had struck to relight the lamp. But her reading flared like her piece of embroidery, all of which, only just begun, filled her cupboard; she took it up, left it, passed on to other books.

Moods seized her when she could easily have been driven to any folly. One day she maintained, against her husband, that she could drink off a large glass of brandy, and, as Charles was stupid enough to dare her to, she swallowed the brandy to the last drop.

In spite of her vapourish airs (as the housewives of Yonville called them), Emma, all the same, never seemed gay, and the corners of her mouth usually

had that immobile contraction which puckers the faces of old maids, and those of men whose ambition has failed. She was pale all over, white as a sheet; the skin of her nose was drawn at the nostrils, her eyes looked at you vaguely. After discovering three grey hairs on her temples, she talked much of her old age.

She often fainted. One day she even spat blood, and, as Charles fussed around her showing his anxiety – 'Bah!' she answered, 'what does it matter?'

Charles fled to his study and wept there, both his elbows on the table, sitting in an armchair at his bureau under the phrenological head.

Then he wrote to his mother begging her to come, and they had many long consultations together on the subject of Emma.

What should they decide? What was to be done since she rejected all medical treatment?

'Do you know what your wife wants?' replied Madame Bovary, senior. 'She wants to be forced to occupy herself with some manual work. If she were obliged, like so many others, to earn her living, she wouldn't have these vapours, that come to her from a lot of ideas she stuffs into her head, and from the idleness in which she lives.'

'Yet she is always busy,' said Charles.

'Ah! always busy at what? Reading novels, bad books, works against religion, and in which they mock at priests in speeches taken from Voltaire. But all that leads you far astray, my poor child. Anyone who has no religion always ends by turning out badly.'

So it was decided to stop Emma reading novels. The enterprise did not seem easy. The good lady undertook it. She was, when she passed through Rouen, to go herself to the lending-library and represent that Emma had discontinued her subscription. Would they not have a right to apply to the police if the librarian persisted all the same in his poisonous trade?

The farewells of mother and daughter-in-law were cold. During the three weeks that they had been together they had not exchanged half a dozen words apart from the enquiries and phrases when they met at table and in the evening before going to bed.

Madame Bovary left on a Wednesday, the marketday at Yonville.

The Place since morning had been blocked by a row of carts, which, on end and their shafts in the air, spread all along the line of houses from the church to the inn. On the other side there were canvas booths, where cotton checks, blankets, and woollen stockings were sold, together with harness for horses, and packets of blue ribbon, whose ends fluttered in the wind. The coarse hardware was spread out on the ground between pyramids of eggs and hampers of cheeses, from which sticky straw stuck out. Near the corn-machines clucking hens passed their necks through the bars of flat cages. The people, crowding in the same place and unwilling to move thence, sometimes threatened to smash the shop-front of the chemist. On Wednesdays his shop was never empty, and the people pushed in less to buy drugs than for consultations, so great was Homais's reputation in the neighbouring villages. His robust aplomb had fascinated the rustics. They considered him a greater doctor than all the doctors.

Emma was leaning out at the window. She was often there; the window in the provinces replaces the theatre and the promenade. She was amusing herself

with watching the crowd of boors when she saw a gentleman in a green velvet coat. He had on yellow gloves, although he wore heavy gaiters; he was coming towards the doctor's house, followed by a peasant walking with bent head and quite a thoughtful air.

'Can I see the doctor?' he asked Justin, who was talking on the doorsteps with Félicité, and, taking him for a servant of the house – 'Tell him that Monsieur Rodolphe Boulanger of La Huchette is here.'

It was not from territorial vanity that the new arrival added 'of La Huchette' to his name, but to make himself the better known. La Huchette, in fact, was an estate near Yonville, where he had just bought the château and two farms that he cultivated himself, without, however, troubling very much about them. He lived as a bachelor, and was supposed to have 'at least fifteen thousand francs a year'.

Charles came into the room. Monsieur Boulanger introduced his man, who wanted to be bled because he felt 'a tingling all over'.

'That'll purge me,' he urged as an objection to all reasoning.

So Bovary ordered a bandage and a basin, and asked Justin to hold it. Then addressing the peasant, who was already pale – 'Don't be afraid, my lad.'

'No, no, sir,' said the other; 'just go on.'

And with an air of bravado he held out his great arm. At the prick of the lancet the blood spurted out, splashing against the looking-glass.

'Hold the basin nearer,' exclaimed Charles.

'Lor'!' said the peasant, 'one would swear it was a little fountain flowing. Fine red blood I've got! That's a good sign, isn't it?'

'Sometimes,' answered the doctor, 'one feels nothing at first, and then syncope sets in, and especially with people of strong constitution like this man.'

At these words the rustic let go the lancet-case he was twisting between his fingers. A shudder of his shoulders made the chair-back creak. His hat fell off.

'I thought as much,' said Bovary, pressing his finger on the vein.

The basin was beginning to tremble in Justin's hands; his knees shook, he turned pale.

'Emma! Emma!' called Charles.

With one bound she came down the staircase.

'Some vinegar,' he cried. 'O dear! two at once!'

And in his emotion he could hardly put on the compress.

'It is nothing,' said Monsieur Boulanger quietly, taking Justin in his arms. He seated him on the table with his back resting against the wall.

Madame Bovary began taking off his cravat. The strings of his shirt had got into a knot, and she was for some minutes moving her light fingers about the young fellow's neck. Then she poured some vinegar on her cambric handkerchief; she moistened his temples with little dabs, and then blew upon them softly. The ploughman revived, but Justin's syncope still lasted, and his eyeballs disappeared in their pale sclerotics like blue flowers in milk.

'We must hide this from him,' said Charles.

Madame Bovary took the basin to put it under the table. With the movement she made in bending down, her dress (it was a summer dress with four flounces, yellow, long in the waist and wide in the skirt) spread out around her on the flags of the room; and as Emma, stooping, staggered a little as she stretched out

her arms, the stuff here and there gave with the curves of her bust. Then she went to fetch a bottle of water, and she was melting some pieces of sugar when the chemist arrived. The servant had been to fetch him in the tumult. Seeing his pupil's eyes staring he drew a long breath; then going around him he looked him up and down.

'Fool!' he said, 'a real little fool! F-O-O-L! A phlebotomy's a big job, isn't it! And a fellow who isn't afraid of anything; a kind of squirrel, just like you see them climbing giddy heights to shake down nuts. Oh, yes! you just talk to me, boast about yourself! Here's a fine fitness for practising pharmacy later on; for in serious circumstances you may find yourself before the courts in order to enlighten the minds of the magistrates, and you would have to keep your head then, to reason, show yourself a man, or else pass for an imbecile.'

Justin did not answer. The chemist went on – 'Who asked you to come? You are always pestering the doctor and madame. On Wednesday, moreover, your presence is indispensable to me. There are now twenty people in the shop. I left everything because of the interest I take in you. Come, get along! Sharp! Wait for me, and keep an eye on the jars.'

When Justin, who was rearranging his dress, had gone, they talked for a little while about fainting-fits. Madame Bovary had never fainted.

'That is extraordinary for a lady,' said Monsieur Boulanger; 'but some people are very susceptible. Thus in a duel, I have seen a second lose consciousness at the mere sound of the loading of pistols.'

'For my part,' said the chemist, 'the sight of other people's blood doesn't affect me at all, but the mere thought of my own flowing would make me faint if I reflected upon it too much.'

Monsieur Boulanger, however, dismissed his servant, advising him to calm himself, since his fancy was over.

'It procured me the advantage of making your acquaintance,' he added, and he looked at Emma as he said this. Then he put three francs on the corner of the table, bowed negligently, and went out.

He was soon on the other side of the river (this was his way back to La Huchette), and Emma saw him in the meadow, walking under the poplars, slackening his pace now and then as one who reflects.

'She is very pretty,' he said to himself; 'she is very pretty, this doctor's wife. Fine teeth, black eyes, a dainty foot, a figure like a Parisienne's. Where the devil does she come from? Wherever did this fat fellow pick her up?'

Monsieur Rodolphe Boulanger was thirty-four; he was of brutal temperament and intelligent perspicacity, moreover, he had had much to do with women, and knew them well. This one had struck him as pretty; so he was thinking about her and her husband.

'I should say he was extremely stupid. She is tired of him, no doubt. He has dirty nails, and hasn't shaved for three days. While he is trotting after his patients, she sits there botching socks. And she gets bored! She would like to live in town and dance polkas every evening. Poor little woman! She is gasping for love like a carp for water on a kitchen-table. With three words of gallantry she'd adore one, I'm sure of it. She'd be tender, charming. Yes; but how get rid of her afterwards?'

Then the difficulties of love-making seen in the

distance made him by contrast think of his mistress. She was an actress at Rouen, whom he kept; and when he had pondered over this image, with which, even in remembrance, he was satiated – 'Ah! Madame Bovary,' he thought, 'is much prettier, especially fresher. Virginie is decidedly beginning to grow too stout. She is so finicky with her pleasures; and, besides, she has a mania for prawns.'

The fields were empty, and around him Rodolphe only heard the regular beating of the grass striking against his boots, with a cry of the grasshopper hidden at a distance among the oats. He again saw Emma in her room, dressed as he had seen her and he undressed her.

'Oh, I will have her,' he cried, striking a blow with his stick at a clod in front of him. And he at once began to consider the political part of the enterprise. He asked himself – 'Where shall we meet? And how? We shall always be having the brat on our hands, and the servant, the neighbours, the husband, all sorts of worries. Pshaw! it would all waste too much time.'

Then he resumed, 'Really, she has eyes that pierce your heart like a gimlet. And that pallor! I adore pale women!'

When he reached the top of the Argueil hills he had made up his mind. 'It's only finding the opportunities. Well, I will call in now and then. I'll send them venison, poultry; I'll have myself bled, if need be. We shall become friends; I'll invite them to my place. By Jove!' he added, 'there's the agricultural show coming on. She'll be there. I'll see her. We'll begin, and boldly too; that's the surest way.'

At last it came, the famous agricultural show. On the morning of the solemnity all the inhabitants at their doors were chatting over the preparations. The pediment of the town hall had been hung with garlands of ivy; a tent had been erected in a meadow for the banquet; and in the middle of the Place, in front of the church, a mortar was to be fired to mark the prefect's arrival and give notice that the names of the farmers who obtained prizes would be announced. The National Guard of Buchy (there was none at Yonville) had come to join the corps of firemen, of whom Binet was captain. On that day he wore a collar even higher than usual; and, tightly buttoned in his tunic, his figure was so stiff and motionless that the whole vital portion of his person seemed to have descended into his legs, which rose in a cadence of set steps with a single movement. As there was some rivalry between the tax-collector and the colonel, they both drilled their men separately, to show off their talents. One saw the red epaulettes and the black breastplates passing and repassing alternately; it was never-ending, and always starting again. Never had there been such a display of pomp. Several citizens had scoured their houses the evening before; tricoloured flags hung from the half-open windows; all the publichouses were full; and in the lovely weather the starched caps, the golden crosses, and the coloured neckerchiefs, seemed whiter than snow, shone in the sun, and relieved with their motley colours the sombre monotony of the frock-coats and blue smocks. The

neighbouring farmers' wives, when they got off their horses, pulled out the long pins that fastened around them their dresses, turned up for fear of mud; and the husbands, for their part, in order to save their hats, kept their handkerchiefs around them, holding one corner between their teeth.

The crowd entered the main street from each end of the village. People poured in from the lanes, the alleys, the houses; and from time to time one heard knockers banging against doors closing behind women, wearing their gloves, who were going out to see the fête. What was most admired were two long lamp-stands covered with lanterns, that flanked a platform on which the authorities were to sit. Besides this there were against the four columns of the town hall four kinds of poles, each bearing a small standard of greenish cloth, embellished with inscriptions in gold letters. On one was written, 'To Commerce'; on the other, 'To Agriculture'; on the third, 'To Industry'; and on the fourth, 'To the Fine Arts'.

But the jubilation that brightened all faces seemed to darken that of Madame Lefrançois, the innkeeper. Standing on her kitchen-steps she muttered to herself, 'What rubbish! what rubbish! With their canvas booth! Do they think the prefect will be glad to dine down there under a tent like a gypsy? They call all this fussing doing good to the place! Then it wasn't worth while sending to Neufchâtel for the keeper of a cookshop! And for whom? For cowherds! tatterdemalions!'

The druggist was passing. He had on a frock-coat, nankeen trousers, beaver shoes, and, for a wonder, a hat with a low crown.

'Your servant! Excuse me, I am in a hurry.' And as

the fat widow asked where he was going – 'It seems odd to you, doesn't it, I who am always more cooped up in my laboratory than the man's rat in his cheese.'

'What cheese?' asked the landlady.

'Oh, nothing! nothing!' Homais continued. 'I merely wished to convey to you, Madame Lefrançois, that I usually live at home like a recluse. Today, however, considering the circumstances, it is necessary – '

'Oh, you're going down there!' she said contemptuously.

'Yes, I am going,' replied the druggist, astonished. 'Am I not a member of the consulting commission?'

Mère Lefrançois looked at him for a few moments, and ended by saying with a smile – 'That's a very different pair of shoes! But what does agriculture matter to you? Do you understand anything about it?'

'Certainly I understand it, since I am a druggist,—that is to say, a chemist. And the object of chemistry, Madame Lefrançois, being the knowledge of the reciprocal and molecular action of all natural bodies, it follows that agriculture is comprised within its domain. And, in fact, the composition of the manure, the fermentation of liquids, the analyses of gases, and the influence of miasmata, what, I ask you, is all this, if it isn't chemistry, pure and simple?'

The landlady did not answer. Homais went on — 'Do you think that to be an agriculturist it is necessary to have tilled the earth or fattened fowls oneself? It is necessary rather to know the composition of the substances in question — the geological strata, the atmospheric actions, the quality of the soil, the minerals, the waters, the density of the different bodies, their capillarity, and what not. And one must

be master of all the principles of hygiene in order to direct, criticise the construction of buildings, the feeding of animals, the diet of domestics. And, moreover, Madame Lefrançois, one must know botany, be able to distinguish between plants, you understand, which are the wholesome and those that are deleterious, which are unproductive and which nutritive, if it is well to pull them up here and re-sow them there, to propagate some, destroy others; in brief, one must keep pace with science by means of pamphlets and public papers, be always on the alert to find out improvements.'

The landlady never took her eyes off the Café Français and the chemist went on – 'Would to God our agriculturists were chemists, or that at least they would pay more attention to the counsels of science. Thus lately I myself wrote a considerable tract, a memoir of over seventy-two pages, entitled, "Cider, its Manufacture and its Effects, together with some New Reflections on the Subject", that I sent to the Agricultural Society of Rouen, and which even procured me the honour of being received among its members – Section, Agriculture; Sub-section, Pomology. Well, if my work had been given to the public – ' But the druggist stopped, Madame Lefrançois seemed so preoccupied.

'Just look at them!' she said. 'It's past comprehension! Such a cookshop as that!' And with a shrug of the shoulders that stretched out over her breast the stitches of her knitted bodice, she pointed with both hands at her rival's inn, whence songs were heard issuing. 'Well, it won't last long,' she added. 'It'll be over before a week.'

Homais drew back with stupefaction. She came

down three steps and whispered in his ear – 'What! you didn't know it? There is to be an execution in next week. It's Lheureux who is selling him out; he has killed him with bills.'

'What a terrible catastrophe!' cried the druggist, who always found expressions in harmony with all imaginable circumstances.

Then the landlady began telling him the story that she had heard from Theodore, Monsieur Guillaumin's servant, and although she detested Tellier, she blamed Lheureux. He was 'a wheedler, a sneak'.

'There!' she said. 'Look at him! he is in the market; he is bowing to Madame Bovary, who's got on a green bonnet. Why, she's taking Monsieur Boulanger's arm.'

'Madame Bovary!' exclaimed Homais. 'I must go at once and pay her my respects. Perhaps she'll be very glad to have a seat in the enclosure under the peristyle.' And, without heeding Madame Lefrançois, who was calling him back to tell him more about it, the druggist walked off rapidly with a smile on his lips, with straight knees, bowing copiously to right and left, and taking up much room with the large tails of his frock-coat that fluttered behind him in the wind.

Rodolphe having caught sight of him from afar, hurried on, but Madame Bovary lost her breath; so he walked more slowly, and, smiling at her, said in a rough tone – 'It's only to get away from the fat fellow, you know, the druggist.' She pressed his elbow.

'What's the meaning of that?' he asked himself. And he looked at her out of the corner of his eyes.

Her profile was so calm that one could guess nothing from it. It stood out in the light from the oval of her bonnet, with pale ribbons on it like the leaves of weeds. Her eyes with their long curved lashes looked straight before her, and though wide open, they seemed slightly puckered by the cheekbones, because of the blood pulsing gently under the delicate skin. A pink line ran along the partition between her nostrils. Her head was bent upon her shoulder, and the pearl tips of her white teeth were seen between her lips.

'Is she making fun of me!' thought Rodolphe.

Emma's gesture, however, had only been meant for a warning; for Monsieur Lheureux was accompanying them, and spoke now and again as if to enter into the conversation.

'What a superb day! Everybody is out! The wind is east!'

And neither Madame Bovary nor Rodolphe answered him, whilst at the slightest movement made by them he drew near, saying, 'I beg your pardon!' and raised his hat.

When they reached the farrier's house, instead of following the road up to the fence, Rodolphe suddenly turned down a path, drawing Madame Bovary with him. He called out – 'Good-evening, Monsieur Lheureux! See you again presently.'

'You gave him the slip all right,' she laughed.

'Why allow oneself to be intruded upon by others?' he went on. 'And as today I have the happiness of being with you -'

Emma blushed. He did not finish his sentence. Then he talked of the fine weather and of the pleasure of walking on the grass. A few daisies had sprung up again.

'Here are some pretty Easter daisies,' he said, 'and enough of them to furnish oracles to all the amorous maids in the place.' He added, 'Shall I pick some? What do you think?'

'Are you in love?' she asked, coughing a little. 'H'm, h'm! who knows?' answered Rodolphe.

The meadow began to fill, and the housewives hustled you with their great umbrellas, their baskets, and their babies. One had often to get out of the way of a long file of country folk, servant-maids with blue stockings, flat shoes, silver rings, and who smelt of milk, when one passed close to them. They walked along holding one another by the hand, and thus they spread over the whole field from the row of open trees to the banquet tent. But this was the examination time, and the farmers one after the other entered a kind of enclosure formed by a long cord supported on sticks.

The beasts were there, their noses towards the cord, and making a confused line with their unequal rumps. Drowsy pigs were burrowing in the earth with their snouts, calves were bleating, lambs baaing, the cows, with knees folded in, were stretching their bellies on the grass, slowly chewing the cud, and blinking their heavy evelids at the gnats that buzzed round them. Ploughmen with bare arms were holding by the halter prancing stallions that neighed with dilated nostrils as they looked across to the mares. These stood quietly, stretching out their heads and flowing manes, while their foals rested in their shadow, or now and then came and sucked them. And above the long undulation of these crowded animals one saw some white mane rising in the wind like a wave, or some sharp horns sticking out, and the heads of men running about. Apart, outside the enclosure, a hundred paces off, was a large black bull, muzzled, with an iron ring in its nostrils, and who moved no more than if he had been in bronze. A child in rags was holding him by a rope.

Between the two lines the committee-men were walking with heavy steps, examining each animal, then consulting one another in a low voice. One who seemed of more importance now and then took notes in a book as he walked along. This was the president of the jury, Monsieur Derozerays de la Panville. On recognising Rodolphe he at once came forward quickly, and smiling amiably, said – 'What! Monsieur Boulanger, you are deserting us?'

Rodolphe protested that he was just coming. But when the president had disappeared – 'Upon my word!' said he, 'I shall not go. Your company is better than his.'

And while poking fun at the show, Rodolphe, to move about more easily, showed the gendarme his blue card, and even stopped now and then in front of some fine beast, which Madame Bovary did not at all admire. He noticed this, and began jeering at the Yonville ladies and their dresses; then he apologised for the negligence of his own. He had that incongruity of common and elegant in which the habitually vulgar think they see the revelation of an eccentric existence, of the perturbations of sentiment, the tyrannies of art, and always a certain contempt for social conventions, that seduces or exasperates them. Thus his cambric shirt with plaited cuffs was blown out by the wind in the opening of his waistcoat of grey ticking, and his broad-striped trousers disclosed at the ankle nankeen boots with patent leather gaiters. These were so polished that they reflected the grass. He trampled on horses' dung with them, one hand in the pocket of his jacket and his straw hat on one side.

'Besides,' added he, 'when one lives in the country –'
'It's waste of time,' said Emma.

'That is true,' replied Rodolphe. 'To think that not one of these people is capable of understanding even the cut of a coat!'

Then they talked about provincial pettiness, of the lives it crushed, of the illusions lost there.

'And I too,' said Rodolphe, 'am drifting into depression.'

'You!' she said in astonishment; 'I thought you very light-hearted.'

'Ah! yes. I seem so, because in the midst of the world I know how to wear the mask of a scoffer upon my face; and yet, how many a time at the sight of a cemetery by moonlight have I not asked myself whether it were not better to join those sleeping there!'

'Oh! and your friends?' she said. 'You do not think of them.'

'My friends! What friends? Have I any? Who cares for me?' And he accompanied the last words with a kind of whistling of the lips.

But they were obliged to separate from each other because of a great pile of chairs that a man was carrying behind them. He was so overladen with them that one could only see the tips of his wooden shoes and the ends of his two outstretched arms. It was Lestiboudois, the gravedigger, who was carrying the church chairs about amongst the people. Alive to all that concerned his interests, he had hit upon this means of turning the show to account; and his idea was succeeding, for he no longer knew which way to turn. In fact, the villagers, who were hot, quarrelled for these seats, whose straw smelt of incense, and they leant against the thick backs, stained with the wax of candles, with a certain veneration.

Madame Bovary again took Rodolphe's arm; he

went on as if speaking to himself – 'Yes, I have missed so many things. Always alone! Ah! if I had some aim in life, if I had met some love, if I had found someone! Oh, how I would have spent all the energy of which I am capable, surmounted everything, overcome everything!'

'Yet it seems to me,' said Emma, 'that you are not to be pitied.'

'Ah! you think so?' said Rodolphe.

'For, after all,' she went on, 'you are free – ' she hesitated, 'rich – '

'Do not mock me,' he replied.

And she protested that she was not mocking him, when the report of a cannon resounded. Immediately all began hustling one another pell-mell towards the village.

It was a false alarm. The prefect seemed not to be coming and the members of the jury felt much embarrassed, not knowing if they ought to begin the meeting, or continue to wait.

At last a large hired landau appeared at the end of the Place, drawn by two skinny horses, which a coachman in a white hat was whipping lustily. Binet had only just time to shout, 'Present arms!' and the colonel to imitate him. All ran towards the enclosure; everyone pushed forward. A few even forgot their collars; but the equipage of the prefect seemed to anticipate the crowd, and the two yoked jades, trapesing in their harness, came up at a little trot in front of the peristyle of the town hall at the very moment when the National Guard and firemen deployed, beating drums and marking time.

'Present!' shouted Binet.

'Halt!' shouted the colonel. 'Left about, march.'

And after presenting arms, during which the clang of the band, letting loose, rang out like a brass kettle rolling downstairs, all the guns were lowered. Then was seen stepping down from the carriage a gentleman in a short coat with silver braiding, with bald brow, and wearing a tuft of hair at the back of his head, of a sallow complexion and the most benign appearance. His eyes, very large and covered by heavy lids, were halfclosed to look at the crowd, while at the same time he raised his sharp nose, and forced a smile upon his sunken mouth. He recognised the mayor by his scarf, and explained that the prefect was not able to come. He himself was a councillor at the prefecture; then he added a few apologies. Monsieur Tuvache responded with compliments; the other confessed himself nervous; and they remained thus, face to face, their foreheads almost touching, with the members of the jury all round, the municipal council, the notable personages, the National Guard and the crowd. The councillor pressing his little cocked hat to his breast repeated his bows, while Tuvache, bent like a bow, also smiled, stammered, tried to say something, protested his devotion to the monarchy and the honour that was being done to Yonville.

Hippolyte, the groom from the inn, took the head of the horses from the coachman, and, limping along with his club-foot, led them to the door of the Lion d'Or where a number of peasants collected to look at the carriage. The drum beat, the howitzer thundered, and the gentlemen one by one mounted the platform, where they sat down in red utrecht velvet armchairs that had been lent by Madame Tuvache.

All these people looked alike. Their fair flabby faces, somewhat tanned by the sun, were the colour of sweet

cider, and their puffy whiskers emerged from stiff collars, kept up by white cravats with broad bows. All the waistcoats were of velvet, double-breasted; all the watches had, at the end of a long ribbon, an oval cornelian seal; everyone rested his two hands on his thighs, carefully stretching the stride of their trousers, whose unsponged glossy cloth shone more brilliantly than the leather of their heavy boots.

The ladies of the company stood at the back under the vestibule between the pillars, while the common herd was opposite, standing up or sitting on chairs. As a matter of fact, Lestiboudois had brought thither all those that he had moved from the field, and he even kept running back every minute to fetch others from the church. He caused such confusion with this piece of business that one had great difficulty in getting to the small steps of the platform.

'I think,' said Monsieur Lheureux to the chemist, who was passing to his place, 'that they ought to have put up two Venetian masts with something rather severe and rich for ornaments; it would have been a very pretty effect.'

'To be sure,' replied Homais; 'but what can you expect? The mayor took everything on his own shoulders. He hasn't much taste. Poor Tuvache! and he is even completely destitute of what is called the genius of art.'

Rodolphe, meanwhile, with Madame Bovary, had gone up to the first floor of the town hall, to the 'council-room', and, as it was empty, he declared that they would enjoy the sight there more comfortably. He fetched three stools from the round table under the bust of the monarch, and having carried them to one of the windows, they sat down by each other.

There was commotion on the platform, long whisperings, much parleying. At last the councillor got up. They knew now that his name was Lieuvain, and in the crowd the name was passed from one to the other. After he had collated a few pages, and bent over them to see better, he began - 'Gentlemen! May I be permitted first of all (before addressing you on the object of our meeting today, and this sentiment will, I am sure, be shared by you all), may I be permitted, I say, to pay a tribute to the higher administration, to the government, to the monarch, gentlemen, our sovereign, to that beloved king, to whom no branch of public or private prosperity is a matter of indifference, and who directs with a hand at once so firm and wise the chariot of the state amid the incessant perils of a stormy sea, knowing, moreover, how to make peace respected as well as war, industry, commerce, agriculture, and the fine arts?'

'I ought,' said Rodolphe, 'to get back a little farther.'

'Why?' said Emma.

But at this moment the voice of the councillor rose to an extraordinary pitch. He declaimed – 'This is no longer the time, gentlemen, when civil discord ensanguined our public places, when the landlord, the businessman, the working-man himself, falling asleep at night, lying down to peaceful sleep, trembled lest he should be awakened suddenly by the noise of incendiary tocsins, when the most subversive doctrines audaciously sapped foundations.'

'Well, someone down there might see me,' Rodolphe resumed, 'then I should have to invent excuses for a fortnight; and with my bad reputation – '

'Oh, you are slandering yourself,' said Emma.

'No! It is dreadful, I assure you.'

'But, gentlemen,' continued the councillor, 'if, banishing from my memory the remembrance of these sad pictures, I carry my eyes back to the actual situation of our dear country, what do I see there? Everywhere commerce and the arts are flourishing; everywhere new means of communication, like so many new arteries in the body of the state, establish within it new relations. Our great industrial centres have recovered all their activity; religion, more consolidated, smiles in all hearts; our ports are full, confidence is born again, and France breathes once more!'

'Besides,' added Rodolphe, 'perhaps from the world's point of view they are right.'

'How so?' she asked.

'What!' said he. 'Do you not know that there are souls constantly tormented? They need by turns to dream and to act, the purest passions and the most turbulent joys, and thus they fling themselves into all sorts of fantasies, of follies.'

Then she looked at him as one looks at a traveller who has voyaged over strange lands, and went on – 'We have not even this distraction, we poor women!'

'A sad distraction, for happiness isn't found in it.'

'But is it ever found?' she asked.

'Yes; one day it comes,' he answered.

'And this is what you have understood,' said the councillor. 'You, farmers, agricultural labourers! you pacific pioneers of a work that belongs wholly to civilisation! you, men of progress and morality, you have understood, I say, that political storms are even more redoubtable than atmospheric disturbances!'

'It comes one day,' repeated Rodolphe, 'one day suddenly, and when one is despairing of it. Then the

horizon expands; it is as if a voice cried, "It is here!" You feel the need of confiding the whole of your life, of giving everything, sacrificing everything to this being. There is no need for explanations; they understand one another. They have seen each other in dreams!' (And he looked at her.) 'In fine, here it is, this treasure so sought after, here before you. It glitters, it flashes; yet one still doubts, one does not believe it; one remains dazzled, as if emerging from darkness into light.'

And as he ended Rodolphe suited the action to the word. He passed his hand over his face, like a man seized with giddiness. Then he let it fall on Emma's. She took hers away.

'And who would be surprised at it, gentlemen? He only who is so blind, so plunged (I do not fear to say it), so plunged in the prejudices of another age as still to misunderstand the spirit of agricultural populations. Where, indeed, is to be found more patriotism than in the country, greater devotion to the public welfare, more intelligence, in a word? And, gentlemen, I do not mean that superficial intelligence, vain ornament of idle minds, but rather that profound and balanced intelligence that applies itself above all else to useful objects, thus contributing to the good of all, to the common amelioration and to the support of the state, born of respect for law and the practice of duty – '

'Ah! again!' said Rodolphe. 'Always "duty". I am sick of the word. They are a lot of old blockheads in flannel vests and of old women with foot-warmers and rosaries who constantly drone into our ears "Duty, duty!" Ah! by Jove! one's duty is to feel what is great, cherish the beautiful, and not accept all the conventions of society with the ignominy that it imposes upon us.'

'Yet - yet - ' objected Madame Bovary.

'No, no! Why cry out against the passions? Are they not the one beautiful thing on the earth, the source of heroism, of enthusiasm, of poetry, music, the arts, of everything, in a word?'

'But one must,' said Emma, 'to some extent bow to the opinion of the world and accept its moral code.'

'Ah! but there are two,' he replied. 'The small, the conventional, that of men, that which constantly changes, that brays out so loudly, that makes such a commotion here below, of the earth earthly, like the mass of imbeciles you see down there. But the other, the eternal, that is about us and above, like the landscape that surrounds us, and the blue heavens that give us light.'

Monsieur Lieuvain had just wiped his mouth with a pocket-handkerchief. He continued - 'And what should I do here, gentlemen, pointing out to you the uses of agriculture? Who supplies our wants? Who provides our means of subsistence? Is it not the agriculturist? The agriculturist, gentlemen, who, sowing with laborious hand the fertile furrows of the country, brings forth the corn, which, being ground, is made into a powder by means of ingenious machinery, comes out thence under the name of flour, and from there, transported to our cities, is soon delivered at the baker's, who makes it into food for poor and rich alike. Again, is it not the agriculturist who fattens, for our clothes, his abundant flocks in the pastures? For how should we clothe ourselves, how nourish ourselves, without the agriculturist? And, gentlemen, is it even necessary to go so far for examples? Who has not frequently reflected on all the momentous things that we get out of that modest

animal, the ornament of poultry-yards, that provides us at once with a soft pillow for our bed, with succulent flesh for our tables, and eggs? But I should never end if I were to enumerate one after the other all the different products which the earth, well cultivated, like a generous mother, lavishes upon her children. Here it is the vine, elsewhere the apple tree for cider, there colza, farther on cheeses and flax. Gentlemen, let us not forget flax, which has made such great strides of late years, and to which I will more particularly call your attention.'

He had no need to call it, for all the mouths of the multitude were wide open, as if to drink in his words. Tuvache by his side listened to him with staring eyes. Monsieur Derozerays from time to time softly closed his eyelids, and farther on the chemist, with his son Napoléon between his knees, put his hand behind his ear in order not to lose a syllable. The chins of the other members of the jury went slowly up and down in their waistcoats in sign of approval. The firemen at the foot of the platform rested on their bayonets; and Binet, motionless, stood with out-turned elbows, the point of his sabre in the air. Perhaps he could hear, but certainly he could see nothing, because of the visor of his helmet, that fell down on his nose. His lieutenant, the youngest son of Monsieur Tuvache, had a bigger one, for his was enormous, and shook on his head, and from it an end of his cotton scarf peeped out. He smiled beneath it with a perfectly infantine sweetness, and his pale little face, whence drops were running, wore an expression of enjoyment and sleepiness.

The square as far as the houses was crowded with people. One saw folk leaning on their elbows at all the windows, others standing at doors, and Justin, in front

of the chemist's shop, seemed quite transfixed by the sight of what he was looking at. In spite of the silence Monsieur Lieuvain's voice was lost in the air. It reached you in fragments of phrases, and interrupted here and there by the creaking of chairs in the crowd; then you suddenly heard the long bellowing of an ox, or else the bleating of the lambs, who answered one another at street corners. In fact, the cowherds and shepherds had driven their beasts thus far, and these lowed from time to time, while with their tongues they tore down some scrap of foliage that hung above their mouths.

Rodolphe had drawn nearer to Emma, and said to her in a low voice, speaking rapidly – 'Does not this conspiracy of the world revolt you? Is there a single sentiment it does not condemn? The noblest instincts, the purest sympathies are persecuted, slandered; and if at length two poor souls do meet, all is so organised that they cannot blend together. Yet they will make the attempt; they will flutter their wings; they will call upon each other. Oh! no matter. Sooner or later, in six months, ten years, they will come together, will love; for fate has decreed it, and they are born one for the other.'

His arms were folded across his knees, and thus lifting his face towards Emma, close by her, he looked fixedly at her. She noticed in his eyes small golden lines radiating from black pupils; she even smelt the perfume of the pomade that made his hair glossy. Then a faintness came over her, she recalled the Viscount who had waltzed with her at Vaubyessard, and his beard exhaled like this air an odour of vanilla and citron, and mechanically she half-closed her eyes the better to breathe it in. But in making this movement,

as she leant back in her chair, she saw in the distance, right on the line of the horizon, the old diligence the 'Hirondelle', that was slowly descending the hill of Leux, dragging after it a long trail of dust. It was in this vellow carriage that Léon had so often come back to her, and by that route yonder that he had gone for ever. She fancied she saw him opposite at his window; then all grew confused; clouds gathered; she seemed to be once more turning in the waltz on the arm of the Viscount, under the light of the lustres, and Léon was not far away, he was coming; yet all the time she was conscious of the scent of Rodolphe's head beside her. This sweetness of sensation pierced through her old desires, and these, like grains of sand under a gust of wind, eddied to and fro in the subtle breath of the perfume which suffused her soul. She opened wide her nostrils several times to drink in the freshness of the ivy round the capitals. She took off her gloves, she wiped her hands, then fanned her face with her handkerchief, while athwart the throbbing of her temples she heard the murmur of the crowd and the voice of the councillor intoning his phrases.

He said – 'Continue, persevere; listen neither to the suggestions of routine, nor to the over-hasty councils of a rash empiricism. Apply yourselves, above all, to the amelioration of the soil, to good manures, to the development of the equine, bovine, ovine, and porcine races. Let these exhibitions be to you pacific arenas, where the victor in leaving it will hold forth a hand to the vanquished, and will fraternise with him in the hope of better success. And you, aged servants, humble domestics, whose hard labour no Government up to this day has taken into consideration, come hither to receive the reward of your silent

virtues, and be assured that the state henceforward has its eye upon you; that it encourages you, protects you; that it will accede to your just demands, and alleviate as much as in it lies the burden of your painful sacrifices.'

Monsieur Lieuvain then sat down; Monsieur Deroze-rays got up, beginning another speech. His was not perhaps so florid as that of the councillor, but it won favour by a more direct style, that is, by more special knowledge and loftier considerations. Thus the praise of the Government took up less space in it; religion and agriculture more. He showed in it the relations of these two, and how they had always contributed to civilisation. Rodolphe with Madame Bovary was talking dreams, presentiments, magnetism. Going back to the cradle of society, the orator painted those fierce times when men lived on acorns in the heart of woods. Then they had left off the skins of beasts, had put on cloth, tilled the soil, planted the vine. Was this good, and in this discovery was there not more of injury than of gain? Monsieur Derozerays set himself this problem. From magnetism little by little Rodolphe had come to affinities, and while the president was citing Cincinnatus and his plough, Diocletian planting his cabbages, and the Emperors of China inaugurating the year by the sowing of seed, the young man was explaining to the young woman that these irresistible attractions find their cause in some previous state of existence.

'Thus we,' he said, 'why did we come to know one another? What chance willed it? It was because across the infinite, like two streams that flow but to unite, our special bents of mind had driven us towards each other.'

And he seized her hand; she did not withdraw it.

'For good farming generally!' cried the president.

'Just now, for example, when I went to your house.'

"To Monsieur Bizet of Quincampoix."

'Did I know I should accompany you?'

'Seventy francs.'

'A hundred times I wished to go; and I followed you – I remained.'

'Manures!'

'And I shall remain tonight, tomorrow, all other days, all my life!'

'To Monsieur Caron of Argueil, a gold medal!'

'For I have never in the society of any other person found so complete a charm.'

'To Monsieur Bain of Givry-Saint-Martin.'

'And I shall carry away with me the remembrance of you.'

'For a merino ram!'

'But you will forget me; I shall pass away like a shadow.'

'To Monsieur Belot of Notre-Dame.'

'Oh, no! I shall be something in your thought, in your life, shall I not?'

'The Porcine class; prizes – equal, to Messrs Lehérissé and Cullembourg, sixty francs!'

Rodolphe was pressing her hand, and he felt it all warm and quivering like a captive dove that wants to fly away; but, whether she was trying to take it away or whether she was answering his pressure, she made a movement with her fingers. He exclaimed – 'Oh, I thank you! You do not repulse me! You are good! You understand that I am yours! Let me look at you; let me contemplate you!'

A gust of wind that blew in at the window ruffled the

cloth on the table, and in the square below all the great caps of the peasant women were uplifted by it like the wings of white butterflies fluttering.

'Use of oil-cakes,' continued the president. He was hurrying on; 'Flemish manurc – flax-growing – drainage – long leases – domestic service.'

Rodolphe was no longer speaking. They looked at one another. A supreme desire made their dry lips tremble, and wearily, without an effort, their fingers intertwined.

'Catherine Nicaise Elizabeth Leroux, of Sassetotla-Guerrière, for fifty-four years of service on the same farm, a silver medal – value, twenty-five francs!'

'Where is Catherine Leroux?' repeated the councillor. She did not present herself, and one could hear voices whispering - 'Go up!'

'Don't be frightened!'

'Oh, how silly she is!'

'Well, is she there?' cried Tuvache.

'Yes; here she is.'

'Then let her come up!'

Then there came forward on the platform a little old woman with timid bearing, who seemed to shrink within her poor clothes. On her feet she wore heavy wooden clogs, and from her hips hung a large blue apron. Her pale face framed in a borderless cap was more wrinkled than a withered russet apple. And from the sleeves looked out two large hands with knotty joints; the dust of barns, the washing soda, the grease of wools, had so encrusted, roughened, hardened these that they seemed dirty, although they had been rinsed in clear water; and by dint of long service they remained half open, as if to bear their own humble witness of all this suffering endured. Something of

monastic rigidity dignified her face. Nothing of sadness or of emotion weakened that pale look. In her constant living with animals she had caught their dumbness and their calm. It was the first time that she found herself in the midst of so large a company, and inwardly scared by the flags, the drums, the gentlemen in frock-coats, and the order of the councillor, she stood stock-still, not knowing whether to go forward or run away, nor why the crowd was pushing her and the jury smiling at her. Thus stood before these radiant bourgeois this half-century of servitude.

'Approach, venerable Catherine Nicaise Elizabeth Leroux!' said the councillor, who had taken the list of prizewinners from the president; and, looking at the piece of paper and the old woman by turns, he repeated in a fatherly tone – 'Approach! approach!'

'Are you deaf?' said Tuvache, fidgeting in his armchair; and he began shouting in her ear, 'Fifty-four years of service. A silver medal! Twenty-five francs! For you!'

Then, when she had her medal, she looked at it, and a smile of beatitude spread over her face; and as she walked away they could hear her muttering – 'I'll give it to our curé up home, to say some masses for me!'

'What fanaticism!' exclaimed the chemist, leaning across to the notary.

The meeting was over, the crowd dispersed, and now that the speeches had been read, each one fell back into his place again, and everything into the old grooves; the masters bullied the servants, and these struck the animals, indolent victors, going back to the stalls, a green crown on their horns.

The National Guards, however, had gone up to the first floor of the town hall with buns spitted on their

bayonets, and the drummer of the battalion carried a basket with bottles. Madame Bovary took Rodolphe's arm; he saw her home; they separated at her door; then he walked about alone in the meadow while he waited for the time of the banquet.

The feast was long, noisy, ill-served; the guests were so crowded that they could hardly move their elbows; and the narrow planks used for forms almost broke down under their weight. They ate hugely. Each one stuffed himself on his own account. Sweat stood on every brow, and a whitish steam, like the vapour of a stream on an autumn morning, floated above the table between the hanging lamps. Rodolphe, leaning against the calico of the tent, was thinking so earnestly of Emma that he heard nothing. Behind him on the grass the servants were piling up the dirty plates, his neighbours were talking; he did not answer them; they filled his glass, and there was silence in his thoughts in spite of the growing noise. He was dreaming of what she had said, of the line of her lips; her face, as in a magic mirror, shone on the plates of the shakos, the folds of her gown fell along the walls, and days of love unrolled to all infinity before him in the vistas of the future.

He saw her again in the evening during the fireworks, but she was with her husband, Madame Homais, and the druggist, who was worrying about the danger of stray rockets, and every moment he left the company to go and give some advice to Binet.

The pyrotechnic pieces sent to Monsieur Tuvache had, through an excess of caution, been shut up in his cellar, and so the damp powder would not light, and the principal set piece, that was to represent a dragon biting his tail, failed completely. Now and then a

meagre Roman-candle went off; then the gaping crowd sent up a shout that mingled with the cry of the women whose waists were being squeezed in the darkness. Emma silently nestled against Charles's shoulder; then, raising her chin, she watched the luminous rays of the rockets against the dark sky. Rodolphe gazed at her in the light of the burning lanterns.

They went out one by one. The stars shone out. A few drops of rain began to fall. She knotted her fichu round her bare head.

At this moment the councillor's carriage came out from the inn. His coachman, who was drunk, suddenly dozed off, and one could see from the distance, above the hood, between the two lanterns, the mass of his body, that swayed from right to left with the giving of the traces.

'Truly,' said the druggist, 'one ought to proceed most rigorously against drunkenness! I should like to see written up weekly at the door of the town hall on a board *ad hoc* the names of all those who during the week got intoxicated on alcohol. Besides, with regard to statistics, one would thus have, as it were, public records that one could refer to in case of need. But excuse me!'

And he once more ran off to the captain. The latter was going back to see his lathe again.

'Perhaps you would not do ill,' Homais said to him, 'to send one of your men or to go yourself – '

'Leave me alone!' answered the tax-collector. 'It's all right!'

'Do not be uneasy,' said the druggist, when he returned to his friends. 'Monsieur Binet has assured me that all precautions have been taken. No sparks have fallen; the pumps are full. Let us go to rest.'

'My word! I want it,' said Madame Homais, yawning at large. 'But never mind; we've had a beautiful day for our fête.'

Rodolphe repeated in a low voice, and with a tender look, 'Oh, yes! very beautiful!'

And having bowed to one another, they separated. Two days later, in the *Fanal de Rouen*, there was a

long article on the show. Homais had composed it with verve the very next morning.

'Why these festoons, these flowers, these garlands? Whither hurries this crowd like the waves of a furious sea under the torrents of a tropical sun pouring its heat upon our heads?'

Then he spoke of the condition of the peasants. Certainly the Government was doing much, but not enough. 'Courage!' he cried to it; 'a thousand reforms are indispensable; let us accomplish them!' Then touching on the entry of the councillor, he did not forget 'the martial air of our militia', nor 'our most merry village maidens', nor the 'bald-headed old men like patriarchs who were there, and of whom some, the remnants of our phalanxes, still felt their hearts beat at the manly sound of the drums'. He cited himself among the first of the members of the jury, and he even called attention in a note to the fact that Monsieur Homais, chemist, had sent a memoir on cider to the agricultural society. When he came to the distribution of the prizes, he painted the joy of the prizewinners in dithyrambic strophes. 'The father embraced the son, the brother the brother, the husband his consort. More than one showed his humble medal with pride; and no doubt when he got home to his good housewife, he hung it up weeping on the modest walls of his cot.

'About six o'clock a banquet prepared in the meadow of Monsieur Leigeard brought together the principal personages of the fête. The greatest cordiality reigned here. Divers toasts were proposed: Monsieur Lieuvain, the King; Monsieur Tuvache, the Prefect; Monsieur Derozerays, Agriculture; Monsieur Homais, Industry and the Fine Arts, those twin sisters; Monsieur Leplichey, Progress. In the evening some brilliant fireworks on a sudden illumined the air. One would have called it a veritable kaleidoscope, a real operatic scene; and for a moment our little locality might have thought itself transported into the midst of a dream of the *Thousand and One Nights*.

'Let us state that no untoward event disturbed this family meeting.' And he added: 'Only the absence of the clergy was remarked. No doubt the sacristy understands progress in another fashion. As you please, messieurs the followers of Loyola!'

Six weeks slipped by. Rodolphe did not come again. At last one evening he appeared.

The day after the show he had said to himself – 'We mustn't go back too soon; that would be a mistake.'

And at the end of a week he had gone off hunting. After the hunting he had thought it was too late, and then he reasoned thus – 'If from the first day she loved me, she must from impatience to see me again love me more. Let's go on with it!'

And he knew that his calculation had been right when, on entering the room, he saw Emma turn pale.

She was alone. The day was drawing in. The small muslin curtain along the windows deepened the twilight, and the gilding of the barometer, on which the rays of the sun fell, shone in the looking glass between the meshes of the coral.

Rodolphe remained standing, and Emma hardly answered his first conventional phrases.

'I,' he said, 'have been busy. I have been ill.'

'Seriously?' she cried.

'Well,' said Rodolphe, sitting down at her side on a footstool, 'no; it was because I did not want to come back.'

'Why?'

'Can you not guess?'

He looked at her again, but so hard that she lowered her head, blushing. He went on – 'Emma!'

'Sir,' she said, drawing back a little.

'Ah! you see,' replied he in a melancholy voice, 'that I was right not to come back; for this name, this name

that fills my whole soul, and that escaped me, you forbid me to use! Madame Bovary! why all the world calls you thus! Besides, it is not your name; it is the name of another!' he repeated, 'of another!' And he hid his face in his hands. 'Yes, I think of you constantly. The memory of you drives me to despair. Ah! forgive me! I will leave you! Farewell! I will go far away, so far that you will never hear of me again; and yet – today – I know not what force impelled me towards you. For one does not struggle against Heaven; one cannot resist the smile of angels; one is carried away by that which is beautiful, charming, adorable.'

It was the first time that Emma had heard such words spoken to herself, and her pride, like one who reposes bathed in warmth, expanded softly and fully at this glowing language.

'But if I did not come,' he continued, 'if I could not see you, at least I have gazed long on all that surrounds you. At night – every night – I arose; I came here; I watched your house glimmering in the moon, the trees in the garden swaying before your window, and the little lamp, a gleam shining through the window-panes in the darkness. Ah! you never knew that there, so near you, so far from you, was a poor wretch!'

She turned towards him with a sob.

'Oh, you are good!' she said.

'No, I love you, that is all! You do not doubt that! Tell me – one word – only one word!'

And Rodolphe imperceptibly glided from the footstool to the ground; but a sound of wooden shoes was heard in the kitchen, and he noticed the door of the room was not closed.

'How kind it would be of you,' he went on, rising, 'if you would humour a whim of mine.' It was to go over

her house; he wanted to know it; and Madame Bovary seeing no objection to this, they both rose, when Charles came in.

'Good-morning, doctor,' Rodolphe said to him.

The doctor, flattered at this unexpected title, launched out into obsequious phrases. Of this the other took advantage to pull himself together a little.

'Madame was speaking to me,' he then said, 'about her health.'

Charles interrupted him; he had indeed a thousand anxieties; his wife's palpitations of the heart were beginning again. Then Rodolphe asked whether riding might not be good.

'Certainly! excellent! just the thing! There's an ideal You ought to follow it up.'

And as she objected that she had no horse, Monsieur Rodolphe offered one. She refused his offer; he did not insist. Then to explain his visit he said that his ploughman, the man of the blood-letting, still suffered from giddiness.

'I'll call around,' said Bovary.

'No, no! I'll send him to you; we'll come; that will be more convenient for you.'

'Ah! very good! I thank you.'

And as soon as they were alone, 'Why don't you accept Monsieur Boulanger's kind offer?'

She assumed a sulky air, invented a thousand excuses, and finally declared that perhaps it would look odd.

'Well, what the deuce do I care for that?' said Charles, making a pirouette. 'Health before everything! You are wrong.'

'And how do you think I can ride when I haven't got a habit?'

'You must order one,' he answered.

The riding-habit decided her.

When the habit was ready, Charles wrote to Monsieur Boulanger that his wife was at his command, and that they counted on his good-nature.

The next day at noon Rodolphe appeared at Charles's door with two saddle-horses. One had pink rosettes at his ears and a deerskin side-saddle.

Rodolphe had put on high soft boots, saying to himself that no doubt she had never seen anything like them. In fact, Emma was charmed with his appearance as he stood on the landing in his great velvet coat and white corduroy breeches. She was ready; she was waiting for him.

Justin escaped from the chemist's to see her start, and the chemist also came out. He was giving Monsieur Boulanger a little good advice.

'An accident happens so easily. Be careful! Your horses perhaps are mettlesome.'

She heard a noise above her; it was Félicité drumming on the windowpanes to amuse little Berthe. The child blew her a kiss; her mother answered with a wave of her whip.

'A pleasant ride!' cried Monsieur Homais. 'Prudence! above all, prudence!' And he flourished his newspaper as he saw them disappear.

As soon as he felt the ground, Emma's horse set off at a gallop. Rodolphe galloped by her side. Now and then they exchanged a word. Her figure slightly bent, her hand well up, and her right arm stretched out, she gave herself up to the cadence of the movement that rocked her in her saddle. At the bottom of the hill Rodolphe gave his horse its head; they started together at a bound, then at the top

suddenly the horses stopped, and her large blue veil fell about her.

It was early in October. There was fog over the land. Hazy clouds hovered on the horizon between the outlines of the hills; others, rent asunder, floated up and disappeared. Sometimes through a rift in the clouds, beneath a ray of sunshine, gleamed from afar the roofs of Yonville, with the gardens at the water's edge, the yards, the walls and the church steeple. Emma half closed her eyes to pick out her house, and never had this poor village where she lived appeared so small. From the height on which they were the whole valley seemed an immense pale lake sending off its vapour into the air. Clumps of trees here and there stood out like black rocks, and the tall lines of the poplars that rose above the mist were like a beach stirred by the wind.

By the side, on the turf between the pines, a brown light shimmered in the warm atmosphere. The earth, ruddy like the powder of tobacco, deadened the noise of their steps, and with the edge of their shoes the horses as they walked kicked the fallen fir cones in front of them.

Rodolphe and Emma thus went along the skirt of the wood. She turned away from time to time to avoid his look, and then she saw only the pine trunks in lines, whose monotonous succession made her a little giddy. The horses were panting; the leather of the saddles creaked.

Just as they were entering the forest the sun shone out.

'God protects us!' said Rodolphe.

'Do you think so?' she said.

'Forward! forward!' he continued.

He 'tchk'd' with his tongue. The two beasts set off at a trot. Long ferns by the roadside caught in Emma's stirrup. Rodolphe leaned forward and removed them as they rode along. At other times, to turn aside the branches, he passed close to her, and Emma felt his knee brushing against her leg. The sky was now blue, the leaves no longer stirred. There were spaces full of heather in flower, and plots of violets alternated with the confused patches of the trees that were grey, fawn, or golden coloured, according to the nature of their leaves. Often in the thicket was heard the fluttering of wings, or else the hoarse, soft cry of the ravens flying off amidst the oaks.

They dismounted. Rodolphe fastened up the horses. She walked on in front on the moss between the paths. But her long habit got in her way, although she held it up by the skirt; and Rodolphe, walking behind her, saw between the black cloth and the black shoe the fineness of her white stocking, seeming to him as a part of her nakedness.

She stopped. 'I am tired,' she said.

'Come, try again,' he went on. 'Courage!'

Then some hundred paces farther on she stopped again, and through her veil, that fell sideways from her man's hat over her hips, her face appeared in a bluish transparency as if she were floating under azure waves.

'But where are we going?'

He did not answer. She was breathing irregularly. Rodolphe looked round him biting his moustache. They came to a larger space where the coppice had been cut. They sat down on the trunk of a fallen tree, and Rodolphe began speaking to her of his love. He did not begin by frightening her with compliments. He was calm, serious, melancholy.

Emma listened to him with bowed head, and stirred the bits of wood on the ground with the tip of her foot.

But at the words, 'Are not our destinies now one? -'

'Oh, no!' she replied. 'You know that well. It is impossible!'

She rose to go. He seized her by the wrist. She stopped. Then, having gazed at him for a few moments with an amorous and humid look, she said hurriedly—'Ah! do not speak of it again! Where are the horses? Let us go back.'

He made a gesture of anger and annoyance. She repeated: 'Where are the horses?' Where are the horses?'

Then smiling a strange smile, his pupil fixed, his teeth set, he advanced with outstretched arms. She recoiled trembling. She stammered: 'Oh, you frighten me! You hurt me! Let me go!'

'If it must be,' he went on, his face changing; and he again became respectful, caressing, timid. She gave him her arm. They went back. He said: 'What was the matter with you? Why? I do not understand. You were mistaken, no doubt. In my soul you are as a Madonna on a pedestal, in a place lofty, secure, immaculate. But I need you to live! I must have your eyes, your voice, your thought! Be my friend, my sister, my angel!'

And he put out his arm round her waist. She feebly tried to disengage herself. He supported her thus as they walked along.

But they heard the two horses browsing on the leaves.

'Oh! one moment!' said Rodolphe. 'Do not let us go! Stay!'

He drew her farther on to a small pool where duckweeds made a greenness on the water. Faded

water-lilies lay motionless between the reeds. At the noise of their steps in the grass, frogs jumped away to hide themselves.

'I am wrong! I am wrong!' she said. 'I am mad to listen to you!'

'Why? Emma! Emma!'

'Oh, Rodolphe!' said the young woman slowly, leaning on his shoulder.

The cloth of her habit caught against the velvet of his coat. She threw back her white neck, swelling with a sigh, and faltering, in tears, with a long shudder and hiding her face, she gave herself up to him.

The shades of night were falling; the level sun passing between the branches dazzled the eyes. Here and there around her, in the leaves or on the ground, trembled luminous patches, as if hummingbirds flying about had scattered their feathers. Silence was everywhere; something sweet seemed to come forth from the trees; she felt her heart, whose beating had begun again, and the blood coursing through her flesh like a stream of milk. Then far away, beyond the wood, on the other hills, she heard a vague prolonged cry, a voice which lingered, and in silence she heard it mingling like music with the last pulsations of her throbbing nerves. Rodolphe, a cigar between his lips, was mending one of the two broken bridles with his penknife.

They returned to Yonville by the same road. On the mud they saw again the traces of their horses side by side, the same thickets, the same stones in the grass; nothing around them seemed changed; and yet for her something had happened more stupendous than if the mountains had moved in their places. Rodolphe now and again bent forward and took her hand to kiss it.

She was charming on horseback – upright, with her slender waist, her knee bent on the mane of her horse, her face somewhat flushed by the fresh air in the red of the evening.

On entering Yonville she made her horse prance in the road. People looked at her from the windows.

At dinner her husband thought she looked well, but she pretended not to hear him when he enquired about her ride, and she remained sitting there with her elbow at the side of her plate between the two lighted candles.

'Emma!' he said.

'What?'

'Well, I spent the afternoon at Monsieur Alexandre's. He has an old cob, still very fine, only a little broken-kneed, and that could be bought, I am sure, for a hundred crowns.' He added, 'And thinking it might please you, I have bespoken it – bought it. Have I done right? Do tell me?'

She nodded her head in assent; then a quarter of an hour later – 'Are you going out tonight?' she asked.

'Yes. Why?'

'Oh, nothing, nothing, my dear!'

And as soon as she had got rid of Charles she went and shut herself up in her room.

At first she felt stunned; she saw the trees, the paths, the ditches, Rodolphe, and she again felt the pressure of his arm, while the leaves rustled and the reeds whistled.

But when she saw herself in the glass she wondered at her face. Never had her eyes been so large, so black, of so profound a depth. Something subtle about her being transfigured her. She repeated, 'I have a lover! a lover!' delighting at the idea as if a second puberty had come to her. So at last she was to know those joys of love, that fever of happiness of which she had despaired! She was entering upon marvels where all would be passion, ecstasy, delirium. An azure of infinity encompassed her, the heights of sentiment sparkled under her thought, and ordinary existence appeared only afar off, down below in the shade, through the interspaces of these heights.

Then she recalled the heroines of the books that she had read, and the lyric legion of these adulterous women began to sing in her memory with the voice of sisters that charmed her. She became herself, as it were, an actual part of these imaginings, and realised the love-dream of her youth as she saw herself in this type of amorous women whom she had so envied. Besides, Emma felt a satisfaction of revenge. Had she not suffered enough? But now she triumphed, and the love so long pent up burst forth in full joyous bubblings. She tasted it without remorse, without anxiety, without trouble.

The day following passed with a new sweetness. They made vows to one another. She told him of her sorrows. Rodolphe interrupted her with kisses; and she, looking at him through half-closed eyes, asked him to call her again by her name – to say that he loved her. They were in the forest, as yesterday, in the shed of some wooden-shoe maker. The walls were of straw, and the roof so low they had to stoop. They were seated side by side on a bed of dry leaves.

From that day forth they wrote to each other regularly every evening. Emma placed her letter at the end of the garden, by the river, in a fissure of the wall. Rodolphe came to fetch it, and put another there, which she always found fault with as too short.

One morning, when Charles had gone out before daybreak, she was seized with the fancy to see Rodolphe at once. She would go quickly to La Huchette, stay there an hour, and be back again at Yonville while everyone was still asleep. This idea made her pant with desire, and she soon found herself in the middle of the field, walking with rapid steps, without looking behind her.

Day was just breaking. Emma from afar recognised her lover's house. Its two dovetailed weathercocks stood out black against the pale dawn.

Beyond the farmyard there was a detached building that she thought must be the château. She entered it as if the doors of her approach had opened wide of their own accord. A large straight staircase led up to the corridor. Emma raised the latch of the door, and suddenly at the end of the room she saw a man sleeping. It was Rodolphe. She uttered a cry.

'You here? You here?' he repeated. 'How did you manage to come? Ah! your dress is damp.'

'I love you,' she answered, throwing her arms about his neck.

This first piece of daring successful, now every time Charles went out early Emma dressed quickly and slipped on tiptoe down the steps that led to the water-side.

But when the plank for the cows was taken up, she had to go by the walls alongside of the river; the bank was slippery; in order not to fall she caught hold of the tufts of faded wallflowers. Then she went across the ploughed fields, in which she sank, stumbling, and clogging her thin shoes. Her scarf, knotted round her head, fluttered to the wind in the meadows. She was afraid of the oxen; she began to run; she arrived out of

breath, with rosy cheeks, and breathing out from her whole person a fresh perfume of sap, of verdure, of the open air. At this hour Rodolphe still slept. It was like a spring morning coming into his room.

The yellow curtains along the windows let a heavy, whitish light enter softly. Emma felt about, opening and closing her eyes, while the drops of dew hanging from her hair formed, as it were, a topaz aureole around her face. Rodolphe, laughing, drew her to him, and pressed her to his breast.

Then she examined the apartment, opened the drawers of the tables, combed her hair with his comb, and looked at herself in his shaving-glass. Often she even put between her teeth the big pipe that lay on the table by the bed, amongst the lemons and pieces of sugar near a bottle of water.

It took them a good quarter of an hour to say goodbye. Then Emma cried. She would have wished never to leave Rodolphe. Something stronger than herself forced her to him; so much so, that one day, seeing her come unexpectedly, he frowned as one put out.

'What is the matter with you?' she said. 'Are you ill? Tell me!'

At last he declared with a serious air that her visits were becoming imprudent – that she was compromising herself.

Gradually Rodolphe's fears took possession of her. At first, love had intoxicated her, and she had thought of nothing beyond. But now that he was indispensable to her life, she feared to lose anything of this, or even that it should be disturbed. When she came back from his house, she looked all about her, anxiously watching every form that passed in the horizon, and every village window from which she could be seen. She listened for steps, cries, the noise of the ploughs, and she stopped short, white, and trembling more than the aspen leaves swaying overhead.

One morning, as she was thus returning, she suddenly thought she saw the long barrel of a carbine apparently aimed at her. It stuck out sideways from the end of a small tub half-buried in the grass on the edge of a ditch. Emma, half-fainting with terror, nevertheless walked on, and a man stepped out of the tub like a Jack-in-the-box. He had gaiters buckled up to the knees, his cap pulled down over his eyes, trembling lips, and a red nose. It was Captain Binet lying in ambush for wild ducks.

'You ought to have called out long ago!' he exclaimed. 'When you see a gun, you should always give warning.'

The tax-collector was thus trying to hide the fright he had had, for a prefectorial order had prohibited duck-hunting except in boats, and Monsieur Binet, despite his respect for the laws, was infringing them, and so every moment he expected to see the rural gendarme on the scene. But this anxiety whetted his pleasure, and, all alone in his tub, he congratulated himself on his luck and acuteness.

At sight of Emma he seemed relieved from a great weight, and at once entered upon a conversation.

'It isn't warm; it's nipping.'

Emma answered nothing. He went on – 'And you're out so early?'

'Yes,' she said stammering; 'I am just coming from the nurse where my child is.'

'Ah! capital! capital! For myself, I have been here, just as you see me, since break of day; but the weather is so muggy, that unless you have the bird at the mouth of the gun –'

'Good-day, Monsieur Binet,' she interrupted him, turning on her heel.

'Your servant, madame,' he replied drily; and he went back into his tub.

Emma regretted having left the tax-collector so abruptly. No doubt he would form unfavourable conjectures. The story about the nurse was the worse possible excuse, everyone at Yonville knowing that the little Bovary had been at home with her parents for a year. Besides, no one was living in this direction; this path led only to La Huchette. Binet, then, would guess whence she came, and he would not keep silence; he would talk, that was certain. She remained until evening racking her brain with every conceivable lying project, and had constantly before her eyes that imbecile with the game-bag.

Charles after dinner, seeing her gloomy, proposed, by way of distraction, to take her to the chemist's, and the first person she caught sight of in the shop was the tax-collector again. He was standing in front of the counter, lit up by the gleams of the red bottle, and was saying - 'Please give me half an ounce of vitriol.'

'Justin,' cried the druggist, 'bring us the sulphuric acid.' Then to Emma, who was going up to Madame Homais's room, 'No, stay here; it isn't worth while going up; she is just coming down. Warm yourself at the stove in the meantime. Excuse me. Good-day, doctor' (for the chemist much enjoyed pronouncing the word 'doctor,' as if addressing another by it reflected on himself some of the grandeur that he found in it). 'Now, take care not to upset the mortars! You'd better fetch some chairs from the little room; you know very well that the armchairs are not to be taken out of the drawing-room.'

And to put his armchair back in its place he was darting away from the counter, when Binet asked him for half an ounce of sugar acid.

'Sugar acid!' said the chemist contemptuously, 'don't know it; I'm ignorant of it! But perhaps you want oxalic acid. It is oxalic acid, isn't it?'

Binet explained that he wanted a corrosive to make himself some copper-water with which to remove rust from his hunting things.

Emma shuddered. The chemist began saying – 'Indeed the weather is not propitious on account of the damp.'

'Nevertheless,' replied the tax-collector, with a sly look, 'there are people who like it.'

She was stifling.

'And give me - '

'Will he never go?' thought she.

'Half an ounce of resin and turpentine, four ounces of yellow wax, and three half-ounces of animal charcoal, if you please, to clean the polished leather of my togs.' The druggist was beginning to cut the wax when Madame Homais appeared, Irma in her arms, Napoléon by her side, and Athalie following. She sat down on the velvet seat by the window, and the lad squatted down on a footstool, while his eldest sister hovered round the jujube box near her papa. The latter was filling funnels and corking phials, sticking on labels, making up parcels. Around him all were silent; only from time to time were heard the weights jingling in the balance, and a few low words from the chemist giving directions to his pupil.

'And how's the little woman?' suddenly asked Madame Homais.

'Silence!' exclaimed her husband, who was writing down some figures in his waste-book.

'Why didn't you bring her?' she went on in a low voice.

'Hush! hush!' said Emma, pointing with her finger to the druggist.

But Binet, absorbed in looking over his bill, had probably heard nothing. At last he went out. Then Emma, relieved, uttered a deep sigh.

'How hard you are breathing!' said Madame Homais.

'Well, you see, it's rather warm,' she replied.

So the next day they talked over how to arrange their rendezvous. Emma wanted to bribe her servant with a present, but it would be better to find some safe house at Yonville. Rodolphe promised to look for one.

All through the winter, three or four times a week, in the dead of night he came to the garden. Emma had on purpose taken away the key of the gate, which Charles thought lost.

To call her, Rodolphe threw a sprinkle of sand at the

shutters. She jumped up with a start; but sometimes he had to wait, for Charles had a mania for chatting by the fireside, and he would not stop. She was wild with impatience; if her eyes could have done it, she would have hurled him out at the window. At last she would begin to undress, then take up a book, and go on reading very quietly as if the book amused her. But Charles, who was in bed, called to her to come too.

'Come, now, Emma,' he said, 'it is time.'

'Yes, I am coming,' she answered.

Then, as the candles dazzled him, he turned to the wall and fell asleep. She escaped, smiling, palpitating, undressed.

Rodolphe had a large cloak; he wrapped her in it, and putting his arm round her waist, he drew her without a word to the end of the garden.

It was in the arbour, on the same seat of old sticks where formerly Léon had looked at her so amorously on the summer evenings. She never thought of him now.

The stars shone through the leafless jasmine branches. Behind them they heard the river flowing, and now and again on the bank the rustling of the dry reeds. Masses of shadow here and there loomed out in the darkness, and sometimes, vibrating with one movement, they rose up and swayed like immense black waves pressing forward to engulf them. The cold of the nights made them clasp closer; the sighs of their lips seemed to them deeper; their eyes, that they could hardly see, larger; and in the midst of the silence low words were spoken that fell on their souls sonorous, crystalline, and that reverberated in multiplied vibrations.

When the night was rainy, they took refuge in the

consulting-room between the cart-shed and the stable. She lighted one of the kitchen candles that she had hidden behind the books. Rodolphe settled down there as if at home. The sight of the library, of the bureau, of the whole apartment, in fine, excited his merriment, and he could not refrain from making jokes about Charles, which rather embarrassed Emma. She would have liked to see him more serious, and even on occasions more dramatic; as, for example, when she thought she heard a noise of approaching steps in the alley.

'Someone is coming!' she said.

He blew out the light.

'Have you your pistols?'

'Why?'

'Why, to defend yourself,' replied Emma.

'From your husband? Oh, poor devil!' And Rodolphe finished his sentence with a gesture that said, 'I could crush him with a flick of my finger.'

She was wonder-stricken at his bravery, although she felt it a sort of indecency and a naïve coarseness that scandalised her.

Rodolphe reflected a good deal on the affair of the pistols. If she had spoken seriously, it was very ridiculous, he thought, even odious; for he had no reason to hate the worthy Charles, not being what is called devoured by jealousy; and on this subject Emma had taken a great vow which he did not think in the best of taste.

Besides, she was growing very sentimental. She had insisted on exchanging miniatures; they had cut off handfuls of hair, and now she was asking for a ring – a real wedding-ring, in sign of an eternal union. She often spoke to him of the evening chimes, of the voices

of nature. Then she talked to him of her mother – hers! and of his mother – his! Rodolphe had lost his twenty years ago. Emma none the less consoled him with caressing words as one would have done a lost child, and she sometimes even said to him, gazing at the moon – 'I am sure that above there together they approve of our love.'

But she was so pretty. He had possessed so few women of such ingenuousness. This love without debauchery was a new experience for him, and, drawing him out of his lazy habits, caressed at once his pride and his sensuality. Emma's enthusiasm, which his bourgeois good sense disdained, seemed to him in his heart of hearts charming, since it was lavished on him. Then, sure of being loved, he no longer kept up appearances, and insensibly his ways changed.

He had no longer, as formerly, words so gentle that they made her cry, nor passionate caresses that made her mad, so that their great love, which engrossed her life, seemed to lessen beneath her like the water of a stream absorbed into its channel, and she could see the bed of it. She would not believe it; she redoubled in tenderness, and Rodolphe concealed his indifference less and less.

She did not know if she regretted having yielded to him, or whether she did not wish, on the contrary, to enjoy him the more. The humiliation of feeling herself weak was turning to rancour, tempered by their voluptuous pleasures. It was not affection; it was like a continual seduction. He subjugated her; she almost feared him.

Appearances, nevertheless, were calmer than ever, Rodolphe having succeeded in carrying out the adultery after his own fancy; and at the end of six

months, when the springtime came, they were to one another like a married couple, tranquilly keeping up a domestic flame.

It was the time of the year when old Rouault sent his turkey in remembrance of the setting of his leg. The present always arrived with a letter. Emma cut the string that tied it to the basket, and read the following lines:

My Dear Children – I hope this will find you well, and that this one will be as good as the others, for it seems to me a little more tender, if I may venture to say so, and heavier. But next time for a change I'll give you a turkey-cock, unless you have a preference for some dabs; and send me back the hamper, if you please, with the two old ones. I have had an accident with my cart-sheds, whose covering flew off among the trees one windy night. The harvest has not been over-good either. Finally, I don't know when I shall come to see you. It is so difficult now to leave the house since I am alone, my poor Emma.

Here there was a break in the lines, as if the old fellow had dropped his pen to dream a little while.

For myself, I am very well, except for a cold I caught the other day at the fair at Yvetot, where I had gone to hire a shepherd, having turned away mine because he was too dainty. How we are to be pitied with such a lot of thieves! Besides, he was also rude. I heard from a pedlar, who was travelling through your part of the country this winter, and had a tooth drawn, that Bovary was working hard as usual. That doesn't surprise me; and he showed me his tooth; we had

some coffee together. I asked him if he had seen you, and he said not, but that he had seen two horses in the stables, from which I conclude that business is looking up. So much the better, my dear children, and may God send you every imaginable happiness! It grieves me not yet to have seen my dear little granddaughter, Berthe Bovary. I have planted an Orleans plum tree for her in the garden under your room, and I won't have it touched unless it is to have jam made for her by and by, which I will keep in the cupboard for her when she comes.

Goodbye, my dear children. I kiss you, my girl, you too, my son-in-law, and the little one on both cheeks. I am, with best compliments, your loving father.

THEODORE ROUAULT

She held the coarse paper in her fingers for some minutes. The spelling mistakes were interwoven one with the other, and Emma followed the kindly thought that cackled right through it like a hen half hidden in a hedge of thorns. The writing had been dried with ashes from the hearth, for a little grey powder slipped from the letter on to her dress, and she almost thought she saw her father bending over the hearth to take up the tongs. How long since she had been with him, sitting on the footstool in the chimney-corner, where she used to burn the end of a bit of wood in the great flame of the sea-sedges! She remembered the summer evenings all full of sunshine. The colts neighed when anyone passed by, and galloped, galloped. Under her window there was a beehive, and sometimes the bees wheeling round in the light struck against her window like rebounding balls of gold. What happiness there had been at that time, what freedom, what hope! What an abundance of illusions! Nothing was left of them now. She had got rid of them all in her soul's life, in all her successive conditions of life, – maidenhood, her marriage, and her love; – thus constantly losing them all her life through, like a traveller who leaves something of his wealth at every inn along his road.

But what then made her so unhappy? What was the extraordinary catastrophe that had transformed her? And she raised her head, looking round as if to seek the cause of that which made her suffer.

An April ray was dancing on the china of the whatnot; the fire burned; beneath her slippers she felt the softness of the carpet; the day was bright, the air warm, and she heard her child shouting with laughter.

In fact, the little girl was just then rolling on the lawn in the midst of the grass that was being turned. She was lying flat on her stomach at the top of rick. The servant was holding her by her skirt. Lestiboudois was raking by her side, and every time he came near she leant forward, beating the air with both her arms.

'Bring her to me,' said her mother, rushing to embrace her. 'How I love you, my poor child! How I love you!'

Then noticing that the tips of her ears were rather dirty, she rang at once for warm water, and washed her, changed her linen, her stockings, her shoes, asked a thousand questions about her health, as if on the return from a long journey, and finally, kissing her again and crying a little, she gave her back to the servant, who stood quite thunder-stricken at this excess of tenderness.

That evening Rodolphe found her more serious than usual.

'That will pass over,' he concluded; 'it's a whim.'

And he missed three rendezvous running. When he did come, she showed herself cold and almost contemptuous.

'Ah! you're losing your time, my lady!'

And he pretended not to notice her melancholy sighs, nor the handkerchief she took out.

Then Emma repented. She even asked herself why she detested Charles; if it had not been better to have been able to love him? But he gave her no opportunities for such a revival of sentiment, so that she was much embarrassed by her desire for sacrifice, when the druggist came just in time to provide her with an opportunity.

He had recently read a eulogy on a new method for curing club-foot, and as a partisan of progress, he conceived the patriotic idea that Yonville, in order to keep to the fore, ought to have some operations for strephopody or club-foot.

'For,' as he said to Emma, 'what risk is there? See' (and he enumerated on his fingers the advantages of the attempt), 'success, almost certain relief and beautifying of the patient, celebrity acquired by the operator. Why, for example, should not your husband relieve poor Hippolyte of the Lion d'Or? Note that he would not fail to tell about his cure to all the travellers, and then' (Homais lowered his voice and looked round him) 'who is to prevent me from sending a short paragraph on the subject to the paper? Eh! goodness me! an article gets about; it is talked of; it ends by making a snowball! And who knows? who knows?'

In fact, Bovary might succeed. Nothing proved to Emma that he was not clever; and what a satisfaction for her to have urged him to a step by which his reputation and fortune would be increased! She only wished to lean on something more solid than love.

Charles, urged by the druggist and by her, allowed himself to be persuaded. He sent to Rouen for Dr Duval's volume, and every evening, holding his head between both hands, plunged into the reading of it.

While he was studying equinus, varus, and valgus, that is to say, *katastrephopody*, *endostrephopody*, and *exostrephopody* (or better, the various turnings of the

foot downwards, inwards, and outwards, with the hypostrephopody and anastrephopody, otherwise torsion downwards and upwards), Monsieur Homais, with all sorts of arguments, was exhorting the lad at the inn to submit to the operation.

'You will scarcely feel anything, perhaps a very slight pain; it is a mere prick, like a little blood-letting, and less than the extraction of some corns.'

Hippolyte, reflecting, rolled his stupid eyes.

'However,' continued the chemist, 'it doesn't concern me. It's for your sake, for pure humanity! I should like to see you, my friend, rid of your hideous caudication, together with that waddling of the lumbar regions which, whatever you say, must considerably interfere with you in the exercise of your calling.'

Then Homais represented to him how much jollier and brisker he would feel afterwards, and even gave him to understand that he would be more likely to please the women; and the stable-boy began to smile heavily. Then he attacked him through his vanity: 'Aren't you a man? Hang it! what would you have done if you had had to go into the army, to go and fight beneath the standard? Ah! Hippolyte!'

And Homais retired, declaring that he could not understand this obstinacy, this blindness in refusing the benefactions of science.

The poor fellow gave way, for it was like a conspiracy. Binet, who never interfered with other people's business, Madame Lefrançois, Artémise, the neighbours, even the mayor, Monsieur Tuvache – everyone persuaded him, lectured him, shamed him; but what finally decided him was that it would cost him nothing. Bovary even undertook to provide the machine for the operation. This generosity was an idea

of Emma's, and Charles consented to it, thinking in his heart of hearts that his wife was an angel.

So by the advice of the chemist, and after three fresh starts, he had a kind of box made by the carpenter, with the aid of the locksmith, that weighed about eight pounds, and in which iron, wood, sheet-iron, leather, screws, and nuts had not been spared.

But to know which of Hippolyte's tendons to cut, it was necessary first of all to find out what kind of club-foot he had.

He had a foot forming almost a straight line with the leg, which, however, did not prevent it from being turned in, so that it was an equinus together with something of a varus, or else a slight varus with a strong tendency to equinus. But with this equinus, wide in foot like a horse's hoof, with rugose skin, dry tendons, and large toes, on which the black nails looked as if made of iron, the club-foot ran about like a deer from morn till night. He was constantly to be seen on the Place, jumping round the carts, thrusting his limping foot forwards. He seemed even stronger on that leg than the other. By dint of hard service it had acquired, as it were, moral qualities of patience and energy; and when he was given some heavy work, he stood on it in preference to its fellow.

Now, as it was an equinus, it was necessary to cut the tendon of Achilles, and, if need were, the anterior tibial muscle could be seen to afterwards for getting rid of the varus; for the doctor did not dare to risk both operations at once; he was even trembling already for fear of injuring some important region that he did not know.

Neither Ambrose Paré, applying a ligature to an artery for the first time since Celsus, after an interval

of fifteen centuries, nor Dupuytren, about to open an abscess in the brain, nor Gensoul when he first took away the superior maxilla, had hearts that trembled, hands that shook, minds so strained as Monsieur Bovary when he approached Hippolyte, his tenotome between his fingers. And, as at hospitals, near by on a table lay a heap of lint, with waxed thread, many bandages - a pyramid of bandages every bandage to be found at the druggist's. It was Monsieur Homais who since morning had been organising all these preparations, as much to dazzle the multitude as to keep up his illusions. Charles pierced the skin; a dry crackling was heard. The tendon was cut, the operation over. Hippolyte could not get over his surprise, but bent over Bovary's hands to cover them with kisses.

'Come, be calm,' said the druggist; 'later on you will show your gratitude to your benefactor.'

And he went down to tell the result to five or six enquirers who were waiting in the yard, and who fancied that Hippolyte would reappear walking properly. Then Charles, having buckled his patient into the machine, went home, where Emma, all anxiety, awaited him at the door. She threw herself on his neck; they sat down to table; he ate much, and at dessert he even wanted to take a cup of coffee, a luxury he only permitted himself on Sundays when there was company.

The evening was charming, full of prattle and dreams together. They talked about their future fortune, and the improvements to be made in their house; he saw people's esteem for him growing, his comforts increasing, his wife always loving him; and she was happy to refresh herself with a new

sentiment, healthier, better, to feel at last some tenderness for this poor fellow who adored her. The thought of Rodolphe for one moment passed through her mind, but her eyes turned again to Charles; she even noticed with surprise that he had not bad teeth.

They were in bed when Monsieur Homais, in spite of the servant, burst into the room, holding a sheet of paper newly written. It was the paragraph he intended for the *Fanal de Rouen*. He brought it for them to read.

'Read it yourself,' said Bovary.

He read – "Despite the prejudices that still invest a part of the face of Europe like a net, the light nevertheless begins to penetrate our country places. Thus on Tuesday our little town of Yonville found itself the scene of a surgical operation which is at the same time an act of loftiest philanthropy. Monsieur Bovary, one of our most distinguished practitioners – "'

'Oh, that is too much! too much!' said Charles, choking with emotion.

'No, no! not at all! What next!'

"- performed an operation on a club-footed man." I have not used the scientific term, because you know in a newspaper everyone would not perhaps understand. The masses must - '

'No doubt,' said Bovary; 'go on!'

'I proceed,' said the chemist. '"Monsieur Bovary, one of our most distinguished practitioners, performed an operation on a club-footed man called Hippolyte Tautain, stable-man for the last twenty-five years at the hotel of the Lion d'Or, kept by Widow Lefrançois, on the Place d'Armes The novelty of the attempt, and the interest incident to the subject, had attracted such a concourse of persons that there was a veritable

obstruction on the threshold of the establishment. The operation, moreover, was performed as if by magic, and barely a few drops of blood appeared on the skin, as though to say that the rebellious tendon had at last given way beneath the efforts of art. The patient, strangely enough - we affirm it as an evewitness - complained of no pain. His condition up to the present time leaves nothing to be desired. Everything tends to show that his convalescence will be brief; and who knows even if at our next village festivity we shall not see our good Hippolyte figuring in the bacchic dance in the midst of a chorus of joyous boon-companions, and thus proving to all eves by his verve and his capers his complete cure? Honour, then, to the generous savants! Honour to those indefatigable spirits who consecrate their vigils to the amelioration or to the alleviation of their kind! Honour, thrice honour! Is it not time to cry that the blind shall see, the deaf hear, the lame walk? But that which fanaticism formerly promised to its elect, science now accomplishes for all men. We shall keep our readers informed as to the successive phases of this remarkable cure"

This did not prevent Mère Lefrançois from coming five days after, scared, and crying out – 'Help! he is dying! I am going crazy!'

Charles rushed to the Lion d'Or, and the chemist, who caught sight of him passing along the Place hatless, abandoned his shop. He appeared himself breathless, red, anxious, and asking everyone who was going up the stairs – 'Why, what's the matter with our interesting strephopode?'

The strephopode was writhing in hideous convulsions, so that the machine in which his leg was enclosed was knocked against the wall enough to break it.

With many precautions, in order not to disturb the position of the limb, the box was removed, and an awful sight presented itself. The outlines of the foot disappeared in such a swelling that the entire skin seemed about to burst, and it was covered with ecchymosis, caused by the famous machine. Hippolyte had already complained of suffering from it. No attention had been paid to him; they had to acknowledge that he had not been altogether wrong, and he was freed for a few hours. But hardly had the oedema gone down to some extent, than the two savants thought fit to put back the limb in the apparatus, strapping it tighter to hasten matters. At last, three days after, Hippolyte being unable to endure it any longer, they once more removed the machine, and were much surprised at the result they saw. The livid tumefaction spread over the leg, with blisters here and there, whence there oozed a black liquid. Matters were taking a serious turn. Hippolyte began to worry himself, and Mère Lefrançois had him installed in the little room near the kitchen, so that he might at least have some distraction.

But the tax-collector, who dined there every day, complained bitterly of this companionship, and Hippolyte was then removed to the billiard-room. There he lay moaning under his heavy coverings, pale with long beard, sunken eyes, and from time to time turning his perspiring head on the dirty pillow, where the flies alighted. Madame Bovary went to see him. She brought him linen for his poultices; she comforted, and encouraged him. Besides, he did not want for company, especially on market-days, when

the peasants were knocking about the billiard-balls round him, fenced with the cues, smoked, drank, sang, and brawled.

'How are you?' they said, clapping him on the shoulder. 'Ah! you're not up to much, it seems, but it's your own fault. You should do this! do that!' And then they told him stories of people who had all been cured by other remedies than his. Then by way of consolation they added – 'You give way too much! Get up! You coddle yourself like a king! All the same, old chap, you don't smell nice!'

Gangrene, in fact, was spreading more and more. Bovary himself turned sick at it. He came every hour, every moment. Hippolyte looked at him with eyes full of terror, sobbing – 'When shall I get well! Oh, save me! How unfortunate I am! How unfortunate I am!'

And the doctor left, always recommending him to diet himself.

'Don't listen to him, my lad,' said Mère Lefrançois. 'Haven't they tortured you enough already? You'll grow still weaker. Here! swallow this.'

And she gave him some good beef-tea, a slice of mutton, a piece of bacon, and sometimes small glasses of brandy, that he had not the strength to put to his lips.

Abbé Bournisien, hearing that he was growing worse, asked to see him. He began by pitying his sufferings, declaring at the same time that he ought to rejoice at them since it was the will of the Lord, and take advantage of the occasion to reconcile himself to Heaven.

'For,' said the ecclesiastic in a paternal tone, 'you rather neglected your duties; you were rarely seen at divine worship. How many years is it since you

approached the holy table? I understand that your work, that the whirl of the world may have kept you from care of your salvation. But now is the time to reflect. Yet don't despair. I have known great sinners, who, about to appear before God (you are not yet at this point I know), had implored His mercy, and who certainly died in the best frame of mind. Let us hope that, like them, you will set us a good example. Thus, as a precaution, what is to prevent you from saying morning and evening a "Hail Mary, full of grace", and "Our Father which art in Heaven"? Yes, do that, for my sake, to oblige me. That won't cost you anything. Will you promise me?"

The poor devil promised. The curé came back day after day. He chatted with the landlady, and even told anecdotes interspersed with jokes and puns that Hippolyte did not understand. Then, as soon as he could, he fell back upon matters of religion, putting on an appropriate expression of face.

His zeal seemed successful, for the club-foot soon manifested a desire to go on a pilgrimage to Bon-Secours if he were cured; to which Monsieur Bournisien replied that he saw no objection; two precautions were better than one; it was no risk anyhow.

The druggist was indignant at what he called the manoeuvres of the priest; they were prejudicial, he said, to Hippolyte's convalescence, and he kept repeating to Madame Lefrançois, 'Leave him alone! leave him alone! You perturb his morals with your mysticism.' But the good woman would no longer listen to him; he was the cause of it all. From the spirit of contradiction she hung up near the bedside of the patient a basin filled with holy water and a branch of box.

Religion, however, seemed no more able to succour

him than surgery, and the invincible gangrene still spread from the extremities towards the stomach. It was all very well to vary the potions and change the poultices; the muscles each day rotted more and more; and at last Charles replied by an affirmative nod of the head when Mère Lefrançois asked him if she could not, as a forlorn hope, send for Monsieur Canivet of Neufchâtel, who was a celebrity.

A doctor of medicine, fifty years of age, enjoying a good position and self-possessed, Charles's colleague did not refrain from laughing disdainfully when he had uncovered the leg, mortified to the knee. Then having flatly declared that it must be amputated, he went off to the chemist's to rail at the asses who could have reduced a poor man to such a state. Shaking Monsieur Homais by the button of his coat, he shouted out in the shop - 'These are the Paris inventions! These are the ideas of those gentry of the capital! It is like strabismus, chloroform, lithotrity, a heap of monstrosities that the Government ought to put down! But they want to be smart fellows, and they cram you with remedies without troubling about the consequences. We are not so clever, not we! We are not savants, coxcombs, fops! We are practitioners; we cure people, and we should not dream of operating on anyone who is in perfect health. Straighten club-feet! As if one could straighten club-feet! It is like wanting, say, to make a hunchback straight!'

Homais suffered as he listened to this discourse, and he concealed his discomfort beneath a courtier's smile; for he needed to humour Monsieur Canivet, whose prescriptions sometimes came as far as Yonville. So he did not take up the defence of Bovary; he did not even make a single remark, and, renouncing his principles,

he sacrificed his dignity to the more serious interests of his business.

This amputation of the thigh by Doctor Canivet was a great event in the village. On that day all the inhabitants got up earlier, and the Grande Rue, although full of people, had something lugubrious about it, as if an execution had been expected. At the grocer's they discussed Hippolyte's illness; the shops did no business, and Madame Tuvache, the mayor's wife, did not stir from her window, such was her impatience to see the operator arrive.

He came in his gig, which he drove himself. But the springs of the right side having at length given way beneath the weight of his corpulence, it happened that the carriage as it rolled along leaned over a little, and on the other cushion near him could be seen a large box covered in red sheep-leather, whose three brass clasps shone grandly.

After he had entered like a whirlwind the porch of the Lion d'Or, the doctor, shouting very loud, ordered them to unharness his horse. Then he went into the stable to see that he was eating his oats all right; for on arriving at a patient's he first of all looked after his mare and his gig. People even said about this – 'Ah! Monsieur Canivet's a character!'

And he was the more esteemed for this imperturbable coolness. The universe to the last man might have died, and he would not have missed the smallest of his habits.

Homais presented himself.

'I count on you,' said the doctor. 'Are we ready? Come along!'

But the druggist, turning red, confessed that he was too sensitive to assist at such an operation.

'When one is a simple spectator,' he said, 'the imagination you know, is impressed. And then I have such a nervous system!'

'Pshaw!' interrupted Canivet; 'on the contrary, you seem to me inclined to apoplexy. Besides, that doesn't astonish me, for you chemist fellows are always poking about your kitchens, which must end by spoiling your constitutions. Now just look at me. I get up every day at four o'clock; I shave with cold water (and am never cold). I don't wear flannels, and I never catch cold; my carcass is good enough! I live now in one way, now in another, like a philosopher, taking potluck; that is why I am not squeamish like you, and it matters as little to me whether I'm carving a Christian or the first fowl that turns up. Then, perhaps, you will just say, habit! habit!'

Then, without any consideration for Hippolyte, who was sweating with agony between his sheets, these gentlemen entered into a conversation, in which the druggist compared the coolness of a surgeon to that of a general; and this comparison was pleasing to Canivet, who launched out on the exigencies of his art. He looked upon it as a sacred office, although the ordinary practitioners dishonoured it. At last, coming back to the patient, he examined the bandages brought by Homais, the same that had appeared for the club-foot, and asked for someone to hold the limb for him. Lestiboudois was sent for, and Monsieur Canivet having turned up his sleeves, passed into the billiard-room, while the druggist stayed with Artémise and the landlady, both whiter than their aprons, and with ears strained towards the door.

Bovary during this time did not dare to stir from his house.

He kept downstairs in the sitting-room by the side of the fireless chimney, his chin on his breast, his hands clasped, his eyes staring. 'What a mishap!' he thought, 'what a mishap!' Perhaps, after all, he had made some slip. He thought it over, but could hit upon nothing. But the most famous surgeons also made mistakes; and that is what no one would ever believe! People, on the contrary, would laugh, jeer! It would spread as far as Forges, as Neufchâtel, as Rouen, everywhere! Who could say if his colleagues would not write against him. Polemics would ensue; he would have to answer in the papers. Hippolyte might even prosecute him. He saw himself dishonoured, ruined, lost; and his imagination, assailed by a world of hypotheses, tossed amongst them like an empty cask borne by the sea and floating upon the waves.

Emma, opposite, watched him; she did not share his humiliation; she felt another – that of having supposed such a man was worth anything. As if twenty times already she had not sufficiently perceived his mediocrity.

Charles was walking up and down the room; his boots creaked on the floor.

'Sit down,' she said; 'you fidget me.'

He sat down again.

How was it that she – she, who was so intelligent – could have allowed herself to be deceived again? and through what deplorable madness had she thus ruined her life by continual sacrifices? She recalled all her instincts of luxury, all the privations of her soul, the sordidness of marriage, of the household, her dream sinking into the mire like wounded swallows; all that she had longed for, all that she had denied herself, all that she might have had! And for what? for what?

In the midst of the silence that hung over the village a heart-rending cry rose on the air. Bovary blanched, as if about to swoon. She knit her brows with a nervous gesture, then went on. And it was for him, for this creature, for this man, who understood nothing, who felt nothing! For he was there quite quiet, not even suspecting that the ridicule of his name would henceforth sully hers as well as his. She had made efforts to love him and she had repented with tears for having yielded to another!

'But perhaps it was a valgus!' suddenly exclaimed Bovary, who was meditating.

At the unexpected shock of this phrase falling on her thoughts like a leaden bullet on a silver plate, Emma, shuddering, raised her head in order to find out what he meant to say; and they looked at the other in silence, almost amazed to see each other, so far sundered were they by their inner thoughts. Charles gazed at her with the dull look of a drunken man, while he listened motionless to the last cries of the sufferer, that followed each other in long-drawn modulations, broken by sharp spasms like the far-off howling of some beast being slaughtered. Emma bit her wan lips, and rolling between her fingers a piece of coral that she had broken, fixed on Charles the burning glance of her eyes, like two arrows of fire about to dart forth. Everything in him irritated her now; his face, his dress, what he did not say, his whole person, his existence, in fine. She repented of her past virtue as of a crime, and what still remained of it crumbled away beneath the furious blows of her pride. She revelled in all the evil ironies of triumphant adultery. The memory of her lover came back to her with dazzling attractions; she threw her whole soul

into it, borne away towards this image with a fresh enthusiasm; and Charles seemed to her as much removed from her life, as absent forever, as impossible and annihilated, as if he had been about to die and were passing under her eyes.

There was a sound of steps on the pavement. Charles looked up, and through the lowered blinds he saw at the corner of the market in the broad sunshine Dr Canivet, who was wiping his brow with his hand-kerchief. Homais, behind him, was carrying a large red box in his hand, and both were going towards the chemist's.

Then with a feeling of sudden tenderness and discouragement Charles turned to his wife saying to her – 'Oh, kiss me, my own!'

'Leave me!' she said, red with anger.

'What is the matter?' he asked, stupefied. 'Be calm; compose yourself. You know well enough that I love you. Come!'

'Enough,' she cried with a terrible look.

And, escaping from the room, Emma closed the door so violently that the barometer fell from the wall and smashed on the floor.

Charles sank back into his armchair overwhelmed, trying to discover what could be wrong with her, fancying some nervous illness, weeping, and vaguely feeling something fatal and incomprehensible whirling round him.

When Rodolph came to the garden that evening, he found his mistress waiting for him at the foot of the steps on the lowest stair. They threw their arms round one another, and beneath the warmth of that kiss all their rancour melted like snow.

They began to love again. Often, even in the middle of the day, Emma suddenly wrote to him, then from the window made a sign to Justin, who, taking his apron off, quickly ran to La Huchette. Rodolphe would come; she had sent for him to tell him that she was bored, that her husband was odious, her life frightful.

'But what can I do?' he cried one day impatiently.

'Ah! if you would - '

She was sitting on the floor between his knees, her hair loose, her look lost.

'Why, what?' said Rodolphe.

She sighed.

'We would go and live elsewhere - somewhere!'

'You are really mad!' he said laughing. 'How could that be possible?'

She returned to the subject; he pretended not to understand, and turned the conversation.

What he did not understand was all this worry about so simple an affair as love. She had a motive, a reason, and, as it were, a pendant to her affection.

Her tenderness, in fact, increased each day with her repulsion to her husband. The more she gave up herself to the one, the more she loathed the other. Never had Charles seemed to her so disagreeable, to have such stodgy fingers, such vulgar ways, to be so dull as when they found themselves together after her meeting with Rodolphe. Then, while playing the spouse and virtuous woman, she was on fire with thoughts of that head whose black hair fell curling over the sunburnt brow, of that form at once so strong and

elegant, of that man, in a word, who had such experience in his reasoning, such passion in his desires. It was for him that she filed her nails with the care of an engraver, and that there was never enough cold-cream for her skin or patchouli for her hand-kerchiefs. She loaded herself with bracelets, rings, and necklaces. When he was coming she filled the two large blue glass vases with roses, and prepared her room and her person like a courtesan expecting a prince. The servant had to be constantly washing linen, and all day Félicité did not stir from the kitchen, where little Justin, who often kept her company, watched her at work.

With his elbows on the long board on which she was ironing, he greedily watched all these women's clothes spread about him, the dimity petticoats, the fichus, the collars, and the drawers with running strings, wide at the hips and growing narrower below.

'What is that for?' asked the young fellow, passing his hand over the crinoline or the hooks and eyes.

'Why, haven't you ever seen anything?' Félicité answered laughing. 'As if your mistress, Madame Homais, didn't wear the same.'

'Oh, I dare say! Madame Homais!' And he added with a meditative air, 'As if she were a lady like madame!'

But Félicité grew impatient of seeing him hanging round her. She was six years older than he, and Theodore, Monsieur Guillaumin's servant, was beginning to pay court to her.

'Let me alone,' she said, moving her pot of starch. 'You'd better be off and pound almonds; you are always dangling about women. Before you meddle with such things, bad boy, wait till you've got a beard to your chin.'

'Oh, don't be cross! I'll go and clean her boots.'

And at once he took down from the shelf Emma's boots all coated with mud, the mud of the rendezvous; it crumbled into powder beneath his fingers, and he watched it gently rising in a ray of sunlight.

'How afraid you are of spoiling them!' said the servant, who wasn't so particular when she cleaned them herself, because as soon as the stuff of the boots was no longer fresh madame handed them over to her.

Emma had a number in her cupboard that she squandered one after the other, without Charles allowing himself the slightest observation. So also he disbursed three hundred francs for a wooden leg that she thought proper to make a present of to Hippolyte. Its top was covered with cork, and it had spring joints, a complicated mechanism, covered over by black trousers ending in a patent-leather boot. But Hippolyte, not daring to use such a handsome leg every day, begged Madame Bovary to get him another more convenient one. The doctor, of course, had again to defray the expense of this purchase.

So little by little the stable-man took up his work again. One saw him running about the village as before, and when Charles heard from afar the sharp noise of the wooden leg, he at once went in another direction.

It was Monsieur Lheureux, the shopkeeper, who had undertaken the order; this provided him with an excuse for visiting Emma. He chatted with her about the new goods from Paris, about a thousand feminine trifles, made himself very obliging, and never asked for his money. Emma yielded to this lazy mode of satisfying all her caprices. Thus she wanted to have a very handsome riding-whip that was at an umbrella-

maker's at Rouen to give to Rodolphe. The week after Monsieur Lheureux placed it on her table.

But next day he called on her with a bill for two hundred and seventy francs, not counting the centimes. Emma was much embarrassed; all the drawers of the writing-table were empty; they owed over a fortnight's wages to Lestiboudois, two quarters to the servant, for any quantity of other things, and Bovary was impatiently expecting Monsieur Derozeray's account, which he was in the habit of paying every year about Midsummer.

She succeeded at first in putting off Lheureux. At last he lost patience; he was being sued; his capital was out, and unless he got some in he should be forced to take back all the goods she had received.

'Oh, very well, take them!' said Emma.

'I was only joking,' he replied; 'the only thing I regret is the whip. My word! I'll ask monsieur to return it to me.'

'No, no!' she said.

'Ah! I've got you!' thought Lheureux.

And, certain of his discovery, he went out repeating to himself in an undertone, and with his usual low whistle – 'Good! we shall see! we shall see!'

She was thinking how to get out of this when the servant coming in put on the mantelpiece a small roll of blue paper 'from Monsieur Derozeray's.' Emma pounced upon and opened it. It contained fifteen napoleons; it was the account. She heard Charles on the stairs; threw the gold to the back of her drawer, and took out the key.

Three days after Lheureux reappeared.

'I have an arrangement to suggest to you,' he said. 'If instead of the sum agreed on, you would take -'

'Here it is,' she said placing fourteen napoleons in his hand.

The tradesman was dumbfounded. Then, to conceal his disappointment, he was profuse in apologies and proffers of service, all of which Emma declined; then she remained a few moments fingering in the pocket of her apron the two five-franc pieces that he had given her in change. She promised herself she would economise in order to pay back later on. 'Pshaw!' she thought, 'he won't think about it again.'

Besides the riding-whip with its silver-gilt handle Rodolphe had received a seal with the motto *Amor nel cor*; furthermore, a scarf for a muffler, and, finally, a cigar-case exactly like the Viscount's, that Charles had formerly picked up on the road, and that Emma had kept. These presents, however, humiliated him; he refused several; she insisted, and he ended by obeying, thinking her tyrannical and over-exacting.

Then she had strange ideas.

'When midnight strikes,' she said, 'you must think of me.'

And if he confessed that he had not thought of her, there were floods of reproaches that always ended with the eternal question – 'Do you love me?'

'Why, of course I love you,' he answered.

'A great deal?'

'Certainly!'

'You haven't loved any others?'

'Did you think you'd got a virgin?' he exclaimed laughing.

Emma cried, and he tried to console her, adorning his protestations with puns.

'Oh,' she went on, 'I love you! I love you so that I could not live without you, do you see? There are

times when I long to see you again, when I am torn by all the anger of love. I ask myself, Where is he? Perhaps he is talking to other women. They smile upon him; he approaches. Oh no; no one else pleases you. There are some more beautiful, but I love you best. I know how to love best. I am your servant, your concubine! You are my king, my idol! You are good, you are beautiful, you are clever, you are strong!'

He had so often heard these things said that they did not strike him as original. Emma was like all his mistresses; and the charm of novelty, gradually falling away like a garment, laid bare the eternal monotony of passion, that has always the same forms and the same language. He did not distinguish, this man of so much experience, the difference of sentiment beneath the sameness of expression. Because lips libertine and venal had murmured such words to him, he believed but little in the candour of her; exaggerated speeches hiding mediocre affections must be discounted; as if the fullness of the soul did not sometimes overflow in the emptiest metaphors, since no one can ever give the exact measure of his needs, nor of his conceptions, nor of his sorrows, and since human speech is like a cracked tin kettle, on which we hammer out tunes to make bears dance when we long to placate the stars.

But with that superior critical judgement that belongs to him who, in no matter what circumstance, holds back, Rodolphe saw other delights to be got out of this love. He thought all modesty a hindrance. He treated her cavalierly. He made of her something supple and corrupt. Hers was an idiotic sort of attachment, full of admiration for him, of voluptuousness for her, a beatitude that benumbed her; her soul sank

into this drunkenness, shrivelled up, drowned in it, like Clarence in his butt of Malmsey.

By the mere effect of her love Madame Bovary's manners changed. Her looks grew bolder, her speech more free; she even committed the impropriety of walking out with Monsieur Rodolphe, a cigarette in her mouth, 'as if to defy people.' At last, those who still doubted doubted no longer when one day they saw her getting out of the 'Hirondelle', her waist squeezed into a waistcoat like a man; and Madame Bovary, senior, who, after a fearful scene with her husband, had taken refuge at her son's, was not the least scandalised of the womenfolk. Many other things displeased her. First, Charles had not attended to her advice about the forbidding of novels; then the 'ways of the house' annoyed her; she allowed herself to make some remarks, and there were quarrels, especially one on account of Félicité.

Madame Bovary, senior, the evening before, passing along the passage, had surprised her in company of a man – a man with a brown collar, about forty years old, who had quickly escaped through the kitchen at the sound of her step. Then Emma began to laugh, but the good lady grew angry, declaring that unless morals were to be laughed at one ought to look after those of one's servants.

'Where were you brought up?' asked the daughterin-law, with so impertinent a look that Madame Bovary asked her if she were not perhaps defending her own case.

'Leave the room!' said the young woman, springing up with a bound.

'Emma! Mamma!' cried Charles, trying to reconcile them.

But both had fled in their exasperation. Emma was stamping her feet as she repeated – 'Oh! what manners! What a boor!'

He ran to his mother; she was beside herself. She stammered – 'She is an insolent, giddy-headed thing, or perhaps worse!'

And she was for leaving at once if the other did not apologise.

So Charles went back again to his wife and implored her to give way; he knelt to her; she ended by saying – 'Very well! I'll go to her.'

And in fact she held out her hand to her mother-inlaw with the dignity of a marchioness as she said – 'Excuse me, madame.'

Then, having gone up again to her room, she threw herself flat on her bed and cried there like a child, her face buried in the pillow.

She and Rodolphe had agreed that in the event of anything extraordinary occurring, she should fasten a small piece of white paper to the blind, so that if by chance he happened to be in Yonville, he could hurry to the lane behind the house. Emma made the signal; she had been waiting three-quarters of an hour when she suddenly caught sight of Rodolphe at the corner of the market. She felt tempted to open the window and call him, but he had already disappeared. She fell back in despair.

Soon, however, it seemed to her that someone was walking on the pavement. It was he, no doubt. She went downstairs, crossed the yard. He was there outside. She threw herself into his arms.

'Do take care!' he said.

'Ah! if you knew!' she replied.

And she began telling him everything, hurriedly,

disjointedly, exaggerating the facts, inventing many, and so prodigal of parenthesis that he understood nothing of it.

'Come, my poor angel, courage! Be comforted! be patient!'

'But I have been patient; I have suffered for four years. A love like ours ought to show itself in the face of heaven. They torture me! I can bear it no longer! Save me!'

She clung to Rodolphe. Her eyes, full of tears, flashed like flames beneath a wave; her breast heaved; he had never loved her so much, so that he lost his head and said – 'What is it? What do you wish?'

'Take me away,' she cried, 'carry me off! Oh, I pray you!'

And she threw herself upon his mouth, as if to seize there the unexpected consent if breathed forth in a kiss.

'But - ' Rodolphe resumed.

'What?'

'Your little girl!'

She reflected a few moments, then replied – 'We will take her! It can't be helped!'

'What a woman!' he said to himself, watching her as she went. For she had run into the garden. Someone was calling her.

On the following days Madame Bovary, senior, was much surprised at the change in her daughter-in-law. Emma, in fact, was showing herself more docile, and even carried her deference so far as to ask for a recipe for pickling gherkins.

Was it the better to deceive them both? Or did she wish by a sort of voluptuous stoicism to feel the more profoundly the bitterness of the things she was about to leave?

But she paid no heed to them; on the contrary, she lived as lost in the anticipated delight of her coming happiness. It was an eternal subject for conversation with Rodolphe. She leant on his shoulder murmuring—'Ah! when we are in the mail-coach! Do you think about it? Can it be? It seems to me that the moment I feel the carriage start, it will be as if we were rising in a balloon, as if we were setting out for the clouds. Do you know that I count the hours? And you?'

Never had Madame Bovary been so beautiful as at this period; she had that indefinable beauty that results from joy, from enthusiasm, from success, and that is only the harmony of temperament with circumstances. Her desires, her sorrows, the experience of pleasure, and her ever-young illusions, that had, as soil and rain and winds and the sun make flowers grow, gradually developed her, and she at length blossomed forth in all the plenitude of her nature. Her eyelids seemed chiselled expressly for her long amorous looks in which the pupil disappeared, while a strong inspiration expanded her delicate nostrils and raised the fleshy corner of her lips, shaded in the light by a little black down. One would have thought an artist apt in conception had arranged the curls of hair upon her neck; they fell in a thick mass, negligently, and with the changing chances of their adultery that unbound them every day. Her voice now took on more mellow inflections, her figure likewise; something subtle and penetrating emanated from the very folds of her gown, from the line of her foot. Charles, as when they were first married, thought her delicious and quite irresistible.

When he came home in the middle of the night, he did not dare to wake her. The porcelain night-light

threw a round trembling gleam upon the ceiling, and the drawn curtains of the little cot formed as it were a white hut standing out in the shade, and by the bedside Charles looked at them. He seemed to hear the light breathing of his child. She would grow big now; every season would bring rapid progress. He already saw her coming from school as the day drew in, laughing, with ink-stains on her jacket, and carrying her basket on her arm. Then she would have to be sent to the boarding-school; that would cost much; how was it to be done? Then he reflected. He thought of hiring a small farm in the neighbourhood, that he would superintend every morning on his way to his patients. He would save up what he brought in; he would put it in the savings-bank. Then he would buy shares somewhere, no matter where; besides, his practice would increase; he counted upon that, for he wanted Berthe to be well-educated, to be accomplished, to learn to play the piano. Ah! how pretty she would be later on when she was fifteen, when, resembling her mother, she would, like her, wear large straw hats in the summer time; from a distance they would be taken for two sisters. He pictured her to himself working in the evening by their side beneath the light of the lamp; she would embroider him slippers; she would look after the house; she would fill all the home with her charm and her gaiety. At last, they would think of her marriage; they would find her some good young fellow with a steady business; he would make her happy; this would last for ever.

Emma was not asleep; she pretended to be; and while he dozed off by her side she awakened to other dreams.

To the gallop of four horses she was carried away for

a week towards a new land, whence they would return no more. They went on and on, their arms entwined, without a word. Often from the top of a mountain there suddenly glimpsed some splendid city with domes, and bridges, and ships, forests of citron trees, and cathedrals of white marble, on whose pointed steeples were storks' nests. They went at a walkingpace because of the great flagstones, and on the ground there were bouquets of flowers, offered you by women dressed in red bodices. They heard the chiming of bells, the neighing of mules, together with the murmur of guitars and the noise of fountains, whose rising spray refreshed heaps of fruit arranged like a pyramid at the foot of pale statues smiling beneath playing waters. And then, one night they came to a fishing village, where brown nets were drying in the wind along the cliffs and in front of the huts. There they would stay; they would live in a low, flat-roofed house, shaded by a palm tree, in the heart of a gulf, by the sea. They would row in gondolas, and swing in hammocks, and their existence would be easy and large as their silk gowns, warm and starspangled as the nights they would contemplate. However, in the immensity of this future that she conjured up, nothing special stood forth; the days, all magnificent, resembled each other like waves; and it swayed in the horizon, infinite, harmonised, azure, and bathed in sunshine. But the child began to cough in her cot or Bovary snored more loudly, and Emma did not fall asleep till morning, when the dawn whitened the windows, and when little Justin was already in the square taking down the shutters of the chemist's shop.

She had sent for Monsieur Lheureux, and had said

to him - 'I want a cloak - a large, lined cloak with a deep collar.'

'You are going on a journey?' he asked.

'No; but - never mind. I may count on you, may I not, and quickly?'

He bowed.

'Besides, I shall want,' she went on, 'a trunk – not too heavy – handy.'

'Yes, yes, I understand. About three feet by a foot and a half, as they are being made just now.'

'And a travelling bag.'

'Decidedly,' thought Lheureux, 'there's trouble afoot here.'

'And,' said Madame Bovary, taking her watch from her belt, 'take this; you can pay yourself out of it.'

But the tradesman cried out that she was wrong; they knew one another; did he doubt her? What childishness!

She insisted, however, on his taking at least the chain, and Lheureux had already put it in his pocket and was going, when she called him back.

'You will leave everything at your own place. As for the cloak' – she seemed to be reflecting – 'do not bring it either; you can give me the maker's address, and tell him to have it ready for me.'

It was the next month that they were to run away. She was to leave Yonville as if she was going on some business to Rouen. Rodolphe would have booked the seats, procured the passports, and even have written to Paris in order to have the whole mail-coach reserved for them as far as Marseilles, where they would buy a carriage, and go on thence without stopping to Genoa. She would take care to send her luggage to Lheureux, whence it would be taken direct to the

'Hirondelle', so that no one would have any suspicion. And in all this there never was any allusion to the child. Rodolphe avoided speaking of her; perhaps he no longer thought about it.

He wished to have two more weeks before him to arrange some affairs; then at the end of a week he wanted two more; then he said he was ill; next he went on a journey. The month of August passed, and, after all these delays, they decided that it was to be irrevocably fixed for the 4th September – a Monday.

At last the Saturday before arrived.

Rodolphe came in the evening earlier than usual.

'Everything is ready?' she asked him.

'Yes.'

Then they walked round a garden-bed, and went to sit down near the terrace on the kerbstone of the wall.

'You are sad,' said Emma.

'No; why?'

And yet he looked at her strangely in a tender fashion.

'Is it because you are going away?' she went on; 'because you are leaving what is dear to you – your life? Ah! I understand. I have nothing in the world! You are all to me; so shall I be to you. I will be your people, your country; I will tend, I will love you!'

'How sweet you are!' he said, seizing her in his arms. 'Really!' she said with a voluptuous laugh. 'Do you love me? Swear it then!'

'Do I love you - love you? I adore you, my love.'

The moon, full and purple-coloured, was rising right out of the earth at the end of the meadow. Quickly she rose between the branches of the poplars, which hid her here and there like a black curtain pierced with holes. Then she came into view dazzling

with whiteness in the empty heavens that she lit up, and now sailing along more slowly, let fall upon the river a great stain that broke into an infinity of stars; and the silver sheen seemed to writhe through the depths like a headless serpent covered with luminous scales; it also resembled some monster candelabra all along which sparkled clustering drops of diamonds. The soft night was about them; masses of shadow filled the branches. Emma, her eyes half closed, breathed in with deep sighs the fresh wind that was blowing. They did not speak, lost as they were in their surging reverie. The tenderness of old days came back to their hearts, full and silent as the flowing river, with the softness of the perfume of the syringas, casting across their memories shadows more vast and more sombre than those of the still willows that lengthened out over the grass. Often some night-animal, hedgehog or weasel, setting out on the hunt, disturbed the lovers, or sometimes they heard a ripe peach falling all alone from the espalier.

'Ah! what a lovely night!' said Rodolphe.

'We shall have others,' replied Emma; and, as if speaking to herself: 'Yet, it will be good to travel. And yet, why should my heart be so heavy? Is it dread of the unknown? The result of a break with the past? Or rather –? No; it is too much happiness. How weak I am, am I not? Forgive me!'

'There is still time!' he cried. 'Reflect! perhaps you may repent!'

'Never!' she cried impetuously. And coming closer to him: 'What ill could come to me? There is no desert, no precipice, no ocean I would not traverse with you. The longer we live together the more it will be like an embrace, every day closer, more heart to heart. There will be nothing to trouble us, no cares, no obstacle. We shall be alone, all to ourselves eternally. Oh, speak! Answer me!'

At regular intervals he answered, 'Yes - Yes - ' She had passed her hands through his hair, and she repeated in a childlike voice, despite the big tears which were falling, 'Rodolphe! Rodolphe! Ah! Rodolphe! dear little Rodolphe!'

Midnight struck.

'Midnight!' said she, 'Come, it is tomorrow. One day more!'

He rose to go; and, as if the movement he made had been the signal for their flight, Emma said, suddenly assuming a gay air – 'You have the passports?'

'Yes.'

'You are forgetting nothing?'

'No.'

'Are you sure?'

'Certainly.'

'It is the Hôtel de Provence, isn't it? You will wait for me at midday?'

He nodded.

'Till tomorrow then!' said Emma in a last caress; and she watched him go.

He did not turn round. She ran after him, and, leaning over the water's edge between the bulrushes – 'Tomorrow!' she cried.

He was already on the other side of the river and walking fast across the meadow.

After a few moments Rodolphe stopped; and when he saw her with her white gown gradually fade away in the shade like a ghost, he was seized with such a beating of the heart that he leant against a tree lest he should fall.

'What a fool I am!' he said with a fearful oath. 'No matter! She was a pretty mistress!'

And immediately Emma's beauty, and all the pleasures of their love, came back to him. For a moment he softened; then he rebelled against her.

'For, after all,' he exclaimed, gesticulating, 'I can't exile myself – I can't have a child on my hands.'

He was saying these things to strengthen himself.

'And besides, the worry, the expense! Oh! no, no, no! a thousand times no! It would be too stupid.'

On reaching home Rodolphe at once sat down at his bureau under the stag's head that hung as a trophy on the wall. But with the pen between his fingers, he could think of nothing, so that, resting on his elbows, he began to reflect. Emma seemed to have receded into a far-off past, as if the resolution he had taken had suddenly placed a distance between them.

To get back something of her, he fetched from the cupboard at the bedside an old Rheims biscuit-box, in which he usually kept his letters from women. From it rose an odour of dry dust and withered roses. First he saw a handkerchief with pale little spots. It was a handkerchief of hers. Once when they were walking her nose had bled; he had forgotten it. Near it, chipped at all the corners, was a miniature given him by Emma: her toilette looked pretentious, and her languishing look in the worst possible taste. Then, from looking at this image and recalling the memory of its original, Emma's features little by little grew confused in his remembrance, as if the living and the painted face, rubbing one against the other, had effaced each other. Finally, he read some of her letters; they were full of explanations relating to their journey, short, technical, and urgent, like business notes. He wanted to see the long ones again, those of old times. In order to find them at the bottom of the box, Rodolphe disturbed all the others, and mechanically began rummaging amidst this mass of papers and things, finding pell-mell bouquets, garters, a black mask, pins, and hair - hair! dark and fair, some even,

catching in the hinges of the box, broke when it was opened.

Dallying thus with his souvenirs, he examined the writing and the style of the letters, as varied as their orthography. They were tender or jovial, facetious or melancholy; there were some asking for love, others asking for money. A word recalled faces to him, certain gestures, the sound of a voice; yet sometimes he could remember nothing at all.

In fact, these women, rushing at once into his thoughts, cramped each other and seemed shrunken, as reduced to a uniform level of love equalising them all. So taking handfuls of the mixed-up letters, he amused himself for some moments with letting them fall in cascades from his right into his left hand. At last, bored and weary, Rodolphe took back the box to the cupboard, saying to himself, 'What a lot of rubbish!' Which summed up his opinion; for pleasures, like schoolboys in a school courtyard, had so trampled upon his heart that no green thing grew there, and that which passed through it, more heedless than children, did not even, like them, leave a name carved upon the wall.

'Come,' said he, 'let's begin.'

He wrote -

Courage, Emma! courage! I would not bring misery into your life.

'After all, that's true,' thought Rodolphe. 'I am acting in her interest; I am honest.'

Have you carefully weighed your resolution? Do you know to what an abyss I was dragging you, poor angel? No, you do not, do you? You were coming

confident and fearless, believing in happiness in the future. Ah! unhappy that we are – insensate!

Rodolphe stopped here to think of some good excuse. 'If I told her all my fortune is lost? No! Besides, that would stop nothing. It would all have to be begun over again later on. As if one could make women like that listen to reason!' He reflected, then went on —

I shall not forget you, oh! believe it; and I shall ever have a profound devotion for you; but someday, sooner or later, this ardour (such is the fate of human things) would have grown less, no doubt. Lassitude would have come to us, and who knows if I should not even have had the atrocious pain of witnessing your remorse, of sharing it myself, since I should have been its cause? The mere idea of the grief that would come to you tortures me, Emma. Forget me! Why did I ever know you? Why were you so beautiful? Is it my fault? O my God! No, no! Accuse only fate.

'That's a word that always tells,' he said to himself.

Ah, if you had been one of those frivolous women that one sees, certainly I might, through egotism, have tried an experiment, in that case without danger for you. But that delicious exaltation, at once your charm and your torment, has prevented you from understanding, adorable woman that you are, the falseness of our future position. Nor had I reflected upon this at first, and I rested in the shade of that ideal of happiness as beneath that of the manchineel tree, without foreseeing the consequences.

'Perhaps she'll think I'm giving it up from avarice.

Ah, well! so much the worse; it must be stopped!'

The world is cruel, Emma. Wherever we might have gone, it would have persecuted us. You would have had to put up with indiscreet questions, calumny, contempt, insult perhaps. Insult to you! Oh! And I, who would place you on a throne! I who bear with me your memory as a talisman! For I am going to punish myself by exile for all the ill I have done you. I am going away. Whither I know not. I am mad. Adieu! Be good always. Preserve the memory of the unfortunate who has lost you. Teach my name to your child; let her repeat it in her prayers.

The wicks of the candles flickered. Rodolphe got up to shut the window, and when he had sat down again - 'I think it's all right. Ah! and this for fear she should come and hunt me up.'

I shall be far away when you read these sad lines, for I have wished to flee as quickly as possible to shun the temptation of seeing you again. No weakness! I shall return, and perhaps later on we shall talk together very coldly of our old love. Adieu!'

And there was a last 'adieu' divided into two words! 'A Dieu!' which he thought in very excellent taste.

'Now how am I to sign?' he said to himself.' "Yours devotedly"? No! "Your friend"? Yes, that's it.'

Your friend.

He re-read his letter. He considered it very good.

'Poor little woman!' he thought with emotion. 'She'll think me harder than a rock. There ought to have been some tears on this; but I can't cry; it isn't my fault.' Then, having emptied some water into a glass,

Rodolphe dipped his finger into it, and let a big drop fall on the paper, that made a pale stain on the ink. Then looking for a seal, he came upon the one 'Amor nel cor'.

'That doesn't at all fit in with the circumstances. Pooh! never mind!'

After which he smoked three pipes and went to bed.

The next day when he was up (at about two o'clock—he had slept late), Rodolphe had a basket of apricots picked. He put his letter at the bottom under some vine leaves, and at once ordered Girard, his ploughman, to take it with care to Madame Bovary. He made use of this means for corresponding with her, sending according to the season fruits or game.

'If she asks after me,' he said, 'you will tell her that I have gone on a journey. You must give the basket to her herself, into her own hands. Get along and take care!'

Girard put on his new blouse, knotted his handkerchief round the apricots, and walking with great heavy steps in his thick iron-bound goloshes, made his way to Yonville.

Madame Bovary, when he got to her house, was arranging a bundle of linen on the kitchen-table with Félicité.

'Here,' said the ploughboy, 'is something for you from the master.'

She was seized with apprehension, and as she sought in her pocket for some coppers, she looked at the peasant with haggard eyes, while he himself looked at her with amazement, not understanding how such a present could so move anyone. At last he went out. Félicité remained. She could bear it no longer; she ran into the sitting-room as if to take the apricots there, overturned the basket, tore away the leaves, found the

letter, opened it, and, as if some fearful fire were behind her, Emma flew to her room terrified.

Charles was there; she saw him; he spoke to her; she heard nothing, and she went on quickly up the stairs, breathless, distraught, dumb, and ever holding this horrible piece of paper, that crackled between her fingers like a plate of sheet-iron. On the second-floor she stopped before the attic-door, which was closed.

Then she tried to calm herself; she recalled the letter; she must finish it; she did not dare to. And where? How? She would be seen! 'Ah, no! here,' she thought, 'I shall be all right.'

Emma pushed open the door and went in.

The slates threw straight down a heavy heat that gripped her temples, stifled her; she dragged herself to the closed garret-window. She drew back the bolt, and the dazzling light burst in with a leap.

Opposite, beyond the roofs, stretched the open country till it was lost to sight. Down beneath her, the village square was empty; the stones of the pavement glittered, the weathercocks on the houses stood motionless. At the corner of the street, from a lower storey, rose a kind of humming with strident modulations. It was Binet turning his lathe.

She leant against the embrasure of the window and reread the letter, gulping with anger. But the more she fixed her attention upon it, the more confused were her ideas. She saw him again, heard him, encircled him with her arms, and the throbs of her heart, that beat against her breast like blows of a sledgehammer, grew faster and faster, with uneven intervals. She looked about her with a wish that the earth might crumble into pieces. Why not end it all? What restrained her? She was free. She advanced,

looked at the paving-stones, saying to herself, 'Come! come!'

The luminous ray that came straight up from below drew the weight of her body towards the abyss. It seemed to her that the ground of the oscillating square went up the walls, and that the floor dipped on end like a tossing boat. She was right at the edge, almost hanging, surrounded by vast space. The blue of the heavens suffused her, the air was whirling in her hollow head; she had but to yield, to let herself be taken; and the humming of the lathe never ceased, like an angry voice calling her.

'Emma! Emma!' cried Charles.

She stopped.

'Wherever are you? Come!'

The thought that she had just escaped from death almost made her faint with terror. She closed her eyes; then she shivered at the touch of a hand on her sleeve; it was Félicité.

'Master is waiting for you, madame; the soup is on the table.'

And she had to go down to sit at table.

She tried to eat. The food choked her. Then she unfolded her napkin as if to examine the darns, and she really thought of applying herself to this work, counting the threads in the linen. Suddenly the remembrance of the letter returned to her. How had she lost it? Where could she find it? But she felt such weariness of spirit that she could not even invent a pretext for leaving the table. Then she became a coward; she was afraid of Charles; he knew all, that was certain! Indeed he pronounced these words in a strange manner: 'We are not likely to see Monsieur Rodolphe soon again, it seems.'

'Who told you?' she said, shuddering.

'Who told me!' he replied, rather astonished at her abrupt tone. 'Why, Girard, whom I met just now at the door of the Café Français. He has gone on a journey, or is to go.'

She gave a sob.

'What surprises you in that? He goes off like that from time to time for a change, and my word! I think he's right when you're a bachelor and well-off too. Besides, he has jolly times, has our friend. He's a bit of a rake. Monsieur Langlois told me –'

He stopped for propriety's sake because the servant came in. She put back into the basket the apricots scattered on the sideboard. Charles, without noticing his wife's colour, had them brought to him, took one, and bit into it.

'Ah! perfect!' said he; 'just taste!'

And he handed her the basket, which she put away from her gently.

'Do just smell! What an odour!' he remarked, passing it under her nose several times.

'I'm choking,' she cried, leaping up. But by an effort of will the spasm passed; then – 'It is nothing,' she said, 'it is nothing! It is nervousness. Sit down and go on with your meal.' For she was afraid of his beginning to question her, and look after her, and not leave her alone.

Charles obediently sat down again, and spat the stones of the apricots into his hands, afterwards putting them on his plate.

Suddenly a blue tilbury passed across the square at a rapid trot. Emma uttered a cry and fell back rigid to the ground.

In fact, Rodolphe, after many reflections, had

decided to set out for Rouen. Now, as from La Huchette to Buchy there is no other way than by Yonville, he had to go through the village, and Emma had recognised him by the rays of the lanterns, as they flashed like lightning through the dusk.

The chemist, at the tumult which broke out in the house, ran in. The table with all the plates was upset; sauce, meat, knives, the salt, and cruet-stand were strewn over the room; Charles was calling for help; Berthe, scared, was crying; and Félicité, whose hands trembled, was unlacing her mistress, whose whole body shivered convulsively.

'I'll run to my laboratory for some aromatic vinegar,' said the druggist.

Then as she opened her eyes on smelling the bottle – 'I was sure of it,' he remarked; 'that would wake a dead man for you!'

'Speak to us,' said Charles; 'collect yourself; it is I – your Charles, who loves you. Do you know me? See! here is your little girl! Oh, kiss her!'

The child stretched out her arms to her mother to cling to her neck. But turning away her head, Emma said in a broken voice – 'No, no! no one!'

She fainted again. They carried her to her bed, where she lay stretched at full length, her lips apart, her eyelids closed, her hands open, motionless, and white as a waxen image. Two streams of tears flowed from her eyes and trickled on to the pillow.

Charles, standing up, was at the back of the alcove, and the chemist, near him, maintained that meditative silence that is becoming on the serious occasions of life.

'Do not be uneasy,' he said, touching his elbow; 'I think the paroxysm is past.'

'Yes, she is resting a little now,' answered Charles, watching her sleep. 'Poor girl! poor girl! She has gone off now!'

Then Homais asked how the accident had come about. Charles answered that she had been taken ill suddenly while she was eating some apricots.

'Extraordinary!' continued the chemist. 'But it might be that the apricots had brought on the syncope. Some natures are so sensitive to certain smells; and it would even be a very fine question to study both in its pathological and physiological relation. The priests know the importance of it, they who have introduced aromatics into all their ceremonies. It is to stupefy the senses and to bring on ecstasies, – a thing, moreover, very easy in persons of the weaker sex, who are more delicate than the other. There are cases cited of people fainting at the smell of burnt hartshorn, of new bread –'

'Take care; you'll wake her!' said Bovary in a low voice.

'And not only,' the druggist went on, 'are human beings subject to such anomalies, but animals also. Thus you are not ignorant of the singularly aphrodisiac effect produced by the *Nepeta cataria*, vulgarly called catmint, on the feline race; and, on the other hand, to quote an example whose authenticity I can answer for, Bridaux (one of my old comrades, at present established in the Rue Malpalu) possesses a dog that falls into convulsions as soon as you hold out a snuffbox to him. He often even makes the experiment before his friends at his summerhouse at Guillaume Wood. Would anyone believe that a simple sternutation could produce such ravages in the organism of a quadruped? It is extremely curious, is it not?'

'Yes,' said Charles, who was not listening to him.

'This shows us,' went on the other, smiling with benign self-sufficiency, 'the innumerable irregularities of the nervous system. With regard to madame, she has always seemed to me, I confess, very susceptible. And so I should by no means recommend to you, my dear friend, any of those so-called remedies that, under the pretence of attacking the symptoms, attack the constitution. No; no useless physicking! Diet, that is all; sedatives, emollients, dulcification. Then, don't you think that perhaps her imagination should be worked upon?'

'In what way? How?' said Bovary.

'Ah! that is it. Such is indeed the question. "That is the question," as I lately read in a newspaper.'

But Emma, awaking, cried out - 'The letter! the letter!'

They thought she was delirious; and she was by midnight. Brain-fever had set in.

For forty-three days Charles did not leave her. He gave up all his patients; he no longer went to bed; he was constantly feeling her pulse, putting on sinapisms and cold-water compresses. He sent Justin as far as Neufchâtel for ice; the ice melted on the way; he sent him back again. He called Monsieur Canivet into consultation; he sent for Dr Larivière, his old master, from Rouen; he was in despair. What alarmed him most was Emma's prostration, for she did not speak, did not listen, did not even seem to suffer, as if her body and soul were both resting together after all their troubles.

About the middle of October she could sit up in bed supported by pillows. Charles wept when he saw her eat her first bread-and-jelly. Her strength returned to

her; she got up for a few hours of an afternoon, and one day, when she felt better, he tried to take her leaning on his arm, for a walk round the garden. The sand of the paths was disappearing beneath the dead leaves; she walked slowly, dragging along her slippers, and leaning against Charles's shoulder. She smiled all the time.

They went thus to the bottom of the garden near the terrace. She drew herself up slowly, shading her eyes with her hand to look. She looked far off, as far as she could, but on the horizon were only great bonfires of grass smoking on the hills.

'You will tire yourself, my darling!' said Bovary. And, pushing her gently to make her go into the arbour, 'Sit down on this seat; you'll be comfortable.'

'Oh! no; not there!' she said in a faltering voice.

She was seized with giddiness, and from that evening her illness recommenced, with a more uncertain character, it is true, and more complex symptoms. Now she suffered in her heart, then in the chest, the head, the limbs; she had vomitings, in which Charles thought he saw the first signs of cancer.

And besides this, the poor fellow was worried about money matters.

To begin with, he did not know how he could pay Monsieur Homais for all the physic supplied by him. and although, as a medical man, he was not obliged to pay for it, he nevertheless felt some shame at this obligation. Then the expenses of the household, now that the servant was mistress, became terrible. Bills rained in upon the house; the tradesmen grumbled; Monsieur Lheureux especially harassed him. In fact, at the height of Emma's illness, the latter, taking advantage of the circumstances to make his bill larger, had hurriedly brought the cloak, the travelling bag, two trunks instead of one, and a number of other things. It was very well for Charles to say he did not want them. The tradesman answered arrogantly that these articles had been ordered, and that he would not take them back; besides, it would vex madame in her convalescence; the doctor had better think it over; in short, he was resolved to sue him rather than give up his rights and take back his goods. Charles subsequently ordered them to be sent back to the shop. Félicité forgot; he had other things to attend to; then thought no more about them. Monsieur Lheureux returned to the charge, and, by turns threatening and whining, so managed that Bovary ended by signing a bill at six months. But hardly had he signed this bill than a bold idea occurred to him, namely, to borrow a thousand francs from Lheureux. So, with an embarrassed air, he asked if it were possible to get them, adding that it would be for a year, at any interest he wished. Lheureux ran off to his

shop, brought back the money, and dictated another bill, by which Bovary undertook to pay to his order on the 1st of September next the sum of one thousand and seventy francs, which, with the hundred and eighty already agreed to, made just twelve hundred and fifty, thus lending at six per cent in addition to one-fourth for commission; and the things bringing him in a good third at the least, this ought in twelve months to give him a profit of a hundred and thirty francs. He hoped that the business would not stop there; that the bills would not be paid; that they would be renewed; and that his poor little money, having thriven at the doctor's as at a hospital, would come back to him one day considerably more plump, and fat enough to burst his bag.

Everything, moreover, succeeded with him. He was adjudicator for a supply of cider to the hospital at Neufchâtel; Monsieur Guillaumin promised him some shares in the turf-pits of Gaumesnil, and he dreamt of establishing a new diligence service between Arcueil and Rouen, which no doubt would not be long in ruining the ramshackle van of the Lion d'Or, and that, travelling faster, at a cheaper rate, and carrying more luggage, would thus put into his hands the whole commerce of Yonville.

Charles several times asked himself by what means he should next year be able to pay back so much money. He reflected, imagined expedients, such as applying to his father or selling something. But his father would be deaf, and he – he had nothing to sell. Then he foresaw such worries that he quickly dismissed so disagreeable a subject of meditation from his mind. He reproached himself with forgetting Emma, as if, all his thoughts belonging to this woman,

it was robbing her of something not to be constantly thinking of her.

The winter was severe, Madame Bovary's convalescence slow. When it was fine they wheeled her armchair to the window that overlooked the square, for she now had an antipathy to the garden, and the blinds on that side were always down. She wished the horse to be sold; what she formerly liked now displeased her. All her ideas seemed to be limited to the care of herself. She stayed in bed taking little meals, rang for the servant to enquire about her gruel or to chat with her. The snow on the market-roof threw a white, still light into the room; then the rain began to fall; and Emma waited daily with a mind full of eagerness for the inevitable return of some trifling events which nevertheless had no relation to her. The most important was the arrival of the 'Hirondelle' in the evening. Then the landlady shouted out, and other voices answered, while Hippolyte's lantern, as he fetched the boxes from the boot, was like a star in the darkness. At midday Charles came in; then he went out again; next she took some beef-tea, and towards five o'clock, as the day drew in, the children coming back from school, dragging their wooden shoes along the pavement, knocked the clapper of the shutters with their rulers one after the other.

It was at this hour that Monsieur Bournisien came to see her. He enquired after her health, gave her the news, exhorted her to religion, in a coaxing little prattle that was not without its charm. The mere sight of his cassock comforted her.

One day, when at the height of her illness, she had thought herself dying, and asked for the communion; and, while they were making the preparations in her room for the sacrament, turning the night table covered with syrups into an altar, and Félicité strewing dahlia flowers on the floor, Emma felt some power passing over her that freed her from her pains, from all perception, from all feeling. Her body, relieved, no longer thought; another life was beginning; it seemed to her that her being, mounting towards God, would be annihilated in that love like a burning incense that melts into vapour. The bedclothes were sprinkled with holy water, the priest drew from the holy pyx the white wafer; and it was fainting with a celestial joy that she put out her lips to accept the body of the Saviour presented to her. The curtains of the alcove floated gently round her like clouds, and the rays of the two tapers burning on the night-table seemed to shine like dazzling halos. Then she let her head fall back, fancying she heard in space the music of seraphic harps, and perceived in an azure sky, on a golden throne in the midst of saints holding green palms, God the Father, resplendent with majesty, who with a sign sent to earth angels with wings of fire to carry her away in their arms.

This splendid vision dwelt in her memory as the most beautiful thing it was possible to dream, so that now she strove to recall her sensation, that still lasted, however, but in a less exclusive fashion and with a deeper sweetness. Her soul, tortured by pride, at length found rest in Christian humility, and, tasting the joy of weakness, she saw within herself the destruction of her will, that must have left a wide entrance for the inroads of heavenly grace. There existed, then, in the place of happiness, still greater joys, – another love beyond all loves, without pause and without end, one that would grow eternally! She saw amid the illusions of her hope a

state of purity floating above the earth mingling with heaven, to which she aspired. She wanted to become a saint. She bought chaplets and wore amulets; she wished to have in her room, by the side of her bed, a reliquary set in emeralds that she might kiss it every evening.

The curé marvelled at this humour, although Emma's religion, he thought, might from its fervour, end by touching on heresy, extravagance. But not being much versed in these matters, as soon as they went beyond a certain limit he wrote to Monsieur Boulard, bookseller to Monsignor, to send him 'something good for a lady who was very clever'. The bookseller, with as much indifference as if he had been sending off hardware to niggers, packed up, pell-mell, everything that was then the fashion in the pious book trade. There were little manuals in questions and answers, pamphlets of aggressive tone after the manner of Monsieur de Maistre, and certain novels in rose-coloured bindings and with a honied style, manufactured by troubadour seminarists or penitent bluestockings. There were the Think it Over: The Man of the World at Mary's Feet, by Monsieur de-, decorated with many Orders; Errors of Voltaire, for the Use of the Young, etc.

Madame Bovary's mind was not yet sufficiently clear to apply herself seriously to anything; moreover, she began this reading in too much hurry. She grew provoked at the doctrines of religion; the arrogance of the polemic writings displeased her by their inveteracy in attacking people she did not know; and the secular stories, relieved with religion, seemed to her written in such ignorance of the world, that they insensibly estranged her from the truths for whose proof she was

looking. Nevertheless, she persevered; and when the volume slipped from her hands, she fancied herself seized with the finest Catholic melancholy that an ethereal soul could conceive.

As for the memory of Rodolphe, she had thrust it back to the bottom of her heart, and it remained there more solemn and more motionless than a king's mummy in a catacomb. An exhalation escaped from this embalmed love, that, penetrating through everything, perfumed with tenderness the immaculate atmosphere in which she longed to live. When she knelt on her gothic prie-dieu, she addressed to the Lord the same suave words that she had murmured formerly to her lover in the outpourings of adultery. It was to make faith come; but no delights descended from the heavens, and she arose with tired limbs and with a vague feeling of a gigantic dupery.

This searching after faith, she thought, was only one merit the more, and in the pride of her devoutness Emma compared herself to those grand ladies of long ago whose glory she had dreamed of over a portrait of LaVallière, and who, trailing with so much majesty the lace-trimmed trains of their long gowns, retired into solitudes to shed at the feet of Christ all the tears of hearts that life had wounded.

Then she gave herself up to excessive charity. She sewed clothes for the poor, she sent wood to women in childbed; and Charles one day, on coming home, found three good-for-nothings in the kitchen seated at the table eating soup. She had her little girl, whom during her illness her husband had sent back to the nurse, brought home. She wanted to teach her to read; even when Berthe cried, she was not vexed. She

had made up her mind to resignation, to universal indulgence. Her language about everything was full of ideal expressions. She said to her child, 'Is your stomachache better, my angel?'

Madame Bovary, senior, found nothing to censure except perhaps this mania for knitting jackets for orphans instead of mending her own house-linen; but, harassed with domestic quarrels, the good woman took pleasure in this quiet house, and she even stayed there till after Easter, to escape the sarcasms of old Bovary, who never failed on Good Friday to order chitterlings.

Besides the companionship of her mother-in-law, who strengthened her a little by the rectitude of her judgement and her grave ways, Emma almost every day had other visitors. These were Madame Langlois, Madame Caron, Madame Dubreuil, Madame Tuvache and regularly from two to five o'clock the excellent Madame Homais, who, for her part, had never believed any of the tittle-tattle about her neighbour. The little Homais also came to see her; Justin accompanied them. He went up with them to her bedroom, and remained standing near the door, motionless and mute. Often even Madame Bovary, taking no heed of him, began her toilette. She began by taking out her comb, shaking her head with a quick movement, and when he for the first time saw all this mass of hair that fell to her knees unrolling in black ringlets, it was to him, poor child! like a sudden entrance into something new and strange, whose splendour terrified him.

Emma, no doubt, did not notice his silent attentions or his timidity. She had no suspicion that the love vanished from her life was there, palpitating by her side, beneath that coarse holland shirt, in that youthful heart open to the emanations of her beauty. Besides, she now enveloped all things with such indifference, she had words so affectionate with looks so haughty, such contradictory ways, that one could no longer distinguish egotism from charity, or corruption from virtue. One evening, for example, she was angry with the servant, who had asked to go out, and stammered as she tried to find some pretext. Then suddenly – 'So you love him?' she said.

And without waiting for any answer from Félicité, who was blushing, she added, 'There! run along; enjoy yourself!'

In the beginning of spring she had the garden turned up from end to end, despite Bovary's remonstrances. However, he was glad to see her at last manifest a wish of any kind. As she grew stronger she displayed more wilfulness. First, she found occasion to expel Mère Rollet, the nurse, who during her convalescence had contracted the habit of coming too often to the kitchen with her two nurslings and her boarder, better off for teeth than a cannibal. Then she got rid of the Homais family, successively dismissed all the other visitors, and even frequented church less assiduously, to the great approval of the druggist, who said to her in a friendly way – 'You were going in a bit for the cassock!'

As formerly, Monsieur Bournisien dropped in every day when he came out after catechism class. He preferred staying out of doors to taking the air 'in the grove', as he called the arbour. This was the time when Charles came home. They were hot; some sweet cider was brought out, and they drank together to madame's complete restoration.

Binet was there; that is to say, a little lower down against the terrace wall, fishing for crayfish. Bovary invited him to have a drink, and he thoroughly understood the uncorking of the stone bottles.

'You must,' he said, throwing a satisfied glance all round him, even to the very extremity of the land-scape, 'hold the bottle perpendicularly on the table, and after the strings are cut, press up the cork with little thrusts, gently, gently, just as they do seltzerwater at restaurants.'

But during his demonstration the cider often spurted right into their faces, and then the ecclesiastic, with a thick laugh, never missed this joke – 'Its goodness leaps to the eye!'

He was, in fact, a good fellow and one day he was not even scandalised at the chemist, who advised Charles to give madame some distraction by taking her to the theatre at Rouen to hear the illustrious tenor, Lagardy. Homais, surprised at this silence, wanted to know his opinion, and the priest declared that he considered music less dangerous for morals than literature.

But the chemist took up the defence of letters. The theatre, he contended, served for railing at prejudices, and, beneath a mask of pleasure, taught virtue.

'Castigat ridendo mores, Monsieur Bournisien! Thus consider the greater part of Voltaire's tragedies; they are cleverly strewn with philosophical reflections, that make them a very school of morals and diplomacy for the people.'

'I,' said Binet, 'once saw a piece called the *Gamin de Paris*, in which there was the character of an old general that is really hit off to a T. He sets down a young swell who had seduced a working girl, who at the ending –'

'Certainly,' continued Homais, 'there is bad literature as there is bad pharmacy, but to condemn in a lump the most important of the fine arts seems to me a stupidity, a Gothic idea, worthy of the abominable times that imprisoned Galileo.'

'I know very well,' objected the curé, 'that there are good works, good authors. But with all these people of both sexes assembled in some enchanting apartment decked with worldly adornments, and then these pagan disguises, that rouge, those lights, those effeminate voices – in the long run it is bound to engender a certain laxity of spirit and to kindle base thoughts and temptations to purity. Such, at any rate, is the opinion of all the Fathers. Finally,' he added, suddenly assuming a mystic tone of voice while he rolled a pinch of snuff between his fingers, 'if the Church has condemned the theatre, it is for a good reason; we must submit to her decrees.'

'Why,' asked the druggist, 'should she excommunicate actors? For formerly they openly took part in religious ceremonies. Yes, in the middle of the chancel they acted; they performed a kind of farce called "Mysteries", which often offended against the laws of decency.'

The ecclesiastic contented himself with uttering a groan, and the chemist went on – 'It's like it is in the Bible; there there are, you know, more than one piquant detail, matters really libidinous!'

And on a gesture of irritation from Monsieur Bournisien – 'Ah! you'll admit that it is not a book to place in the hands of a young girl, and I should be sorry if Athalie – '

'But it is the Protestants, and not we,' cried the other impatiently, 'who recommend the Bible.'

'No matter,' said Homais. 'I am surprised that in our days, in this century of enlightenment, anyone should still persist in proscribing an intellectual relaxation that is inoffensive, moralising, and sometimes even hygienic; is it not, doctor?'

'No doubt,' replied the doctor carelessly, either because, sharing the same ideas, he wished to offend no one, or else because he had not any ideas.

The conversation seemed at an end when the chemist thought fit to shoot a Parthian arrow.

'I've known priests who put on ordinary clothes to go and see dancers kick about.'

'Come, come!' said the cure.

'Ah! I've known some!' And separating the words of his sentence, Homais repeated, 'I – have – known – some!'

'Well, they did wrong,' said Bournisien, resigned to anything.

'And my word! plenty other wrongs too!' exclaimed the druggist.

'Sir!' replied the ecclesiastic, with such angry eyes that the druggist was intimidated.

'I only mean to say,' he replied in less brutal a tone, 'that toleration is the surest way to draw people to religion.'

'That is true! that is true!' agreed the worthy man, sitting down again on his chair. But he stayed only a few moments.

Then, as soon as he had gone, Monsieur Homais said to the doctor – 'That's what I call a cockfight. I beat him, did you see, in a way! – Now, take my advice. Take madame to the theatre, if it were only for once in your life, to enrage one of these ravens, hang it! If anyone could take my place, I would accompany you

myself. Be quick about it. Lagardy is only going to give one performance; he's engaged to go to England at a high salary. From what I hear, he's a regular dog; he's rolling in money; he's taking three mistresses and a cook along with him. All these great artists burn the candle at both ends; they require a dissolute life, that suits the imagination to some extent. But they die at the hospital, because they haven't the sense when young to lay by. Well, a pleasant dinner! Goodbye till tomorrow.'

The idea of the theatre quickly germinated in Bovary's head, for he at once communicated it to his wife, who at first refused, alleging the fatigue, the worry, the expense, but, for a wonder, Charles did not give in, so sure was he that this recreation would be good for her. He saw nothing to prevent it: his mother had sent them three hundred francs which he had no longer expected; the current debts were not very large, and the falling in of Lheureux's bills was still so far off that there was no need to think about them. Besides, imagining that she was refusing from delicacy, he insisted the more; so that by dint of worrying her she at last made up her mind, and the next day at eight o'clock they set out in the 'Hirondelle'.

The druggist, whom nothing whatever kept at Yonville, but who thought himself bound not to budge from it, sighed as he saw them go.

'Well, a pleasant journey!' he said to them; 'happy mortals that you are!'

Then addressing himself to Emma, who was wearing a blue silk gown with, four flounces – 'You are as lovely as a Venus. You'll cut quite a figure in Rouen.'

The diligence stopped at the Croix-Rouge in the Place Beauvoisine. It was the inn that is in every

provincial faubourg, with large stables and small bedrooms, where one sees in the middle of the court chickens pilfering the oats under the muddy gigs of the commercial travellers; - a good old house, with worm-eaten balconies that creak in the wind on winter nights, always full of people, noise, and feeding, whose black tables are sticky with coffee and brandy, the thick windows made yellow by the flies, the damp napkins stained with cheap wine, and that always smells of the village, like ploughboys dressed in Sunday-clothes, has a café on the street, and towards the countryside a kitchen-garden. Charles at once set out. He muddled up the stage-boxes with the gallery, the pit with the boxes; asked for explanations, did not understand them; was sent from the box-office to the acting-manager; came back to the inn, returned to the theatre, and thus several times traversed the whole length of the town from the theatre to the boulevard.

Madame Bovary bought a bonnet, gloves, and a bouquet. The doctor was much afraid of missing the beginning, and, without having had time to swallow a plate of soup, they presented themselves at the doors of the theatre, which were still closed.

The crowd was waiting against the wall, symmetrically enclosed between the balustrades. At the corner of the neighbouring streets huge bills repeated in baroque lettering 'Lucia di Lammermoor – Lagardy – Opera – etc.' The weather was fine, the people were hot, perspiration trickled amid the curls, and hand-kerchiefs taken from pockets were mopping red foreheads; and now and then a warm wind that blew from the river gently stirred the border of the tick awnings hanging from the doors of the public-houses. A little lower down, however, one was refreshed by a current of icy air that smelt of tallow, leather, and oil. This was an exhalation from the Rue des Charrettes, full of large black warehouses where they make casks.

For fear of seeming ridiculous, Emma before going in wished to have a little stroll in the harbour, and Bovary prudently kept his tickets in his hand, in the pocket of his trousers, which he pressed against his stomach.

Her heart began to beat as soon as she reached the vestibule. She involuntarily smiled with vanity on seeing the crowd rushing to the right by the other corridor while she went up the staircase to the reserved seats. She was as pleased as a child at pushing the large tapestried door with her finger. She breathed as deeply as she could of the dusty smell of the lobbies, and when she was seated in her box she bent forward with the air of a duchess.

The theatre was beginning to fill; opera-glasses were taken from their cases, and the subscribers, catching sight of one another, were bowing. They came to seek relaxation in the fine arts after the anxieties of business; but 'business' was not forgotten; they still talked cotton, spirits of wine, or indigo. The heads of old men were to be seen, inexpressive and peaceful, with their hair and complexions looking like silver medals tarnished by steam of lead. The young beaux were strutting about in the pit, showing in the opening of their waistcoats their pink or apple-green cravats, and Madame Bovary from above admired them leaning on their canes with golden knobs in the open palm of their yellow gloves.

Now the lights of the orchestra were lit, the lustre, let down from the ceiling, throwing by the glimmering of its facets a sudden gaiety over the theatre; then the musicians came in one after the other; and first there was the protracted hubbub of the basses grumbling, violins squeaking, cornets trumpeting, flutes and flageolets fifing. But the three knocks were heard on the stage, a rolling of drums began, the brass instruments played some chords, and the rising curtain discovered a country scene.

It was the crossroads of a wood, with a fountain shaded by an oak to the left. Peasants and lords with plaids on their shoulders were singing a hunting-song together; then a captain suddenly came on, who evoked the spirit of evil by lifting both his arms to Heaven. Another appeared; they went away, and the hunters started afresh. She felt herself transported to the reading of her youth, into the midst of Walter Scott. She seemed to hear through the mist the sound of the Scotch bagpipes re-echoing over the heather. Then her remembrance of the novel helping her to understand the libretto, she followed the story phrase

by phrase, while vague thoughts that came back to her dispersed at once again with the bursts of music. She gave herself up to the lullaby of the melodies, and felt all her being vibrate as if the violin bows were drawn over her nerves. She had not eyes enough to look at the costumes, the scenery, the actors, the painted trees, that shook when anyone walked, and the velvet caps, cloaks, swords - all those imaginary things that floated amid the harmony as in the atmosphere of another world. But a young woman stepped forward, throwing a purse to a squire in green. She was left alone, and the flute was heard like the murmur of a fountain or the warbling of birds. Lucia attacked her cavatina in G major brayely. She plained of love; she longed for wings. Emma, too, fleeing from life, would have liked to fly away in an embrace. Suddenly Edgar Lagardy appeared.

He had that splendid pallor that gives something of the majesty of marble to the ardent races of the South. His vigorous form was tightly clad in a browncoloured doublet; a small chiselled poniard hung against his left thigh, and he cast round laughing looks showing his white teeth. They said that a Polish princess having heard him sing one night on the beach at Biarritz, where he mended boats, had fallen in love with him. She had ruined herself for him. He had deserted her for other women, and this sentimental celebrity did not fail to enhance his artistic reputation. The diplomatic mummer took care always to slip into his advertisements some poetic phrase on the fascination of his person and the susceptibility of his soul. A fine organ, imperturbable coolness, more temperament than intelligence, more power of emphasis than of real singing, made up the charm of this admirable charlatan nature, in which there was something of the hairdresser and the toreador.

From the first scene he evoked enthusiasm. He pressed Lucia in his arms, he left her, he came back, he seemed desperate; he had outbursts of rage, then elegaic gurglings of infinite sweetness, and the notes escaped from his bare neck full of sobs and kisses. Emma lent forward to see him, clutching the velvet of the box with her nails. She was filling her heart with these melodious lamentations that were drawn out to the accompaniment of the double-basses, like the cries of the drowning in the tumult of a tempest. She recognised all the intoxication and the anguish that had almost killed her. The voice of the prima donna seemed to her to be but echoes of her conscience, and this illusion that charmed her as some very thing of her own life. But no one on earth had loved her with such love. He had not wept like Edgar that last moonlit night when they said, 'Tomorrow! tomorrow!' The theatre rang with cheers; they recommenced the entire movement; the lovers spoke of the flowers on their tomb, of vows, exile, fate, hopes; and when they uttered the final adieu, Emma gave a sharp cry that mingled with the vibrations of the last chords.

'But why,' asked Bovary, 'does that gentleman persecute her?'

'No, no!' she answered; 'he is her lover!'

'Yet he vows vengeance on her family, while the other one who came on before said, "I love Lucia and she loves me!" Besides, he went off with her father arm in arm. For he certainly is her father, isn't he – that ugly little man with a cock's feather in his hat?'

Despite Emma's explanations, as soon as the recitative duet began in which Gilbert lays bare his

abominable machinations to his master Ashton, Charles, seeing the false troth-ring that is to deceive Lucia, thought it was a love-gift sent by Edgar. He confessed, moreover, that he did not understand the story because of the music, which interfered very much with the words.

'What does it matter?' said Emma. 'Do be quiet!'

'Yes, but you know,' he went on, leaning against her shoulder, 'I like to understand things.'

'Be quiet! be quiet!' she cried impatiently.

Lucia advanced, half supported by her women, a wreath of orange blossoms in her hair, and paler than the white satin of her gown. Emma dreamed of her marriage day; she saw herself at home again amid the corn in the little path as they walked to the church. Oh, why had not she, like this woman, resisted, implored? She, on the contrary, had been joyous, without seeing the abyss into which she was throwing herself. Ah! if in the freshness of her beauty, before the soiling of marriage and the disillusions of adultery she could have anchored her life upon some great, strong heart, then virtue, tenderness, voluptuousness, and duty blending, she would never have fallen from so high a happiness. But that happiness, no doubt, was a lie invented for the despair of all desire. She knew now the smallness of the passions that art exaggerated. So, striving to divert her thoughts, Emma determined now to see in this reproduction of her sorrows only a plastic fantasy, well enough to please the eye, and she even smiled inwardly with disdainful pity when at the back of the stage under the velvet hangings a man appeared in a black cloak.

His large Spanish hat fell at a sweep of his hand, and immediately the instruments and the singers began

the sextet. Edgar, flashing with fury, dominated all the others with his clearer voice; Ashton hurled homicidal provocations at him in deep notes; Lucia uttered her shrill plaint, Arthur at one side, his modulated tones in the middle register, and the bass of the minister pealed forth like an organ, while the voices of the women repeating his words took them up in chorus delightfully. They were all in a row gesticulating, and anger, vengeance, jealousy, terror, and stupefaction breathed forth at once from their half-open mouths. The outraged lover brandished his naked sword; his guipure ruffle rose with jerks to the movements of his chest, and he walked from right to left with long strides, clanking against the boards the silver-gilt spurs of his soft boots, widening out at the ankles. He, she thought, must have an inexhaustible love to lavish it upon the crowd with such effusion. All her small faultfindings faded before the poetry of the part that absorbed her; and, drawn towards this man by the illusion of the character, she tried to imagine to herself his life - that life resonant, extraordinary, splendid, and that might have been hers if fate had willed it. They would have known one another, loved one another. With him, through all the kingdoms of Europe, she would have travelled from capital to capital, sharing his fatigues and his pride, picking up the flowers thrown to him, herself embroidering his costumes. Then each evening, at the back of the box, behind the golden trellis-work, she would have drunk in eagerly the expansions of this soul that would have sung for her alone; from the stage, even as he acted, he would have looked at her. But the mad idea seized her that he was looking at her; it was certain. She longed to run to his arms, to take refuge in his strength, as in

the incarnation of love itself, and to say to him, to cry out, 'Take me away! carry me with you! let us go! Thine, thine! all my ardour and all my dreams!'

The curtain fell.

The smell of the gas mingled with one's breath; the waving of fans made the air more suffocating. Emma wanted to go out; the crowd filled the corridors, and she fell back in her armchair with choking palpitations. Charles, fearing that she would faint, ran to the refreshment-room to get a glass of barley-water.

He had great difficulty in getting back to his seat, for his elbows were jerked at every step because of the glass he held in his hands, and he even spilt three-fourths on the shoulders of a Rouen lady in short sleeves, who feeling the cold liquid running down to her loins, uttered cries like a peacock, as if she were being assassinated. Her husband, who was a millowner, railed at the clumsy fellow, and while she used her handkerchief to wipe the stains from her handsome cherry-coloured taffeta gown, he angrily muttered about indemnity, costs, reimbursement. At last Charles reached his wife, saying to her, quite out of breath – 'My word! I thought I should have had to stay there. There is such a crowd – *such* a crowd!'

He added - 'Just guess whom I met up there! Monsieur Léon!'

'Léon?'

'Himself! He's coming along to pay his respects.' And as he finished these words the ex-clerk of Yonville entered the box.

He held out his hand with the ease of a gentleman; and Madame Bovary extended hers, without doubt obeying the attraction of a stronger will. She had not felt it since that spring evening when the rain fell upon

the green leaves, and they had said goodbye standing at the window. But soon recalling herself to the necessities of the situation, with an effort she shook off the torpor of her memories, and began stammering a few hurried words.

'Ah, how do you do! What! you here?'

'Silence!' cried a voice from the pit, for the third act was beginning.

'So you are at Rouen?'

'Yes.'

'And since when?'

'Turn them out! turn them out!' People were looking at them. They were silent.

But from that moment she listened no more; and the chorus of the guests, the scene between Ashton and his servant, the grand duet in D major, all were for her as far off as if the instruments had grown less sonorous and the characters more remote. She remembered the games at cards at the druggist's, and the walk to the nurse's, the reading in the arbour, the *tête-à-tête* by the fireside – all that poor love, so calm and so protracted, so discreet, so tender, and that she had nevertheless forgotten. And why had he come back? What combination of circumstances had brought him back into her life. He was standing behind her, leaning with his shoulder against the wall of the box; now and again she felt herself shuddering beneath the hot breath from his nostrils falling upon her hair.

'Does this amuse you?' said he, bending over her so closely that the end of his moustache brushed her cheek. She replied carelessly – 'Oh, dear me, no, not much.'

Then he proposed that they should leave the theatre and go and take an ice somewhere.

'Oh, not yet; let us stay,' said Bovary. 'Her hair's undone; this is going to be tragic.'

But the mad scene did not at all interest Emma, and the acting of the singer seemed to her exaggerated.

'She screams too loud,' said she, turning to Charles, who was listening.

'Yes – a little,' he replied, undecided between the frankness of his pleasure and his respect for his wife's opinion.

Then with a sigh Léon said - 'The heat is -'

'Unbearable! Yes!'

'Do you feel unwell?' asked Bovary.

'Yes, I am stifling; let us go.'

Monsieur Léon put her long lace shawl carefully about her shoulders, and all three went off to sit down in the harbour, in the open air, outside the windows of a café.

First they spoke of her illness, although Emma interrupted Charles from time to time, for fear, she said, of boring Monsieur Léon, and the latter told them that he had come to spend two years at Rouen in a large office, in order to get practice in his profession, which was different in Normandy and Paris. Then he enquired after Berthe, the Homais, Mère Lefrançois, and as they had nothing more to say to each other, in the husband's presence, the conversation soon ended.

People coming out of the theatre passed along the pavement, humming or shouting at the top of their voices, 'O bel ange, ma Lucie!' Then Léon, playing the dilettante, began to talk music. He had seen Tamburini, Rubini, Persiani, Grisi, and, compared with them, Lagardy, despite his grand outburst, was nowhere.

'Yes,' interrupted Charles, who was slowly sipping

his rum-sherbet, 'they say that he is quite admirable in the last act. I regret leaving before the end, because it was beginning to amuse me.'

'Why,' said the clerk, 'he will soon give another performance.'

But Charles replied that they were going back next day. 'Unless,' he added, turning to his wife, 'you would like to stay alone, kitten?'

And changing his tactics at this unexpected opportunity that presented itself to his hopes, the young man sang the praises of Lagardy in the last number. It was really superb, sublime. Then Charles insisted – 'You would get back on Sunday. Come, make up your mind. You are wrong if you feel that this is doing you the least good.'

The tables round them, however, were emptying; a waiter came and stood discreetly near them. Charles, who understood, took out his purse; the clerk held back his arm, and did not forget to leave two more silver coins which he chinked on the marble.

'I am really sorry,' said Bovary, 'about the money which you are - '

The other made a careless gesture full of cordiality, and taking his hat said – 'It is settled, isn't it? Tomorrow at six o'clock?'

Charles explained once more that he could not absent himself longer, but that nothing prevented Emma – 'But,' she stammered, with a strange smile, 'I am not sure – '

'Well, you must think it over. We'll see. Night brings counsel.' Then to Léon, who was walking along with them, 'Now that you are in our part of the world, I hope you'll come and ask us for some dinner now and then.'

The clerk declared he would not fail to do so, being obliged, moreover, to go to Yonville on some business for his office. And they parted before the Saint-Herbland Passage just as the clock in the cathedral struck half-past eleven.

FACTOR TO A STATE

The time decide of the raid action of a septemble decided on the septemble of the septemble of the septemble of the septemble decided of the septemble decided on the septe

PART THREE

Ι

Monsieur Léon, while studying law, had gone pretty often to the dancing-rooms, where he was even a great success amongst the grisettes, who thought he had a distinguished air. He was the best-mannered of the students; he wore his hair neither too long nor too short, didn't spend all his quarter's money on the first day of the month, and kept on good terms with his professors. As for excesses, he had always abstained from them, as much from cowardice as from refinement.

Often when he stayed in his room to read, or else when sitting of an evening under the lime trees of the Luxembourg, he let his Code fall to the ground, and the memory of Emma came back to him. But gradually this feeling grew weaker, and other desires gathered over it, although it still persisted through them all. For Léon did not lose all hope; there was for him, as it were, a vague promise floating in the future, like a golden fruit suspended from some fantastic tree.

Then, seeing her again after three years of absence, his passion reawakened. He must, he thought, at last make up his mind to possess her. Moreover, his timidity had worn off by contact with his gay companions, and he returned to the provinces despising everyone who had not with varnished shoes trodden the asphalt of the boulevards. By the side of a lace-

gowned Parisienne, in the drawing-room of some illustrious physician, a person driving his carriage and wearing many orders, the poor clerk would no doubt have trembled like a child; but here at Rouen, on the quays, with the wife of this small doctor he felt at his ease, sure beforehand he would shine. Self-possession depends on its environment. We don't speak on the first floor as on the fourth; and the wealthy woman seems to have, about her, to guard her virtue, all her bank-notes, like a cuirass, in the lining of her corset.

On leaving the Bovarys the night before, Léon had followed them through the streets at a distance; then having seen them stop at the Croix-Rouge, he turned on his heel, and spent the night meditating a plan.

So the next day about five o'clock he walked into the kitchen of the inn, with a choking sensation in his throat, pale cheeks, and that resolution of cowards that stops at nothing.

'The gentleman isn't in,' answered a servant.

This seemed to him a good omen. He went upstairs. She was not disturbed at his approach; on the

She was not disturbed at his approach; on the contrary, she apologised for having neglected to tell him where they were staying.

'Oh, I divined it!' said Léon.

He pretended he had been guided towards her by chance, by instinct. She began to smile; and at once, to repair his folly, Léon told her that he had spent his morning in looking for her in all the hotels in the town one after the other.

'So you have made up your mind to stay?' he added.

'Yes,' she said, 'and I am wrong. One ought not to accustom oneself to impossible pleasures when there are a thousand demands upon one.'

'Oh, I can imagine!'

'Ah! no; for you, you are a man!'

But men too had had their trials, and the conversation went off into certain philosophical reflections. Emma expatiated much on the misery of earthly affections, and the eternal isolation in which the heart remains entombed.

To show off, or from a naïve imitation of this melancholy which called forth his, the young man declared that he had been awfully bored during the whole course of his studies. The law irritated him, other vocations attracted him, and his mother never ceased worrying him in every one of her letters. As they talked they explained more and more fully the motives of their sadness, working themselves up in their progressive confidence. But they sometimes stopped short of the complete exposition of their thought, and then sought to invent a phrase that might express it all the same. She did not confess her passion for another; he did not say that he had forgotten her.

Perhaps he no longer remembered his suppers with girls after masked balls; and no doubt she did not recollect the rendezvous of old when she ran across the fields in the morning to her lover's house. The noises of the town hardly reached them, and the room seemed small, as if on purpose to hem in their solitude more closely. Emma, in a dimity dressing-gown, leant her head against the back of the old armchair; the yellow wallpaper formed, as it were, a golden background behind her, and her bare head was mirrored in the glass with the white parting in the middle, and the tip of her ears peeping out from the folds of her hair.

'But pardon me!' she said. 'It is wrong of me. I weary you with my eternal complaints.'

'No, never, never!'

'If you knew,' she went on, raising to the ceiling her beautiful eyes, in which a tear was trembling, 'all that I had dreamed!'

'And I! Oh, I too have suffered! Often I went out; I went away. I dragged myself along the quays, seeking distraction amid the din of the crowd without being able to banish the heaviness that weighed upon me. In an engraver's shop on the boulevard there is an Italian print of one of the Muses. She is draped in a tunic, and she is looking at the moon, with forget-me-nots in her flowing hair. Something drove me there continually; I stayed there hours together.' Then in a trembling voice, 'She resembled you a little.'

Madame Bovary turned away her head that he might not see the irrepressible smile she felt rising to her lips.

'Often,' he went on, 'I wrote you letters and tore them up.'

She did not answer. He continued – 'I sometimes fancied that some chance would bring you. I thought I recognised you at street-corners, and I ran after all the carriages through whose windows I saw a shawl fluttering, a veil like yours.'

She seemed resolved to let him go on speaking without interruption. Crossing her arms and bending down her face, she looked at the rosettes on her slippers, and at intervals made little movements inside the satin of them with her toes.

At last she sighed.

'But the most wretched thing, is it not – is to drag out a useless existence as I do. If only our pains were of some use to someone, we might find consolation in the thought of the sacrifice.'

He started off in praise of virtue, duty, and silent

immolation, having himself an incredible longing for self-sacrifice that he could not satisfy.

'I should much like,' she said, 'to be a nurse at a hospital.'

'Alas! men have none of these holy missions, and I see nowhere any calling – unless perhaps that of a doctor.'

With a slight shrug of her shoulders, Emma interrupted him to speak of her illness, which had almost killed her. What a pity! She should not be suffering now! Léon at once envied the calm of the tomb, and one evening he had even made his will, asking to be buried in that beautiful rug with velvet stripes he had received from her. For this was how they would have wished to be, each setting up an ideal to which they were now adapting their past life. Besides, speech is a rolling-mill that always thins out the sentiment.

But at this invention of the rug she asked, 'But why?' 'Why?' He hesitated. 'Because I loved you so!' And congratulating himself at having surmounted the difficulty, Léon watched her face out of the corner of his eyes.

It was like the sky when a gust of wind drives the clouds across. The mass of sad thoughts that darkened them seemed to be lifted from her blue eyes; her whole face shone. He waited. At last she replied – 'I always suspected it.'

Then they went over all the trifling events of that far-off existence, whose joys and sorrows they had just summed up in one word. They recalled the arbour with clematis, the dresses she had worn, the furniture of her room, the whole of her house.

'And our poor cactuses, where are they?'
'The cold killed them this winter.'

'Ah! how I have thought of them, do you know? I often saw them again as of yore, when on the summer mornings the sun beat down upon your blinds, and I saw your two bare arms passing out amongst the flowers.'

'Poor friend!' she said, holding out her hand to him. Léon swiftly pressed his lips to it. Then, when he had taken a deep breath—'At that time you were to me I know not what incomprehensible force that took captive my life. Once, for instance, I went to see you; but you, no doubt, do not remember it.'

'I do,' she said; 'go on.'

'You were downstairs in the ante-room, ready to go out, standing on the last stair; you were wearing a bonnet with small blue flowers; and without any invitation from you, in spite of myself, I went with you. Every moment, however, I grew more and more conscious of my folly, and I went on walking by you, not daring to follow you completely, and unwilling to leave you. When you went into a shop I waited in the street, and I watched you through the window taking off your gloves and counting the change on the counter. Then you rang at Madame Tuvache's; you were let in, and I stood like an idiot in front of the great heavy door that had closed after you.'

Madame Bovary, as she listened to him, wondered that she was so old. All these things reappearing before her seemed to widen out her life; it was like some sentimental immensity to which she returned; and from time to time she said in a low voice, her eyes half closed – 'Yes, it is true – true – true!'

They heard eight strike on the different clocks of the Beauvoisine quarter, which is full of schools, churches, and large empty hotels. They no longer spoke, but they felt as they looked upon each other a buzzing in their heads, as if something sonorous had escaped from the fixed eyes of each of them. They were hand in hand now, and the past, the future, reminiscences and dreams, all were confounded in the sweetness of this ecstasy. Night was darkening over the walls, on which still shone, half hidden in the shade, the coarse colours of four bills representing four scenes from the 'Tour de Nesle', with a motto in Spanish and French at the bottom. Through the sashwindow a patch of dark sky was seen between the pointed roofs.

She rose to light two wax-candles on the drawers, then she sat down again.

'Well!' said Léon.

'Well!' she replied.

He was thinking how to resume the interrupted conversation, when she said to him – 'How is it that no one has ever before expressed such sentiments to me?'

The clerk said that ideal natures were difficult to understand. He from the first moment had loved her, and he despaired when he thought of the happiness that would have been theirs, if thanks to fortune, meeting her earlier, they had been indissolubly bound to one another.

'I have sometimes thought of it,' she went on.

'What a dream!' murmured Léon. And fingering gently the blue bindings of her long white sash, he added, 'And who prevents us from beginning now?'

'No, my friend,' she replied; 'I am too old; you are too young. Forget me! Others will love you; you will love them.'

'Not as you!' he cried.

'What a child you are! Come, let us be sensible. I wish it.'

She showed him the impossibility of their love, and that they must remain, as formerly, on the simple terms of a fraternal friendship.

Was she speaking thus seriously? No doubt Emma did not herself know, quite absorbed as she was by the charm of the seduction, and the necessity of defending herself from it; and contemplating the young man with a moved look, she gently repulsed the timid caresses that his trembling hands attempted.

'Oh! forgive me!' he cried, drawing back.

Emma was seized with a vague fear at this shyness, more dangerous to her than the boldness of Rodolphe when he advanced to her open-armed. No man had ever seemed to her so beautiful. An exquisite candour emanated from his being. He lowered his long fine eyelashes, that curled upwards. His cheek with the soft skin reddened, she thought, with the desire of her person, and Emma felt an invincible longing to press her lips to it. Then, leaning towards the clock as if to see the time – 'Ah! how late it is!' she said; 'how we do chatter!'

He understood the hint and took up his hat.

'It has even made me forget the theatre. And poor Bovary has left me here especially for that. Monsieur Lormeaux, of the Rue Grand-Pont, was to take me and his wife.'

And the opportunity was lost, as she was to leave the next day.

'Really!' said Léon.

'Yes.'

'But I must see you again,' he went on. 'I wanted to tell you – '

'What?'

'Something – important – serious. Oh, no! Besides, you will not go; it is impossible. If you should – listen to me. Then you have not understood me; you have not guessed – '

'Yet you speak plainly,' said Emma.

'Ah! you can jest. Enough! enough! Oh, for pity's sake, let me see you once – only once!'

'Well -' She stopped; then, as if thinking better of it, 'Oh, not here!'

'Where you will.'

'Will you - 'She seemed to reflect; then abruptly, 'Tomorrow at eleven o'clock in the cathedral.'

'I shall be there,' he cried, seizing her hands, which she disengaged.

And as they were both standing up, he behind her, and Emma with her head bent, he stooped over her and pressed long kisses on her neck.

'You are mad! Ah! you are mad!' she said, with sounding little laughs, while the kisses multiplied.

Then bending his head over her shoulder, he seemed to beg the consent of her eyes. They fell upon him full of an icy dignity.

Léon stepped back to go out. He stopped on the threshold; then he whispered with a trembling voice, 'Tomorrow!'

She answered with a nod, and disappeared like a bird into the next room.

In the evening Emma wrote the clerk an interminable letter, in which she cancelled the rendezvous; all was over; they must not, for the sake of their happiness, meet again. But when the letter was finished, as she did not know Léon's address, she was puzzled.

'I'll give it to him myself,' she said; 'he will come.'

The next morning, at the open window, and humming on his balcony, Léon himself varnished his pumps with several coatings. He put on white trousers, fine socks, a green coat, emptied all the scent he had into his handkerchief, then having had his hair curled, he uncurled it again, in order to give it a more natural elegance.

'It is still too early,' he thought, looking at the hairdresser's cuckoo-clock, that pointed to the hour of nine. He read an old fashion journal, went out, smoked a cigar, walked up three streets, thought it was time, and went slowly towards the porch of Notre Dame.

It was a beautiful summer morning. Silver plate sparkled in the jeweller's windows, and the light falling obliquely on the cathedral made mirrors of the corners of the grey stones; a flock of birds fluttered in the grey sky round the trefoil bell-turrets; the square, resounding with cries, was fragrant with the flowers that bordered its pavement, roses, jasmines, pinks, narcissi, and tuberoses, unevenly spaced out between moist grasses, catmint, and chickweed for the birds; the fountains gurgled in the centre, and under large umbrellas, amidst melons, piled up in heaps, flowerwomen, bareheaded, were twisting paper round bunches of violets.

The young man took one. It was the first time that he had bought flowers for a woman, and his breast, as he smelt them, swelled with pride, as if this homage that he meant for another had recoiled upon himself.

But he was afraid of being seen; he resolutely entered the church. The beadle, who was just then standing on the threshold in the middle of the left

doorway, under the 'Dancing Marianne', with feather cap, and rapier dangling against his calves, came in, more majestic than a cardinal, and gleaming like a saint on a holy pyx.

He came towards Léon, and, with that smile of wheedling benignity assumed by ecclesiastics when they question children – 'The gentleman, no doubt, does not belong to these parts? The gentleman would like to see the curiosities of the church?'

'No!' said the other.

And he first went round the lower aisles. Then he went out to look at the Place. Emma was not coming yet. He went up again to the choir.

The nave was reflected in the full fonts with the beginning of the arches and some portions of the glass windows. But the reflections of the paintings, broken by the marble rim, were continued farther on upon the flagstones, like a many-coloured carpet. The broad daylight from without streamed into the church in three enormous rays from the three opened portals. From time to time at the upper end a sacristan passed, making the oblique genuflexion of devout persons in a hurry. The crystal lustres hung motionless. In the choir a silver lamp was burning, and from the side chapels and dark places of the church sometimes rose sounds like sighs, with the clang of a closing grating, its echo reverberating under the lofty vault.

Léon walked with solemn steps along by the walls. Life had never seemed so good to him. She would come directly, charming, agitated, looking back at the glances that followed her, and with her flounced dress, her gold eyeglass, her thin shoes, with all sorts of elegant trifles that he had never enjoyed, and with the ineffable seduction of yielding virtue. The church like

a huge boudoir spread around her; the arches bent down to gather in the shade the confession of her love; the windows shone resplendent to illumine her face, and the censers would burn that she might appear like an angel amid the fumes of the sweet-smelling odours.

But she did not come. He sat down on a chair, and his eyes fell upon a blue stained window representing boatmen carrying baskets. He looked at it long, attentively, and he counted the scales of the fishes and the buttonholes of the doublets, while his thoughts wandered off towards Emma.

The beadle, standing aloof, was inwardly angry at this individual who took the liberty of admiring the cathedral by himself. He seemed to him to be conducting himself in a monstrous fashion, to be robbing him in a sort, and almost committing sacrilege.

But a rustle of silk on the flags, the tip of a bonnet, a lined cloak – it was she! Léon rose and ran to meet her.

Emma was pale. She walked fast.

'Read this!' she said, holding out a paper to him. 'Oh, no!'

And she abruptly withdrew her hand to enter the chapel of the Virgin, where, kneeling on a chair, she began to pray.

The young man was irritated at this bigot fancy; then he nevertheless experienced a certain charm in seeing her, in the middle of a rendezvous, thus lost in her devotions, like an Andalusian marchioness; then he grew bored, for she seemed never coming to an end.

Emma prayed, or rather strove to pray, hoping that some sudden resolution might descend to her from Heaven; and to draw down divine aid she filled full her eyes with the splendours of the tabernacle. She

breathed in the perfumes of the full-blown flowers in the large vases, and listened to the stillness of the church, that only heightened the tumult of her heart.

She rose, and they were about to leave, when the beadle came forward, hurrically saying – 'Madame, no doubt, does not belong to these parts? Madame would like to see the curiosities of the church?'

'Oh, no!' cried the clerk.

'Why not?' said she. For she clung with her expiring virtue to the Virgin, the sculptures, the tombs – anything.

Then, in order to proceed 'in due order,' the beadle conducted them right to the entrance near the square, where, pointing out with his cane a large circle of block-stones without inscription or carving – 'This,' he said majestically, 'is the circumference of the beautiful bell of Amboise. It weighed forty thousand pounds. There was not its equal in all Europe. The workman who cast it died of the joy – '

'Let us go on,' said Léon.

The old fellow started off again; then, having got back to the chapel of the Virgin, he stretched forth his arm with an all-embracing gesture of demonstration, and, prouder than a country squire showing you his espaliers, went on – 'This simple stone covers Pierre de Brézé, lord of Varenne and of Brissac, grand marshal of Poitou, and governor of Normandy, who died at the battle of Montlhéry on the 16th of July, 1465.'

Léon bit his lips, fuming.

'And on the right, this gentleman all encased in iron, on the prancing horse, is his grandson, Louise de Brézé, lord of Breval and of Montchauvet, Count de Maulevrier, Baron de Mauny, chamberlain to the

King, Knight of the Order, and also governor of Normandy; died on the 23rd of July, 153I – a Sunday, as the inscription specifies; and below, this figure, about to descend into the tomb, portrays the same person. It is not possible, is it, to see a more perfect representation of the void?'

Madame Bovary put up her eyeglasses. Léon, motionless, looked at her, no longer even attempting to speak a single word, to make a gesture, so discouraged was he at this twofold obstinacy of gossip and indifference.

The everlasting guide went on – 'Near him, this kneeling woman who weeps is his spouse, Diane de Poitiers, Countess de Brézé, Duchess de Valentinois, born in 1499, died in 1566, and to the left, the one with the child is the HolyVirgin. Now turn to this side; here are the tombs of the Amboise. They were both cardinals and archbishops of Rouen. That one was minister under Louis XII. He did a great deal for the cathedral. In his will he left thirty thousand gold crowns for the poor.'

And without stopping, still talking, he pushed them into a chapel full of balustrades, some put away, and disclosed a kind of block that certainly might once have been an ill-made statue.

'Truly,' he said with a groan, 'it adorned the tomb of Richard Coeur de Lion, King of England and Duke of Normandy. It was the Calvinists, sir, who reduced it to this condition. They had buried it for spite in the earth, under the episcopal seat of Monsignor. See! this is the door by which Monsignor passes to his house. Let us pass on to see the gargoyle windows.'

But Léon hastily took some silver from his pocket and seized Emma's arm. The beadle stood dumbfounded,

not able to understand this untimely munificence when there were still so many things for the stranger to see. So calling him back, he cried – 'Sir! sir! The spire! the spire!'

'No, thank you!' said Léon.

'You are wrong, sir! It is four hundred and forty feet high, nine less than the great pyramid of Egypt. It is all cast; it – '

Léon fled, for it seemed to him that his love, petrified for nearly two hours now in the church like the stones, would vanish like a vapour through that sort of truncated funnel, or oblong cage, or open chimney that rises so grotesquely from the cathedral like the extravagant attempt of some fantastic brazier.

'But where are we going?' she said.

Making no answer, he walked on with a rapid step; and Madame Bovary was already dipping her finger in the holy water when they heard behind them a panting breath interrupted by the regular sound of a cane. Léon turned back.

'Sir!'

'What is it?'

And he recognised the beadle, holding under his arms and balancing against his stomach some twenty large sewn volumes. They were works 'which treated of the cathedral.'

'Idiot!' growled Léon, rushing out of the church.

A lad was playing about the close.

'Go and get me a cab!'

The child bounded off like a ball by the Rue Quatre-Vents; then they were alone a few minutes, face to face, and a little embarrassed.

'Ah! Léon! Really – I don't know – if I ought,' she whispered. Then with a more serious air, 'Do you know, it is very improper?'

'How so?' replied the clerk. 'It is done at Paris.'

And that, as an irresistible argument, decided her.

Still the cab did not come. Léon was afraid she might go back into the church. At last the cab appeared.

'At all events, go out by the north porch,' cried the beadle, who was left alone on the threshold, 'so as to see the Resurrection, the Last Judgement, Paradise, King David, and the Condemned in Hell-flames.'

'Where to, sir?' asked the coachman.

'Where you like,' said Léon, forcing Emma into the cab.

And the lumbering machine set out. It went down the Rue Grand-Pont, crossed the Place des Arts, the Quai Napoleon, the Pont Neuf, and stopped short before the statue of Pierre Corneille.

'Go on,' cried a voice that came from within.

The cab went on again, and as soon as it reached the Carrefour Lafayette, set off downhill, and entered the station at a gallop.

'No, straight on!' cried the same voice.

The cab came out by the gate, and soon having reached the Cours, trotted quietly beneath the elm trees. The coachman wiped his brow, put his leather hat between his knees, and drove his carriage beyond the side alley by the meadow to the margin of the waters.

It went along by the river, along the towing path paved with sharp pebbles, and for a long while in the direction of Oyssel, beyond the isles.

But suddenly it turned with a dash across Quatremares, Sotteville, La Grande-Chaussée, the Rue d'Elbeuf, and made its third halt in front of the Jardin des Plantes.

'Get on, will you?' cried the voice more furiously.

And at once resuming its course, it passed by Saint-Sever, by the Quai des Curandiers, the Quai aux Meules, once more over the bridge, by the Place du Champ de Mars, and behind the hospital gardens, where old men in black coats were walking in the sun along the terrace all green with ivy. It went up the Boulevard Bouvreuil, along the Boulevard Cauchoise, then the whole of Mont-Riboudet to the Deville hills.

It came back; and then, without any fixed plan or direction, wandered about at hazard. The cab was seen at Saint-Pol, at Lescure, at Mont Gargan, at the Rouge-Mare, and the Place du Gaillardbois; in the Rue Maladrerie, Rue Dinanderie, before Saint-Romain, Saint-Vivien, Saint-Maclou, Saint-Nicaise in front of the Customs, at the Basse Vieille Tour, at the Trois Pipes, and the Monumental Cemetery. From time to time the coachman, on his box, cast despairing eyes at the public-houses. He could not understand what furious desire for locomotion urged these individuals never to wish to stop. He tried to now and then, and at once exclamations of anger burst forth behind him. Then he lashed his perspiring jades afresh, but indifferent to their jolting, running up against things here and there, not caring if he did, demoralised, and almost weeping with thirst, fatigue, and depression.

And on the harbour, in the midst of the drays and casks, and in the streets, at the corners, the good folk opened large wonder-stricken eyes at this sight, so extraordinary in the provinces, a cab with blinds drawn, and which appeared thus constantly shut more closely than a tomb, and tossing about like a vessel.

Once in the middle of the day, in the open country,

just as the sun beat most fiercely against the old plated lanterns, a bare hand slipped beneath the small blinds of yellow canvas, and threw out some scraps of paper that scattered in the wind, and farther off lighted like white butterflies on a field of red clover in full bloom.

About six o'clock the carriage stopped in a back street of the Beauvoisine Quarter, and a woman got out; she walked away with her veil down, and without turning her head. On reaching the inn, Madame Bovary was surprised not to see the diligence. Hivert, who had waited for her fifty-three minutes, had at last started.

Yet nothing forced her to go; but she had given her word that she would return that same evening. Moreover, Charles expected her, and in her heart she felt already that cowardly docility that is for some women at once the chastisement and atonement of adultery.

She packed her box quickly, paid her bill, took a cab in the yard, hurrying on the driver, urging him on, every moment enquiring about the time and the miles traversed. He succeeded in catching up the 'Hirondelle' as it neared the first houses of Quincampoix.

Hardly was she seated in her corner than she closed her eyes, and opened them at the foot of the hill, when from afar she recognised Félicité, who was on the look-out in front of the farrier's shop. Hivert pulled in his horses and the servant, climbing up to the window, said mysteriously – 'Madame, you must go to Monsieur Homais at once. It's for something important.'

The village was silent as usual. At the corner of the streets were small pink heaps smoking in the air, for this was the time for jam-making, and everyone at Yonville prepared his supply on the same day. But in front of the chemist's shop might be admired a far larger heap, surpassing the others with the superiority that a laboratory must have over ordinary stores, a general need over an individual fancy.

She went in. The large armchair was upset, and even the Fanal de Rouen lay on the ground, out-spread between two pestles. She pushed open the lobby door, and in the middle of the kitchen, amid brown jars full of picked currants, of powdered sugar and lump sugar, of the scales on the table, and of the pans on the fire, she saw all the Homais, small and large, with aprons reaching to their chins and forks in their hands. Justin was standing up with bowed head, and the chemist was shouting – 'Who told you to go and fetch it in the capharnaüm?'

'What is it? What is the matter?'

'What is it?' replied the druggist. 'We are making preserves; they are simmering; but they were about to boil over, because there is too much juice, and I ordered another pan. Then, from indolence, in sheer laziness, he went and took the key of the *capharnaüm* hanging on its nail in my laboratory.'

It was thus the druggist called a small room under the leads, full of the utensils and goods of his trade. He often spent long hours there alone, labelling, decanting, and doing up again; and he looked upon it not as a simple store, but as a veritable sanctuary, whence there afterwards issued, elaborated by his hands, all sorts of pills, boluses, infusions, lotions, and potions, that would bear his fame far and wide. No one soul set foot there, and such was his own respect for it that he swept it himself. Finally, if the pharmacy, open to all comers, was the spot where he displayed his pride, the capharnaüm was the refuge where, egoistically concentrating himself, Homais delighted in the exercise of his predilections, so that Justin's thoughtlessness seemed to him a monstrous piece of irreverence, and redder than the currants, he repeated - 'Yes, from the

capharnaüm! The key that locks up the acids and caustic alkalis! To go and get a spare pan! a pan with a lid! and that I shall perhaps never use! Everything is of importance in the delicate operations of our art! But, devil take it! one must make distinctions, and not employ for almost domestic purposes that which is meant for pharmaceutical! It is as if one were to carve a fowl with a scalpel; as if a magistrate — '

'Now be calm,' said Madame Homais.

And Athalie, pulling at his coat, cried 'Papa! papa!'

'No, let me alone,' went on the druggist, 'let me alone, hang it! My word! One might as well set up for a grocer. That's it! go it! respect nothing! break, smash, let loose the leeches, burn the mallow-paste, pickle the gherkins in the window jars, tear up the bandages!'

'I thought you had - ' said Emma.

'Presently! Do you know to what you exposed yourself? Didn't you see anything in the corner, on the left, on the third shelf? Speak, answer, articulate something.'

'I – don't – know,' stammered the young fellow.

'Ah! you don't know! Well, then, I do know! You saw a bottle of blue glass, sealed with yellow wax, that contains a white powder, on which I have even written 'Dangerous!' And do you know what is in it? Arsenic! And you go and touch it! You take a pan that was next to it!'

'Next to it!' cried Madame Homais, clasping her hands. 'Arsenic! You might have poisoned us all.'

And the children began howling as if they already had frightful pains in their entrails.

'Or poison a patient!' continued the druggist. 'Do you want to see me in the prisoner's dock with

criminals, in a court of justice? To see me dragged to the scaffold? Don't you know what care I take in managing things, although I am so thoroughly used to it? Often I am horrified myself when I think of my responsibility; for the Government persecutes us, and the absurd legislation that rules us is a veritable Damocles' sword over our heads.'

Emma no longer dreamed of asking what they wanted her for, and the druggist went on in breathless phrases – 'That is your return for all the kindnesses we have shown you! That is how you recompense me for the really paternal care that I lavish on you! For without me where would you be? What would you be doing? Who provides you with food, education, clothes, and all the means of figuring one day with honour in the ranks of society? But you must pull hard at the oar if you're to do that, and get, as people say, callosities upon your hands. Fabricando fit faber, age quod agis.'

He was so exasperated that he quoted Latin. He would have quoted Chinese or Eskimo had he known those languages, for he was in one of those crises in which the whole soul shows indistinctly what it contains, like the ocean, which, in the storm, opens itself from the seaweeds on its shores down to the sands of its abysses.

And he went on – 'I am beginning to repent terribly of having taken you up! I should certainly have done better to have left you to rot in your poverty and the dirt in which you were born. Oh, you'll never be fit for anything but to herd animals with horns! You have no aptitude for science! You hardly know how to stick on a label! And there you are, dwelling with me snug as a parson, living in clover, taking your ease!'

But Emma, turning to Madame Homais, 'I was told to come here – '

'Oh, dear me!' interrupted the good woman, with a sad air, 'how am I to tell you? It is a misfortune!'

She could not finish, the druggist was thundering – 'Empty it! Clean it! Take it back! Be quick!'

And seizing Justin by the collar of his blouse, he shook a book out of his pocket. The lad stooped, but Homais was the quicker, and, having picked up the volume, contemplated it with staring eyes and open mouth.

'Married – Love!' he said, slowly separating the two words. 'Ah! very good! very good! very pretty! And illustrations! Oh, this is too much!'

Madame Homais came forward.

'No, do not touch it!'

The children wanted to look at the pictures.

'Leave the room,' he said imperiously; and they went out.

First he walked up and down with the open volume in his hand, rolling his eyes, choking, tumid, apoplectic. Then he came straight to his pupil, and planting himself in front of him with crossed arms – 'Have you all the vices, then, you little wretch? Take care! You are on the downward path. Didn't you reflect that this infamous book might fall in the hands of my children, kindle a spark in their minds, tarnish the purity of Athalie, corrupt Napoléon. He is already shaping into a man. Are you quite sure, anyhow, that they have not read it? Can you certify to me – '

'But really, sir,' said Emma, 'you wished to tell me -'

'Ah! yes! madame. Your father-in-law is dead.'

And it was so: Monsieur Bovary, senior, had expired suddenly the evening before from an attack of

apoplexy on rising from table, and by way of greater precaution, on account of Emma's sensibility, Charles had begged Homais to break the horrible news to her gradually. Homais had thought over his speech; he had rounded it, polished it, made it rhythmical; it was a masterpiece of prudence and transitions, of subtle turns and delicacy; but anger had got the better of rhetoric.

Emma, giving up all chance of hearing any details, left the pharmacy; for Monsieur Homais had taken up the thread of his vituperations. However, he was growing calmer, and was now grumbling in a paternal tone whilst he fanned himself with his skullcap.

'It is not that I entirely disapprove of the work. Its author was a doctor! There are certain scientific points in it that it is not ill a man should know, and I would even venture to say that a man must know. But later – later! At any rate, not till you are a man yourself and your temperament is formed.'

When Emma knocked at the door, Charles, who was waiting for her, came forward with open arms and said to her with tears in his voice – 'Ah! my dear one!'

And gently he bent over to kiss her. But at the contact of his lips the memory of the other seized her, and she passed her hand over her face shuddering.

But she made answer, 'Yes, I know, I know!'

He showed her the letter in which his mother told the event without any sentimental hypocrisy. She only regretted her husband had not received the consolations of religion, as he had died at Daudeville, in the street, at the door of a café after a patriotic dinner with some ex-officers.

Emma gave him back the letter; then at dinner, for appearance's sake, she affected a certain repugnance.

But as he urged her to try, she resolutely began eating, while Charles opposite her sat motionless in a dejected attitude.

Now and then he raised his head and gave her a long look full of distress. Once he sighed, 'I should have liked to see him again!'

She was silent. At last, understanding that she must say something, 'How old was your father?' she asked.

'Fifty-eight.'

'Ah!'

And that was all.

A quarter of an hour after he added, 'My poor mother! what will become of her now?'

She made a gesture that signified she did not know. Seeing her so taciturn, Charles imagined her much affected, and forced himself to say nothing, not to reawaken this sorrow which moved him. And, shaking off his own – 'Did you enjoy yourself yesterday?' he asked.

'Yes.'

When the cloth was removed, Bovary did not rise, nor did Emma; and, as she looked at him, the monotony of the spectacle drove little by little all pity from her heart. He seemed to her paltry, weak, a cipher – in a word, a poor thing in every way. How to get rid of him? What an interminable evening! Something stupefying like the fumes of opium seized her.

They heard in the passage the sharp noise of a wooden leg on the boards. It was Hippolyte bringing back Emma's luggage. In order to put it down he described painfully a quarter of a circle with his stump.

'He doesn't even remember any more about it,' she thought, looking at the poor devil, whose coarse red hair was wet with perspiration.

Bovary was searching at the bottom of his purse for a centime, and without appearing to understand all there was of humiliation for him in the mere presence of this man, who stood there like a personified reproach to his incurable incapacity.

'Hallo! you've a pretty bouquet,' he said, noticing Léon's violets on the chimney.

'Yes,' she replied indifferently; 'it's a bouquet I bought just now from a beggar.'

Charles picked up the flowers, and freshening his eyes, red with tears, against them, smelt them delicately.

She took them quickly from his hand and put them in a glass of water.

The next day Madame Bovary, senior, arrived. She and her son wept much. Emma, on the pretext of giving orders, disappeared. The following day they had a talk over the mourning. They went and sat down with their workboxes by the waterside under the arbour.

Charles was thinking of his father, and was surprised to feel so much affection for this man whom hitherto he had thought he cared little about. Madame Bovary, senior, was thinking of her husband. The worst days of the past seemed enviable to her. All was forgotten beneath the instinctive regret of such a long habit, and from time to time whilst she sewed, a big tear rolled along her nose and hung suspended there a moment. Emma was thinking that it was scarcely forty-eight hours since they had been together, far from the world, all in a frenzy of joy, and not having eyes enough to gaze upon each other. She tried to recall the slightest details of that past day. But the presence of her husband and mother-in-law worried her. She would

have liked to hear nothing, to see nothing, so as not to disturb the meditation on her love, that, do what she would, became lost in external sensations.

She was unpicking the lining of a dress, and the strips were scattered around her. Madame Bovary, senior, was plying her scissors without looking up, and Charles in his list slippers and his old brown surtout that he used as a dressing-gown, sat with both hands in his pockets, and did not speak either; near them Berthe, in a little white pinafore, was raking the sand in the walks with her spade.

Suddenly she saw Monsieur Lheureux, the linendraper, come in through the gate.

He came to offer his services 'under the sad circumstances.' Emma answered that she thought she could do without. The shopkeeper was not to be beaten.

'I beg your pardon,' he said, 'but I should like to have a private talk with you.' Then in a low voice, 'It's about that affair – you know.'

Charles crimsoned to his ears. 'Oh, yes! certainly.' And in his confusion, turning to his wife, 'Couldn't you, my darling?'

She seemed to understand him, for she rose; and Charles said to his mother, 'It is nothing particular. No doubt, some household trifle.' He did not want her to know the story of the bill, fearing her reproaches.

As soon as they were alone, Monsieur Lheureux in sufficiently clear terms began to congratulate Emma on the inheritance, then to talk of indifferent matters, of the espaliers, of the harvest, and of his own health, which was always so-so, always having ups and downs. In fact, he had to work devilish hard, although he didn't make enough, in spite of all people said, to find butter for his bread.

Emma let him talk on. She had bored herself so prodigiously the last two days.

'And so you're quite well again?' he went on. 'My word! I saw your husband in a sad state. He's a good fellow, though we did have a little misunderstanding.'

She asked what misunderstanding, for Charles had said nothing of the dispute about the goods supplied to her.

'Why, you know well enough,' cried Lheureux. 'It was about your little fancies – the travelling trunks.'

He had drawn his hat over his eyes, and, with his hands behind his back, smiling and whistling, he looked straight at her in an unbearable manner. Did he suspect anything? She was lost in all kinds of apprehensions. At last, however, he went on – 'We made it up, all the same, and I've come again to propose another arrangement.'

This was to renew the bill Bovary had signed. The doctor, of course, would do as he pleased; he was not to trouble himself, especially just now, when he would have a lot of worry. 'And he would do better to give it over to someone else, – to you, for example. With a power of attorney it could be easily managed, and then we (you and I) would have our little business transactions together.'

She did not understand. He was silent. Then, passing to his trade, Lheureux declared that Madame must require something. He would send her a black barège, twelve yards, just enough to make a gown.

'The one you've on is good enough for the house, but you want another for calls. I saw that the very moment that I came in. I've the American eye!'

He did not send the stuff; he brought it. Then he came again to measure it; he came again on other

pretexts, always trying to make himself agreeable, useful, 'enfeoffing himself', as Homais would have said, and always dropping some hint to Emma about the power of attorney. He never mentioned the bill; she did not think of it. Charles, at the beginning of her convalescence, had certainly said something about it to her, but so many emotions had passed through her head that she no longer remembered it. Besides, she took care not to talk of any money questions. Madame Bovary seemed surprised at this, and attributed the change in her ways to the religious sentiments she had contracted during her illness.

But as soon as she was gone, Emma greatly astounded Bovary by her practical good sense. It would be necessary to make enquiries, to look into mortgages, and see if there were any occasion for a sale by auction or of liquidation. She quoted technical terms casually, pronounced the grand words of order, the future, foresight, and constantly exaggerated the difficulties of settling his father's affairs so much, that at last one day she showed him the rough draft of a power of attorney to manage and administer his business, arrange all loans, sign and endorse all bills, pay all sums, etc. She had profited by Lheureux's lessons.

Charles naïvely asked her where this paper came from.

'Monsieur Guillaumin'; and with the utmost coolness she added, 'I don't trust him overmuch. Notaries have such a bad reputation. Perhaps we ought to consult – we only know – no one.'

'Unless Léon -' replied Charles, who was reflecting. But it was difficult to explain matters by letter. Then she offered to make the journey, but he thanked her. She insisted. It was quite a contest of mutual

consideration. At last she cried with affected waywardness - 'No, I will go!'

'How good you are!' he said, kissing her forehead.

The next morning she set out in the 'Hirondelle' to go to Rouen to consult Monsieur Léon, and she stayed there three days. They were three full, exquisite days – a true honeymoon. They were at the Hôtel de Boulogne, on the quays; and there they lived, with drawn blinds and closed doors, with flowers on the floor, and iced syrups brought to them from early morning.

Towards evening they took a covered boat and went to dine on one of the islands. It was the hour when one hears from the dockyard the caulking-mallets sounding against the hulls of vessels. The tar-smoke rose between the trees; there were large fatty drops on the water undulating in the purple colour of the sun, like floating plaques of Florentine bronze.

They rowed down amid moored boats, whose long oblique cables grazed lightly against the bottom of their boat. The din of the town gradually grew distant; the rumble of carriages, the tumult of voices, the yelping of dogs on the decks of vessels. She took off her bonnet, and they landed on their island.

They sat down in the low-ceilinged room of a tavern, at whose door hung black nets. They are fried smelts, cream and cherries. They lay down upon the grass; they kissed behind the poplars; and they would fain, like two Robinsons, have lived for ever in this little place, which seemed to them in their beatitude the most magnificent on earth. It was not the first time that they had seen trees, a blue sky, meadows; that they had heard the water flowing and the wind blowing in the leaves; but, no doubt, they had never admired all this, as if Nature had not existed before, or had only begun to be beautiful since the gratification of their desires.

At night they returned. The boat glided along the shores of the islands. They sat at the bottom, both hidden by the shade, in silence. The square oars rang in the iron thwarts, and, in the stillness, seemed to mark time like the beating of a metronome, while at the stern the rudder trailing behind plashed ceaselessly against the water.

Once the moon rose; and then they did not fail to make fine phrases, finding the orb melancholy and full of poetry.

She even began to sing - 'One night, do you remember, we were sailing', etc.

Her faint, musical voice died away along the waves, and the winds carried off the trills that Léon heard pass like the flapping of wings about him.

She was facing him, leaning against the partition of the shallop, through one of whose raised blinds the moon streamed in. Her black dress, whose drapery spread out like a fan, made her seem more slender, taller. Her head was raised, her hands clasped, her eyes turned towards Heaven. At times the shadow of the willows hid her completely; then she reappeared suddenly, like a vision in the moonlight.

Léon, on the floor by her side, found under his hand a ribbon of scarlet silk. The boatman looked at it, and at last said – 'Perhaps it belongs to the party I took out the other day. A lot of jolly folk, gentlemen and ladies, with cakes, champagne, cornets – everything in style! There was one especially, a tall handsome man with small moustaches, who was that funny! And they all kept saying, 'Now tell us something, Adolphe – Dolpe, I think.'

A shudder passed through her.

'Are you in pain?' asked Léon, coming closer to her.

'Oh, it's nothing! No, doubt it is only the night air.'
'And who doesn't want for women, either,' softly added the sailor, thinking he was paying the stranger a compliment.

Then, spitting on his hands, he took the oars again.

Yet they had to part. The adieux were sad. He was to send his letters to Mère Rollet, and she gave him such precise instructions about a double envelope that he admired greatly her amorous astuteness.

'So you can assure me it is all right?' she said with her last kiss.

'Yes, certainly.'

'But why,' he thought afterwards as he came back through the streets alone, 'is she so very anxious to get this power of attorney?' Léon soon put on an air of superiority before his comrades, avoided their company, and completely neglected his work.

He waited for her letters; he re-read them; he wrote to her. He called her to mind with all the strength of his desires and of his memories. Instead of lessening with absence, this longing to see her again grew, so that at last on Saturday morning he escaped from his office.

When, from the summit of the hill, he saw in the valley below the church-spire with its tin flag swinging in the wind, he felt that delight mingled with triumphant vanity and egoistic tenderness that millionaires must experience when they come back to their native village.

He went rambling round her house. A light was burning in the kitchen. He watched for her shadow behind the curtains, but nothing appeared.

Mère Lefrançois, when she saw him, uttered many exclamations. She thought he 'had grown and was thinner,' while Artémise, on the contrary, thought him stouter and darker.

He dined in the little room as in the old days, but alone, without the tax-collector; for Binet, tired of waiting for the 'Hirondelle', had definitely put forward his meal one hour, and now dined punctually at five, and yet he usually declared the rickety old concern was late.

Léon, however, made up his mind, and knocked at the doctor's door. Madame was in her room, and did

not come down for a quarter of an hour. The doctor seemed delighted to see him, but he never stirred out that evening nor all the next day.

He saw her alone in the evening, very late, behind the garden in the lane – in the lane, as she had the other one! It was a stormy night, and they talked under an umbrella by lightning flashes.

Their separation was becoming intolerable. 'I would rather die!' said Emma. She was writhing in his arms, weeping. 'Farewell! Farewell! When shall I see you again?'

They came back again to embrace once more, and it was then that she promised him to find soon, by no matter what means, a regular opportunity for seeing one another in freedom at least once a week. Emma never doubted she should be able to do this. Besides, she was full of hope. Some money was coming to her.

On the strength of it she bought a pair of yellow curtains with large stripes for her room, whose cheapness Monsieur Lheureux had commended; she dreamed of getting a carpet, and Lheureux, declaring that it wasn't asking the impossible, politely undertook to supply her with one. She could no longer do without his services. Twenty times a day she sent for him, and he at once put by his business without a murmur. People could not understand either why Mère Rollet breakfasted with her every day, and even paid her private visits.

It was about this time, that is to say, the beginning of winter, that she seemed seized with great musical fervour.

One evening when Charles was listening to her, she began the same piece four times over, each time with much vexation, while he, not noticing any difference,

cried - 'Bravo! very good! You are wrong to stop. Go on!'

'Oh, no; it is execrable! My fingers are quite rusty.'
The next day he begged her to play him something again.

'Very well; to please you!'

And Charles confessed she had gone off a little. She played wrong notes and blundered; then, stopping short – 'Ah! it is no use. I ought to take some lessons; but – 'She bit her lips and added, 'Twenty francs a lesson, that's too dear!'

'Yes, it is – rather,' said Charles, giggling stupidly. 'But it seems to me that one might be able to do it for less; for there are artists of no reputation, and who are often better than the celebrities.'

'Find them!' said Emma.

The next day when he came home he looked at her shyly, and at last could no longer keep back the words.

'How obstinate you are sometimes! I went to Barfeuchères today. Well, Madame Liégeard assured me that her three young ladies who are at La Miséricorde have lessons at fifty sous apiece, and that from an excellent mistress!'

She shrugged her shoulders and did not open her piano again. But when she passed by it (if Bovary were there), she sighed – 'Ah! my poor piano!'

And when anyone came to see her, she did not fail to inform them she had given up music, and could not begin again now for important reasons. Then people commiserated her – 'What a pity! she was so talented!'

They even spoke to Bovary about it. They put him to shame, and especially the chemist.

'You are wrong. One should never let any of the faculties of nature lie fallow. Besides, just think, my

good friend, that by inducing madame to study, you are economising on the subsequent musical education of your child. For my own part, I think that mothers ought themselves to instruct their children. That is an idea of Rousseau's, still rather new perhaps, but that will end by triumphing, I am certain of it, like mothers nursing their own children and vaccination.'

So Charles returned once more to this question of the piano. Emma replied bitterly that it would be better to sell it. This poor piano, that had given her vanity so much satisfaction – to see it go was to Bovary like the indefinable suicide of a part of herself.

'If you liked,' he said, 'a lesson from time to time, that wouldn't after all be very ruinous.'

'But lessons,' she replied, 'are only useful when you keep them up.'

And thus it was she set about obtaining her husband's permission to go to town once a week to see her lover. At the end of a month it was considered that she had made considerable progress.

She went on Thursdays. She got up and dressed silently, so as not to awaken Charles, who would have made remarks about her getting ready too early. Next she walked up and down, went to the windows, and looked out at the Place. The early dawn was broadening between the pillars of the market, and the chemist's shop, with the shutters still up, showed in the pale light of the dawn the large letters of his signboard.

When the clock pointed to a quarter past seven, she went off to the Lion d'Or, whose door Artémise opened yawning. The girl then made up the coals covered by the cinders, and Emma remained alone in the kitchen. Now and again she went out. Hivert was leisurely harnessing his horses, listening, moreover, to Mère Lefrançois, who, passing her head and nightcap through a grating, was charging him with commissions and giving him explanations that would have confused anyone else. Emma kept beating the soles of her boots against the pavement of the yard.

At last, when he had eaten his soup, put on his cloak, lighted his pipe, and grasped his whip, he calmly installed himself on his seat.

The 'Hirondelle' started at a slow trot, and for about a mile stopped here and there to pick up passengers who waited for it, standing at the border of the road, in front of their yard gates.

Those who had secured seats the evening before kept it waiting; some even were still in bed in their houses. Hivert called, shouted, swore; then he got

down from his seat and went and knocked loudly at the doors. The wind blew through the cracked windows.

The four seats, however, filled up. The carriage rolled off; rows of apple trees followed one upon another, and the road between its two long ditches, full of yellow water, rose constantly narrowing towards the horizon.

Emma knew it from end to end; she knew that after a meadow there was a signpost, next an elm, a barn, or the hut of a lime-kiln tender. Sometimes even, in the hope of getting some surprise, she shut her eyes, but she never lost the clear perception of the distance to be traversed.

At last the brick houses began to follow one another more closely, the earth resounded beneath the wheels, the 'Hirondelle' glided between the gardens, where through an opening one saw statues, a periwinkle plant, clipped yews, and a swing. Then on a sudden the town appeared. Sloping down like an amphitheatre, and drowned in the fog, it widened out beyond the bridges confusedly. Then the open country spread away with a monotonous movement till it touched in the distance the vague line of the pale sky. Seen thus from above, the whole landscape looked immovable as a picture; the anchored ships were massed in one corner, the river curved round the foot of the green hills, and the isles, oblique in shape, lay on the water, like large, motionless, black fishes. The factory chimneys belched forth immense brown fumes that were blown away at the top. One heard the rumbling of the foundries, together with the clear chimes of the churches, rising up in the mist. The leafless trees on the boulevards made purplish thickets amid the houses,

and the roofs, all shining with the rain, threw back irregular reflections, according to the height of the quarters in which they were. Sometimes a gust of wind drove the clouds towards the slopes of Saint Catherine, like aerial waves breaking silently against a cliff.

A giddiness seemed to her to detach itself from this mass of existence, and her heart swelled as if the hundred and twenty thousand souls that palpitated there had all at once sent into it the vapour of the passions she fancied theirs. In the presence of this vastness her love grew, and expanded tumultuously to the vague murmurings that rose towards her. She poured it forth upon the square, the walks, the streets, and the old Norman city outspread before her eves as an enormous capital, as a Babylon into which she was entering. She leant with both hands against the window, drinking in the breeze; the three horses galloped, the stones grated in the mud, the diligence rocked, and Hivert, from afar, hailed the carts on the road, while the townspeople who had spent the night at the Guillaume woods came quietly down the hill in their little family carriages.

They stopped at the barrier; Emma undid her overshoes, put on another pair of gloves, rearranged her shawl, and some twenty paces farther she got down from the 'Hirondelle'.

By then the town was waking up. Shop-boys in caps were cleaning up the shop-fronts, and women with baskets against their hips uttered sonorous cries at intervals at the street corners. She walked with downcast eyes, hugging the walls, and smiling with pleasure under her lowered black veil.

For fear of being observed, she did not usually take

the most direct road. She plunged into dark alleys, and, all perspiring, reached the bottom of the Rue Nationale, near the fountain standing there. It is the quarter of theatres, taverns, and whores. Often a cart would pass her, bearing some shaking scenery. Waiters in aprons were sprinkling sand on the flagstones between the green shrubs. It all smelt of absinthe, cigars, and oysters.

She turned down a street; she recognised him by his curling hair that escaped from beneath his hat.

Léon walked along the pavement. She followed him to the hotel. He went up, opened the door, entered – What an embrace!

The kisses over, words gushed forth. They told each other of the week's sorrows, the presentiments, the anxiety for the letters; but now everything was forgotten; they gazed into each other's faces with voluptuous laughs, and tender names.

The bed was large, of mahogany, in the shape of a boat. The curtains were of red levantine, hanging from the ceiling and drooping too far down towards the bulging bolster; and nothing in the world was so lovely as her brown head and white skin standing out against this purple colour, when, with a gesture of modesty, she crossed her bare arms to hide her face in her hands.

The warm room, with its discreet carpet, its gay ornaments, and its calm light, seemed made for the intimacies of passion. The curtain-rods, ending in arrows, their brass pcgs, and the great balls of the firedogs shone suddenly when the sun came in. On the mantelpiece between the candlesticks stood two of those pink shells in which the murmur of the sea sounds if they are held to the ear.

How they loved that dear room, so full of gaiety, despite its rather faded splendour! They always found the furniture in the same place, and sometimes hairpins, that she had forgotten the Thursday before, under the pedestal of the clock. They lunched by the fireside on a little round table, inlaid with rosewood. Emma carved, put bits on his plate with all sorts of winning tricks, and gave a ringing, roguish laugh when the froth of the champagne ran over from the glass to the rings on her fingers. They were so utterly lost in the possession of each other that they thought themselves in their own house, and that they would live there till death, a married pair for ever young. They said 'our room,' 'our carpet,' she even said 'my slippers,' a gift of Léon's, a whim she had had. They were pink satin, bordered with swansdown. When she sat on his knees, her leg, then too short, hung in the air, and the dainty shoe, that had no back to it, was held only by the toes to her bare foot.

For the first time he enjoyed the inexpressible delicacy of feminine refinements. He had never met this grace of language, this reserve of clothing, these poses of the weary dove. He admired the exaltation of her soul and the lace on her petticoat. Besides, was she not 'a lady' and a married woman – a real mistress, in fine?

By the diversity of her humour, in turn mystical or mirthful, talkative, taciturn, passionate, careless, she roused in him a thousand desires, quickening instincts and memories. She was the mistress of all the novels, the heroine of all the dramas, the vague 'she' of all the poetry books. He found again on her shoulder the amber colouring of the 'Odalisque Bathing'; she had the long waist of feudal châtelaines, and she resembled

the 'Pale Lady of Barcelona'. But above all she was the Angel!

Often looking at her, it seemed to him that his soul, escaping towards her, spread like a wave about the outline of her head, and fell drawn down into the whiteness of her breast. He knelt on the ground before her, and with both elbows on her knees looked at her with a smile, his face upturned.

She bent over him, and murmured as if choking with intoxication – 'Oh, don't move! don't speak! look at me! Something so sweet comes from your eyes that does me such good!'

She called him 'child'. 'Child, do you love me?'

And in the haste of her lips seeking his mouth she did not listen for his answer.

On the clock there was a bronze cupid, smirking as he bent his arm beneath a golden garland. They had laughed at it many a time, but when they had to part everything seemed serious to them.

Motionless in front of each other, they kept repeating, 'Till Thursday, till Thursday.'

Suddenly she seized his head between her hands, kissed him hurriedly on the forehead, crying 'Goodbyel' and rushed down the stairs.

She went to a hairdresser's in the Rue de la Comédie to have her hair arranged. Night fell; the gas was lighted in the shop. She heard the bell at the theatre calling the players to the performance, and opposite she saw men with white faces and women in faded gowns going in at the stage-door.

It was hot in the room, small and too low, where the stove was hissing in the midst of wigs and pomades. The smell of the tongs, together with the greasy hands that handled her head, soon stunned her, and she dozed a little in her wrapper. Often, as he did her hair, the man offered her tickets for a masked ball.

Then she went away. She went up the streets; reached the Croix-Rouge, put on her overshoes, hidden in the morning under the seat, and sank into her place among the impatient passengers. Some got out at the foot of the hill. She remained alone in the vehicle. Every turning brought the lights of the town more and more completely into view, spreading a great luminous vapour about the dim houses. Emma knelt on the cushions, and her eyes wandered over the dazzling light. She sobbed, called on Léon, sent him tender words and kisses lost in the wind.

There was a poor vagabond wretch who wandered that hillside with his stick, right amongst the diligences. A mass of rags covered his shoulders, and an old staved-in beaver, turned out like a basin, hid his face; but when he took it off he discovered in the place of eyelids empty and bloody orbits. The flesh hung in red shreds, and there flowed from it liquids that congealed into green scale down to the nose, whose black nostrils sniffed convulsively. To speak to you he threw back his head with an idiotic laugh; then his bluish eyeballs, rolling constantly, at the temples beat against the edge of the open wound. He sang a little song as he followed the carriages —

Maids in the warmth of a summer day Dream of love, and of love alway.

And all the rest was about birds and sunshine and green leaves.

Sometimes he suddenly appeared behind Emma, bareheaded. She drew back with a cry. Hivert made fun of him. He would advise him to get a booth at the

Saint Romain fair, or else ask him, laughing, how his young woman was.

Often they had started when, with a sudden movement, his hat entered the diligence through the small window, while he clung with his other arm to the footboard, between the wheels splashing mud. His voice, feeble at first and quavering, grew sharp; it resounded in the night like the indistinct moan of a vague distress; and through the ringing of the bells, the murmur of the trees, and the rumbling of the empty vehicle, it had a far-off sound that disturbed Emma. It went to the bottom of her soul, like a whirlwind in an abyss, and carried her away into the distances of a boundless melancholy. But Hivert, noticing a weight behind, gave the blind man sharp cuts with his whip. The thong lashed his wounds, and he fell back into the mud with a yell. Then the passengers in the 'Hirondelle' ended by falling asleep, some with open mouths, others with lowered chins, leaning against their neighbour's shoulder, or with their arm passed through the strap, oscillating regularly with the jolting of the carriage; and the reflection of the lantern swinging outside, on the crupper of the wheeler, penetrating into the interior through the chocolate calico curtains, threw dark blood-red shadows over the motionless people. Emma, bemused with grief, shivered in her clothes, feeling her feet grow colder and colder, feeling death in her soul.

At home Charles was waiting for her; the 'Hirondelle' was always late on Thursdays. Madame arrived at last, and scarcely kissed the child. Dinner was not ready. No matter! She excused the servant. This girl now seemed allowed to do just as she liked.

Often her husband, noting her pallor, asked if she were unwell.

'No,' said Emma.

'But,' he replied, 'you seem so strange this evening.'
'Oh, it's nothing! nothing!'

There were even days when she had no sooner come in than she went up to her room; and Justin, happening to be there, moved about noiselessly, quicker at helping her than the best of maids. He put the matches ready, the candlestick, a book, arranged her nightgown, turned back the bedclothes.

'Come!' said she, 'that will do. Now you can go.'

For he stood there, his hands hanging down and his eyes wide open, as if entangled in the countless threads of sudden reverie.

The next day was frightful, and those that came after still more unbearable, because of her impatience again to be grasping her happiness; an ardent lust, inflamed by the images of past experience, and that burst forth freely on the seventh day beneath Léon's caresses. His ardours were hidden beneath outbursts of wonder and gratitude. Emma tasted this love in a discreet, absorbed fashion, maintained it by all the artifices of her tenderness, and trembled a little lest it should be lost later on.

She often said to him, with her sweet, melancholy voice – 'Ah! you, too, you will leave me! You will marry! You will be like all the others.'

He asked, 'What others?'

'Why, like all men,' she replied. Then added, repulsing him with a languid movement – 'You are all scoundrels!'

One day as they were talking philosophically of earthly disillusions, in order to test his jealousy, or

yielding perhaps to an over-strong need to pour out her heart, she told him that in the past she had loved someone before him. 'Not like you,' she went on quickly, protesting by the head of her child that 'nothing had passed between them.'

The young man believed her, but none the less questioned her to find out what *he* was.

'He was a naval captain, my dear.'

Was not that a safeguard against enquiry, and, at the same time, assuming a higher ground through this pretended fascination exercised over a man who must have been of warlike nature and accustomed to receive homage?

The clerk then felt the lowliness of his position; he longed for epaulettes, crosses, titles. All that would please her – he gathered as much from her spendthrift habits.

Emma nevertheless concealed many of these extravagant fancies, such as her wish to have a blue tilbury to drive into Rouen, drawn by an English horse and driven by a groom in top-boots. It was Justin who had inspired her with this whim, by begging her to take him into her service as *valet-de-chambre*, and if the privation of it did not lessen the pleasure of her arrival at each rendezvous, it certainly augmented the bitterness of the return.

Often, when they talked together of Paris, she ended by murmuring, 'Ah! how happy we should be there!'

'Are we not happy?' gently answered the young man, passing his hands over her hair.

'Yes, that is true,' she said. 'I am mad. Kiss me!'

To her husband she was more charming than ever. She made him pistachio-creams, and played him

waltzes after dinner. So he thought himself the most fortunate of men, and Emma had no cares, when suddenly one evening he said – 'It is Mademoiselle Lempereur, isn't it, who gives you lessons?'

'Yes.'

'Well, I saw her just now,' Charles went on, 'at Madame Liégeard's. I mentioned you to her, but she doesn't know you.'

This was a thunderbolt. However, she replied quite naturally – 'Oh! she must have forgotten my name.'

'But perhaps,' said the doctor, 'there are several ladies of that name in Rouen who are musicmistresses.'

'Possibly!' Then quickly - 'But I have my receipts here. Look!'

And she went to the writing-table, ransacked all the drawers, rummaged the papers, and at last lost her head so completely that Charles earnestly begged her not to take so much trouble about those wretched receipts.

'Oh, I will find them,' she said.

And, in fact, on the following Friday, as Charles was putting on one of his boots in the dark cabinet where his clothes were kept, he felt a piece of paper between the leather and his sock. He took it out and read –

Received, for three months' lessons and several pieces of music, the sum of sixty-three francs. –

FÉLICIE LEMPEREUR, Professor of Music

'How the devil did it get into my boots?'

'It must have fallen from the old box of bills that is on the edge of the shelf.'

From that moment her existence was simply one long tissue of lies, in which she enveloped her love as in

veils to hide it. It was a craving, a mania, a pleasure, reaching such a pitch that if she said she had the day before walked on the right side of a road, one might be sure that she had taken the left.

One morning, when she had gone, as usual, rather lightly clad, it suddenly began to snow, and as Charles was watching the weather from the window, he caught sight of Monsieur Bournisien in the chaise of Monsieur Tuvache, who was driving him to Rouen. So he went down to give the priest a thick shawl which he was to hand over to Emma as soon as he reached the Croix-Rouge. When Monsieur Bournisien got to the inn, he asked for the wife of the Yonville doctor. The landlady replied that she very rarely came to her establishment. So that evening, recognising Madame Bovary in the 'Hirondelle', the curé told her his dilemma, without, however, appearing to attach much importance to it, for he began praising a preacher who was doing wonders at the cathedral, and whom all the ladies were flocking to hear.

Still, if he did not ask for any explanation, others, later on, might prove less discreet. So she thought well to get down each time at the Croix-Rouge, so that the good folk of her village who saw her on the stairs should suspect nothing.

One day, however, Monsieur Lheureux met her coming out of the Hôtel de Boulogne on Léon's arm; and she was frightened, thinking he would gossip. He was not such a fool. But three days after he came to her room, shut the door, and said, 'I must have some money.'

She declared she could not give him any. Lheureux burst into lamentations, and reminded her of all the kindnesses he had shown her. In fact, of the two bills signed by Charles, Emma up to the present had paid only one. As to the second, the shopkeeper, at her request, had consented to replace it by another, which again had been renewed for a long date. Then he drew from his pocket a list of goods not paid for; to wit the curtains, the carpet, the material for the armchairs, several dresses, and divers articles of dress, the bills for which amounted to about two thousand francs.

She bowed her head. He went on – 'But if you haven't any ready money, you have an estate.' And he reminded her of a miserable little hovel situated at Barneville, near Aumale, that brought in almost nothing. It had formerly been part of a small farm sold by Monsieur Bovary senior; for Lheureux knew everything, even to the number of acres and the names of the neighbours.

'If I were in your place,' he said, 'I should clear myself of my debts, and have some money left over.'

She pointed out the difficulty of getting a purchaser. He held out the hope of finding one; but she asked him how she should manage to sell it.

'Haven't you your power of attorney?' he replied.

The phrase came to her like a breath of fresh air. 'Leave me the bill,' said Emma.

'Oh, it isn't worth while,' answered Lheureux.

He came back the following week and boasted of having, after much trouble, at last discovered a certain Langlois, who, for a long time, had had an eye on the property, but without mentioning his price.

'Never mind the price!' she cried.

But they would, on the contrary, have to wait, to sound the fellow. The thing was worth a journey, and, as she could not undertake it, he offered to go to the

place to have an interview with Langlois. On his return he announced that the purchaser proposed four thousand francs.

Emma was radiant at this news.

'Frankly,' he added, 'that's a good price.'

She drew half the sum at once, and when she was about to pay her account the shopkeeper said – 'It really grieves me, on my word! to see you depriving yourself all at once of such a big sum as that.'

Then she looked at the bank-notes, and dreaming of the unlimited number of rendezvous represented by those two thousand francs, she stammered – 'What! what!'

'Oh!' he went on, laughing good-naturedly, 'one puts anything one likes on receipts. Don't you think I know what household affairs are?' And he looked at her fixedly, while in his hand he held two long papers that he slid between his nails. At last, opening his pocketbook, he spread out on the table four bills to order, each for a thousand francs.

'Sign these,' he said, 'and keep it all!'

She cried out, scandalised.

'But if I give you the surplus,' replied Monsieur Lheureux impudently, 'is that not helping you?'

And taking a pen he wrote at the bottom of the account, 'Received of Madame Bovary – four thousand francs.'

'Now who can trouble you, since in six months you'll draw the arrears of your cottage, and I don't make the last bill due till after you've been paid?'

Emma grew rather confused in her calculations, and her ears tingled as if gold pieces, bursting from their bags, rang all round her on the floor. At last Lheureux explained that he had a very good friend,

Vinçart, a broker at Rouen, who would discount these four bills. Then he himself would hand over to madame the remainder after the actual debt was paid.

But instead of two thousand francs he brought only eighteen hundred, for the friend Vinçart ('as was only fair') had deducted two hundred francs for commission and discount. Then he carelessly asked for a receipt.

'You understand – in business – sometimes. And with the date, if you please, with the date.'

A horizon of realisable whims opened out before Emma. She was prudent enough to lay by a thousand crowns, with which the first three bills were paid when they fell due; but the fourth, by chance, came to the house on a Thursday, and Charles, greatly upset, patiently awaited his wife's return for an explanation.

If she had not told him about this bill, it was only to spare him such domestic worries; she sat on his knees, caressed him, cooed to him, gave a long enumeration of all the indispensable things that had been got on credit.

'Really, you must confess, considering the quantity, it isn't too dear.'

Charles, at his wits' end, soon had recourse to the eternal Lheureux, who swore he would arrange matters if the doctor would sign him two bills, one of which was for seven hundred francs, payable in three months. In order to arrange for this he wrote his mother a pathetic letter. Instead of sending a reply she came herself; and when Emma wanted to know whether he had got anything out of her, 'Yes,' he replied; 'but she wants to see the account.'The next morning at daybreak Emma ran to Lheureux to beg him to make out another account for not more than a thousand francs, for to

show the one for four thousand it would be necessary to say that she had paid two-thirds, and confess, consequently, the sale of the estate – a negotiation admirably carried out by the shopkeeper, and which, in fact, was only actually known later on.

Despite the low price of each article, Madame Bovary senior, of course, thought the expenditure extravagant.

'Couldn't you do without a carpet? Why have recovered the armchairs? In my time there was a single armchair in a house, for elderly persons, – at any rate it was so at my mother's, who was a good woman, I can tell you. Everybody can't be rich! No fortune can hold out against waste! I should be ashamed to coddle myself as you do! And yet I am old. I need looking after. And there! there! fitting up gowns! fallals! What! silk for lining at two francs, when you can get jaconet for ten sous, or even eight, that would do well enough!'

Emma, lying on a lounge, replied as quietly as possible - 'Ah! Madame, enough! enough!'

The other went on lecturing her, predicting they would end in the workhouse. But it was Bovary's fault. Luckily he had promised to destroy that power of attorney.

'What?'

'Ah! he swore he would,' went on the good woman. Emma opened the window, called Charles, and the poor fellow was obliged to confess the promise torn from him by his mother.

Emma disappeared, then came back quickly, and majestically handed her a thick piece of paper.

'Thank you,' said the old woman. And she threw the power of attorney into the fire.

Emma began to laugh, a strident, piercing, continuous laugh; she had an attack of the hysterics.

'Oh, my God!' cried Charles. 'Ah! you really are wrong! You come here and make scenes with her!'

His mother, shrugging her shoulders, declared it was 'all put on.'

But Charles, rebelling for the first time, took his wife's part, so that Madame Bovary, senior, said she would leave. She went the very next day, and on the threshold, as he was trying to detain her, she replied – 'No, no! You love her better than me, and you are right. It is natural. For the rest, so much the worse! You will see. Good day – for I am not likely to come soon again, as you say, to make scenes.'

Charles nevertheless was very crestfallen before Emma, who did not hide the resentment she still felt at his want of confidence, and it needed many prayers before she would consent to have another power of attorney. He even accompanied her to Monsieur Guillaumin to have a second one, just like the other, drawn up.

'I understand,' said the notary; 'a man of science can't be worried with the practical details of life.'

And Charles felt relieved by this comfortable reflection, which gave his weakness the flattering appearance of higher preoccupation.

And what an outburst the next Thursday at the hotel in their room with Léon! She laughed, cried, sang, sent for sherbets, wanted to smoke cigarettes, seemed to him wild and extravagant but adorable, superb.

He did not know what refashioning of her whole being drove her more and more to plunge into the pleasures of life. She was becoming irritable, greedy, voluptuous; and she walked about the streets with him

carrying her head high, without fear, so she said, of compromising herself. At times, however, Emma shuddered at the sudden thought of meeting Rodolphe, for it seemed to her that, although they were separated forever, she was not completely free from her subjugation to him.

One night she did not return to Yonville at all. Charles lost his head with anxiety, and little Berthe would not go to bed without her mamma, and sobbed as if to break her heart. Justin had gone out searching the road at random. Monsieur Homais even had left his pharmacy.

At last, at eleven o'clock, able to bear it no longer, Charles harnessed his chaise, jumped in, whipped up his horse, and reached the Croix-Rouge about two o'clock in the morning. No one there! He thought that the clerk had perhaps seen her; but where did he live? Happily, Charles remembered his employer's address, and rushed off there.

Day was breaking; he could distinguish the plaques over the door, and knocked. Someone, without opening the door, shouted out the required information, adding a few insults to those who disturb people in the middle of the night.

The house inhabited by the clerk had neither bell, knocker, nor porter. Charles knocked loudly at the shutters with his hands. A policeman happened to pass by. Then he was frightened, and went away.

'I am mad,' he said; 'no doubt they kept her to dinner at Monsieur Lormeaux's.' But the Lormeaux no longer lived at Rouen.

'She probably stayed to look after Madame Dubreuil. Why, Madame Dubreuil has been dead these ten months! Where can she be?' An idea occurred to him. At a café he asked for a Directory, and hurriedly looked for the name of Mademoiselle Lempereur, who lived at No. 74 Rue de la Renelle-des-Maroquiniers.

As he was turning into the street, Emma herself appeared at the other end of it. He threw himself upon her rather than embraced her, crying – 'What kept you yesterday?'

'I was not well.'

'What was it? Where? How?'

She passed her hand over her forehead and answered, 'At Mademoiselle Lempereur's.'

'I was sure of it! I was going there.'

'Oh, it isn't worth while,' said Emma. 'She went out just now; but in future don't worry. I don't feel free, you see, if I think that the least delay upsets you like this.'

This was a sort of permission that she gave herself, so as to get perfect freedom in her escapades. And she profited by it freely and fully. When seized with the desire to see Léon, she set out upon any pretext; and as he was not expecting her on that day, she went to fetch him at his office.

It was a great joy at first, but soon he no longer concealed the truth, which was, that his master complained very much about these interruptions.

'Pshaw! come along,' she said.

And he slipped out.

She wanted him to dress all in black, and grow a pointed beard, to look like the portraits of Louis XIII. She wanted to see his lodgings; thought them poor. He blushed at them, but she did not notice this, then advised him to buy some curtains like hers, and as he objected to the expense – 'Ah, ha! you have an eye for your sixpences!' she said laughing.

Each time Léon had to tell her everything that he had done since their last meeting. She asked him for some verses – some verses 'for herself', a 'love-poem' in her honour. But he never succeeded in getting a rhyme for the second verse; and at last ended by copying a sonnet in a 'Keepsake'. This was less from vanity than from the one desire of pleasing her. He did not question her ideas; he accepted all her tastes; he was rather becoming her mistress than she his. She had tender words and kisses that thrilled his soul. Where could she have learnt this corruption almost incorporeal in the strength of its profundity and dissimulation?

During the journeys he made to see her, Léon had often dined at the chemist's, and he felt obliged from politeness to invite him in turn.

'With pleasure!' Monsieur Homais replied; 'besides, I must invigorate my mind, for I am getting rusty here. We'll go to the theatre, to the restaurant; we'll make a night of it!'

'Oh, my dear!' tenderly murmured Madame Homais, alarmed at the vague perils he was preparing to brave.

'Well, what? Do you think I'm not sufficiently ruining my health living here amid the continual emanations of the pharmacy? But there! that is the way with women! They are jealous of science, and then are opposed to our taking the most legitimate distractions. No matter! Count upon me. One of these days I shall turn up at Rouen, and we'll have a fling together.'

The druggist would formerly have taken good care not to use such an expression, but he was cultivating a gay Parisian style, which he thought in the best taste; and, like his neighbour Madame Bovary, he questioned the clerk curiously about the customs of the capital; he even talked slang to dazzle the bourgeois, using a number of current 'flash' phrases.

So one Thursday Emma was surprised to meet Monsieur Homais in the kitchen of the Lion d'Or, wearing travelling clothes, that is to say, wrapped in an old cloak which no one knew he had, while he carried a valise in one hand and the foot-warmer of his establishment in the other. He had confided his

intentions to no one, for fear of his absence causing public anxiety.

The idea of again seeing the place where his youth had been spent no doubt excited him, for during the whole journey he never ceased talking, and instantly on arrival he jumped out of the diligence to go in search of Léon. In vain the clerk tried to get rid of him. Monsieur Homais dragged him off to the large Café de la Normandie, which he entered majestically, not raising his hat, thinking it very provincial to uncover in any public place.

Emma waited for Léon three-quarters of an hour. At last she ran to his office, and, lost in all sorts of conjectures, accusing him of indifference, and reproaching herself for her weakness, she spent the afternoon, her face pressed against the windowpanes.

At two o'clock they were still at table opposite each other. The large room was emptying; the stovepipe, in the shape of a palm tree, spread its gilt leaves over the white ceiling, and near them, outside the window, in the bright sunshine, a little fountain gurgled in a white basin, where, in the midst of watercress and asparagus, three torpid lobsters stretched across to some quails that lay heaped up in a pile on their sides.

Homais was enjoying himself. Although he was even more intoxicated with the luxury than the rich fare, the Pomard wine all the same rather excited his faculties; and when the omelette *au rhum* appeared, he began propounding immoral theories about women. What seduced him above all else was *chic*. He admired an elegant toilette in a well-furnished apartment, and, as to bodily qualities, he didn't dislike a young girl.

Léon watched the clock in despair. The druggist went on drinking, eating, and talking.

'You must be very lonely,' he said suddenly, 'here at Rouen. To be sure your lady-love doesn't live far away.'

And the other blushed – 'Come, now, be frank. Can you deny that at Yonville – '

The young man stammered something.

'At Madame Bovary's, you're not making love to -'

'The servant!'

He was not joking; but, vanity getting the better of all prudence, Léon, in spite of himself, protested. Besides, he only liked dark women.

'I approve of that,' said the chemist; 'they are more passionate.'

And, whispering into his friend's ear, he detailed the symptoms by which one could find out if a woman had passion. He even launched into an ethnographic digression: the German woman was vapourish, the French licentious, the Italian passionate.

'And negresses?' asked the clerk.

'They are an artistic taste!' said Homais. 'Waiter! two cups of coffee!'

'Are we going?' at last asked Léon impatiently.

'Yes!' he answered in English.

But before leaving he wanted to see the proprietor of the establishment and made him a few compliments. Then the young man, to be alone, alleged he had some business engagement.

'Ah! I will escort you,' said Homais.

And all the while he was walking through the streets with him he talked of his wife, his children, of their future, and of his business; told him in what a decayed condition it had formerly been, and to what a degree of perfection he had raised it.

Arrived in front of the Hôtel de Boulogne, Léon left

him abruptly, ran up the stairs, and found his mistress in great excitement. At mention of the chemist she flew into a passion. He, however, piled up good reasons; it wasn't his fault; didn't she know Homais – did she believe that he would prefer his company? But she turned away; he drew her back, and, sinking on his knees, clasped her waist with his arms in a languorous pose, full of concupiscence and supplication.

She was standing up, her large flashing eyes looked at him seriously, almost terribly. Then tears obscured them, her red eyelids were lowered, she gave him her hands, and Léon was pressing them to his lips when a servant appeared to tell the gentleman that he was wanted.

'You will come back?' she said.

'Yes.'

'But when?'

'Immediately.'

'It's a trick,' said the chemist, when he saw Léon. 'I wanted to interrupt this visit, that seemed to me to annoy you. Let's go and have a glass of *garus* at Bridoux's.'

Léon vowed that he must get back to his office. Then the druggist joked him about quill-drivers and the law.

'Leave Cujas and Barthole alone a bit. Who the devil prevents you? Be a man! Let's go to Bridoux's. You'll see that dog of his. It's very interesting.'

And as the clerk still insisted – 'I'll go with you. I'll read a paper while I wait for you, or turn over the leaves of a "Code".'

Léon, bewildered by Emma's anger, Monsieur Homais's chatter, and, perhaps, by the heaviness of the luncheon, was undecided, and, as it were, fascinated by the chemist, who kept repeating – 'Let's go to Bridoux's. It's just by here, in the Rue Malpalu.'

Then, through cowardice, through stupidity, through that indefinable feeling that drags us into the most distasteful acts, he allowed himself to be led off to Bridoux's, whom they found in his small yard, superintending three workmen, who panted as they turned the large wheel of a machine for making seltzer-water. Homais gave them some good advice. He embraced Bridoux; they took some *garus*. Twenty times Léon tried to escape, but the other seized him by the arm saying – 'Presently! I'm coming! We'll go to the *Fanal de Rouen* to see the fellows there. I'll introduce you to Thomassin.'

At last he managed to get rid of him, and rushed straight to the hotel. Emma was no longer there. She had just left in a fit of anger. She detested him now. This failing to keep their rendezvous seemed to her an insult, and she tried to rake up other reasons to separate herself from him. He was incapable of heroism, weak, commonplace, more spiritless than a woman, avaricious too, and cowardly.

Then, growing calmer, she at length discovered that she had, no doubt, calumniated him. But the disparaging of those we love always alienates us from them to some extent. Idols must not be touched; the gilt sticks to the fingers.

They gradually came to talking more frequently of matters outside their love, and in the letters that Emma wrote him she spoke of flowers, verses, the moon and the stars, naïve resources of a waning passion striving to keep itself alive by all external aids. She was constantly promising herself a profound felicity on her next journey. Then she confessed to

herself that she felt nothing extraordinary. This disappointment quickly gave way to a new hope, and Emma returned to him more inflamed, more eager than ever. She undressed brutally, tearing off the thin laces of her corset that nestled around her hips like a gliding snake. She went on tiptoe, barefooted, to see once more that the door was closed, then, pale, serious, and, without speaking, with one movement, she threw herself upon his breast with a long shudder.

Yet there was upon that brow covered with cold drops, on those quivering lips, in those wild eyes, in the strain of those arms, something vague and dreary that Léon felt gliding subtly between them as if to part them.

He did not dare question her; but, seeing her so skilled, she must have passed, he thought, through every experience of suffering and of pleasure. What once had charmed now frightened him a little. Besides, he rebelled against his absorption, daily more marked, by her personality. He grudged Emma this constant victory. He even strove not to love her; then, when he heard the creaking of her boots, he turned coward, like drunkards at the sight of strong drinks.

Indeed, she did not fail to lavish all sorts of attentions upon him, from delicacies of food to coquetries of dress and languishing looks. She brought roses in her breast from Yonville, and threw them into his face; was anxious about his health, gave him advice as to his conduct; and, in order the more surely to keep her hold on him, hoping perhaps that heaven would take her part, she tied a medal of the Virgin round his neck. She enquired about his companions like a virtuous mother. She said to him —

'Don't see them; don't go out; think only of ourselves; love me!'

She would have liked to be able to watch over his life, and the idea occurred to her of having him followed in the streets. Near the hotel there was always a kind of loafer who accosted travellers, and who would not refuse. But her pride revolted at this.

'Bah! so much the worse. Let him deceive me! What does it matter to me? As if I cared for him!'

One day, when they had parted early and she was returning alone along the boulevard, she saw the walls of her convent; then she sat down on a form in the shade of the elm trees. How calm that time had been! How she longed for the ineffable sentiments of love that she had tried to figure to herself out of books! The first month of her marriage, her rides in the wood, the viscount who waltzed, and Lagardy singing, all passed again before her eyes. And Léon suddenly appeared to her as far off as the others.

'Yet I love him,' she said to herself.

No matter! She was not happy – she never had been. Whence came this insufficiency in life – this instantaneous turning to decay of everything on which she leant? But if there were somewhere a being strong and beautiful, a valiant nature, full at once of exaltation and refinement, a poet's heart in an angel's form, a lyre with sounding chords, ringing out elegaic epithalamia to heaven, why, perchance should she not find him? Ah! how impossible! Besides, nothing was worth the trouble of seeking it; everything was a lie. Every smile hid a yawn of boredom, every joy a curse, all pleasure satiety, and the sweetest kisses left upon your lips only the unattainable desire for a greater delight.

A metallic clang droned through the air, and four strokes were heard from the convent clock. Four o'clock! And it seemed to her that she had been there on that form an eternity. But an infinity of passions may be contained in a minute, like a crowd in a small space.

Emma lived all absorbed in hers, and troubled no more about money matters than an archduchess.

Once, however, a wretched-looking man, rubicund and bald, came to her house, saying he had been sent by Monsieur Vinçart of Rouen. He took out the pins that held together the side-pockets of his long green overcoat, stuck them into his sleeve, and politely handed her a paper.

It was a bill for seven hundred francs, signed by her, and which Lheureux, in spite of all his professions, had paid away to Vinçart. She sent her servant for him. He could not come. Then the stranger, who had remained standing, casting right and left curious glances, that his thick, fair eyebrows hid, asked with a naïve air – 'What answer am I to take Monsieur Vinçart?'

'Oh,' said Emma, 'tell him that I haven't got it. I will send next week; he must wait; yes, till next week.'

And the fellow went off without another word.

But the next day at twelve o'clock she received a summons, and the sight of the stamped paper, on which appeared several times in large letters, 'Maître Hareng, bailiff at Buchy,' so frightened her that she rushed in hot haste to the linen-draper's. She found him in his shop, doing up a parcel.

'Your obedient!' he said; 'I am at your service.'

But Lheureux, all the same, went on with his work, helped by a young girl of about thirteen, somewhat hunchbacked, who was at once his clerk and his servant.

Then, his clogs clattering on the shop-boards, he went up in front of Madame Bovary to the first door, and introduced her into a narrow closet, where, in a large bureau in sapon-wood lay some ledgers, protected by a horizontal padlocked iron bar. Against the wall, under some remnants of calico, one glimpsed a safe, but of such dimensions that it must contain something besides bills and money. Monsieur Lheureux, in fact, went in for pawnbroking, and it was there that he had put Madame Bovary's gold chain, together with the earrings of poor old Tellier, who, at last forced to sell out, had bought a meagre store of grocery at Quincampoix, where he was dying of catarrh amongst his candles, that were less yellow than his face.

Lheureux sat down in a large cane armchair, saying:

'What news?'

'See!'

And she showed him the paper.

'Well how can I help it?'

Then she grew angry, reminding him of the promise he had given not to pay away her bills. He acknowledged it.

'But I was pressed myself; the knife was at my own throat.'

'And what will happen now?' she went on.

'Oh, it's very simple; a judgment and then a distraint – that's about it!'

Emma kept down a desire to strike him, and asked gently if there was no way of quieting Monsieur Vinçart.

'I dare say! Quieting Vinçart! You don't know him; he's fiercer than an Arab!' Still, Monsieur Lheureux must step in.

'Well, listen. It seems to me so far I've been very good to you.' And opening one of his ledgers, 'See,' he said. Then running up the page with his finger, 'Let's see! let's sec! August 3rd, two hundred francs; June 17th, a hundred and fifty; March 23rd, forty-six. In April –'

He stopped, as if afraid of making some mistake.

'Not to speak of the bills signed by Monsieur Bovary, one for seven hundred francs, and another for three hundred. As to your little instalments, with the interest, why, there's no end to them; one gets quite muddled over them. I'll have nothing more to do with it.'

She wept; she even called him 'her dear Monsieur Lheureux.' But he always fell back upon 'that rascal Vinçart.' Besides, he hadn't a brass farthing; no one was paying him nowadays; they were eating the coat off his back; a poor shopkeeper like him couldn't advance money.

Emma was silent, and Monsieur Lheureux, who was biting the feathers of a quill, no doubt became uneasy at her silence, for he went on – 'Unless one of these days I have something coming in I might –'

'Besides,' said she, 'as soon as the balance of Barneville - '

'What!'

And on hearing that Langlois had not yet paid he seemed much surprised. Then in a honeyed voice – 'And we agree, you say?'

'Oh! to anything you like.'

On this he closed his eyes to reflect, wrote down a few figures, and declaring it would be very difficult for him, that the affair was shady, and that he was being

bled, he wrote out four bills for two hundred and fifty francs each, to fall due month by month.

'Provided that Vinçart will listen to me! However, it's settled. I don't play the fool; I'm straight enough.'

Next he carelessly showed her several new goods, not one of which, however, was in his opinion worthy of madame.

'When I think that there's a dress at threepencehalf-penny a yard, and warranted fast colours! And yet they actually swallow it! Of course you understand one doesn't tell them what it really is!' He hoped by this confession of dishonesty to others to quite convince her of his probity to her.

Then he called her back to show her three yards of guipure that he had lately picked up 'at a sale.'

'Isn't it lovely?' said Lheureux. 'It is very much used now for the backs of armchairs. It's quite the rage.'

And, more ready than a juggler, he wrapped up the guipure in some blue paper and put it in Emma's hands.

'But at least let me know - '

'Yes, another time,' he replied, turning on his heel.

That same evening she urged Bovary to write to his mother, to ask her to send as quickly as possible the whole of the balance due from the father's estate. The mother-in-law replied that she had nothing more, the winding up was over, and there was due to them besides Barneville an income of six hundred francs, that she would pay them punctually.

Then Madame Bovary sent in accounts to two or three patients, and she made large use of this method, which was very successful. She was always careful to add a postscript: 'Do not mention this to my husband; you know how proud he is. Excuse me.

Yours obediently.' There were some complaints; she intercepted them.

To get money she began selling her old gloves, her old hats, the old odds and ends, and bargained rapaciously, her peasant blood standing her in good stead. Then on her journey to town she picked up knick-knacks second-hand, which failing anyone else, Monsieur Lheureux would certainly take off her hands. She bought ostrich feathers, Chinese porcelain, and trunks; she borrowed from Félicité, from Madame Lefrançois, from the landlady at the Croix-Rouge, from everybody, no matter where. With the money she at last received from Barneville she paid two bills; the other fifteen hundred francs fell due. She renewed the bills, and thus it went endlessly on.

True, sometimes she tried to reckon things up, she tried to make a calculation, but she discovered them so exorbitant that she was incredulous. Then she started again, soon got confused, gave it all up, and put it out of her mind.

The house was very dreary now. Tradesmen were seen leaving it with angry faces. Handkerchiefs were lying about on the stoves, and little Berthe, to the great scandal of Madame Homais, wore stockings with holes in them. If Charles timidly ventured a remark, she answered roughly that it wasn't her fault.

What was the meaning of all these fits of temper? He explained everything through her old nervous illness, and reproaching himself with having taken her infirmities for faults, accused himself of egotism, and longed to go and take her in his arms.

'Ah, no!' he said to himself; 'I should worry her.'

And he did not stir.

After dinner he walked about alone in the garden;

he took little Berthe on his knees, and unfolding his medical journal, tried to teach her to read. But the child, who never had any lessons, soon looked up with large, sad eyes and began to cry. Then he comforted her; went to fetch water in her can to make rivers on the sand path, or broke off branches from the privet hedges to plant trees in the beds. This did not spoil the garden much, all choked now with long weeds. They owed Lestiboudois for so many days. Then the child grew cold and asked for her mother.

'Call your nurse,' said Charles. 'You know, dear, that mamma does not like to be disturbed.'

Autumn was setting in, and the leaves were already falling, as they did two years ago when she was ill. Where would it all end? And he walked up and down, his hands behind his back.

Madame was in her room, which no one entered. She stayed there all day long, torpid, half dressed, and from time to time burning Turkish pastilles which she had bought at Rouen in an Algerian's shop. In order not to have at night this sleeping man stretched at her side, by dint of manoeuvring, she at last succeeded in banishing him to the second floor, while she read till morning extravagant books full of orgiastic pictures and outrageous situations. Often, seized with fear, she would cry out, and Charles hurried to her.

'Oh, go away!' she would say.

Or at other times, consumed more ardently than ever by that inner flame to which adultery added fuel, panting, tremulous, all desire, she threw open her window, breathed in the cold air, shook loose in the wind her burdensome masses of hair, and, gazing upon the stars, longed for some princely love. She thought of him, of Léon. She would then have given

anything for a single one of those meetings that surfeited her.

These were her gala days. She wanted them to be sumptuous, and when he alone could not pay the expenses, she made up the deficit liberally, which nearly always happened every time. He tried to make her understand that they would be quite as comfortable somewhere else, in a smaller hotel, but she always found some objection.

One day she drew six small silver-gilt spoons from her bag (they were old Rouault's wedding present), begging him to pawn them at once for her, and Léon obeyed, though the proceeding annoyed him. He was afraid of compromising himself.

Then, on reflection, he began to think his mistress's ways were growing odd, and that perhaps they were not wrong in wishing to separate him from her.

In fact someone had sent his mother a long anonymous letter to warn her that he was 'ruining himself with a married woman,' and the good lady at once conjuring up the eternal bugbear of families, the vague pernicious creature, the siren, the monster, who dwells fantastically in depths of love, wrote to Monsieur Dubocage the lawyer who employed him. He behaved perfectly in the affair. He kept him for three-quarters of an hour trying to open his eyes, to warn him of the abyss into which he was falling. Such an intrigue would damage him later on, when he set up for himself. He implored him to break with her, and, if he would not make this sacrifice in his own interest, to do it at least for his, Dubocage's, sake.

At last Léon swore he would not see Emma again, and he reproached himself with not having kept his word, considering all the worry and lectures this woman might still draw down upon him, without reckoning the jokes made by his companions as they sat round the stove in the morning. Besides, he was soon to be head clerk, it was time to settle down. So he gave up his flute, exalted sentiments, and poetry; for every bourgeois in the flush of his youth, were it but for a day, a moment, has believed himself capable of immense passions, of lofty enterprises. The most paltry libertine has dreamed of sultanas; every notary bears within him the débris of a poet.

He was bored now when Emma suddenly began to sob on his breast, and his heart, like the people who can only stand a certain amount of music, dozed to the sound of a love whose delicacies he no longer noted.

They knew one another too well for any of those surprises of possession that increase its joys a hundred-fold. She was as sick of him as he was weary of her. In adultery Emma was finding again all the platitudes of marriage.

But how to get rid of him? Then, though she might fee humiliated at the baseness of such enjoyment, she clung to it from habit or from corruption; and every day she hungered after them the more, exhausting all felicity in wishing for too much of it. She accused Léon of her baffled hopes, as if he had betrayed her; and she even longed for some catastrophe that would bring about their separation, since she had not the courage to make up her mind to it herself.

Nevertheless, she continued to write him love letters, simply because a woman is supposed to write to her lover.

But whilst she wrote, it was another man she saw, a phantom fashioned out of her most ardent memories, of her finest reading, her most ardent desires, and at

last he became so real, and tangible, that she panted in wonderment, without, however, having the power to imagine him clearly, so lost was he, like a god, beneath the abundance of his attributes. He dwelt in the azure land where silk ladders hang from balconies under breathing flowers, in the light of the moon. She felt him near her; he was coming, he would carry her right away in a kiss.

Then she fell back exhausted, for these transports of shadowy love wearied her more than great indulgence.

She now felt a constant aching all over her. Often she even received summonses, stamped paper that she barely looked at. She would have liked not to be alive, or to be always asleep.

At Mid-Lent she did not return to Yonville, but went to a masked ball in the evening. She wore velvet breeches, red stockings, a club wig, and threecornered hat cocked on one side. She danced all night to the blaring of trombones; people gathered round her, and in the morning she found herself on the steps of the theatre together with five or six masks, woodcutters and sailors, Léon's comrades, who were talking about having supper.

The neighbouring cafés were full. They caught sight of one on the quay, a very indifferent restaurant, whose proprietor showed them to a little room on the fourth floor.

The men were whispering in a corner, no doubt consulting about expenses. There were a clerk, two medical students, and a shopman – what company for her! As to the women, Emma soon perceived from the tone of their voices that they must almost belong to the lowest class. Then she was frightened, pushed back her chair, and cast down her eyes.

The others began to eat; she ate nothing. Her head was on fire, her eyes smarted, and her skin was ice-cold. In her head she seemed to feel the floor of the ballroom rebounding again beneath the rhythmical pulsation of the thousands of dancing feet. And now the smell of the punch, the smoke of the cigars, made her giddy. She fainted, and they carried her to the window.

Day was breaking, and a great stain of purple colour broadened out in the pale horizon over the St Catherine hill. The livid river was shivering in the wind; there was no one on the bridges; the street lamps were going out.

She revived, and began thinking of Berthe asleep yonder in the servant's room. Then a cart filled with long strips of iron passed by, and made a deafening metallic vibration against the walls of the houses.

She slipped away suddenly, threw off her costume, told Léon she must get back, and at last was alone at the Hôtel de Boulogne. Everything, even herself, was now unbearable to her. She wished that, taking wing like a bird, she could fly somewhere, far away to regions of purity, and there grow young again.

She went out, crossed the Boulevard, the Place Cauchoise and the Faubourg, as far as an open street overlooking some gardens. She walked rapidly, the fresh air calming her; and, little by little, the faces of the crowd, the masks, the quadrilles, the lights, the supper, those women, all, disappeared like mists fading away. Then, reaching the Croix-Rouge, she threw herself on the bed in her little room on the second floor, where there were pictures of the 'Tour de Nesle'. At four o'clock Hivert awoke her.

When she got home, Félicité showed her behind the

clock a grey paper. She read - 'In virtue of the seizure in execution of a judgment'.

What judgment? As a matter of fact, the evening before another paper had been brought that she had not yet seen, and she was stunned by these words – 'By order of the king, law, and justice, to Madame Bovary', Then, skipping several lines, she read, 'Within twenty-four hours, without fail – 'But what?' To pay the sum of eight thousand francs'. And there was even at the bottom, 'She will be constrained thereto by every form of law, and notably by a writ of distraint on her furniture and effects'.

What was to be done? In twenty-four hours – tomorrow. Lheureux, she thought, wanted to frighten her again; for she saw through all his devices, the object of his kindnesses. What reassured her was the very magnitude of the sum.

However, by dint of buying and not paying, of borrowing, signing bills, and renewing these bills that grew at each new falling-in, she had ended by preparing a capital for Monsieur Lheureux which he was impatiently awaiting for his speculations.

She presented herself at his place with an offhand air.

'You know what has happened to me? No doubt it's a joke!'

'No.'

'How so?'

He turned away slowly, and folding his arms, said to her: 'My good lady, did you think I should go on to all eternity being your purveyor and banker, for the love of God? Now be just. I must get back what I've laid out. Now be just.'

She cried out against the debt.

'Ah! so much the worse. The court has admitted it. There's a judgment. It's been notified to you. Besides, it isn't my fault. It's Vinçart's.'

'Could you not -?'

'Oh, nothing whatever.'

'But still, now talk it over.'

And she began beating about the bush; she had known nothing about it; it was a surprise.

'Whose fault is that?' said Lheureux, bowing ironically. 'While I'm slaving like a nigger, you go gallivanting about.'

'Ah! no lecturing.'

'It never does any harm,' he replied.

She turned coward; she implored him; she even pressed her pretty white and slender hand against the shopkeeper's knee.

'There, that'll do! Anyone'd think you wanted to seduce me!'

'You are a wretch!' she cried.

'Oh, oh! go it! go it!'

'I will show you up. I shall tell my husband.'

'All right! I too, I'll show your husband something.'
And Lheureux drew from his strongbox the receipt
for eighteen hundred francs that she had given him
when Vincart had discounted the bills.

'Do you think,' he added, 'that he won't understand your little theft, the poor dear man?'

She collapsed, more overcome than if felled by the blow of a poleaxe. He was walking up and down from the window to the bureau, repeating all the while – 'Ah! I'll show him! I'll show him!'Then he approached her, and in a soft voice said – 'It isn't pleasant, I know; but, after all, no bones are broken, and, since that is the only way that is left for you paying back my money – '

'But where am I to get any?' said Emma, wringing her hands.

'Bah! when one has friends like you!'

And he looked at her in so keen, so terrible a fashion, that she shuddered to her very heart.

'I promise you,' she said, 'to sign - '

'I've enough of your signatures.'

'I will sell something.'

'Get along!' he said, shrugging his shoulders; 'you've not got anything.'

And he called through the peep-hole that looked down into the shop – 'Annette, don't forget the three coupons of No. 14.'

The servant appeared. Emma understood, and asked how much money would be wanted to put a stop to the proceedings.

'It is too late.'

'But if I brought you several thousand francs – a quarter of the sum – a third – perhaps the whole?'

'No; it's no use!'

And he pushed her gently towards the staircase.

'I implore you, Monsieur Lheureux, just a few days more!' She was sobbing.

'There! tears now!'

'You are driving me to despair!'

'What do I care?' said he, shutting the door.

She was stoical the next day when Maître Hareng, the bailiff, presented himself, with two assistants, at her house to draw up the inventory for the distraint.

They began with Bovary's consulting-room, and did not write down the phrenological head, which was considered an 'instrument of his profession'; but in the kitchen they counted the plates, the saucepans, the chairs, the candlesticks, and in the bedroom all the knick-knacks on the what-not. They examined her dresses, the linen, the dressing-room; and her whole existence, to its most intimate details, was outspread before the eyes of these three men like a corpse in an autopsy.

Maître Hareng, buttoned up in his thin black coat, wearing a white choker and very tight foot-straps, repeated from time to time – 'Allow me, madame. You allow me?' Often he uttered exclamations. 'Charmingl very pretty.' Then he began writing again, dipping his pen into the horn inkstand in his left hand.

When they had done with the rooms they went up to the attic. She kept a desk there in which Rodolphe's letters were locked. It had to be opened.

'Ah! a correspondence,' said Maître Hareng, with a discreet smile. 'But allow me, for I must make sure the box contains nothing else.' And he tipped up the papers lightly, as if to shake out napoleons. Then she felt anger at the sight of this coarse hand, with its red fingers, pulpy like slugs, touching those pages against which her heart had beaten.

They went at last. Félicité came back. Emma had

sent her out to watch for Bovary in order to keep him off, and they hurriedly installed the man in possession under the roof, where he swore he would remain.

During the evening Charles seemed to her careworn. Emma watched him with a look of anguish, fancying she saw an accusation in every line of his face. Then, when her eyes wandered over the chimney-piece ornamented with Chinese screens, over the large curtains, the armchairs, all those things, in a word, that had softened the bitterness of her life, remorse seized her or rather an immense regret, that, far from crushing, irritated her passion. Charles placidly poked the fire, both his feet on the firedogs.

Once the man, no doubt bored in his hiding-place, made a slight noise.

'Is anyone walking upstairs?' said Charles.

'No,' she replied; 'it is a window left open, and rattling in the wind.'

The next day, Sunday, she went to Rouen to call on all the brokers whose names she knew. They were at their country-places or on journeys. She was not discouraged; and those whom she did manage to see she asked for money, declaring she must have some, and that she would pay it back. Some laughed in her face; all refused.

At two o'clock she hurried to Léon, and knocked at the door. No one answered. At length he appeared.

'What brings you here?'

'Do I disturb you?'

'No; but -' And he admitted that his landlord didn't like his having 'women' there.

'I must speak to you,' she went on.

Then he took down the key, but she stopped him.

'No, no! Down there, in our home!'

And they went to their room at the Hôtel de Boulogne.

On arriving she drank off a large glass of water. She was very pale. She said to him – 'Léon, will you do me a service?'

And, shaking him by both hands that she grasped tightly, she added – 'Listen, I want eight thousand francs.'

'But you are mad!'

'Not yet.'

And thereupon, telling him the story of the distraint, she explained her distress to him; for Charles knew nothing of it; her mother-in-law detested her; old Rouault could do nothing; but he, Léon, he would set about finding this indispensable sum.

'How on earth can I?'

'What a coward you are!' she cried.

Then he said stupidly, 'You are exaggerating the difficulty. Perhaps a thousand crowns or so could stop the fellow.'

All the greater reason to try and do something; it was impossible that they could not find three thousand francs. Besides, Léon could be security instead of her.

'Go, try, try! I will love you so!'

He went out, and came back an hour later, saying, with solemn face – 'I have been to three people with no success.'

Then they remained sitting face to face at the two chimney corners, motionless, in silence. Emma shrugged her shoulders as she stamped her feet. He heard her murmuring – 'If I were in your place I should soon get some.'

'But where?'

'At your office.' And she looked at him.

An infernal boldness looked out from her burning eyes, and their lids drew close together with a lascivious and encouraging look, so that the young man felt himself growing weak beneath the mute will of this woman who was urging him to a crime. Then he was afraid, and to avoid any explanation he smote his forehead, crying – 'Morel is to come back tonight; he will not refuse me, I hope' (this was one of his friends, the son of a very rich merchant); 'and I will bring it you tomorrow,' he added.

Emma did not seem to welcome this hope with all the joy he had expected. Did she suspect the lie? He went on, blushing – 'However, if you don't see me by three o'clock do not wait for me, my darling. I must be off now; forgive me! Goodbye!'

He pressed her hand, but it felt quite lifeless. Emma had no strength left for any sentiment.

Four o'clock struck, and she rose to return to Yonville, mechanically obeying the force of old habits.

The weather was fine. It was one of those March days, clear and sharp, when the sun shines in a perfectly white sky. The Rouen folk were walking about in Sunday clothes with happy looks. She reached the Place du Parvis. People were coming out after vespers; the crowd flowed out through the three doors like a stream through the three arches of a bridge, and in the middle one, motionless as a rock, stood the beadle.

Then she remembered the day when, all anxious and full of hope, she had entered that vast nave; it had opened out before her, less profound than her love; and she walked on weeping beneath her veil, giddy, staggering, almost fainting.

'Take care!' cried a voice issuing from the gate of a courtyard that was thrown open.

She stopped to let pass a black horse, pawing the ground between the shafts of a tilbury, driven by a gentleman in sable furs. Who was it? She knew him. The carriage darted by and disappeared.

Why, it was he – the Viscount. She turned away; the street was empty. She was so overwhelmed, so sad, that she had to lean against a wall to keep herself from falling.

Then she thought she had been mistaken. Anyhow, she did not know. All within her and around her was abandoning her. She felt lost, sinking at random into indefinable abysses, and it was almost with joy that, on reaching the Croix-Rouge, she saw the good Homais, who was watching a large box full of pharmaceutical stores being hoisted on to the 'Hirondelle'. In his hand he held tied in a silk handkerchief six *cheminots* for his wife.

Madame Homais was very fond of these small, heavy turban-shaped loaves, that are eaten in Lent with salt butter; a last vestige of Gothic food that goes back, perhaps, to the time of the Crusades, and with which the robust Normans gorged themselves of yore, fancying they saw on the table, in the light of the yellow torches, between tankards of hippocras and huge boars' heads, the heads of Saracens to be devoured. The druggist's wife crunched them up as they had done – heroically, despite her wretched teeth. And so whenever Homais journeyed to town, he never failed to bring her home some that he bought at the great baker's in the Rue Massacre.

'Charmed to see you,' he said, offering Emma a hand to help her into the 'Hirondelle'. Then he hung up his

cheminots to the cords of the netting, and remained bareheaded in a pensive, Napoleonic attitude.

But when the blind man appeared as usual at the foot of the hill he exclaimed – 'I can't understand why the authorities tolerate such culpable industries. Such unfortunates should be locked up and forced to work. Progress, my word! creeps at a snail's pace. We are floundering about in mere barbarism.'

The blind man held out his hat, that flapped about at the door, as if it were a bag in the lining that had come unnailed.

'This,' said the chemist, 'is a scrofulous affection.'

And though he knew the poor devil, he pretended to see him for the first time, murmured something about 'cornea', 'opaque cornea', 'sclerotic', 'facies', then asked him in a paternal tone – 'My friend, have you long had this terrible infirmity? Instead of getting drunk at the wine-shop, you'd do better to diet yourself.'

He advised him to take good wine, good beer, and good joints. The blind man went on with his song; he seemed, moreover, almost idiotic. At last Monsieur Homais opened his purse – 'Now there's a sou; give me back two liards, and don't forget my advice: you'll be the better for it.'

Hivert openly cast some doubt on its efficacy. But the druggist said that he would cure him himself with an antiphlogistic ointment of his own composition, and he gave his address: 'Monsieur Homais, near the market, pretty well known.'

'Now,' said Hivert, 'for all this trouble you'll give us your performance.'

The blind man sank down on his haunches, with his head thrown back, whilst he rolled his greenish eyes,

lolled out his tongue, and rubbed his stomach with both hands, as he uttered a kind of hollow yell like a famished dog. Emma, filled with disgust, threw him over her shoulder a five franc piece. It was her whole fortune. It struck her as superb to fling it away like this.

The coach had gone on again when suddenly Monsieur Homais leant out through the window, crying – 'No farinaceous or milk food, wear wool next the skin, and expose the diseased parts to the smoke of juniper berries.'

The sight of the well-known objects that defiled before her eyes gradually diverted Emma from her present trouble. An intolerable fatigue overwhelmed her, and she reached home stupefied, discouraged, almost asleep.

'Come what may come!' she said to herself. 'And then, who knows? Why, at any moment could not some extraordinary event occur? Lheureux might even die!'

At nine o'clock in the morning she was awakened by the sound of voices in the Place. There was a crowd round the market reading a large bill fixed to one of the posts, and she saw Justin, who was climbing on to a stone and tearing down the bill. But at this moment the rural guard seized him by the collar. Monsieur Homais came out of his shop, and Mère Lefrançois, in the midst of the crowd, seemed to be perorating.

'Madame! madame!' cried Félicité, running in, 'it's abominable!'

And the poor girl, deeply moved, handed her a yellow paper that she had just torn off the door. Emma read with a glance that all her furniture was for sale.

Then they looked at one another silently. The servant and mistress had no secret one from the other.

At last Félicité sighed - 'If I were you, madame, I should go to Monsieur Guillaumin.'

'Do you think - '

And this question meant to say - 'You who know the house through the servant, has the master spoken sometimes of me?'

'Yes, you'd do well to go there.'

She dressed, put on her black gown, and her hood with jet beads, and that she might not be seen (there was still a crowd on the Place), she took the path by the river, outside the village.

She reached the notary's gate quite breathless. The sky was sombre, and a little snow was falling. At the sound of the bell, Theodore, in a red waistcoat, appeared on the steps; he came to open the door almost familiarly, as to an acquaintance, and showed her into the dining-room.

A large porcelain stove crackled beneath a cactus that filled up the niche in the wall, and in black wood frames against the oak-stained paper hung Steuben's 'Esmeralda' and Schopin's 'Potiphar'. The ready-laid table, the two silver chafing-dishes, the crystal doorknobs, the parquet and the furniture, all shone with a scrupulous, English cleanliness; the windows were ornamented at each corner with stained glass.

'Now this,' thought Emma, 'is the dining-room I ought to have.'

The notary came in pressing his palm-leaf dressinggown to his breast with his left arm, while with the other hand he raised and quickly put on again his brown velvet cap, pretentiously cocked on the right side, whence looked out the ends of three fair curls drawn from the back of the head, following the line of his bald skull.

After he had offered her a seat he sat down to breakfast, apologising profusely for his rudeness.

'I have come,' she said, 'to beg you, sir -'

'What, madame? I am listening.'

And she began explaining her position to him. Monsieur Guillaumin knew it, being secretly associated with the linen-draper, from whom he always got capital for the loans on mortgages that he was asked to make.

So he knew (and better than she herself) the long story of the bills, small at first, bearing different names as endorsers, made out at long dates, and constantly renewed up to the day, when, gathering together all the protested bills, the shopkeeper had bidden his friend Vinçart take in his own name all the necessary proceedings, not wishing to pass for a tiger with his fellow-citizens.

She mingled her story with recriminations against Lheureux, to which the notary replied from time to time with some insignificant word. Eating his cutlet and drinking his tea, he buried his chin in his sky-blue cravat, into which were thrust two diamond pins, held together by a small gold chain; and he smiled a singular smile, in a sugary, ambiguous fashion. But noticing that her feet were damp, he said – 'Do get closer to the stove; put your feet up against the porcelain.'

She was afraid of dirtying it. The notary replied in a gallant tone – 'Beautiful things spoil nothing.'

Then she tried to move him, and, growing moved herself, she began telling him about the poorness of her home, her worries, her wants. He could understand that; an elegant woman! and, without leaving off eating, he had turned completely round towards her,

so that his knee brushed against her boot, the sole of which curled as it smoked against the stove.

But when she asked for a thousand écus, he closed his lips, and declared he was very sorry he had not had the management of her fortune before, for there were hundreds of ways very convenient, even for a lady, of turning her money to account. They might, either in the turf-peats of Grumesnil or building-ground at Havre, almost without risk, have ventured on some excellent speculations; and he let her consume herself with rage at the thought of the fabulous sums that she would certainly have made.

'How was it,' he went on, 'that you didn't come to me?'

'I hardly know,' she said.

'Why, hey? Did I frighten you so much? It is I on the contrary, who ought to complain. We hardly know one another; yet I am very devoted to you. You do not doubt that, I hope?'

He held out his hand, took hers, covered it with a greedy kiss, then held it on his knee; and he played delicately with her fingers murmuring a thousand blandishments. His insipid voice murmured like a running brook; a light shone in his eyes through the glimmering of his spectacles, and his hand was advancing up Emma's sleeve to press her arm. She felt against her cheek his panting breath. This man oppressed her horribly.

She sprang up and said to him – 'Sir, I am waiting.' 'For what?' said the notary, who suddenly became very pale.

'This money.'

But - 'Then, yielding to the outburst of too powerful a desire, 'Well, yes!'

He dragged himself towards her on his knees, regardless of his dressing-gown.

'For pity's sake, stay. I love you!'

He seized her by her waist. Madame Bovary's face flushed purple. She recoiled with a terrible look, crying – 'You are taking a shameless advantage of my distress, sir! I am to be pitied – not to be sold.'

And she went out.

The notary remained quite stupefied, his eyes fixed on his fine embroidered slippers. They were a love gift, and the sight of them at last consoled him. Besides, he reflected that such an adventure might have carried him too far.

'What a wretch! what a scoundrel! what an infamy!' she said to herself, as she fled with nervous steps beneath the aspens of the path. The disappointment of her failure increased the indignation of her outraged modesty; it seemed to her that Providence pursued her implacably, and, strengthening herself in her pride, she had never felt so much esteem for herself nor so much contempt for others. A spirit of warfare transformed her. She would have liked to strike all men, to spit in their faces, to crush them, and she walked rapidly straight on, pale, quivering, maddened, searching the empty horizon with tear-dimmed eyes, and as it were rejoicing in the hate that was choking her.

When she saw her house a numbness came over her. She could not go on; and yet she must. Besides, whither could she flee?

Félicité was waiting for her at the door. 'Well?'

'No!' said Emma.

And for a quarter of an hour the two of them went over the various persons in Yonville who might perhaps be inclined to help her. But each time that Félicité

named someone Emma replied - 'Impossible! they will not!'

'And the master'll soon be in?'

'I know that well enough. Leave me alone.'

She had tried everything; there was nothing more to be done now; and when Charles came in she would have to say to him – 'Go away! This carpet on which you are walking is no longer ours. In your own house you do not possess a chair, a pin, a straw, and it is I, poor man, who have ruined you.'

Then there would be a great sob; next he would weep abundantly, and at last, the surprise past, he would forgive her.

'Yes,' she murmured, grinding her teeth, 'he will forgive me, he who would give me a million if I would forgive him for having known me! Never! never!'

This thought of Bovary's superiority to her exasperated her. Then, whether she confessed or did not confess, presently, immediately, tomorrow he would know the catastrophe all the same; so she must wait for this horrible scene, and bear the weight of his magnanimity. The desire to return to Lhcureux's seized her – what would be the use? To write to her father – it was too late; and perhaps she began to repent now that she had not yielded to that other, when she heard the trot of a horse in the alley. It was he; he was opening the gate; he was whiter than the plaster wall. Rushing to the stairs, she ran out quickly to the square; and the wife of the mayor, who was talking to Lestiboudois in front of the church, saw her go into the tax-collector's.

She hurried off to tell Madame Caron, and the two ladies went up to the attic, where, hidden by some linen spread across props, they stationed themselves comfortably for overlooking the whole of Binet's room.

He was alone in his garret, busy imitating in wood one of those indescribable bits of ivory, composed of crescents, of spheres hollowed out one within the other, the whole as straight as an obelisk, and of no use whatever; and he was beginning on the last piece – he was nearing his goal. In the twilight of the workshop the white dust was flying from his tools like a shower of sparks under the hoofs of a galloping horse; the two wheels turned and droned; Binet smiled, his chin lowered, his nostrils distended, and, in a word, seemed lost in one of those complete happinesses that, no doubt, belong only to commonplace occupations, which amuse the mind with facile difficulties, and satisfy by a realisation of that beyond which such minds have not a dream.

'Ah! there she is!' exclaimed Madame Tuvache.

But it was impossible because of the lathe to hear what she was saying.

At last these ladies thought they made out the word 'francs,' and Madame Tuvache whispered in a low voice – 'She is begging him to give her time to pay her taxes.'

'Apparently!' replied the other.

They saw her walking up and down, examining the napkin-rings, the candlesticks, the bannister rails against the walls, while Binet stroked his beard with satisfaction.

'Do you think she wants to order something of him?' said Madame Tuvache.

'Why, he doesn't sell anything,' objected her neighbour.

The tax-collector seemed to be listening with

wide-open eyes, as if he did not understand. She went on in a tender, suppliant manner. She came nearer to him, her breast heaving; they no longer spoke.

'Is she making him advances?' said Madame Tuvache.

Binet was scarlet to his very ears. She took hold of his hands.

'Oh, it's too much!'

And no doubt she was suggesting something abominable to him; for the tax-collector – yet he was brave, had fought at Bautzen and at Lutzen, had been through the French campaign, and had even been recommended for the cross – suddenly, as at the sight of a serpent, recoiled as far as he could from her, crying – 'Madame! what do you mean?'

'Women like that ought to be whipped,' said Madame Tuvache.

'But where is she?' continued Madame Caron, for she had disappeared whilst they spoke; then catching sight of her going up the Grande Rue, and turning to the right as if making for the cemetery, they were lost in conjectures.

'Mère Rollet,' she said on reaching the nurse's, 'I am choking; unlace me!' She fell on the bed sobbing. Mére Rollet covered her with a petticoat and remained standing beside her. Then, as she did not answer, the good woman withdrew, took her wheel and began spinning her flax.

'Oh, leave off!' she murmured, fancying she heard Binet's lathe.

'What's bothering her?' said the nurse to herself. 'Why has she come here?'

She had rushed thither, impelled by a kind of horror that drove her from her home.

Lying motionless on her back, with staring eyes, she saw things but vaguely, although she tried to with inane persistence. She stared at the scales on the walls, at two brands smoking end to end, at a long spider crawling over her head in the hollow of the roof tree. At last she began to collect her thoughts. She remembered – one day – Léon – Oh! how long ago that was – the sun was shining on the river, and the clematis were perfuming the air. Then, carried away as by a rushing torrent, she soon began to recall the day before.

'What time is it?' she asked.

Mère Rollet went out, raised the fingers of her right hand to that side of the sky that was brightest, and came back slowly, saying – 'Nearly three.'

'Ah! thanks, thanks!'

For he would come; he would have found some money. But he would, perhaps, go down yonder, not guessing she was there, and she told the nurse to run to her house to fetch him.

'Be quick!'

'But, my dear lady, I'm going, I'm going!'

She wondered now that she had not thought of him from the first. Yesterday he had given his word; he would not break it. And already she saw herself at Lheureux's spreading out her three bank-notes on his bureau. Then she would have to invent some story to explain matters to Bovary. What should it be?

The nurse, however, was a long while gone. But, as there was no clock in the cot, Emma feared she was perhaps exaggerating the length of time. She began walking round the garden, step by step; she went into the path by the hedge, and returned quickly, hoping that the woman would have come back by another road. At last, weary of waiting, assailed by fears that

she thrust from her, no longer conscious whether she had been here a century or a moment, she sat down in a corner, closed her eyes, and stopped her ears. The gate grated; she sprang up. Before she had spoken Mère Rollet said to her – 'There is no one at your house!'

'What?'

'Oh, no one! And the doctor is crying. He is calling for you; they're looking for you.'

Emma answered nothing. She gasped as she turned her eyes about her, while the peasant woman, frightened at her face, drew back instinctively, thinking her mad. Suddenly she struck her brow and uttered a cry; for the thought of Rodolphe, like a flash of lightning in a dark night, had passed into her soul. He was so good, so delicate, so generous! And besides, should he hesitate to do her this service, she would know well enough how to constrain him to it by re-waking, in a single moment, their lost love. So she set out towards La Huchette, blind to the fact that she was hastening to offer herself to the very thing which had so lately infuriated her, quite unconscious of her prostitution.

She wondered as she walked, 'What am I going to say? How shall I begin?' And as she went on she began to recognise the thickets, the trees, the sea-rushes on the hill, the château yonder. All the sensations of her first tenderness came back to her, and her poor aching heart opened out amorously. A warm wind blew in her face; the melting snow dripped from the buds to the grass.

She entered, as she used to, through the small parkgate. She reached the avenue bordered by its double row of dense lime trees. They were swaying their long whispering branches to and fro. The dogs in their kennels all barked, and the noise of their voices resounded, but brought out no one.

She went up the large straight staircase with wooden balusters that led to the corridor paved with dusty flags, on to which a row of doors opened, as in a monastery or an inn. His was at the top, right at the end, on the left. When she placed her fingers on the latch her strength suddenly deserted her. She was afraid, almost wished he would not be there, though this was her only hope, her last chance of salvation. She collected her thoughts for one moment, and, strengthening herself by the feeling of present necessity, went in.

He was in front of the fire, both feet on the mantelpiece, smoking a pipe.

'What! is that you?' he said, rising hurriedly.

'Yes, it is I, Rodolphe. I should like to ask your advice.' And, despite all her efforts, it was impossible for her to open her lips.

'You have not changed; you are as charming as ever!'

'Oh,' she replied bitterly, 'they are poor charms since you disdained them.'

Then he began a long explanation of his conduct, excusing himself in vague terms, in default of being able to invent better.

She yielded to his words, still more to his voice and the sight of him, so that she pretended to believe, or perhaps believed, in the pretext he gave for their rupture; this was a secret on which depended the honour, the very life of a third person.

'No matter!' she said, looking at him sadly. 'I have suffered much.'

He replied philosophically 'Such is life!'

'Has life,' Emma went on, 'been good to you at least, since our separation?'

'Oh, neither good nor bad.'

'Perhaps it would have been better never to have parted.'

'Yes, perhaps.'

'You think so?' she said, drawing nearer, and she sighed. 'Oh, Rodolphe! if you but knew! I loved you so!'

It was then that she took his hand, and they remained some time, their fingers intertwined, like that first day at the Show. With a gesture of pride he struggled against this emotion. But sinking upon his breast she said to him – 'How did you think I could live without you? One cannot lose the habit of happiness. I was desolate. I thought I should die. I will tell you about all that and you will see. And you – you fled from me!'

For all the three years he had carefully avoided her in consequence of that natural cowardice that characterises the stronger sex. Emma went on with roguish little nods more coaxing than an amorous kitten —

'You love others, confess it! Oh, I understand them, dear! I excuse them. You probably seduced them as you seduced me. You are indeed a man; you have everything to make one love you. But we'll begin again, won't we? We will love one another. See! I am laughing; I am happy! Oh, speak!'

And she was charming to see, with her eyes, in which trembled a tear, like the rain of a storm in a blue corolla

He had drawn her on his knees, and the back of his hand was caressing her smooth hair, where one last ray of the sun in the twilight was mirrored like a golden arrow. She lowered her brow; at last he kissed her gently on the eyelids with the tips of his lips.

'Why, you have been crying! What for?'

She burst into tears. Rodolphe thought this was an outburst of her love. As she did not speak, he took this silence for a last remnant of resistance, and then he cried out – 'Oh, forgive me! You are the only one who pleases me. I was imbecile and cruel. I love you. I will love you always. What is it? Tell me!' He was kneeling by her.

'Well, I am ruined, Rodolphe! You must lend me three thousand francs.'

'But – but – ' said he, getting up slowly, while his face assumed a grave expression.

'You know,' she went on quickly, 'that my husband had placed his whole fortune at a notary's. He ran away. So we borrowed; the patients don't pay us. Moreover, the settling of the estate is not finished yet; we shall have the money later on. But today we are to be sold up for want of three thousand francs. It is to be at once, this very moment, and, counting upon your friendship. I have come to you.'

'Ah!' thought Rodolphe, turning very pale, 'that's what she came for.' At last he said with a calm air – 'Dear madame, I have not got them.'

He did not lie. If he had had them, he would, no doubt, have given them, although it is generally disagreeable to do such fine things: a demand for money being, of all the winds that blow upon love, the coldest and most destructive.

First she looked at him for some moments.

'You have not got them!' she repeated several times. 'You have not got them! I ought to have spared myself this last shame. You never loved me. You are no better than the others.'

She was betraying, ruining herself.

Rodolphe interrupted her, declaring he was 'hard up' himself.

'Ah! I pity you,' said Emma. 'Yes - very much.

And fixing her eyes upon an embossed carbine, that shone against its panoply, 'But when one is so poor one doesn't have silver on the butt of one's gun. One doesn't buy a clock inlaid with tortoiseshell,' she went on, pointing to a buhl timepiece, 'nor silver-gilt whistles for one's whips,' and she touched them, 'nor charms for one's watch. Oh, he wants for nothing! even to a liqueur-stand in his room! For you love yourself; you live well. You have a château, farms, woods; you go hunting; you travel to Paris. Why, if it were but that,' she cried, taking up two studs from the mantelpiece, 'Why! one could get money for the least of these trifles! Oh, I don't want them; keep them!'

And she threw the two links away, and their gold chain broke as it struck the wall.

'But I! I would have given you everything. I would

have sold all, worked for you with my hands, I would have begged on the highroads for a smile, for a look, to hear you say "Thanks!" And you sit there quietly in your armchair, as if you had not made me suffer enough already! But for you, and you know it, I might have lived happily. What made you do it? Was it a bet? Yet you loved me - you said so. And but a moment since - Ah! it would have been better to have driven me away. My hands are hot with your kisses, and there is the spot on the carpet where at my knees you swore an eternity of love! You made me believe you; for two years you held me in the most magnificent, the sweetest dream! Eh! Our plans for the journey, do you remember? Oh, your letter! your letter? it tore my heart! And then when I come back to him - to him, rich, happy, free - to implore the help the first stranger would give, a suppliant, and bringing back to him all my tenderness, he repulses me because it would cost him three thousand francs!'

'I haven't got them,' replied Rodolphe, with that perfect calm with which resigned rage covers itself as with a shield.

She went out. The walls trembled, the ceiling was crushing her, and she passed back through the long alley, stumbling against the heaps of dead leaves scattered by the wind. At last she reached the ha-ha hedge in front of the gate; she broke her nails against the lock in her haste to open it. Then a hundred steps farther on, breathless, almost falling, she stopped. And now turning round, she once more saw the impassive château, with the park, the gardens, the three courts, and all the windows of the façade.

She remained lost in stupor, and having no more consciousness of herself than through the beating of her arteries, that she seemed to hear bursting forth like a deafening music filling all the fields. The earth beneath her feet was more yielding than the sea, and the furrows seemed to her immense brown waves breaking into foam. Everything in her head, of memories, ideas, went off at once like a thousand pieces of fireworks. She saw her father, Lheureux's closet, their room at home, another landscape. Madness was coming upon her; she grew afraid, and managed to recover herself, in a confused way, it is true, for she did not in the least remember the cause of the terrible condition she was in, that is to say, the question of money. She suffered only in her love, and felt her soul passing from her in this memory, as wounded men, dying, feel their life ebb from their bleeding wounds.

Night was falling, crows were wheeling in the sky.

Suddenly it seemed as if fiery spheres were exploding in the air like fulminating balls when they strike, and were whirling, whirling, to melt at last upon the snow between the branches of the trees. In the midst of each of them appeared the face of Rodolphe. They multiplied and drew near her, penetrating her. Everything vanished; she recognised the lights of the houses shining through the mist.

Now her situation, like an abyss, rose up before her. She was panting as if her heart would burst. Then in an ecstasy of heroism, that made her almost joyous, she ran down the hill, crossed the cow-plank, the footpath, the alley, the market, and reached the chemist's shop. She was about to enter, but at the sound of the bell someone might come, and slipping in by the gate, holding her breath, feeling her way along the walls, she went as far as the door of the

kitchen, where a candle stuck on the stove was burning. Justin in his shirtsleeves was carrying out a dish.

'Ah! they are dining; I will wait.'

He returned; she tapped at the window. He went out.

'The key! the one for upstairs where he keeps the -' 'What?'

And he looked at her, astonished at the pallor of her face, that stood out white against the black background of the night. She seemed to him extraordinarily beautiful and majestic as a phantom. Without understanding what she wanted, he had the presentiment of something terrible.

But she went on quickly in a low voice, in a sweet, melting voice, 'I want it; give me it.'

The partition wall was thin and they could hear the clatter of forks on the plates in the dining-room.

She claimed that she wanted to kill rats which kept her from sleeping.

'I must tell master.'

'No, stop!' Then, with an indifferent air, 'It's not worth while; I'll tell him presently. Come, light me upstairs.'

She entered the corridor into which the laboratory door opened. Against the wall was a key labelled *Capharnaüm*.

'Justin!' called the druggist impatiently.

'Let us go up.'

And he followed her. The key turned in the lock, and she went straight to the third shelf, so well did her memory guide her, seized the jar, tore out the cork, plunged in her hand, and withdrawing it full of a white powder, she began eating it.

'Stop!' he cried, rushing at her.

'Hush! someone will come.'

He was in despair, he wanted to call out.

'Not a word, or all the blame will fall on your master.'

Then she went home, suddenly calmed, and with something of the serenity of one who has performed a duty.

When Charles, distracted by the news of the distraint, returned home, Emma had just gone out. He cried aloud, wept, fainted, but she did not return. Where could she be? He sent Félicité to Homais, to Monsieur Tuvache, to Lheureux, to the Lion d'Or, everywhere, and in the intervals of his agony he saw his reputation destroyed, their fortune lost, Berthe's future ruined. By what? – Not a word! He waited till six in the evening. At last, unable to bear it any longer, and fancying she had gone to Rouen, he set out along the highroad, walked a mile, met no one, again waited, and returned home. She had come back.

'What was the matter? Why? Explain to me.'

She sat down at her writing-table and wrote a letter, which she sealed slowly, adding the date and the hour. Then she said in a solemn tone: 'You are to read it tomorrow; till then, I pray you, do not ask me a single question. No, not one!'

'But - '

'Oh, leave me!'

She lay down full length on her bed. A bitter taste that she felt in her mouth awakened her. She saw Charles, and again closed her eyes.

She was studying herself curiously, to see if she were not suffering. But no! nothing as yet. She heard the

ticking of the clock, the crackling of the fire, and Charles breathing as he stood upright by her bed.

'Ah! it is but a little thing, death!' she thought. 'I shall fall asleep and all will be over.'

She drank a mouthful of water and turned to the wall. The frightful taste of ink continued.

'I am thirsty; oh, so thirsty,' she sighed.

'What is it?' said Charles, who was handing her a glass.

'It is nothing! Open the window; I am choking.'

She was seized with a sickness so sudden that she had hardly time to draw out her handkerchief from under the pillow.

'Take it away,' she said quickly; 'throw it away.'

He spoke to her; she did not answer. She lay motionless, afraid that the slightest movement might make her vomit. But she felt an icy cold creeping from her feet to her heart.

'Ah! it is beginning,' she murmured.

'What did you say?'

She turned her head from side to side with a gentle movement full of agony, while constantly opening her mouth as if something very heavy were weighing upon her tongue. At eight o'clock the vomiting began again.

Charles noticed that at the bottom of the basin there was a sort of white sediment sticking to the sides of the porcelain.

'This is extraordinary – very singular,' he repeated. But she said in a firm voice, 'No, you are mistaken.'

Then gently, and almost as caressing her, he passed his hand over her stomach. She uttered a sharp cry. He fell back terror-stricken.

Then she began to groan, faintly at first. Her shoulders were shaken by a strong shuddering, and she was growing paler than the sheets in which her clenched fingers buried themselves. Her unequal pulse was now almost imperceptible.

Drops of sweat oozed from her bluish face, that seemed as if rigid in the exhalations of a metallic vapour. Her teeth chattered, her dilated eyes looked vaguely about her, and to all questions she replied only with a shake of the head; she even smiled once or twice. Gradually, her moaning grew louder; a hollow shriek burst from her; she pretended she was better and that she would get up presently. But she was seized with convulsions and cried out – 'Oh, God! It's horrible!'

He threw himself on his knees by her bed.

'What have you been eating? Tell me! Answer, for heaven's sake!'

And he looked at her with such tenderness in his eyes as she had never seen.

'Well, there – there!' she said in a faint voice. He flew to the writing-table, tore open the seal, and read aloud: 'Accuse no one.' He stopped, passed his hands across his eyes, and read it over again.

'What! help - help!'

He could only keep repeating the word: 'Poisoned! poisoned!' Félicité ran to Homais, who proclaimed it in the marketplace; Madame Lefrançois heard it at the Lion d'Or; some got up to go and tell their neighbours, and all night the village was on the alert.

Distraught, faltering, reeling, Charles wandered about the room. He knocked against the furniture, tore his hair, and the chemist had never believed that there could be so terrible a sight.

He went home to write to Monsieur Canivet and to Doctor Larivière. He lost his head, and made more than fifteen rough copies. Hippolyte went to Neufchâtel, and Justin so spurred Bovary's horse that he left it foundered and three parts dead by the hill at Bois-Guillaume.

Charles tried to look up his medical dictionary, but could not read it; the lines were dancing.

'Be calm,' said the druggist; 'we have only to administer a powerful antidote. What is the poison?'

Charles showed him the letter. It was arsenic.

'Very well,' said Homais, 'we must make an analysis.' For he knew that in cases of poisoning an analysis must be made; and the other, who did not understand, answered – 'Oh, do anything! save her!'

Then going back to her, he sank upon the carpet, and lay there with his head leaning against the edge of her bed; sobbing.

'Don't cry,' she said to him. 'Soon I shall not trouble you any more.'

'Why was it? Who drove you to it?'

She replied. 'It had to be, my dear!'

'Weren't you happy? Is it my fault? I did all I could!'

'Yes, that is true - you are good - you.'

And she pressed her hand slowly over his hair. The sweetness of this sensation deepened his sadness; he felt his whole being dissolving in despair at the thought that he must lose her, just when she was confessing more love for him than ever. And he could think of nothing; he did not know, he did not dare; the urgent need for some immediate resolution gave the finishing stroke to the turmoil of his mind.

So she had done, she thought, with all the treachery, and meanness, and numberless desires that had tortured her. She hated no one now; a twilight dimness was settling upon her thoughts, and, of all

earthly noises, Emma heard none but the intermittent lamentations of this poor heart, sweet and indistinct like the echo of a symphony dying away.

'Bring me the child,' she said, raising herself on her

elbow.

'You are not worse, are you?' asked Charles.

'No, no!'

Solemn and still half-asleep, the child was carried in on the servant's arm in her long white nightgown, her bare feet peeping out. She looked wondering at the disordered room, and screwed up her eyes, dazzled by the candles burning on the table. They reminded her, no doubt, of the morning of New Year's day and Mid-Lent, when thus awakened early by candlelight she came to her mother's bed to fetch her presents, for she began saying – 'But where is it, mamma?' And as everybody was silent, 'But I can't see my little stocking.'

Félicité held her over the bed while she still kept looking towards the mantelpiece.

'Has nurse taken it?' she asked.

And at this name, that carried her back to the memory of her adulteries and her calamities, Madame Bovary turned away her head, as at the loathing of another bitterer poison that rose to her mouth. But Berthe remained perched on the bed.

'Oh, how big your eyes are, mamma! How pale you

are! how hot you are!'

Her mother looked at her. 'I am frightened!' cried the child, recoiling.

Emma took her hand to kiss it; the child struggled. 'That will do. Take her away,' cried Charles, who

was sobbing in the alcove.

Then the symptoms ceased for a moment; she seemed less agitated; and at every insignificant word, at every respiration a little more easy, he regained hope. At last, when Canivet came in, he threw himself into his arms.

'Ah! it is you. Thanks! You are good! But she is better. See! look at her.'

His colleague was by no means of this opinion, and, as he said of himself, 'never beating about the bush,' he prescribed an emetic in order to empty the stomach completely.

Before long she was vomiting blood. Her lips became drawn. Her limbs were convulsed, her whole body covered with brown spots, and her pulse slipped beneath the fingers like a stretched thread, like a harpstring nearly breaking.

Then she began to scream horribly. She cursed the poison, railed at it, and implored it to be quick, and her stiffened arms thrust away everything that Charles, in a worse agony than herself, tried to make her drink. He stood up, weeping, his handkerchief to his lips, with a rattling sound in his throat, and choked by sobs that shook his whole body. Félicité was running hither and thither in the room. Homais stood motionless, giving vent to great sighs; and Monsieur Canivet, still retaining his self-command, nevertheless began to feel uneasy.

'The devil! yet she has been purged, and from the moment that the cause ceases -'

'The effect must cease,' said Homais, 'that is evident.'

'Oh, save her!' cried Bovary.

And, without listening to the chemist, who was still venturing the hypothesis, that it was 'perhaps a salutary paroxysm,' Canivet was about to administer some theriac, when they heard the cracking of a whip;

all the windows rattled, and a post-chaise drawn by three horses abreast, up to their ears in mud, drove at a gallop round the corner of the market. It was Doctor Larivière.

The apparition of a god would not have caused more commotion. Bovary raised his hands; Canivet stopped short; and Homais pulled off his skullcap long before the doctor had come in.

He belonged to that great school of surgery begotten of Bichat, to that generation, now extinct, of philosophical practitioners, who, loving their art with a fanatical love, exercised it with enthusiasm and wisdom. Everyone in his hospital trembled when he was angry; and his students so revered him that they tried, as soon as they were themselves in practice, to imitate him as much as possible. So that in all the towns about they were found wearing his long wadded merino overcoat and black frock-coat, whose buttoned cuffs slightly covered his brawny hands very beautiful hands, and that never knew gloves, as though to be more ready to plunge into suffering. Disdainful of honours, of titles, and of academies, like one of the old Knight-Hospitallers, generous, fatherly to the poor, and practising virtue without believing in it, he would almost have passed for a saint if the keenness of his intellect had not caused him to be feared as a demon. His glance, more penetrating than his bistouries, looked straight into your soul, and dissected every lie behind all assertions and all reticences. And thus he went along, full of that debonair majesty that is given by the consciousness of great talent, of fortune, and of forty years of a laborious and irreproachable life.

He frowned as soon as he had passed the door when

he saw the cadaverous face of Emma stretched out on her back with gaping mouth. Then, while apparently listening to Canivet, he rubbed his fingers up and down beneath his nostrils, and repeated – 'Good! good!'

But he made a slow gesture with his shoulders. Bovary watched him; they looked at one another; and this man, accustomed as he was to the sight of pain, could not keep back a tear that fell on his shirt-frill.

He tried to take Canivet into the next room. Charles followed him.

'She is very ill, isn't she? If we put on sinapisms? Anything! Oh, think of something, you who have saved so many!'

Charles caught him in both his arms, and gazed at him wildly, imploringly, half-fainting against his breast.

'Come, my poor fellow, courage! There is nothing more to be done.'

And Doctor Larivière turned away.

'You are going?'

'I will come back.'

He went out only to give an order to the coachman, with Monsieur Canivet, who did not care either to have Emma die under his hands.

The chemist rejoined them on the Place. He could not by temperament keep away from celebrities, so he begged Monsieur Larivière to do him the signal honour of accepting some breakfast.

He sent quickly to the Lion d'Or for some pigeons; to the butcher's for all the cutlets that were to be had; to Tuvache for cream; and to Lestiboudois for eggs; and the druggist himself aided in the preparations, while Madame Homais was saying as she pulled

together the strings of her jacket – 'You must excuse us, sir, for in this poor place, when one hasn't been told the night before – '

'Wine glasses!' whispered Homais.

'If only we were in town, we could fall back upon stuffed trotters.'

'Be quiet! Sit down, doctor!'

He thought fit, after the first few mouthfuls, to give some details as to the catastrophe.

'We first had a feeling of siccity in the pharynx, then intolerable pains at the epigastrium, super-purgation, coma.'

'But how did she poison herself?'

'I don't know, doctor, and I don't even know where she can have procured the arsenious acid.'

Justin, who was just bringing in a pile of plates, began to tremble.

'What's the matter?' said the chemist.

At this question the young man dropped the whole lot on the ground with a crash.

'Imbecile!' cried Homais, 'you awkward lout! blockhead! you confounded ass!'

But suddenly controlling himself – 'I wished, doctor, to make an analysis, and *primo* I delicately introduced a tube – '

'You would have done better,' said the physician, 'to push your fingers down her throat.'

His colleague was silent, having just before privately received a severe lecture about his emetic, so that this good Canivet, so arrogant and so verbose at the time of the club-foot, was today very modest. He smiled without ceasing in an approving manner.

Homais dilated in amphitryonic pride, and the affecting thought of Bovary vaguely contributed to his

pleasure by a kind of egotistic reflex upon himself. Then the presence of the doctor transported him. He displayed his erudition, cited pell-mell cantharides, upas, the manchineel, vipers.

'I have even read that various persons have found themselves under toxicological symptoms, and, as it were, thunderstricken by black-pudding that had been subjected to too vehement a fumigation. At least, this was stated in a very fine report drawn up by one of our pharmaceutical chiefs, one of our masters, the illustrious Cadet de Gassicourt!'

Madame Homais reappeared, carrying one of those shaky machines that are heated with spirits of wine; for Homais liked to make his coffee at table, having, moreover, torrefied it, pulverised it, and mixed it himself.

'Saccharum, doctor?' said he, offering the sugar.

Then he had all his children brought down, anxious to have the physician's opinion on their constitutions.

At last Monsieur Larivière was about to leave, when Madame Homais asked for a consultation about her husband. He was making his blood too thick by going to sleep every evening after dinner.

'Oh, it isn't his blood that's too thick,' said the physician.

And, smiling a little at his unnoticed joke, the doctor opened the door. But the chemist's shop was full of people; he had the greatest difficulty in getting rid of Monsieur Tuvache, who feared his spouse would get inflammation of the lungs, because she was in the habit of spitting on the ashes; then of Monsieur Binet, who sometimes experienced sudden attacks of great hunger; and of Madame Caron, who suffered from tinglings; of Lheureux, who had vertigo; of

Lestiboudois, who had rheumatism; and of Madame Lefrançois, who had heartburn. At last the three horses started; and it was the general opinion that he had not shown himself at all obliging.

Public attention was distracted by the appearance of Monsieur Bournisien, who was going across the market with the holy oil.

Homais, as was due to his principles, compared priests to ravens attracted by the odour of death. The sight of an ecclesiastic was personally disagreeable to him, for the cassock made him think of the shroud, and he detested the one from some fear of the other.

Nevertheless, not shrinking from what he called his mission, he returned to Bovary's in company with Canivet whom Monsieur Larivière, before leaving, had strongly urged to make this visit; and he would, but for his wife's objections, have taken his two sons with him, in order to accustom them to great occasions; that this might be a lesson, an example, a solemn picture, that should remain in their heads later on.

The room when they went in was full of mournful solemnity. On the work-table, covered over with a white cloth, there were five or six small balls of cotton in a silver dish, near a large crucifix between two lighted candles.

Emma, her chin sunken upon her breast, had her eyes inordinately wide open, and her poor hands wandered over the sheets with that hideous and soft movement of the dying, that seems as if they wanted already to cover themselves with the shroud. Pale as a statue and with eyes red as fire, Charles, weeping, stood facing her at the foot of the bed, while the priest, bending one knee, was muttering in a low voice.

Slowly she turned her face, and seemed filled with joy on seeing suddenly the violet stole, no doubt finding again, in the midst of a temporary lull in her pain, the lost voluptuousness of her first mystical transports, with the visions of eternal beatitude that were beginning.

The priest rose to take the crucifix; then she stretched forward her neck as one who is athirst, and gluing her lips to the body of the Man-God, she pressed upon it with all her expiring strength the fullest kiss of love that she had ever given. Then he recited the Misereatur and the Indulgentiam, dipped his right thumb in the oil, and began to give extreme unction. First, upon the eyes, that had so coveted all worldly pomp; then upon the nostrils, that had been greedy of the warm breeze and amorous odours; then upon the mouth, that had uttered lies, that had curled with pride and cried out in lewdness; then upon the hands that had delighted in sensual touches; and finally upon the soles of the feet, once so swift when she was running to satisfy her desires, and which now would walk no more.

The curé wiped his fingers, cast the oil-drenched shred of cotton into the fire, and sat down by the dying woman, to tell her that she must now mingle her sufferings with those of Jesus Christ and abandon herself to the divine mercy.

Finishing his exhortations, he tried to place in her hand a blessed candle, symbol of the celestial glory wherewith she was soon to be enveloped. Emma was too weak; she could not close her fingers, and but for Monsieur Bournisien, the taper would have fallen to the ground.

However, she was not quite so pale, and her face

had an expression of serenity, as if the sacrament had cured her.

The priest did not fail to point this out; he even explained to Bovary that the Lord sometimes prolonged the life of persons when he thought it meet for their salvation; and Charles remembered the day when, so near death, she had received the communion. Perhaps there was no need to despair, he thought.

In fact, she looked around her slowly, as one awakening from a dream; then in a distinct voice she asked for her looking-glass, and remained some time bending over it, until the big tears fell from her eyes. Then she turned away her head with a sigh and fell back upon the pillows.

Her chest soon began panting rapidly; the whole of her tongue protruded from her mouth; her eyes, as they rolled, grew paler, like the two globes of a lamp that is going out, so that one might have thought her already dead but for the fearful labouring of her ribs, shaken by violent breathing, as if the soul were struggling to free itself. Félicité knelt down before the crucifix, and the druggist himself slightly bent his knees, while Monsieur Canivet looked out vaguely at the Place. Bournisien had again begun to pray, his face bowed against the edge of the bed, his long black cassock trailing behind him in the room. Charles was on the other side, on his knees, his arms outstretched towards Emma. He had taken her hands and pressed them, shuddering at every beat of her heart, as at the shaking of a falling ruin. As the death-rattle became stronger the priest prayed faster; his prayers mingled with the stifled sobs of Bovary, and sometimes everything seemed lost in the muffled murmur of these

Latin syllables tolling like a passing-bell.

Suddenly on the pavement was heard the noise of heavy clogs, and the clatter of a stick; and a voice rose – a raucous voice – singing –

'Maids in the warmth of a summer day Dream of love and of love alway.'

Emma raised herself like a galvanised corpse, her hair undone, her eyes fixed, staring.

'Where the sickle blades have been, Nanette, gathering ears of corn, Passes, bending down, my queen, To the earth where they were born.'

'The blind man!' she cried.

And Emma began to laugh, an atrocious, frenzied, despairing laugh, thinking she saw the hideous face of the poor wretch rising like a threat against the darkness of eternity.

'The wind was strong that summer day, Her petticoat has flown away.'

She fell back upon the mattress in a convulsion. They all drew near. She was no more.

A death always gives birth to a kind of stupefaction, so difficult is it to grasp this advent of nothingness and to resign ourselves to believe in it. But when he saw that she did not move, Charles threw himself upon her, crying –

'Farewell! farewell!'

Homais and Canivet dragged him from the room.

'Restrain yourself!'

'Yes,' said he, struggling, 'I'll be quiet. I'll not do anything. But leave me alone. I want to see her. She is my wife!'

And he wept.

'Cry,' said the chemist; 'let nature take her course; that will solace you.'

Weaker than a child, Charles let himself be led downstairs into the sitting-room, and Monsieur Homais soon went home. On the Place he was accosted by the blind man, who had dragged himself as far as Yonville in the hope of getting the antiphlogistic pomade, and was asking every passerby where the druggist lived.

'There now! as if I hadn't got other fish to fry. Well, so much the worse; you must come later on.'

And hurriedly he entered the shop.

He had to write two letters, prepare a sedative for Bovary, invent some lie that would conceal the poisoning, and work it up into an article for the *Fanal*, not to mention the people waiting to get the news from him; and when the villagers had all heard his story of the arsenic which she had mistaken for

sugar in making a vanilla cream, Homais returned to Bovary's.

He found him alone (Monsieur Canivet had left), sitting in an armchair near the window, staring with an idiotic look at the flags of the floor.

'Now,' said the chemist, 'you ought to fix the hour for the ceremony yourself.'

'Why? What ceremony?' Then, in a stammering, frightened voice, 'Oh, no! not that. No! I want to see her here.'

Homais, to keep himself in countenance, took up a water-bottle on the what-not to water the geraniums.

'Ah! thanks,' said Charles; 'you are good.'

But he did not finish, choking beneath the crowd of memories that this action of the druggist recalled to him.

Then to distract him, Homais thought fit to talk a little horticulture: plants wanted humidity. Charles bowed his head in sign of approbation.

'Besides, the fine days will soon be here again.'

'Ah!' said Bovary.

The druggist, at his wits' end, began softly to draw aside the small window-curtain.

'Hallo! there's Monsieur Tuvache passing.'

Charles repeated like a machine – 'Monsieur Tuvache passing!'

Homais did not dare to speak to him again about the funeral arrangements; it was the priest who succeeded in reconciling him to them.

He shut himself up in his consulting-room, took a pen, and after sobbing for some time, wrote – 'I wish her to be buried in her wedding-dress, with white shoes, and a wreath. Her hair is to be spread out over her shoulders. Three coffins, one of oak, one of

mahogany, one of lead. Let no one say anything to me. I shall have strength. Over all there is to be placed a large piece of green velvet. This is my wish; see that it is done.'

The two men were much surprised at Bovary's romantic ideas. The chemist at once went to him and said – 'This velvet seems to me a superfetation. Besides, the expense – '

'What's that to you?' cried Charles. 'Leave me! You did not love her. Go!'

The priest took him by the arm for a turn in the garden. He discoursed on the vanity of earthly things. God was very great, was very good: one must submit to his decrees without a murmur; nay, must even thank him.

Charles burst out into blasphemies: 'I hate your God!'

'The spirit of rebellion is still upon you,' sighed the ecclesiastic.

Bovary was far away. He was walking with great strides along by the wall, near the espalier, and he ground his teeth; he raised to heaven looks of malediction, but not so much as a leaf stirred.

A fine rain was falling: Charles, whose chest was bare, at last began to shiver; he went in and sat down in the kitchen.

At six o'clock a noise like a clatter of old iron was heard on the Place; it was the 'Hirondelle' coming in, and he remained with his forehead against the windowpane, watching all the passengers get out, one after the other. Félicité put down a mattress for him in the drawing-room. He threw himself upon it and fell asleep.

Although a philosopher, Monsieur Homais respected

the dead. So bearing no grudge to poor Charles, he came back again in the evening to sit up with the body, bringing with him three volumes and a pocketbook for taking notes.

Monsieur Bournisien was there, and two large candles were burning at the head of the bed, that had been taken out of the alcove. The druggist, on whom the silence weighed, was not long before he began formulating some regrets about this 'unfortunate young woman,' and the priest replied that there was nothing to do now but pray for her.

'Yet,' Homais went on, 'one of two things; either she died in a state of grace (as the Church has it) and then she has no need of our prayers; or else she departed impertinent (that is, I believe, the ecclesiastical expression), and then –'

Bournisien interrupted him, replying testily that it was none the less necessary to pray.

'But,' objected the chemist, 'since God knows all our needs, what can be the use of prayer?'

'What!' cried the ecclesiastic, 'prayer! Why, aren't you a Christian?'

'Excuse me,' said Homais; 'I admire Christianity. To begin with, it enfranchised the slaves, introduced into the world a morality – '

'That isn't the question. All the texts - '

'Oh! As to texts, look at history; it is known that all the texts have been falsified by the Jesuits.'

Charles came in, and advancing towards the bed, slowly drew the curtains.

Emma's head was turned towards her right shoulder, the corner of her mouth, which was open, seemed like a black hole at the lower part of her face; her two thumbs were bent into the palms of her hands; a kind of white dust besprinkled her lashes, and her eyes were beginning to disappear in that viscous pallor that looks like a thin web, as if spiders had spun it over. The sheet drooped from her breast to her knees, then rose at the tips of her toes, and it seemed to Charles that infinite masses, an enormous load, were weighing her down.

The church clock struck two. They could hear the loud murmur of the river flowing in the darkness at the foot of the terrace. Monsieur Bournisien from time to time blew his nose noisily, and Homais's pen was scratching over the paper.

'Come, my good friend,' he said, 'withdraw; this spectacle is tearing you to pieces.'

Charles once gone, the chemist and the curé recommenced their discussions.

'Read Voltaire,' said the one, 'read D'Holbach, read the *Encyclopaedia*!'

'Read the Letters of some Portuguese Jews,' said the other; 'read The Meaning of Christianity, by Nicolas, formerly a magistrate.'

They grew warm, they grew red, they both talked at once without listening to each other. Bournisien was scandalised at such audacity; Homais marvelled at such stupidity; and they were on the point of growing offensive when Charles suddenly reappeared. A fascination drew him. He was continually coming upstairs.

He stood opposite her, the better to see her, and he lost himself in a contemplation so deep that it was no longer painful.

He recalled stories of catalepsy, the marvels of magnetism, and he said to himself that by willing it with all his force he might perhaps succeed in reviving her. Once he even bent towards her, and cried in a low voice, 'Emma! Emma!' His strong breathing made the flames of the candles tremble against the wall.

At daybreak Madame Bovary, senior, arrived. Charles as he embraced her burst into another flood of tears. She tried, as the chemist had done, to make some remarks to him on the expenses of the funeral. He became so angry that she was silent, and he even commissioned her to go to town at once and buy what was necessary.

Charles remained alone the whole afternoon; they had taken Berthe to Madame Homais's; Félicité was in the room upstairs with Madame Lefrançois.

In the evening he had some visitors. He rose, pressed their hands, unable to speak. Then they sat down near one another, and formed a large semicircle in front of the fire. With lowered faces, and swinging one leg crossed over the other knee, they uttered deep sighs at intervals; each one was inordinately bored, and yet none would be the first to go.

Homais, when he returned at nine o'clock (for the last two days only Homais seemed to have been on the Place), was laden with a stock of camphor, of benzine, and aromatic herbs. He also carried a large jar full of chlorine water, to keep off all miasmata. Just then the servant, Madame Lefrançois, and Madame Bovary, senior, were busy about Emma, finishing dressing her, and they were drawing down the long stiff veil that covered her to her satin shoes.

Félicité was sobbing – 'Ah! my poor mistress! my poor mistress!'

'Look at her,' said the landlady, sighing; 'how pretty she still is! Now, couldn't you swear she was going to get up in a minute?'

Then they bent over her to put on her wreath. They

had to raise the head a little, and a rush of black liquid issued, as if she were vomiting, from her mouth.

'Oh, goodness! The dress; take care!' cried Madame Lefrançois. 'Now, just come and help,' she said to the chemist. 'Perhaps you're afraid?'

'I afraid?' replied he, shrugging his shoulders. 'I dare say! I've seen all sorts of things at the hospital when I was studying pharmacy. We used to make punch in the dissecting room! Nothingness does not terrify a philosopher; and, as I often say, I even intend to leave my body to the hospitals, in order, later on, to serve science.'

The curé on his arrival enquired how Monsieur Bovary was, and, on the reply of the druggist, went on – 'The blow, you see, is still too recent.'

Then Homais congratulated him on not being exposed, like other people, to the loss of a beloved companion; whence there followed a discussion on the celibacy of priests.

'For,' said the chemist, 'it is unnatural that a man should do without women! There have been crimes -'

'But, good heaven!' cried the ecclesiastic, 'how do you expect an individual who is married to keep the secrets of the confessional, for example?'

Homais fell foul of the confessional. Bournisien defended it; he enlarged on the acts of restitution that it brought about. He cited various anecdotes about thieves who had suddenly become honest. Military men on approaching the tribunal of penitence had felt the scales fall from their eyes. At Fribourg there was a minister —

His companion was asleep. Then he felt somewhat stifled by the over-heavy atmosphere of the room; he opened the window; this awoke the chemist.

'Come, take a pinch of snuff,' he said to him. 'Take it, it'll relieve you.'

A continual barking was heard in the distance. 'Do you hear that dog howling?' said the chemist.

'They smell the dead,' replied the priest. 'It's like bees; they leave their hives on the decease of any person.'

Homais made no remark upon these prejudices, for he had again dropped asleep. Monsieur Bournisien, stronger than he, went on moving his lips gently for some time, then insensibly his chin sank down, he let fall his big black boot, and began to snore.

They sat opposite one another, with protruding stomachs, puffed-up faces, and frowning looks, after so much disagreement uniting at last in the same human weakness, and they moved no more than the corpse by their side, that seemed to be sleeping.

Charles coming in did not wake them. It was the last time; he came to bid her farewell.

The aromatic herbs were still smoking, and spirals of bluish vapour blended at the window-sash with the fog that was coming in. There were few stars, and the night was warm. The wax of the candles fell in great drops upon the sheets of the bed. Charles watched them burn, tiring his eyes against the glare of their yellow flame.

The watering on the satin gown shimmered white as moonlight. Emma was lost beneath it; and it seemed to him that, spreading beyond her own self, she blended confusedly with everything around her – the silence, the night, the passing wind, the damp odours rising from the ground.

Then suddenly he saw her in the garden at Tostes, on a bench against the thorn hedge, or else at Rouen

in the streets, on the threshold of their house, in the yard at Bertaux. He again heard the laughter of the happy boys beneath the apple trees: the room was filled with the perfume of her hair; and her dress rustled in his arms with a noise like electricity. The dress was still the same.

For a long while he thus recalled all his lost joys, her attitudes, her movements, the sound of her voice. Upon one fit of despair followed another, and even others, inexhaustible as the waves of an overflowing sea.

A terrible curiosity seized him. Slowly, with the tips of his fingers, palpitating, he lifted her veil. But he uttered a cry of horror that awoke the other two.

They dragged him down into the sitting-room. Then Félicité came up to say that he wanted some of her hair.

'Cut some off,' replied the druggist.

And as she did not dare to, he himself stepped forward, scissors in hand. He trembled so that he pierced the skin of the temple in several places. At last, stiffening himself against emotion, Homais gave two or three great cuts at random that left white patches amongst that beautiful black hair.

The chemist and the curé plunged anew into their occupations, not without sleeping from time to time, of which they accused each other reciprocally at each fresh awakening. Then Monsieur Bournisien sprinkled the room with holy water and Homais threw a little chlorine water on the floor.

Félicité had taken care to put on the chest of drawers, for each of them, a bottle of brandy, some cheese, and a large roll; and the druggist, who could not hold out any longer, about four in the morning

sighed - 'My word! I should like to take some sustenance.'

The priest did not need any persuading; he went out to go and say mass, came back, and then they ate and hobnobbed, giggling a little without knowing why, stimulated by that vague gaiety that comes upon us after times of sadness, and at the last glass the priest said to the druggist, as he clapped him on the shoulder – 'We shall end by understanding one another.'

In the passage downstairs they met the undertaker's men, who were coming in. Then Charles for two hours had to suffer the torture of hearing the hammer resound against the wood. Next day they lowered her into her oak coffin, that was fitted into the other two; but as the bier was too large, they had to fill up the gaps with the wool of a mattress. At last, when the three lids had been planed down, nailed, soldered, it was placed outside in front of the door; the house was thrown open, and the people of Yonville began to flock round.

Old Rouault arrived. He fainted on the Place when he saw the black cloth.

He had only received the chemist's letter thirty-six hours after the event; and, in consideration for his feelings, Homais had so worded it that it was impossible to make out what it was all about.

First, the old fellow had fallen as if struck by apoplexy. Next, he understood that she was not dead, but she might be. At last, he had put on his blouse, taken his hat, fastened his spurs to his boots, and set out at full speed; and the whole of the way old Rouault, panting, was torn by anguish. Once even he was obliged to dismount. He was dizzy; he heard voices round about him; he felt himself going mad.

Day broke. He saw three black hens asleep in a tree. He shuddered, horrified at this omen. Then he promised the Holy Virgin three chasubles for the church, that he would go barefoot from the graveyard at the Bertaux to the chapel of Vassonville.

He entered Maromme shouting for the people of the inn, burst open the door with a thrust of his shoulder, made for a sack of oats, emptied a bottle of sweet cider into the manger, and again mounted his nag, whose feet struck fire as it dashed along.

He told himself that no doubt they would save her; the doctors would discover some remedy surely. He remembered all the miraculous cures he had heard of. Then she appeared to him dead. There she was before his eyes, lying on her back in the middle of the road. He reined up, and the hallucination vanished.

At Quincampoix, to give himself heart, he drank three cups of coffee in succession. He fancied they had made a mistake in the name in writing. He looked for the letter in his pocket, felt it there, but did not dare to open it.

At last he began to think it was all a joke; someone's spite, the jest of some wag; and besides, if she were dead, one would have known it. But no! There was nothing extraordinary about the country; the sky was blue, the trees swayed; a flock of sheep passed. He saw the village; he was seen coming bending forward upon his horse, belabouring it with great blows, the girths dripping with blood.

When he had recovered consciousness, he fell, weeping, into Bovary's arms: 'My girl! Emma! my child! tell me -'

The other replied, sobbing, 'I don't know! I don't know! It's a curse!'

The druggist separated them. 'These horrible details are useless. I will tell this gentleman all about it. Here are the people coming. Dignity! Come now! Philosophy!'

The poor fellow tried to show himself brave, and repeated several times, 'Yes! courage!'

'Oh,' cried the old man, 'so I will have, by God! I'll go along o' her to the end!'

The bell began tolling. All was ready; they had to start. And seated in a stall of the choir, side by side, they saw pass and repass in front of them continually the three chanting choristers.

The serpent-player was blowing with all his might. Monsieur Bournisien, in full vestments, was singing in a shrill voice. He bowed before the tabernacle, raising his hands, stretched out his arms. Lestiboudois went about the church with his whalebone stick. The bier stood near the lectern, between four

rows of candles. Charles felt inclined to get up and put them out.

Yet he tried to stir himself to a feeling of devotion, to throw himself into the hope of a future life in which he should see her again. He imagined to himself she had gone on a long journey, far away, for a long time. But when he thought of her lying there, and that all was over, that they would lay her in the earth, he was seized with a fierce, gloomy, despairful rage. At times he thought he felt nothing more, and he enjoyed this lull in his pain, whilst at the same time he reproached himself for being a wretch.

The sharp noise of an iron-ferruled stick was heard on the stones, striking them at irregular intervals. It came from the end of the church, and stopped short at the lower aisles. A man in a coarse brown jacket knelt down painfully. It was Hippolyte, the stable-boy at the Lion d'Or. He had put on his new leg.

One of the choristers went round the nave making a collection, and the coppers chinked one after the other on the silver plate.

'Oh, make haste! I am in pain!' cried Bovary, angrily throwing him a five-franc piece. The churchman thanked him with a deep bow.

They sang, they knelt, they stood up; it was endless! He remembered that once, in the early times, they had been to mass together, and they had sat down on the other side, on the right, by the wall. The bell began again. There was a great moving of chairs; the bearers slipped their three staves under the coffin, and everyone left the church.

Then Justin appeared at the door of the shop. He suddenly went in again, pale, staggering.

People were at the windows to see the procession

pass. Charles at the head walked erect. He affected a brave air, and saluted with a nod those who, coming out from the lanes or from their doors, stood amidst the crowd.

The six men, three on either side, walked slowly, panting a little. The priests, the choristers, and the two choirboys recited the *De profundis*, and their voices echoed over the fields, rising and falling with their undulations. Sometimes they disappeared in the windings of the path; but the great silver cross rose always between the trees.

The women followed in black cloaks with turneddown hoods; each of them carried in her hands a large lighted candle, and Charles felt himself growing weaker at this continual repetition of prayers and torches, beneath this oppressive odour of wax and of cassocks. A fresh breeze was blowing; the rye and colza were sprouting, little dewdrops trembled at the roadsides and on the hawthorn hedges. All sorts of joyous sounds filled the air; the jolting of a cart rolling afar off in the ruts, the crowing of a cock, repeated again and again, or the gambolling of a foal running away under the apple trees. The pure sky was fretted with rosy clouds; a bluish haze rested upon the cots covered with iris. Charles as he passed recognised each courtyard. He remembered mornings like this, when, after visiting some patient, he came out from one and returned to her.

The black cloth bestrewn with white beads blew up from time to time, laying bare the coffin. The tired bearers walked more slowly, and it advanced with constant jerks, like a boat that pitches with every wave.

They reached the cemetery. The men went right down to a place in the grass where a grave was dug.

They ranged themselves all round; and while the priest spoke, the red soil thrown up at the sides kept noiselessly slipping down at the corners.

Then when the four ropes were arranged the coffin was placed upon them. He watched it descend; it seemed descending for ever. At last a thud was heard; the ropes creaked as they were drawn up. Then Bournisien took the spade handed to him by Lestiboudois; with his left hand all the time sprinkling water, with the right he vigorously threw in a large spadeful; and the wood of the coffin, struck by the pebbles, gave forth that dread sound that seems to us the reverberation of eternity.

The ecclesiastic passed the holy water sprinkler to his neighbour. This was Homais. He swung it gravely, then handed it to Charles, who sank to his knees in the earth and threw in handfuls of it, crying, 'Adieu!' He sent her kisses; he dragged himself towards the grave, to engulf himself with her. They led him away, and he soon grew calmer, feeling perhaps, like the others, a vague satisfaction that it was all over.

Old Rouault on his way back began quietly smoking a pipe, which Homais in his innermost conscience thought not quite the thing. He also noticed that Monsieur Binet had not been present, and that Tuvache had 'made off' after mass, and that Theodore, the notary's servant, wore a blue coat, 'as if one could not have got a black coat, since that is the custom, by Jove!' And to share his observations with others he went from group to group. They were deploring Emma's death, especially Lheureux, who had not failed to come to the funeral.

'Poor little woman! What a trouble for her husband!'
The druggist continued, 'Do you know that but for

me he would have committed some fatal attempt upon himself?'

'Such a good woman! To think that I saw her only last Saturday in my shop.'

'I haven't had leisure,' said Homais, 'to prepare a few words that I would have cast upon her tomb.'

Charles on getting home undressed, and old Rouault put on his blue blouse. It was a new one, and as he had often during the journey wiped his eyes on the sleeves, the dye had stained his face, and the traces of tears made lines in the layer of dust that covered it.

Madame Bovary senior was with them. All three were silent. At last the old fellow sighed – 'Do you remember, my friend, that I went to Tostes once, when you had just lost your first deceased? I consoled you at that time. I thought of something to say then, but now – 'Then, with a loud groan that shook his whole chest, 'Ah! this is the end for me, do you see! I saw my wife go, then my son, and now today it's my daughter.'

He wanted to go back at once to the Bertaux, saying that he could not sleep in this house. He even refused to see his granddaughter.

'No, no! It would grieve me too much. Only you'll kiss her many times for me. Goodbye! you're a good fellow! And then I shall never forget that,' he said, slapping his thigh. 'Never fear, you shall always have your turkey.'

But when he reached the top of the hill he turned back, as he had turned once before on the road of Saint-Victor when he had parted from her. The windows of the village were all on fire beneath the slanting rays of the sun sinking behind the field. He put his hand over his eyes, and saw in the horizon

an enclosure of walls, where trees here and there formed black clusters between white stones; then he went on his way at a gentle trot, for his nag had gone lame.

Despite their fatigue, Charles and his mother stayed very long that evening talking together. They spoke of the days of the past and of the future. She would come to live at Yonville; she would keep house for him; they would never part again. She was ingenious and caressing, rejoicing in her heart at gaining once more an affection that had wandered from her for so many years. Midnight struck. The village as usual was silent, and Charles, awake, thought always of her.

Rodolphe, who, to distract himself, had been rambling about the wood all day, was sleeping quietly in his château, and Léon, down yonder, always slept.

There was another who at that hour was not asleep.

On the grave between the pine trees a child was on his knees weeping, and his heart, rent by sobs, was beating in the shadow beneath the load of an immense regret, sweeter than the moon and fathomless as the night. The gate suddenly grated. It was Lestiboudois; he came to fetch his spade, that he had forgotten. He recognised Justin climbing over the wall, and at last knew who the culprit was who stole his potatoes. The next day Charles had the child brought back. She asked for her mamma. They told her she was away; that she would bring her back some toys. Berthe spoke of her again several times, then at last thought no more of her. The child's gaiety broke Bovary's heart, and he had to bear besides the intolerable consolations of the chemist.

Money troubles soon began again, Monsieur Lheureux urging on anew his friend Vinçart, and Charles pledged himself for exorbitant sums, for he would never consent to let the smallest of the things that had belonged to *her* be sold. His mother was exasperated with him; he grew even more angry than she did. He had altogether changed. She left the house.

Then everyone began 'taking advantage' of him. Mademoiselle Lempereur presented a bill for six months' teaching, although Emma had never taken a lesson (despite the receipted bill she had shown Bovary); it was an arrangement between the two women. The man at the circulating library demanded three years' subscriptions; Mère Rollet claimed the postage due for some twenty letters, and when Charles asked for an explanation, she had the delicacy to reply – 'Oh, I don't know. It was for her business affairs.'

With every debt he paid Charles thought he had come to the end of them. But others followed cease-lessly. He sent in accounts for professional attendance. He was shown the letters his wife had written. Then he had to apologise.

Félicité now wore Madame Bovary's gowns; not all, for he had kept some of them, and he went up to look at them in her dressing-room, locking himself in there; she was about her height, and often Charles, seeing her from behind, was seized with an illusion, and cried out – 'Oh, stay, stay!'

But at Whitsuntide she bolted from Yonville, carried off by Theodore, and stealing all that was left of the wardrobe.

It was about this time that the widow Dupuis had the honour to inform him of the marriage 'of Monsieur Léon Dupuis her son, notary at Yvetot, to Mademoiselle Léocadié Leboeuf of Bondeville.' Charles, among the other congratulations he sent him, wrote this sentence – 'How glad my poor wife would have been!'

One day when, wandering aimlessly about the house, he had gone up to the attic, he felt a pellet of fine paper under his slipper. He opened it and read: 'Courage, Emma, courage. I would not bring misery into your life'. It was Rodolphe's letter, fallen to the ground between the boxes, where it had remained, and that the wind from the dormer-window had just blown towards the door. And Charles stood, motionless and staring, in the very same place where, long ago, Emma, in despair, and paler even than he, had thought of dving. At last he discovered a small R at the bottom of the second page. What did this mean? He remembered Rodolphe's attentions, his sudden disappearance, his constrained air when they had met two or three times since. But the respectful tone of the letter deceived him

'Perhaps they loved each other platonically,' he said to himself.

Besides, Charles was not one to go to the bottom of things; he shrank from proofs, and his vague jealousy was lost in the immensity of his woe.

Everyone, he thought, must have adored her; all men assuredly must have coveted her. She seemed but the more beautiful to him for this; he was seized with a lasting, furious desire for her, that inflamed his despair, and that was boundless, because it was now unrealisable.

To please her, as if she were still living, he adopted her predilections, her ideas; he bought patent leather boots and took to wearing white cravats. He put cosmetics on his moustache, and, like her, signed notes of hand. She corrupted him from beyond the grave.

He was obliged to sell his silver piece by piece; next he sold the drawing-room furniture. All the rooms were stripped; but the bedroom, her own room, remained as before. After his dinner Charles went up there. He pushed the round table in front of the fire, and drew up *her* armchair. He sat down opposite it. A candle burnt in one of the gilt candlesticks. Berthe by his side was painting prints.

He suffered, poor man, at seeing her so badly dressed, with unlaced boots, and the armholes of her pinafore torn down to the hips; for the charwoman took no care of her. But she was so sweet, so pretty, and her little head bent forward so gracefully, letting the dear fair hair fall over her rosy cheeks, that an infinite joy came upon him, a happiness mingled with bitterness, like those ill-made wines that taste of resin. He mended her toys, made her puppets from cardboard, or sewed up half-torn dolls. Then, if his eyes fell upon the work-box, a ribbon lying about or even a pin

left in a crack of the table, he began to dream, and looked so sad that she became as sad as he.

No one now came to see them, for Justin had run away to Rouen, where he was a grocer's assistant, and the druggist's children saw less and less of the child, Monsieur Homais not caring, seeing the difference of their social position, to continue the intimacy.

The blind man, whom he had not been able to cure with the pomade, had gone back to the hill of Bois-Guillaume, where he told the travellers of the vain attempt of the druggist, to such an extent that Homais, when he went to town, hid behind the curtains of the 'Hirondelle' to avoid meeting him. He detested him, and wishing in the interests of his own reputation to get rid of him at all costs, he directed against him a secret battery, that betrayed the depth of his intellect and the baseness of his vanity. Thus, for six consecutive months, one could read in the Fanal de Rouen paragraphs such as these - 'All who bend their steps towards the fertile plains of Picardy have, no doubt, remarked, by the Bois-Guillaume hill, a wretch suffering from a horrible facial wound. He importunes, persecutes one, and levies a regular tax on all travellers. Are we still living in the monstrous times of the Middle Ages, when vagabonds were permitted to display in our public places leprosy and scrofulas they had brought back from the Crusades?'

Or-

'In spite of the laws against vagabondage, the approaches to our great towns continue to be infected by bands of beggars. Some are seen going about alone, and these are not, perhaps, the least dangerous. What are our ediles about?'

Then Homais invented anecdotes - 'Yesterday by

the Bois-Guillaume hill, a skittish horse – 'And then followed the story of an accident caused by the presence of the blind man.

He contrived things so well that the fellow was locked up. But he was released. He began again, and Homais began again. It was a struggle. Homais won, for his foe was condemned to lifelong confinement in an asylum.

This success emboldened him, and henceforth there was no longer a dog run over, a barn burnt down, a woman beaten in the parish, of which he did not immediately inform the public, guided always by love of progress and hatred of priests. He drew comparisons between the elementary and clerical schools, to the detriment of the latter; called to mind the massacre of St Bartholomew àpropos of a grant of one hundred francs to the church, and denounced abuses, aired new views. That was his phrase. Homais was digging and delving; he was becoming dangerous.

However, he was stifling in the narrow limits of journalism, and soon he was hankering after a book – a work! Whereupon he composed *General Statistics of the Canton of Yonville, followed by Climatological Remarks.* The statistics drove him to philosophy. He busied himself with great questions: the social problem, moralisation of the poorer classes, pisciculture, india-rubber, railways, etc. He even began to blush at being a bourgeois. He affected the artistic style. He smoked. He bought two *chic* Pompadour statuettes to adorn his drawing-room.

He by no means gave up his shop. On the contrary, he kept well abreast of new discoveries. He followed the great movement of chocolates; he was the first to introduce 'cocoa' and 'revalenta' into the Seine-

Inférieure. He was enthusiastic about the hydroelectric Pulvermacher chains; he wore one himself, and when at night he took off his flannel vest, Madame Homais stood quite dazzled before the golden spiral beneath which he was hidden, and felt her ardour redouble for this man more bandaged than a Scythian, and splendid as one of the Magi.

He had fine ideas about Emma's tomb. First he proposed a broken column with some drapery, next a pyramid, then a Temple of Vesta, a sort of rotunda, or else a 'ruined pile.' And in all his plans Homais always stuck to the weeping willow, which he regarded as the indispensable emblem of grief.

Charles and he made a journey to Rouen together to look at some tombs at a funeral furnisher's, accompanied by an artist, one Vaufrylard, a friend of Bridoux's, who made puns all the time. At last, after having examined some hundred designs, having ordered an estimate and made another journey to Rouen, Charles decided in favour of a mausoleum, which on the two principal sides was to have a 'spirit bearing an extinguished torch.'

As to the inscription, Homais could thing of nothing so fine as 'Sta viator', and he got no further; he racked his brain, he constantly repeated 'Sta viator'. At last he hit upon 'Amabilem conjugem calcas', which was adopted.

A strange thing was that Bovary, while continually thinking of Emma, was forgetting her. He grew desperate as he felt this image fading from his memory despite all efforts to hold it. Yet every night he dreamt of her; it was always the same dream. He drew near her, but when he was about to clasp her she fell into decay in his arms.

For a week he was seen going to church in the evening, Monsieur Bournisien even paid him two or three visits, then gave him up. Moreover, the old fellow was growing intolerant, fanatic, said Homais. He thundered against the spirit of the age, and never failed, every other week, in his sermon, to recount the death agony of Voltaire, who died devouring his excrements, as everyone knows.

In spite of the economy with which Bovary lived, he was far from being able to pay off his old debts. Lheureux refused to renew any more bills. A distraint became imminent. Then he appealed to his mother, who consented to let him take a mortgage on her property, but with a great many recriminations against Emma; and in return for her sacrifice she asked for a shawl that had escaped the depredations of Félicité. Charles refused to give it her; they quarrelled.

She made the first overtures of reconciliation by offering to have the little girl, who could help her in the house, to live with her. Charles consented to this, but when the time for parting came, all his courage failed him. Then there was a final, complete rupture.

As his affections vanished, he clung more closely to the love of his child. She made him anxious, however, for she coughed sometimes, and had red spots on her cheeks.

Opposite his house, flourishing and merry, was the family of the chemist, with whom everything was prospering. Napoléon helped him in the laboratory, Athalie embroidered him a skullcap, Irma cut out rounds of paper to cover the preserves, and Franklin recited Pythagoras' table in a breath. He was the happiest of fathers, the most fortunate of men.

Not so! A secret ambition devoured him. Homais

hankered after the cross of the Legion of Honour. He had plenty of claims to it.

'First, having at the time of the cholera distinguished myself by a boundless devotion; second, by having published, at my expense, various works of public utility, such as' (and he recalled his pamphlet entitled, Cider, its manufacture and effects, besides observations on the lanigerous plant-louse, sent to the Academy; his volume of statistics, and even his pharmaceutical thesis); 'not to mention that I am a member of several learned societies' (he was a member of exactly one).

'In short!' he cried, with a flourish, 'if it were only for distinguishing myself at fires!'

Then Homais inclined towards the Government. He secretly did the prefect great service during the elections. He sold himself – in a word, prostituted himself. He even addressed a petition to the sovereign in which he implored him to 'do him justice,' he called him 'our good king,' and compared him to Henri IV.

And every morning the druggist rushed for the paper to see if his nomination were in it. It was never there. At last, unable to bear it any longer, he had a grass plot in his garden designed to represent the Star of the Cross of Honour with two little strips of grass running from the top to imitate the ribbon. He walked round it with folded arms, meditating on the folly of the government and the ingratitude of men.

From respect, or from a sort of sensuality that made him carry on his investigations slowly, Charles had not yet opened the secret drawer of a rosewood desk which Emma had generally used. One day, however, he sat down before it, turned the key, and pressed the spring. All Léon's letters were there. This time there could be no doubt. He devoured them to the very last, ransacked every corner, all the furniture, all the drawers, behind the walls, sobbing, crying aloud, distraught, mad. He found a box and broke it open with a kick. Rodolphe's portrait flew full in his face in the midst of the overturned love-letters.

People wondered at his despondency. He never went out, saw no one, refused even to visit his patients. Then they began to say that 'he shut himself up to drink.'

Sometimes, however, some curious person climbed on to the garden hedge, and saw with amazement this wild, long-bearded, shabbily clothed man, weeping aloud as he walked to and fro.

On summer evenings he took his little girl with him and led her to the cemetery. They came back at nightfall, when the only light left in the Place was that in Binet's window.

The voluptuousness of his grief was, however, incomplete, for he had no one near him to share it, and he paid visits to Madame Lefrançois to be able to speak of her. But the landlady only listened with half an ear, having troubles like himself. For Lheureux had at last established the 'Favorites du Commerce', and Hivert, who enjoyed a great reputation for doing errands, insisted on a rise of wages and was threatening to go over 'to the opposition shop.'

One day when he had gone to the market at Argueil to sell his horse – his last resource – he met Rodolphe.

They both turned pale at sight of each other. Rodolphe, who had only sent his card, first stammered some apologies, then grew bolder, and even pushed his assurance (it was in the month of August and very hot) to the point of inviting him to have a bottle of beer at the public-house.

Leaning on the table opposite him, he chewed his cigar as he talked, and Charles was lost in reverie at this face that she had loved. He seemed to see again something of her in it. It was a marvel to him. He would have liked to have been this man.

The other went on talking agriculture, cattle, pasturage, filling out with banal phrases all the gaps where an allusion might slip in. Charles was not listening to him; Rodolphe noticed it, and he followed the succession of memories that crossed his face. This gradually grew redder; the nostrils throbbed fast, the lips quivered. There was at last a moment when Charles, full of sombre fury, fixed his eyes on Rodolphe, who, in something of fear, stopped talking. But soon the old look of weary lassitude returned to his face.

'I don't blame you,' he said.

Rodolphe was dumb. And Charles, his head in his hands, went on in a broken voice, and with the resigned accent of infinite sorrow – 'No, I don't blame you now.'

He even added a fine phrase, the only one he ever made – 'It is the fault of fatality!'

Rodolphe, who had managed the fatality, thought the remark very offhand from a man in his position, comic even, and a little mean.

The next day Charles went to sit down on the seat in the arbour. Rays of light were straying through the trellis, the vine leaves threw their shadows on the sand, the jasmines perfumed the air, the heavens were blue, Spanish flies buzzed round the lilies in bloom, and Charles was suffocating like a youth beneath the vague love influences that filled his aching heart.

At seven o'clock little Berthe, who had not seen him all the afternoon, went to fetch him to dinner.

His head was thrown back against the wall, his eyes closed, his mouth open, and in his hand was a long tress of black hair.

'Come along, papa,' she said.

And thinking he wanted to play, she pushed him gently. He fell to the ground. He was dead.

Thirty-six hours after, at the druggist's request, Monsieur Canivet arrived on the scene. He made a post-mortem and found nothing.

When everything had been sold, twelve francs seventy-five centimes remained, which served to pay for Mademoiselle Bovary's going to her grandmother. The good woman died the same year; old Roualt was paralysed, and it was an aunt who took charge of her. She is poor, and sends the child to a cotton-factory to earn a living.

Since Bovary's death three doctors have followed one another at Yonville without any success, so severely did Homais batter them. He has an enormous practice; the authorities treat him with consideration, and public opinion protects him.

He has just received the cross of the Legion of Honour.

Afterword

When Madame Bovary was first serialised in the Revue de Paris in 1856, it caused a national scandal. The authorities were up in arms over the immoral behaviour of its eponymous heroine, and mounted a legal attack. A worried Flaubert was accused of offending the public morality, and brought to trial the following year at the Palais de Justice in Paris. It was rumoured at the time that the authorities, sick of irreligious authors, were out to make an example of him, and had been requesting that he be sentenced to at least two years in jail. However, with a little assistance from Flaubert's brilliant defence lawyer, Monsieur Sénard, the court found that the nation's morality had not been jeopardised, and the author was acquitted.

Although the novel might seem rather tame by today's standards, it is not hard to see why it caused such a stir in the eighteen-fifties. It repeatedly deals with adultery, and – for its time – is comparatively daring in its presentation of the sexual act. Even when not 'explicit', the novel has a strong sensual flavour: the erotic thrill that many of its characters get from brushing against another person's clothes, or from a glimpse of their flesh, must have raised a few eyebrows in nineteenth-century Paris. Added to this, there is the blasphemous element: the adulterous nature of Emma's life and, more importantly, her eventual suicide, are clearly against the law of God; as are Monsieur Homais's bad-tempered rants about Christianity.

One hundred and fifty years later, of course, society is much less alarmed by such issues. However, it is a testament to its greatness as a novel that *Madame Bovary* has lost none of its impact. Now that changes in public attitudes have robbed it of its controversial status, it is justly remembered as not only Flaubert's masterpiece, but also as a landmark in the history of world literature. All of which makes it a little surprising to learn that this difficult, challenging, and ultimately very rewarding book, was also its author's first. To do justice to its many attributes would take more than a brief afterword, but a quick evaluation of what makes the novel so unique is possible.

One of the things that marks Madame Bovary out as a true work of genius is the clipped, precise nature of its prose style. Flaubert was notoriously exact in his choice of phrase and syntax; endlessly searching, as he put it, for 'le mot juste'. He was born the son of a surgeon (his father was the model for Bovary's Dr Larivière), and, as many critics have noted, there is a remarkably clinical element to his writing: a whiff, perhaps, of the post-mortem room. In his letters, Flaubert once described literature as 'the dissection of a beautiful woman', and this description is doubly apt for Madame Bovary. The author cuts cleanly and quickly to the heart of what is going on. This, added to the fact that Bovary is a 'realist' novel (part of a nineteenth century French tradition which also includes Balzac and Zola), gives the whole work a vivid clarity only rarely glimpsed in other writing.

Through this carefully-honed mixture of realism and linguistic precision, Flaubert conjures up a view of provincial country life that is so clear in the mind's eye, that one could almost be looking at a painting.

AFTERWORD

The detail of his brushwork is delicate: he always makes sure that we know the colour of the sky, the texture of the buildings and the streets, and the style and cut of the characters' clothes. He uses light like an Old Master too; casting subtle shade and brightness over his scenes, and always taking care to tell us how a room is lit. The beautifully visual feel of the book seduces the reader into an imaginative landscape which feels every bit as real as the world of Emma's romantic novels must seem to her.

However, Flaubert was not merely a follower of an established literary school. He was a great experimenter and innovator himself. In Madame Bovary, he is, for instance, constantly testing the boundaries of narrative form. Like the Modernist authors of the twentieth century, such as Virginia Woolf and James Joyce, Flaubert was keen to allow the psychology of his characters to have a bearing on the 'voice' of the book: a technique known in French as 'style indirect libre'. This technique - roughly translated as 'free indirect discourse' - means that happenings are described as if from the point of view of a character, but without actually using that character's voice. So it is that Madame Bovary is told through the impressions, emotions, and opinions of its protagonists. Everyone with whom the novel deals - Charles, Homais, even the long-dead Normans, eating their Lenten cakes in Part Three, Chapter 4 - are allowed to stamp their sensations and beliefs upon the text. It is through the thoughts of Emma, however, that the novel is predominantly told.

Madame Bovary herself is a striking and important figure in the history of literature, despite – or perhaps because of – the fact that she is emphatically not a

conventional heroine. Although she is very beautiful, as shown by the many men who fall in love with her through the course of the book, Emma is essentially unsympathetic. She is (at least to nineteenth-century eyes) 'immoral', with a strong selfishness at the core of her being. Because of this self-absorption, her husband dies a bankrupt, and Berthe, her daughter, ends up a pauper, working in a cotton-mill. However, what is so skilful about Flaubert's presentation of his leading lady is that, despite these failings, the reader still manages to understand, and even sympathise with her.

Emma's life begins in loneliness and isolation. Her childhood is spent on a country farm, far off from other children and wider society, and she enters a convent school at the age of thirteen. It is here that she begins to use her vivid imagination as a means of escape from the boredom of her surroundings. She becomes obsessed by romantic novels, dreaming of the idealised lovers she reads about in the novels of Sir Walter Scott. When her mother dies, Emma sees herself as a tragic heroine, achieving through her grief 'that exquisite ideal of wan decline from which the mediocre heart is ever excluded.' After this period of her life, she believes - crucially - that she has 'nothing more to learn and nothing more to feel'. In other words, her emotional development stops when her romanticised vision of the world takes root. It is this childishly unrealistic view of life and love that leads to the unhappiness and tragedy of her adult life.

One of the key themes of *Madame Bovary* is the discrepancy between illusion and reality. Throughout the book, Emma (along with many of the other characters) does not want to see life as it actually is.

AFTERWORD

She projects romantic ideals and feelings on to men, like Rodolphe and Leon, who clearly do not match them in actual fact. She spends Charles's limited money as if she was a millionairess. She sees herself as well-bred and genteel when she is, in fact, the lowly wife of a loutish country doctor.

This unrealistic view of the world might not have mattered but for Emma's other tragedy: that she has been born a woman in a man's world. This unavoidable fact of her social position is the one that ultimately frustrates all of her dreamy ambitions. She is a powerful, dominant, individual, living at a time when women were supposed to be meek and subservient. Had she been a man, she could easily have run off, like Leon, to the big city. She could have been rich, and moved in fashionable circles, like Rodolphe. She could have shaped her own destiny, without having to be dependent on a lazy and weak-willed husband. When she learns she is pregnant, she longs for a son, because she knows that a 'woman is forever hedged about . . . Always she feels the pull of some desire, the restraining pressure of some social restriction.' The wish for a boy, like all of her other wishes, does not, of course, come true.

Towards the end of her life, Flaubert makes explicit what has been implied all along: that Emma must, in some way, prostitute herself to get what she wants. When the debt collectors are knocking at her door, she frantically rushes to Maitre Guillaumin, who, like Lhereux before him, implies that, were she to sleep with him, her debts might be cancelled. Although she is repulsed by this suggestion, she quickly realises that such an arrangement might be her only option, and offers herself, for money, to Binet and Rodolphe.

When they refuse, she decides that suicide is her only way out. Yet even then, she must exploit her sexual hold over the young Justin to get arsenic from Homais's loft.

Thus, the tragedy of Madame Bovary's life and death leads us to the ultimate conclusion that perhaps it is masculine society, and not Emma herself, which is essentially immoral. She has committed adultery and defrauded her husband because such things were the only means she had of moulding her fate in a world dominated by men. The only tools she has ever had at her disposal have been her good-looks, and Charles's money. She has had enough strength of character to realise this, and exploit it. However flawed or unrealistic her vision of a perfect life might have been, she has stuck to it with great tenacity, and fought to achieve it, against overwhelming odds, with every weapon in her limited armoury. She has, at the last, remained faithful to herself, if not to her husband. It is this perverse strength of character that makes her such a memorable, and even touching, character, and which has assured her place in the gallery of the great literary figures.

Charles Bovary, on the other hand, is one of the most neglected and derided of literature's heroes. Over the years, critics and readers alike have dismissed him as boorish, ignorant, and, in some cases, lacking in any character at all. This is, however, unfair. We must remember that most of what we get to know about Charles comes through Emma's unflattering view of him. When Flaubert allows Monsieur Bovary's thoughts to take over the narrative, he comes across in a much more sympathetic light. However, his wife refuses to acknowledge this side of

AFTERWORD

his character, shunning him whenever he tries to reach out to her.

Emma's dismissiveness towards her husband is all the more poignant because, at heart, Charles is closer to Emma's idealised vision of a lover than any of the men with whom she conducts an affair. He also has more in common with her temperament. Charles Bovary clearly loves his wife very much, and would do anything to make her happy. He is, like her, something of a dreamer, with his own romantic ideals of life which are also ultimately frustrated. After her death, he is every bit as picky as she would have been over the choice of coffin, and every bit as dismissive of the extravagant expense of the funeral. And when she has finally been buried, he plays the melancholy role of a grieving romantic hero to the full, before eventually dving of a broken heart. If only husband and wife had made some meaningful contact, their sad lives and lonely deaths might have turned out very differently.

Bibliography

Sherrington, R. J., *Three Novels by Flaubert*, Clarendon Press, 1970

Starkie, Enid, Flaubert: The Making of the Master, Weidenfeld and Nicolson, 1967

Starkie, Enid, *Flaubert the Master*, Weidenfeld and Nicolson, 1971

Biography

Gustave Flaubert was born in Rouen in 1821. He initially studied to become a lawyer, but gave it up after a bout of ill-health, and devoted himself to writing. After travelling extensively, and working on many unpublished projects, he completed *Madame Bovary* in 1856. This was published to great scandal and acclaim, and Flaubert became a celebrated literary figure. His reputation was cemented with *Salammbô* (1862) and *Sentimental Education* (1869). He died in 1880, probably of a stroke, leaving his last work, *Bouvard et Pécuchet*, unfinished.